An Eakins Masterpiece Restored

D1224248

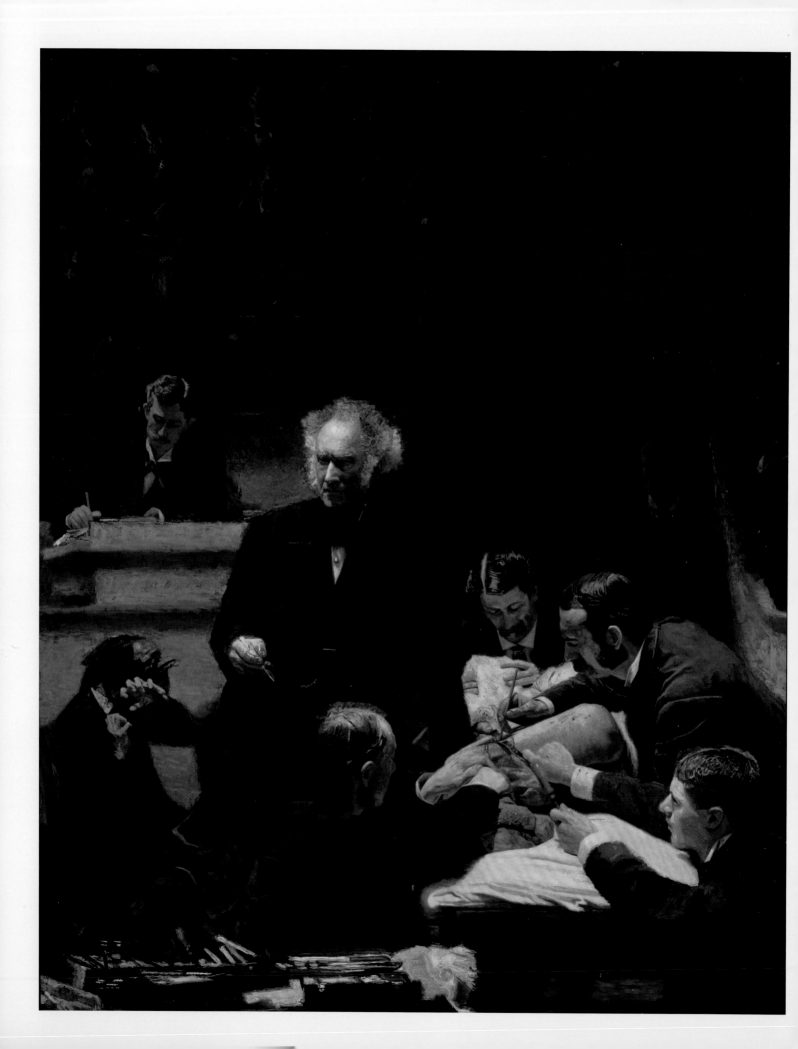

An Eakins Masterpiece Restored

Seeing *The Gross Clinic* Anew

EDITED BY

Kathleen A. Foster

Mark S. Tucker

WITH ESSAYS BY

Steven Conn

Kathleen A. Foster

Mark S. Schreiner, MD

Mark S. Tucker

Philadelphia Museum of Art

in association with

Yale University Press

New Haven and London

This publication was made possible by a grant from The Richard C. von Hess Foundation with additional support from the Center for American Art at the Philadelphia Museum of Art. The Richard C. von Hess Foundation generously supported the conservation of Thomas Eakins's *The Gross Clinic* and the related documentary, produced on the occasion of the exhibition *An Eakins Masterpiece Restored: Seeing "The Gross Clinic" Anew* (July 23, 2010–January 9, 2011). The exhibition was made possible by Joan and John Thalheimer, by the Robert J. Kleberg, Jr. and Helen C. Kleberg Foundation, by The Pew Charitable Trusts, and by Wachovia, a Wells Fargo Company.

Front cover (detail) and frontispiece: Thomas Eakins (American, 1844–1916), *Portrait of Dr. Samuel D. Gross (The Gross Clinic)*, 1875. Oil on canvas, 8 feet × 6 feet 6 inches (243.8 × 198.1 cm). Gift of the Alumni Association to Jefferson Medical College in 1878 and purchased by the Pennsylvania Academy of the Fine Arts and the Philadelphia Museum of Art in 2007 with the generous support of more than 3,600 donors, 2007-1-1

Back cover: Dissection kit belonging to Thomas Eakins, c. 1870–90. Philadelphia Museum of Art. Gift of an anonymous donor, 1985

Produced by the Publishing Department
Philadelphia Museum of Art
Sherry Babbitt
The William T. Ranney Director of Publishing
2525 Pennsylvania Avenue
Philadelphia, PA 19130 USA
www.philamuseum.org

Published by the Philadelphia Museum of Art
in association with
Yale University Press
P.O. Box 209040
302 Temple Street
New Haven, CT 06520-9040 USA
www.yalebooks.com/art

Edited by David Updike
Production by Richard Bonk
Designed by Bessas & Ackerman, Guilford, CT
Printed and bound in Canada by Transcontinental Litho Acme, Montreal

Library of Congress Cataloging-in-Publication Data

An Eakins masterpiece restored : seeing *The Gross Clinic* anew / edited by Kathleen A. Foster and Mark S. Tucker ; with essays by Steven Conn, Kathleen A. Foster, Mark S. Schreiner, MD, Mark S. Tucker.
 pages cm
 ISBN 978-0-87633-235-1 (PMA)
 ISBN 978-0-300-17979-8 (Yale)
1. Eakins, Thomas, 1844–1916. Gross Clinic. 2. Eakins, Thomas, 1844–1916—Criticism and interpretation. I. Foster, Kathleen A. II. Tucker, Mark S.
ND237.E15A64 2012
759.13—dc23 2012002520

Contents

This publication is dedicated to
ANNE D'HARNONCOURT (1943–2008),
and to the many other people whose passion and generosity ensured that
The Gross Clinic would find a permanent home in the city in which it was made.

The Gross Clinic was purchased in 2007 by the Pennsylvania Academy of the Fine Arts and the Philadelphia Museum of Art through The Joseph E. Temple Fund of the Pennsylvania Academy of the Fine Arts and the gift of Mrs. Thomas Eakins and Miss Mary Adeline Williams (by exchange) to the Philadelphia Museum of Art, and with the support of the following individuals and institutions:

The Annenberg Foundation
Athena and Nicholas Karabots
Robert L. McNeil, Jr.
Marguerite and Gerry Lenfest
Jeanette and Joe Neubauer
The Pew Charitable Trusts

The Dorrance H. Hamilton
 Charitable Trust
Leslie Miller and Richard Worley
Mrs. J. Maxwell Moran
Penelope P. Wilson

Jan and Warren Adelson in memory of
 Margaret and Raymond Horowitz
American Art Search
Mrs. Gustave G. Amsterdam
Graham Arader
Barbara B. and Theodore R. Aronson
Helen and Jack Bershad
Estate of Frank Paul Bowman
Michael and Veronica Bradley
Robert W. Brano
Mr. and Mrs. William C. Buck
William C. Bullitt
Donald R. Caldwell
Clara Callahan and Peter Goodman
Mr. and Mrs. Tristram C. Colket, Jr.
Connelly Foundation
Sarah and Frank Coulson
Maude de Schauensee
Anne d'Harnoncourt
Mrs. Fitz Eugene Dixon, Jr.
Jaimie and David Field
Mrs. Joanna G. Gabel

David W. Haas
Frederick R. Haas and Daniel K. Meyer, M.D.
Joseph and Sherry Hanley
Hannah L. and J. Welles Henderson
Barbara B. and Paul M. Henkels
Holly Beach Public Library Association
Lynne and Harold Honickman
James A. Michener Art Museum
Dr. and Mrs. Henry A. Jordan,
 in honor of Robert L. McNeil, Jr.
Kaiserman Family
Paul K. Kania
Jill and Peter Kraus
Carolyn Payne Langfitt
Larking Hill Foundation
Harriet and Ronald Lassin
Ellen and Jerry Lee
Judy and Peter Leone
Mr. and Mrs. John J. Lombard, Jr.
Mrs. Louis C. Madeira IV
Mr. and Mrs. Larry Magid
Agnes M. Mulroney

Dr. and Mrs. J. Brien Murphy and family
Elizabeth Anne O'Donnell
Jeffrey Orleans
Natalie Y. Peris Memorial Fund
Andrew M. Rouse
Susan K. Shapiro
1675 Foundation
Mr. and Mrs. E. Newbold Smith
Dr. Stanton and SaraKay Smullens
Marilyn L. Steinbright
Deborah W. Troemner
Veritable, LP
The William Penn Foundation
The Women's Committee of the
 Philadelphia Museum of Art
and two anonymous donors

with additional gifts from over 3,600
donors, including trustees and staff of the
Pennsylvania Academy of the Fine Arts and
the Philadelphia Museum of Art

Foreword

In November 2006, Thomas Jefferson University in Philadelphia announced that it had sold Thomas Eakins's 1875 masterpiece *The Gross Clinic* to the National Gallery of Art in Washington, DC, and Alice Walton, who was acquiring work for her new Crystal Bridges Museum of American Art in Bentonville, Arkansas. According to the terms of sale, the painting could remain in Philadelphia only if the buyers' price—$68 million—was matched locally within forty-five days. The challenge of raising that much money in such a short time seemed insurmountable to many. Yet for thousands of individuals the prospect of losing this great work, a powerful emblem of Philadelphia's high achievement in the arts and sciences, stirred deep feelings. Cultural and civic leaders, rallied by Philadelphia Museum of Art Director Anne d'Harnoncourt, were mobilized by their belief that Eakins's legacy and the region would be best served by keeping the painting in its richest context— the city that served as the artist's home and chief inspiration. In tandem with the Pennsylvania Academy of the Fine Arts (PAFA), the Museum launched a fundraising campaign of astonishing ambition and intensity, attracting more than 3,600 donors from all fifty states and abroad (some of whom are listed on the facing page). By their will and generosity the goal was reached, an exhilarating triumph of idealism and regional pride. In January 2007, the Academy and the Museum became joint owners of *The Gross Clinic*,

ensuring that Philadelphia would forever remain the home of a celebrated native son's greatest masterpiece.

The staff of both institutions had already been directly involved in the painting's care for decades. Thomas Jefferson University had turned to the Museum for conservation expertise in 1960–61, when Theodor Siegl carried out a desperately needed treatment with two assistants from PAFA, Louis B. Sloan and Joseph Amarotico. Siegl, a respected Eakins scholar in his own right, advised Jefferson on the care of the painting until his death in 1976. In 1982, a newly hired Philadelphia Museum of Art conservator, Mark S. Tucker (now the Museum's Vice Chair of Conservation and The Aronson Senior Conservator of Paintings), first worked on *The Gross Clinic*, along with other Eakins paintings, in preparation for the retrospective of the artist's work presented by the Museum in that year. He went on to assume the role of conservation advisor for some twenty-five years for the paintings by Eakins in the collection of Thomas Jefferson University, in which capacity he examined *The Gross Clinic* many times, so that by 2007 he had a depth of knowledge of its technique and condition rare for a painting just entering a museum collection. The artist likewise became Tucker's primary focus during the seminal research and conservation treatments done for the Museum's 2001–2 Eakins retrospective, which traveled to the Musée d'Orsay, Paris, and The Metropolitan Museum of Art, New York. Foster, the Philadelphia

Museum of Art's Robert L. McNeil, Jr., Senior Curator of American Art and Director of the Center for American Art, had also served for a decade as curator at PAFA, where she was responsible for the landmark 1985 acquisition of Charles Bregler's Thomas Eakins Collection. Her thoughtful study of the manuscripts and groundbreaking analysis of the drawings, paintings, and photographs in this collection opened a new door to Eakins's process, revealing the artist's preparatory works as evidence of a strongly individual sensibility.

Members of the Philadelphia Museum of Art and Pennsylvania Academy of the Fine Arts executive, curatorial, and conservation staffs, whose combined experience and qualifications boded especially well for the enterprise, came together in 2008 to discuss the stewardship of the painting. This group, which, in addition to Foster and Tucker, included PAFA President and Chief Executive Officer David R. Brigham, curator Anna O. Marley, and conservator Aella Diamantopoulos—and which I joined the following year when I arrived in Philadelphia—determined to probe this much-studied painting's history more deeply to identify what changes had occurred in its condition and appearance. The archival and technical research conducted in 2009 established that not long after Eakins's death in 1916 an improper cleaning had significantly altered the painting's original appearance, which the artist had taken great care to produce.

Since the painting was last cleaned and restored in 1961, major breakthroughs have been achieved in our knowledge of Eakins's aesthetics and technique. Particularly within the last decade, that information has been applied to the cleaning and restoration of his paintings, enabling Philadelphia Museum of Art conservators to return them to a state more representative of the artist's intentions. The stewardship committee reconvened in 2009 and, after reviewing the results of the examination and research, decided to move forward with a restoration of *The Gross Clinic* that would be informed by new historical research and technical analysis and sympathetic to Eakins's documented artistic convictions.

From the outset it was apparent that the circumstances under which the work would be done—the facilities, research resources, and, most importantly, staff expertise—were uniquely favorable at this time. The Museum's new Joan and John Thalheimer Paintings Conservation Studio, located in the Perelman Building (just a few blocks, incidentally, from the house where Eakins painted *The Gross Clinic*), is a spacious, well-equipped facility with high ceilings and abundant natural light, ideally suited to the conservation project. For purposes of research, Philadelphia holds the richest concentration of Eakins historical and technical material in the records and archives of the Museum, PAFA, and Thomas Jefferson University. The project staff's access to and familiarity with these documentary resources were indispensable to the task at hand. The Eakins scholars who oversaw the project, Foster and Tucker, are especially accustomed to curatorial/conservation collaboration, and during the work on the painting in 2010 Tucker called upon the talents of two notably gifted Museum conservators: Allen Kosanovich, Andrew W. Mellon Fellow in Paintings Conservation, and Teresa Lignelli, Conservator of Paintings and a veteran of previous Eakins treatments at the Museum.

Completion of the cleaning and restoration in 2010 was marked by a celebratory exhibition, *An Eakins Masterpiece Restored: Seeing "The Gross Clinic" Anew*, organized by Foster and Tucker. The newly restored painting was presented with a selection of works by the artist, as well as historical objects and explanatory materials, including a documentary film produced by Suzanne Penn, PMA Conservator of Modern and Contemporary Paintings. The rich context for consideration of the painting from multiple points of view encouraged an enthusiastic audience of tens of thousands to see this familiar painting with fresh eyes and renewed appreciation.

The exhibition was part of a larger program to share as widely as possible the work our institutions have done to study, preserve, and restore *The Gross Clinic*. Joining us in this endeavor were Steven Conn and Mark S. Schreiner, MD, whose contributions to the symposium presented at the PMA in September 2010 developed into the essays in this book that place Eakins and his painting in the larger contexts of, respectively, civic identity and activism, and the

revolutionary advances in medicine to which *The Gross Clinic* and its companion, *The Agnew Clinic* (1889; University of Pennsylvania Art Collection, Philadelphia), bear witness.

We are extraordinarily grateful to The Richard C. von Hess Foundation for supporting the research and treatment project, the documentary film for the exhibition, and the present publication. For funding the exhibition, we are deeply indebted to Joan and John Thalheimer; the Robert J. Kleberg, Jr., and Helen C. Kleberg Foundation; The Pew Charitable Trusts; and Wachovia, a Wells Fargo Company. The exhibition was greatly enriched by the generosity of lenders, including Daniel W. Dietrich II; the Worcester Art Museum, Massachusetts; the University of Pennsylvania, Philadelphia; the Crystal Bridges Museum of American Art, Bentonville, Arkansas; and the Archives of Thomas Jefferson University, Philadelphia.

This book, as well as the exhibition out of which it grew, is offered as sincere tribute to the cultural and civic consciousness of the thousands of donors far and wide who stepped forward to keep the painting in Philadelphia, and all who, like us, marvel at the transfixing power of this icon of American culture.

Timothy Rub
*The George D. Widener Director
and Chief Executive Officer*

Acknowledgments

The joint acquisition of *The Gross Clinic* in 2006 launched a collaboration with our colleagues at the Pennsylvania Academy of the Fine Arts to preserve and present the painting. We are grateful for their commitment to this project, especially the Steering Committee members, curator Anna O. Marley and conservator Aella Diamantopoulos, as well as registrar Gale Rawson and archivist Cheryl Leibold.

Colleagues at the institutions lending works to the exhibition offered valuable assistance throughout our recent research and treatment of *The Gross Clinic*: at Thomas Jefferson University, archivist F. Michael Angelo was helpful with many aspects of our research, as was Julie Berkowitz, previously curator of Jefferson's art collection, who generously offered her personal research files, which have now been gathered into the Eakins Archives at the Philadelphia Museum of Art. Thanks also to curator Chris Crosman, collections supervisor Liz Workman, and registrar Elizabeth Weinman at the Crystal Bridges Museum of American Art in Bentonville, Arkansas; Lynn Marsden-Atlass, curator of collections at the University of Pennsylvania, Philadelphia; Susan E. Phillips, Senior Vice President for Public Affairs at the University of Pennsylvania Health System; and then-curator William Rudolph and conservator Rita Albertson of the Worcester Art Museum, Massachusetts.

Additional research assistance was provided by colleagues at The Metropolitan Museum of Art in New York, including curator H. Barbara Weinberg, imaging manager Barbara Bridgers, and image librarian Julie Zeftel, who supplied the superb images of the museum's watercolor replica and 1917 photograph of *The Gross Clinic*. Other helpful colleagues throughout the development of the exhibition and book have included Robert E. Booth, Jr., MD, Alan C. Braddock, David B. Brownlee, Kenneth Finkel, Hannes Jarka-Sellers, Michael Leja, Michael J. Lewis, Kimberly Orcutt, Steven J. Peitzman, MD, Marc Simpson, Jennifer Stettler Parsons, and Amy B. Werbel. Special thanks to Thomas O. Halloran and Eric N. Tucker for their invaluable assistance in our attempts to understand Eakins's perspective scheme.

Many past and present staff members at the Philadelphia Museum of Art assisted with the conservation project, the exhibition, and this publication. We wish to express special personal thanks to three valued colleagues in Paintings Conservation at the Philadelphia Museum of Art with whom it was our great privilege to work on *The Gross Clinic*. The restoration benefited beyond measure from the talents, dedication, and insight of Terry Lignelli, Conservator of Paintings, and Allen Kosanovich, Andrew W. Mellon Fellow in Paintings Conservation. Their unsurpassed visual and inpainting skills, rigorous standards, and extraordinarily thoughtful, sensitive approach were crucial to this complex undertaking at every stage and to its ultimate results. Suzanne Penn made time in her schedule as the museum's Conservator of

Modern and Contemporary Paintings to script, produce, and co-direct the documentary film that accompanied the 2010–11 exhibition, assisted by Stephen A. Keever, Robert Bell, and Jennifer Schlegel of the Museum's Audio-Visual Department. In concise and compelling form, the film recounts the fundraising effort that secured the painting's future as a Philadelphia landmark, introduces the artist and his subject, and deftly illuminates our research, issues posed by the painting's condition, and the reasoning and practical measures by which our restoration addressed those issues. Penn's firsthand knowledge of specialists' concerns, combined with her ability to engage museum audiences, made a key contribution to the exhibition. Principal photographic documentation of the painting and conservation treatment was expertly provided by Conservation Photographer Joe Mikuliak, assisted by Steven Crossot. In the American Art Department, collegial support came from Elisabeth Agro, David Barquist, Alexandra Kirtley, Mark Mitchell, and Carol Soltis, and prior staff members Nan Goff, Audrey Lewis, W. Douglass Paschall, and Darrel Sewell, with special thanks to Quillan Rosen and Center for American Art fellows Julie McGinnis and Layla Bermeo, who assisted with catalogue research and exhibition details. Thanks also go to Peter Barberie, Dilys E. Blum, Felice Fischer, Kristina Haugland, Sharon Hildebrand, John Ittmann, and Shelley Langdale, who offered advice and assistance with objects in their departments; to the endlessly patient and resourceful staff of the museum's library for assistance with research, and especially to Archivist Susan Anderson; to Jeffrey Sitton and Andrew Slavinskas of the Installation Design Department for their ingenuity in accommodating our ideas about the look and content of the exhibition; to Barb Metzger, Erika Remmy, and Maia Wind of the Editorial and Graphic Design Department for the exhibition graphics; to Sherry Babbitt, David Updike, Richard Bonk, and Mary Cason of the Publishing Department for help with this book, and to Jo Ellen Ackerman for its handsome design.

On the occasion of the publication of this book, we would like to cite the example we saw in the work of the late Philadelphia Museum of Art Conservator Theodor Siegl, who not only applied his most conscientious care to the treatment of *The Gross Clinic* and many other paintings, but through his publications showed an admirable commitment to sharing knowledge and raising awareness of the challenges and responsibilities of museum stewardship. Siegl received wonderfully sympathetic support from the distinguished Director of this Museum for whom he worked for the last twelve years of his life, Evan H. Turner. A learned devotee of the art of Thomas Eakins, Dr. Turner visited during the 2010 restoration of *The Gross Clinic* and the subsequent exhibition; we were gratified by his thoughtful enthusiasm for our research and conservation effort, and, as this book affirms, are in full agreement with his exclamation that "You must publish this!" We also reiterate our gratitude to Anne d'Harnoncourt, Director of the Museum for thirty-six years and prime mover of the campaign to keep Eakins's masterpiece in its hometown. We regret that Anne, champion of the artists of Philadelphia, did not live to witness the restoration of *The Gross Clinic* and savor the publication of this book. Timothy Rub, who arrived to lead the Museum as Director when the project was under way, urged us to open the process of research and conservation to the public, insisting "You must do a show!" We are grateful for his support, and for the tremendous opportunity presented by such a project. As a curator and conservator who have studied the work of Eakins for decades, it has been among the greatest privileges and pleasures of our careers to work together on the research, conservation treatment, and exhibition of *The Gross Clinic* and on this book that marks the moment and shares what we have learned, thought, and done.

Kathleen A. Foster
The Robert L. McNeil, Jr., Senior Curator of American Art and Director of the Center for American Art

Mark S. Tucker
Vice Chair of Conservation and The Aronson Senior Conservator of Paintings

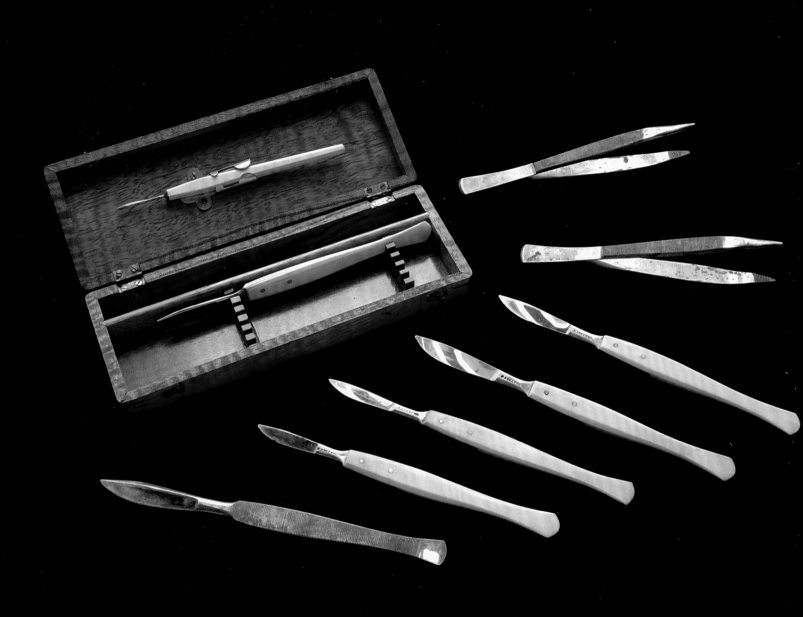

Fig. 1.1. Dissection kit belonging to Thomas Eakins, c. 1870–90.
The artist's own bone-handled knives, identical to the
professional scalpels used by Samuel D. Gross, demonstrate his
identification with the medical community of his day.
Philadelphia Museum of Art. Gift of an anonymous donor, 1985

Kathleen A. Foster and Mark S. Tucker

Introduction:
Studying *The Gross Clinic*

THE GROSS CLINIC IS A DAUNTING OBJECT. Recognized as the artist's masterpiece, it was greeted with both lavish praise and shocked criticism from the moment it was painted. The critic William J. Clark, Jr., declared in 1876, "We know of nothing greater that has ever been executed in America"; three years later, Susan N. Carter called it "a degradation of Art."[1] In the twentieth century the horrified commentary gave way to a chorus of admiration that grew along with the reputation of the artist and the historical significance of the painting. But *The Gross Clinic* has remained provocative, inspiring generations of response and analysis that have revealed layers of meaning in the painting and discovered new contexts for appreciation. Our intensive examination in 2009–10, before, during, and after its most recent cleaning and restoration, has offered a unique opportunity to take a fresh look at these layers, which, like the glazing on its surface, contribute to the import of *The Gross Clinic*.

The newest layers of interpretation emerged during the triumphant campaign in 2006 to keep the painting in Philadelphia. By the time *The Gross Clinic* was jointly acquired by the Pennsylvania Academy of the Fine Arts and the Philadelphia Museum of Art in early 2007, it had become a symbol of the city's sense of place and an emblem of local self-esteem, part of a wider cultural phenomenon examined here by historian Steven Conn in his lively essay, "Local Hero: *The Gross Clinic* and Our Sense of Civic Identity." That more than 3,600 donors, including residents of all fifty states and five foreign countries, felt *The Gross Clinic* should stay in Philadelphia—that it held special meaning to residents of the city and that the city itself added meaning to the painting—suggests the startling expansion of its status as an icon in the twenty-first century. Surely the artist, bruised by the criticism of his painting in its early years, would be amazed to see its value to Philadelphia today.

Eakins might be less surprised (though more gratified) to see the admiration that *The Gross Clinic* has won from doctors over the years, particularly the graduates of

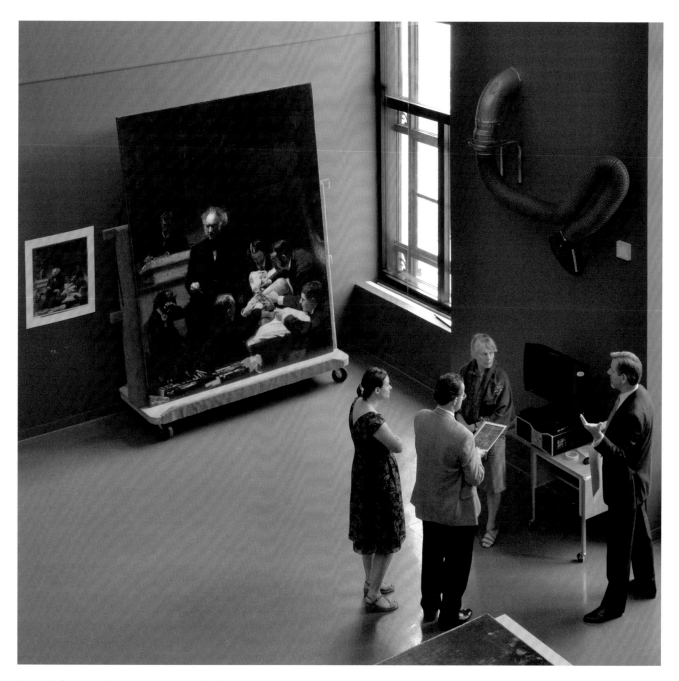

Fig. 1.2. Left to right, Pennsylvania Academy of the Fine Arts
curator Anna O. Marley and chief executive officer David R.
Brigham, with Philadelphia Museum of Art curator Kathleen
A. Foster and paintings conservator Mark S. Tucker, discuss
The Gross Clinic in the Joan and John Thalheimer Conserva-
tion Studio at the Philadelphia Museum of Art in 2009.
Conservation Department, Philadelphia Museum of Art

Jefferson Medical College (now part of Thomas Jefferson University), who see the heroic, pioneering days of their school represented in this portrait of one of its most famous graduates and professors, Samuel D. Gross. Exploring the meanings a scientific audience might find embedded in this painting and its great sequel, *The Agnew Clinic*, painted for the School of Medicine at the University of Pennsylvania in 1889, Dr. Mark S. Schreiner's essay, "Eakins as Witness: The Birth of Modern Surgery, 1844–89," gives an accessible account of the revolution in medical practices and teaching methods depicted in the artist's two great clinic paintings. From a doctor's viewpoint, we see the reality of nineteenth-century medicine, its triumphs and obstacles, its courage and vulnerability, its message of progress and teamwork—a narrative that was deeply embedded in Eakins's project, the first and most obvious subject of his work.

Another set of meanings emerges from the biography of the artist and the context of the painting's creation. In "A Portrait of Ambition: Eakins, the Centennial, and *The Gross Clinic*," Kathleen A. Foster introduces Philadelphia's great world's fair of 1876 and the ambitious, thirty-one-year-old artist who was determined to make his mark at this exposition with a spectacular portrait of one of the world's most famous surgeons. Many other scholars have told pieces of this story; our goal here is to establish the context of Eakins's project and its place in his development as an artist, as well as the fraught circumstances of its first exhibition.[2]

Eakins himself wrote very little about *The Gross Clinic*; his few letters that mention it are included in the Appendix to this volume, along with the published commentaries of many viewers in the artist's lifetime. Some of these remarks—such as Clark's extraordinary praise quoted in the first paragraph of this introduction—have been cited frequently, as have excerpts from less favorable reviews, usually focusing on the most sensational, indignant, and quotable criticisms. The volubility of Victorian art criticism begs for condensation, but selective quotations inevitably sound condescending, as they invite the reader to cluck over the colorful expressions of our benighted predecessors. On closer scrutiny of the full reviews, we might conclude

that while some of Eakins's critics were hasty and short-sighted, others offered more nuanced or ambivalent appraisals, judiciously mixing praise with censure. So we decided to include in the Appendix all the substantive known commentary on *The Gross Clinic*, giving modern readers an unexpurgated sense of the impact of *The Gross Clinic* in Eakins's lifetime. What was said—or not said—in period criticism begins to frame the meaning of this painting in its own day.

Taking cues from the shocked viewers of the 1870s, and combining research on the context of the Centennial with the surprisingly scant information about the artist's private life, many scholars in recent decades have sought in the bloody, provocative subject of *The Gross Clinic* insights into Eakins's personality. Was a young, ambitious artist intentionally seeking a sensationalist effect? Inured by years of anatomical study, was he naïve about the public's response? Can we find deeper layers of meaning in this painting? A new era in Eakins studies was opened by Michael Fried in 1985, when he explored the symbolic system of *The Gross Clinic*, with its array of sharp tools—scalpel, pencil, probe, pen—representing writing, penetration, knowledge, and control.[3] Fried's Freudian reading opened a door to psychoanalytical study of Eakins and the unconscious currents of emulation, fear, and need for control that are said to lie beneath the painting's surface. Subsequently, scholars interested in themes of misogyny, gender identity, and power relations have offered their interpretations of *The Gross Clinic*.[4] For others, Eakins's paintings have become portals through which to explore the mental illness that haunted the artist and his family.[5]

The psychobiographical analysis of Eakins's behavior and motives—at best based on disciplined application of theoretical tools (such as Freudianism), at worst speculative and sensationalizing—depends on linking the artist's paintings and the unhappiest moments in his life to confusingly contradictory testimonies. Passionately attacked and defended in his own day, he was a polarizing figure, charismatic, arrogant, and aggressively unconventional. Fragmentary, biased, or, in the case of Eakins's own writings, self-serving surviving documents and testimonies complicate the

inherent challenge of measuring the most elusive aspects of long-lost human beings from written records.[6] More concrete is the evidence that rests in the art itself. "For the public, I believe my life is all in my work," Eakins wrote in 1893, surely hoping to dodge the kind of biographical scrutiny that he has received in the last three decades.[7] His hope was futile, but his statement bears attention, for *The Gross Clinic* indeed offers an exceptionally rich text inviting understanding of the artist, not just because it is large and complex, but because it is so clearly the result of careful planning and patient, systematic execution, willfully applied to the creation of an intended effect.

Exploring that effect, seeking to understand the evidence of the painting itself, opens a new path to the pysche of the artist. Rather than psychoanalyzing Eakins from a distance, we chose to place his material, pictorial statement at the center of our inquiry. His struggle to organize and build an image in oil paint on canvas was the first story, upon which all subsequent content depends, and our project has been driven by the wish to understand Eakins's formal intentions and to recover, as much as possible, his original effect. This approach also has an inherently elusive subject of study: a painting inevitably changes over time, even without deliberate or accidental interventions, so it is impossible to know exactly how it looked when it was new or to completely restore that appearance. For some viewers, the changes wrought by time are part of the history of an object, to be respected and left undisturbed; for others, such changes matter little, for they see the object as intrinsically unstable and shifting, made anew in each viewer's perception. Bringing his or her own life experiences and subjective responses to the work, each person creates a fresh, unique fusion of meanings, sometimes far removed from the original intentions of the artist. This is the reality of the postmodern museum world, where objects are displayed out of context and often freely combined, repurposed, and reinterpreted in the flow of global culture. Great works such as *The Gross Clinic* tend to thrive on the accrual of new meanings, remaining interesting and relevant to new audiences despite (or sometimes because of) alterations in their appearance. But the curator and the conservator also recognize the

value in rescuing, whenever possible, the message an object carries from its own time and bringing that story to present-day audiences. Rather than refashioning Eakins's concerns to reflect our own, we wished to understand what he thought was important, and to set that against the opinions of his contemporaries. With our sensitivities directed toward the values and conditions of Eakins's world, we stood poised to learn something new, or perhaps rediscover something forgotten.

Fortunately, we found an unusual abundance of evidence upon which to ground this historical enterprise. Mark S. Tucker's thirty years of working with *The Gross Clinic* and other Eakins paintings provided the knowledge needed to recognize the consequences of misguided cleanings on the appearance of this master work, and especially on the painstakingly calibrated balance of light and dark tones that had been a hallmark of Eakins's judgment and skill. Our examination of the painting, seeking evidence of the original surface, was augmented by study of early reproductions and preparatory sketches for *The Gross Clinic*, as well as period commentary on the exalted role tonal control played for painters and critics of Eakins's generation. Added to a sense of Eakins's habits in other paintings of the same moment, this research allowed us to walk through the construction of the painting, as told in our essay "The Making of *The Gross Clinic*." More than just a study of process, this analysis offers a view of the creativity, thinking, and artistic values central to Eakins's personality and training.

This historical and material understanding, supplemented by the critical response outlined in Foster's "*The Gross Clinic* in Philadelphia and New York, 1875–79," informs our sense of the painting's initial impact. The shocked consensus of early viewers refreshes our sense of the strangeness of the subject and the power of the artist's illusion, and we are made sensitive to the darkness of the image—both its literal blackness and its violence—in the eyes of Eakins's contemporaries.

Fourteen years after the Centennial, Eakins was given the opportunity to revisit the subject of surgery when he was commissioned by students at the University of Pennsylvania to paint their beloved retiring professor, D. Hayes Agnew. Eakins reconsidered almost

every aspect of his earlier composition and modernized his subject, but received the same divided response. Foster's comparative study in "The Challenge Revisited: *The Gross Clinic* and *The Agnew Clinic*" launches fresh discussion of the artistic choices and meanings shared by this pair of monumental clinic paintings, recognized in the 1890s as among the artist's finest works.

Period commentaries, key early records of its appearance, and concrete visual evidence also inform our sense of the alterations to *The Gross Clinic* after Eakins's death in 1916. In "The Changing Painting: *The Gross Clinic* in the Nineteenth, Twentieth, and Twenty-First Centuries," Tucker assesses previous treatments and their impact on the condition of the painting prior to its purchase in 2007. His account of the subsequent research campaign undertaken in 2009–10 details the evidence that supported the entire restoration project. In our search to recover the past, we recognize that our solutions will inevitably be colored by present-day tastes as well as the quality of information available; the reversible methods and materials used for the 2010 restoration will allow future admirers of *The Gross Clinic* who may have better knowledge or different opinions to return to the surviving surface of Eakins's painting and begin again.

Restored, the painting invites us to reconsider some of the oldest themes in the commentary on *The Gross Clinic*: its forcefulness on exhibition, the shocking impression of reality that the artist commanded, and the unprecedented aggressiveness and modernity of its subject matter. Close study of the painting reveals how Eakins constructed that sense of reality and also makes us aware of the artist's planning, his choices and adjustments, his complex and obsessive manipulation of light and dark. As a record of creative imagination, personality, and artistic ambition, the painting stands as the richest possible introduction to his idiosyncratic genius.

The full impact of the restored *Gross Clinic* was witnessed firsthand by the thousands who visited the exhibition at the Philadelphia Museum of Art in 2010–11, including many who had added their support to the acquisition of the painting in 2006, and others who had lived with the painting at Jefferson for decades. Their responses, recorded in the museum's visitor book, gave witness to the renewed power of the painting and confirmed the public's interest in the alliance of conservation and curatorial scholarship that was indispensible to this project, and which now inspires this book.

1. William J. Clark, Jr., "The Fine Arts: Eakins' Portrait of Dr. Gross," *Philadelphia Evening Telegraph*, April 28, 1876, p. 4. Susan. N. Carter, "Exhibition of the Society of American Artists," *Art Journal* (New York), n.s., vol. 5 (May 1879), p. 156.

2. The first monograph on the artist, Lloyd Goodrich's *Thomas Eakins: His Life and Work* (New York: Whitney Museum of American Art, 1933), gives an account of *The Gross Clinic* (pp. 49–54) that was revised and expanded in Goodrich's later biography, *Thomas Eakins* (Cambridge, MA: Harvard University Press for the National Gallery of Art, 1982), vol. 1, pp. 123–38; the latter publication remains the cornerstone of Eakins studies. Gordon Hendricks enlarged the story in "Thomas Eakins's *Gross Clinic*," *Art Bulletin*, vol. 51, no. 1 (March 1969), pp. 57–64. The medical context of the painting was studied by Elizabeth Johns in *Thomas Eakins: The Heroism of Modern Life* (Princeton, NJ: Princeton University Press, 1983), pp. 46–81. Julie S. Berkowitz, in *Adorn the Halls: History of the Art Collection at Thomas Jefferson University* (Philadelphia: Thomas Jefferson University, 1999), pp. 162–92, summarized much of the earlier bibliography on the painting and added new information. Key sources are cited in the essays in this volume and in the Bibliography; for known period texts about the painting, see the Appendix.

3. Fried finds a Freudian "family romance" in the painting, with Eakins identifying with Gross, as a father figure, and also with the abject patient. The horrified female spectator is read as a projection of Eakins's mother. See Michael Fried, "Realism, Writing, and Disfiguration in Thomas Eakins's *Gross Clinic*, with a Postscript on Stephen Crane's 'Upturned Faces,'" *Representations*, vol. 9 (Winter 1985), pp. 33–104; revised and expanded as *Realism, Writing, Disfiguration: On Thomas Eakins and Stephen Crane* (Chicago: University of Chicago Press, 1987).

4. Eric M. Rosenberg, like Fried, tried to recover the shock of the painting in "'. . . One of the Most Powerful, Horrible, and Yet Fascinating Pictures . . .': Thomas Eakins' *The Gross Clinic* as History Painting," in *Redefining American History Painting*, ed. Patricia M. Burnham and Lucretia Hoover Giese (Cambridge: Cambridge University Press, 1995), pp. 174–92. Taking a structural tack, Rosenberg found the figure of the hysterical mother key to the gender polarities of the painting. Eakins's treatment of nudes and sexuality received study in Doreen Bolger and Sarah Cash, eds., *Thomas Eakins and the Swimming Picture*, exh. cat. (Fort Worth, TX: Amon Carter Museum, 1996). Jennifer Doyle developed Fried's Freudian analysis and explored period sexual identities with subtlety in "Sex, Scandal, and Thomas Eakins's *The Gross Clinic*," *Representations*, no. 68 (Autumn 1999), pp. 1–33. Martin A. Berger usefully investigated themes of compensatory masculinity in *Man Made: Thomas Eakins and the Construction of Gilded Age Manhood* (Berkeley: University of California Press, 2000). Alan C. Braddock scrutinized the culture of medical schools and class in "'Jeff College Boys': Thomas Eakins, Dr. Forbes, and Anatomical Fraternity in Postbellum Philadelphia," *American Quarterly*, vol. 57, no. 2 (June 2005), pp. 355–83.

5. Lloyd Goodrich noted the death of Eakins's mother Caroline in 1872 "from exhaustion from mania" and speculated that she was manic-depressive, but little information survives to give additional texture to this family tragedy,

which surely had an impact on the artist; see Goodrich, *Thomas Eakins*, vol. 1, pp. 76–79. The publication of the papers in Charles Bregler's Thomas Eakins Collection at the Pennsylvania Academy of the Fine Arts opened a new era of biographical studies in 1989, but little new material about the artist's mother emerged. However, many documents came to light that were pertinent to other traumas and scandals, such as the suicide of his niece, Ella Crowell, which her parents blamed on Eakins; for an introduction to these papers, see Kathleen A. Foster and Cheryl Leibold, *Writing about Eakins: The Manuscripts in Charles Bregler's Thomas Eakins Collection* (Philadelphia: University of Pennsylvania Press, 1989). William Innes Homer, the first scholar to use the Bregler papers to inform a new biography of the artist, found misogynistic patterns in these scandals; see *Thomas Eakins: His Life and Art* (New York: Abbeville, 1992). Sarah Burns studied these papers as she assessed the response to *The Gross Clinic,* usefully noting the public's sensitivity to images of anatomical dissection following controversies over grave-robbing and vivisection in this period. Finding pathological patterns in Eakins's behavior, she proposed a less-than-convincing diagnosis of Asperger syndrome; see *Painting the Dark Side: Art and Gothic Imagination in Nineteenth-Century America* (Berkeley: University of California Press, 2004). Burns further detected obsessive anxieties about health, mental illness, and femininity in "Ordering the Artist's Body: Thomas Eakins's Acts of Self-Portrayal," *American Art*, vol. 19, no. 1 (Spring 2005), p. 92. Pressing deeper into the "dark side," Henry Adams continued down the path of Freudian analysis and speculative diagnosis, reading the Bregler documents as evidence of childhood abuse and bipolar, exhibitionistic, and obsessive-compulsive disorders; see *Eakins Revealed: The Secret Life of an American Artist* (Oxford: Oxford University Press, 2005). For a critique of Adams, see Jennifer Roberts, "Gross Clinic: A New Book Dishes the Dirt on Thomas Eakins," *Bookforum* (October/November 2005), pp. 27–29.

6. Although the documents relating to the scandals and traumas of Eakins's biography have been pressed hard, remarkably little is known about the artist's interior life. Most of his surviving papers are youthful letters sent home from Europe, when he was between twenty-two and twenty-five years old, and most of the accounts of his personality and behavior were given to his first biographer, Lloyd Goodrich, about 1930, fifteen years after the artist's death, by people who knew him late in life. On the difficulties of extracting "truth" from surviving documents in the Bregler Collection, as well as alternate readings possible from this material, see Foster, in *Writing about Eakins*, pp. 1–18, 39–40, 69–90, 95–122.

7. Goodrich, *Thomas Eakins*, vol. 2, p. 6. In addition to the publications already mentioned, Sidney Kirkpatrick produced a popular biography, *The Revenge of Thomas Eakins* (New Haven, CT: Yale University Press, 2006), and William S. McFeeley probed the melancholy affect of the artist's work in *Portrait: A Life of Thomas Eakins* (New York: W. W. Norton, 2007).

Steven Conn

Local Hero: *The Gross Clinic* and Our Sense of Civic Identity

Dr. Samuel D. Gross died in 1884 after nearly thirty years as a surgeon and professor at Jefferson Medical College, but it is probably fair to say that he truly arrived in Philadelphia on November 11, 2006. On that morning the art world—and the rest of us—woke up to the stunning news that the college, now Thomas Jefferson University, was selling its magisterial portrait of the good doctor. That portrait, *The Gross Clinic*, had been painted by Thomas Eakins for Philadelphia's Centennial Exhibition in 1876 to celebrate the surgeon and his accomplishments. Purchased two years later by the school's Alumni Association, Eakins's canvas would soon become a landmark at Jefferson, widely recognized as one of the crowning achievements of American painting.

News of the sale shocked many of us. Some were galled by the buyer, a mysterious partnership between the National Gallery of Art in Washington, DC, and Wal-Mart heiress Alice Walton and her new museum in Crystal Bridges, Arkansas. All were staggered by the price tag: $68 million. One hundred and twenty-two years after his death, Dr. Gross was front-page news in Philadelphia and around the nation. In fairness, when Jefferson officials announced the deal, they also gave the city's cultural institutions until December 26 to match the Walton–National Gallery offer. Six weeks, $68 million. Happy holidays!

Until that day in November, *The Gross Clinic* had led a pretty quiet life. The painting had caused a small kerfuffle in 1876 when it was refused entry into the fine arts gallery at the Centennial, and wound up shunted instead to the U.S. Army Post Hospital, where it went on display along with the very latest in scalpels and forceps (see figs. 6.4, 6.5)—an episode that foreshadowed Eakins's uneasy relationship with the city's guardians of

This essay is based on a talk delivered at the symposium *Seeing "The Gross Clinic" Anew*, held at the Philadelphia Museum of Art, September 19, 2010.

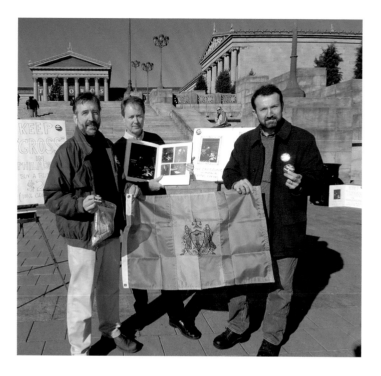

Figs. 2.1, 2.2. Philadelphia artists (left to right) Stanley Bielen, Charles Cushing, and Patrick Connors, all graduates of the Pennsylvania Academy of the Fine Arts, organized street demonstrations in November and December 2006 at which they sold buttons and collected donations for the purchase of *The Gross Clinic*

artistic taste. Then it returned to Jefferson, where it hung in a variety of places, becoming a fixture of the institution. It also became a staple of art history survey courses everywhere, and teachers had to explain to countless students that the "Gross" in the title was a proper name, not a reference to the blood on the surgeon's hand. In the mid-twentieth century, it was installed in a specially built vaultlike gallery at Jefferson, complete with an imposing gate that was kept locked much of the time.

With the announcement of its impending sale, however, *The Gross Clinic* found itself at the center of an angry storm. The howls of protest that greeted this proposed transaction from art historians, museum people, and Jefferson's own staff and alumni were perfectly predictable—though oddly Jefferson's administrators seemed a bit taken aback. The real surprise, however, was the much wider outrage the news generated among artists, students, state and local politicians, and ordinary Philadelphians of many stripes. At one point, Philadelphia mayor John Street threatened to tie up the sale in court for months by having the painting declared a historical landmark. Protests spilled out into the streets. Walking around central Philadelphia during those six

weeks, one might well have been handed a leaflet and asked to sign a petition or buy a button in support of keeping *The Gross Clinic* in Philadelphia (figs. 2.1, 2.2).

Toward the end of November, I was invited to discuss the controversy on the radio, and not on National Public Radio, mind you, but on AM talk radio—the station that broadcasts Rush Limbaugh to the Philadelphia region—and during drive-time no less! (Locally, the station is referred to as "The Big Talker," which my family thought fitting since that is what they usually call me.) I had expected to defend the idea that we should care at all about the sale of this painting and was caught off-guard when I realized that not only the host but several of the callers were hopping mad about it too.

I confess that when I woke up on November 11 and found out about the sale of *The Gross Clinic*, my first thought was of dinosaurs—not just any dinosaurs, of course, but the dinosaurs discovered by the great nineteenth-century paleontologist Edward Drinker Cope (1840–1897), mostly in the western United States, and brought back to Philadelphia. Penniless by the end of his life, Cope sold his spectacular fossil collection to the American Museum of Natural History in New

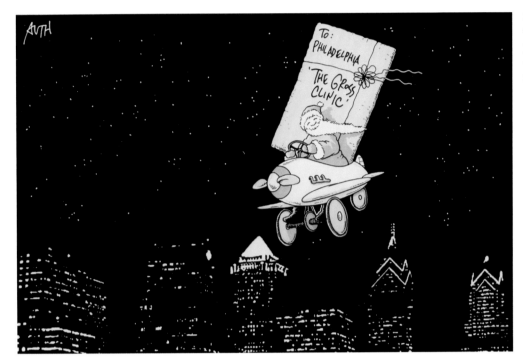

Fig. 2.3. "To: Philadelphia, 'The Gross Clinic,'" editorial cartoon by Tony Auth, published in the *Philadelphia Inquirer*, December 24, 2006. Reproduced by permission of the artist

York; no one in Philadelphia thought it was important enough to keep. I also thought about Joseph Widener's collection of Old Master paintings, which he donated in 1939 to the National Gallery of Art, not to the Philadelphia Museum of Art, and about the Annenberg Collection of Impressionist and Postimpressionist masterworks, which now resides on Fifth Avenue in New York, not on Benjamin Franklin Parkway. I thought about several other episodes in Philadelphia's history where the city watched, apparently helpless, as some of its cultural treasures left town.

With all that in mind, when the radio host asked me point blank whether I thought *The Gross Clinic* could be kept in Philadelphia, I confidently said, "No." Not on that schedule and not in this town. After all, I'm a historian; I knew the history.

A wise friend of mine never tires of reminding me that historians have a hard enough time understanding the past; they should never try to predict the future. And so it was that just a few weeks after I made my prediction on The Big Talker, I found myself happily proven wrong. Galvanized by the widespread public outcry, the Philadelphia Museum of Art and the Pennsylvania

Academy of the Fine Arts (PAFA) had joined to spearhead a fundraising campaign that included local banks, foundations, politicians, and thousands of individual contributors large and small. It worked, and Dr. Gross will now reside in Philadelphia forever (figs. 2.3–2.5).

This is a happy ending indeed, but one that requires some explanation. Why, after all, did this portrait of a long-dead surgeon capture the attention of Philadelphians and others during those tense weeks at the end of 2006—and capture it to the tune of $68 million? Without question, *The Gross Clinic* is a great painting. Indeed, it is arguably *the* great American painting of the nineteenth century, whatever such assertions are worth. But Eakins's canvas was hard to access, locked away as it was, and few people actually saw it in any given year. So why did anyone care about a painting effectively hidden from public view?

Let me offer this explanation: whatever might be said about the art-historical importance of *The Gross Clinic*, it is unarguably a Philadelphia painting—a Philadelphia story told through a Philadelphia doctor in a Philadelphia medical school by the preeminent Philadelphia painter. Keeping it in the city thus

became a crusade about civic identity, about what it means to be a Philadelphian.

Thomas Eakins, of course, spent his entire professional life in the city. He trained at PAFA and taught there until he was fired in 1886 for flaunting the conventions of the day. He made his career painting the city and, even more, its people.

Dr. Samuel Gross, the subject of the portrait, came from modest circumstances. He spent his childhood up the Delaware River in Easton, Pennsylvania, and graduated from Jefferson in 1828. In 1833 he took a job in Cincinnati and after that went to Louisville. Almost three decades after his graduation, Gross returned to Jefferson as a professor in 1856. There he became a giant in his field and a founder of modern American surgery.

Gross was seventy years old when Eakins painted him, but he does not look it. He lectures to students as he performs an operation, troubled not at all by the blood on his hand, entirely confident in his abilities. Eakins presents him as thoroughly commanding, almost heroic. It is hard to imagine a nobler brow. He was a perfect subject for Eakins, who admired (and often painted) Philadelphians who were talented rather than privileged, accomplished rather than merely rich. *The Gross Clinic* is decidedly not a society portrait, after all. It portrays a man at work, and gloriously so. Gross is simply the best at what he does, and Eakins shows him doing it.

As Philadelphians learned about all this in 2006, through a remarkably successful educational blitz orchestrated by the Philadelphia Museum of Art, PAFA, and others, I think the prospect of losing Dr. Gross, of having him shuttle ceaselessly between Washington and Arkansas, offended Philadelphians as Philadelphians. My sense is that the response to the threatened sale of *The Gross Clinic* grew from a shared sense of civic identity, the sense that as Philadelphians we needed to rally and save this important piece of our shared cultural history. To put this in a more locally succinct way, when Philadelphians heard that Alice Walton was going to buy *their* painting, they responded by saying: "Yo! You tawkin' 'bout *that* painting? Getouttahere!"

The Gross Clinic stirred this sense of civic identification because, like its maker and its subject, it is so

Fig. 2.4. Pennsylvania Academy of the Fine Arts board chair Donald R. Caldwell and Philadelphia Museum of Art director and chief executive officer Anne d'Harnoncourt celebrating the acquisition of *The Gross Clinic* in January 2007

rooted in its place. It hit a nerve of civic identity to such an extent that political leaders, business figures, cultural institutions, and ordinary citizens came together to raise, in a remarkably short time, the money needed to purchase the painting. With that in mind, let me explore further the relationship between identity and a sense of place, and the role of cultural objects in fostering them both.

There is a bit in an old *Seinfeld* episode where Jerry discovers that his Catholic dentist wants to convert to Judaism so that he can tell Jewish jokes. Jerry is upset

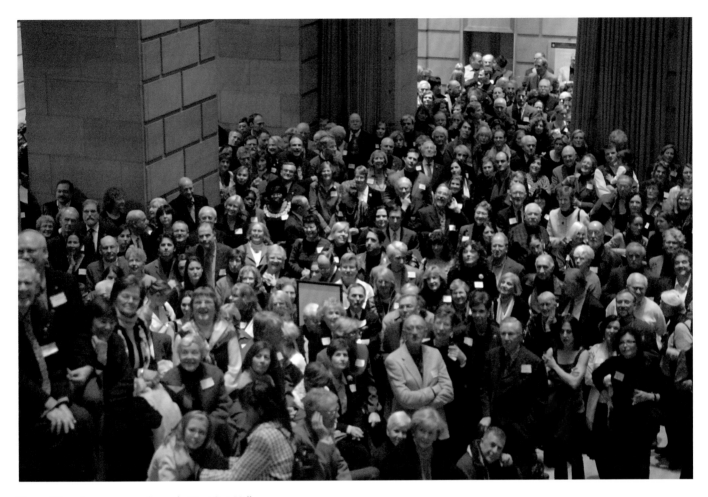

Fig. 2.5. Triumphant supporters throng the Great Stair Hall following the installation of the painting at the Philadelphia Museum of Art, January 20, 2007

about this, so he finds a priest and tells him about the situation. The priest responds, "And this offends you as a Jew?" To which Jerry replies, "No, it offends me as a comedian." The scene is funny because we are so accustomed to discussing questions of identity in ethnoracial terms. Who we are, at some essential level, has been reduced in so much of our political and academic discourse to the accidents of our biology: gay or straight, male or female, white or black or Asian or Latino or Native. In this *Seinfeld* scene, however, Jerry tells us that in this case being a comedian is more important to him than being Jewish.

For our purposes, the identity politics of the last thirty or forty years have influenced the cultural world in two ways. First, they have driven much of the museum-building that has taken place since the 1960s. There are now at least three "Italian-American" museums around the country; they join the Japanese-American National Museum in Los Angeles and the Vesterheim Norwegian-American Museum in Decorah, Iowa, which is not too far from the National Czech and Slovak Museum in Cedar Rapids. The Arab American National Museum opened in Dearborn, Michigan, in 2005, one year after the National

Museum of the American Indian on the Mall in Washington, DC, where the National Museum of African American History and Culture is soon to begin construction.

The second and more controversial way in which identity politics has impacted museums is through the vexed question of repatriation. In the United States, most repatriation requests are brought under the frameworks established by the Native American Graves Protection and Repatriation Act (NAGPRA) of 1990, but in fact repatriation has become an international issue. Whatever one thinks about the efficacy of repatriation, the claims made by one group for the return of cultural material from a museum rest on some combination of genetics and geography. So, for example, when Rocco Buttiglione of the Italian cultural ministry demanded that the Metropolitan Museum of Art in New York return the Euphronios krater to Italy, he said that he wanted the museum "to give back to the Italian people what belongs to our culture, to our tradition, and what stands within the rights of the Italian people."[1] Of course, by the time the krater got to the Met, its provenance was more than a little dodgy, but in point of fact it is originally Greek, not Italian. How it wound up in an Etruscan tomb is something of a mystery. So, as the philosopher Kwame Anthony Appiah has nicely put it, Italian "patrimony, here, equals imperialism plus time."[2] Astute as that observation might be, the Met nonetheless returned the krater to the Italians in 2008.

We all carry within us multiple identities, and, as Amartya Sen reminds us in his lovely little book *Identity and Violence*, to insist on singular identities, usually of the ethnoracial or religious kind, often leads to unhappy results.[3] One problem with essentialist notions of identity that rest on genetics and geography is that they are necessarily exclusive. They don't simply create categories of "us" and "them"—they posit an impermeable boundary between the two. As a consequence, I can't lay any cultural claim on the Euphronios krater, because, though I might decide to live in Italy, I can never really be part of the "Italian people" as Buttiglione defined them.

Likewise, the survey data we have indicate that most visitors to ethnically specific museums are, well, ethnically specific.[4] Polish Americans go to the Polish American museum, and while the curators there would love to show Ukrainian Americans the exhibits, Ukrainian Americans go to the Ukrainian American museum. And though the bulk of its visitors would not be Native American, those who shaped the National Museum of the American Indian spoke frankly about their desire to build a museum specifically for that population.

This all strikes me as sad, not to mention antithetical to the very purpose of painting, literature, music, and other cultural productions. Art of any sort matters precisely because it helps us transcend the relatively small sum of our own individual experiences and broadens our capacity to understand just how enormous the human experience is and always has been. Toni Morrison put this beautifully in an interview some years ago: "I never asked Tolstoy to write for me, a little colored girl from Lorain, Ohio. I never asked Joyce not to mention Catholicism or the world of Dublin. Never. . . . Faulkner wrote what I suppose could be called regional literature and had it published all over the world."[5]

Among the other identities that define us are those rooted in locality and the local. This is what I mean by the term *civic identity*: A sense of belonging to a place. That aspect of identity has atrophied in the United States, at least according to any number of surveys and sociological studies. In the nineteenth century, as historian Robert Wiebe demonstrated in his now classic book *The Search for Order*, many Americans lived in "island communities" and thought of themselves in intensely local terms. They were Iowans first, or Chicagoans, or residents of Franklin County; they were Americans second, or even third.[6]

Now we go bowling alone, a country of exiles inhabiting a geography of nowhere, to play with the titles of just three of the books that describe us as a country of atomized, alienated, and rootless people.[7] Indeed, I might argue that the rising appeal of ethnoracial identities over the last thirty or forty years corresponds exactly to the erosion of that sense of civic identity, of belonging to a place. Our fascination with genealogical roots has grown in proportion to our relocation into private worlds disconnected from the places in which we happen to find ourselves.

Cultivating that sense of local identity lay behind any number of cultural projects in the late nineteenth and early twentieth centuries. Cities competed against each other to build splendid public libraries, museums, symphony orchestras, parks, and more: Philadelphia against Boston, Cleveland against Detroit, Chicago always against New York. Even New York was not immune to this civic anxiety: while the city claimed to be the first to propose building a great museum of science and technology, Chicago beat it to the punch in 1926. Upon learning this, the *New York Times* lamented, "We of New York continue 'saying' the thing. While we are still saying it Chicago has risen to do it." The *Times* hastened to assure its readers that Chicago's project "will not lessen the need of a like museum here—even a greater one."[8] You can almost hear the *Times* editors gnashing their teeth.

The Gross Clinic was created in and for that world of civic boosterism and competition. The painting glorifies Dr. Gross as the celebrated surgeon that he was; he, in turn, helped Jefferson Medical College, founded in 1824, rise to national prominence, and by extension helped bolster the primacy of Philadelphia in the world of American medicine. Eakins, as a faculty member at PAFA, would teach in its big new building, opened during the same year that *The Gross Clinic* went on display. Everything about the painting asserted the importance of the city.

Civic identity hasn't disappeared in the United States by any means, but we don't see it often, and when we do it tends to be associated with professional sports. Say what you will about our national obsession with sports, and about the obscene amounts of money that get spent on them each year, but sporting events do provide occasions for people to share in a collective experience and to transcend the usual boundaries that divide us. Our loyalty to sports teams usually comes from the places that matter to us—as often as not, where we grew up or where we have chosen to call home as adults. It is a loyalty rooted in place, and one not easily transferable even if it is associated with heartbreak. My father, for example, has not yet recovered from the day in 1958 when the Brooklyn Dodgers moved to Los Angeles. He has never rooted for what he regards as the faux Dodgers.

The Gross Clinic affair demonstrated that culture—writ large—has the potential to touch those same nerves and to mobilize some of those same feelings. Not everyone in Philadelphia cared about the painting. Not everyone in the city cares about the Phillies either. But during the campaign to save *The Gross Clinic*, students and seniors, bankers and artists, politicians and museum curators all found themselves rooting for the same outcome. And when it was over and the money had been raised, for those people it felt like winning the World Series.

Maybe we shouldn't have been surprised by the city's reaction in the first place. Maybe if I had thought about events in Philadelphia's recent past, rather than in its more distant history, I wouldn't have embarrassed myself on talk radio.

After all, *The Gross Clinic* campaign had a warm-up act of sorts in 1998 with the crisis of *The Dream Garden* (fig. 2.6), a dazzling glass mosaic designed by the artist Maxfield Parrish (1870–1966) and executed by Louis C. Tiffany (1848–1933) and the Tiffany Studio. Measuring fifteen by forty-nine feet, it is probably the largest Tiffany creation in the world. Parrish's painting of a dreamy, idyllic landscape is here rendered in some 100,000 pieces of hand-blown glass ranging across an iridescent palette of 260 colors. Commissioned by publishing giant Edward Bok, it was installed in the lobby of the Curtis Building at Sixth and Walnut streets in Philadelphia, the new headquarters for his publishing empire, in 1916. It is entrancingly beautiful.

The Dream Garden and *The Gross Clinic* share a few things in common. Both are masterpieces of their kind, though it is hard to know just to what *The Dream Garden* can be compared. And both existed in a kind of public obscurity, always there but never fully appreciated. Hundreds of people walked past *The Dream Garden* every day, but it is likely that few stopped to take it in. Until June 1998, that is. That was when the owner of the Curtis Building decided to sell the mosaic to casino mogul Steve Wynn, who in turn planned to have it dismantled and carted off, glass piece by glass piece, to Las Vegas.

Outrage ensued.

Fig. 2.6. Maxfield Parrish (American, 1870–1966) and Louis Comfort Tiffany (American, 1848–1933), *The Dream Garden*, 1914–16. Favrile glass mosaic, 15 feet × 49 feet (457.2 × 1493.5 cm). Courtesy Pennsylvania Academy of the Fine Arts, Philadelphia. Partial bequest of John W. Merriam; partial purchase with funds provided by a grant from The Pew Charitable Trusts; partial gift of Bryn Mawr College, The University of the Arts, and The Trustees of the University of Pennsylvania, 2001.15

Although few Philadelphians lingered in front of it, *The Dream Garden* had become an important part of the civic furniture and of their cultural landscape. And just as happened during the holiday season of 2006, that outrage turned into money, though in this case a mere $3.5 million, most of it donated by The Pew Charitable Trusts in collaboration with PAFA. PAFA now technically owns the mosaic, but it sits where it always has in the lobby of the Curtis Building, open to anyone who walks through the doors. So when the sale of *The Gross Clinic* was announced eight years later, Philadelphians already had some practice defending their cultural patrimony.

Even while *The Gross Clinic* controversy was in full boil, Sixth Street was the site of another episode of civic cultural activism. Just two blocks north of *The Dream Garden*, at the corner of Sixth and Market, Philadelphians were involved in a fight over the President's House that pitted historians, politicians, and commu-

nity activists, not against a wealthy collector, but against the federal government. In 2002, the National Park Service was in the midst of redesigning the "Independence Mall" area of Independence National Historical Park. As part of that redesign, the Liberty Bell would be moved from its 1976 glass box, designed by Mitchell/Giurgola Architects, into a new, bigger building running along Sixth Street. In January of that year, however, Philadelphia historian Edward Lawler, Jr., published "The President's House in Philadelphia: The Rediscovery of a Lost Landmark" in the *Pennsylvania Magazine of History and Biography*. Lawler's article gave us the most thorough scholarly reconstruction of just where the nation's first "White House" stood and what it might have looked like. Most dramatically, he drew a "conjectural floorplan" identifying the quarters he believed had been occupied by the slaves George Washington brought with him to Philadelphia from Mount Vernon when he served as president.[9] And if

you placed Lawler's plan over the one for the new Liberty Bell Center, those slave quarters lay virtually beneath the Liberty Bell's new front door. The History Channel couldn't have scripted the irony any better.

Waving copies of Lawler's article, a group calling itself (somewhat unimaginatively) the Ad Hoc Historians joined with community activists calling themselves (somewhat more inspiringly) the Avenging the Ancestors Coalition to demand that the National Park Service include the President's House—and, more to the point, some recognition of slavery on that site—in its new plans for the Mall. At first, the National Park Service and the Interior Department balked. At its worst moment, the Interior Department followed the Bush administration's pattern of attacking the messenger while denying the message. Besides, their plans were too far along; they didn't have the money; and, they offered, the interpretive material in the new Liberty Bell Center would discuss abolition and slavery, at least a little bit. No need for anything more.

Like Steve Wynn before, and Alice Walton shortly thereafter, the National Park Service lost that fight, finding itself no match for the civic energy and persistence of the historians, activists, and politicians who came together to force this issue. In the summer of 2007, the Park Service commissioned an archeological excavation of the site, and while many were worried that this roped-off hole in the ground would disrupt the tourist season, the dig was a hit with visitors, 300,000 of whom climbed onto the temporary wooden viewing platform to watch history being uncovered.

In December 2010 the efforts of these activists culminated in the opening of the permanent exhibit *The President's House: Freedom and Slavery in the Making of a New Nation*. The exhibit is not without its problems, but its very existence stands as a triumph for civic cultural activism.[10] The paradox at the center of American history is that freedom and slavery were inextricably linked at the nation's founding, and there is no better piece of real estate in America in which to illustrate that paradox than the corner of Sixth and Market streets in Philadelphia. Given the initial intransigence and obstructionism of the Interior Department, we would have no exhibit on this site

were it not for the hard work of those who mobilized and insisted that the Park Service do the right thing.

The groundswell that kept *The Gross Clinic* in Philadelphia was not, therefore, a singular event, nor did it come out of the blue. It is of a piece with the rescue of *The Dream Garden* and the President's House. In all three cases, the threat of losing—or erasing—a shared part of the city's cultural history tapped into a sense of shared civic identity. All three episodes also demonstrate what is possible when the power of that civic sense is unleashed.

Cultivating a sense of civic identity strikes me as important for all sorts of reasons, not the least of which is that our democracy itself is a place-based political process. With the exception of the presidency, our system of representation is rooted in geographical units. We elect county commissioners and town mayors and city council members and send congresspeople to Washington from specific districts. If fewer and fewer of us feel the shared connections of place, then that process doesn't work very well. Another great advantage of an identity rooted in place, it seems to me, is that it is precisely inclusive: it invites anyone who shares a connection to that place to join, participate, contribute, and in turn benefit from the satisfactions of so doing. Civic identity is something we can choose. In this way, it can help us overcome identities that, because they are based in the unalterable facts of biology, necessarily divide rather than unite.

In other words, hating the Yankees transcends all racial, class, and religious distinctions.

Philly can be a tough town, as Steve Wynn, Alice Walton, and Bush administration Interior Secretary Gayle Norton all discovered to their chagrin. That chagrin, however, should excite the rest of us.

The events surrounding *The Dream Garden*, the President's House, and *The Gross Clinic* remind us that art, history, and culture matter to a wider cross-section of people than we often think. Although the circumstances in each case were different, all three episodes posed a threat to that collective sense of belonging the city gives to people. All three reminded Philadelphians of various kinds who we are and what we share. Had the President's House been paved over, or *The Gross Clinic*

been sold, that collective sense would have been diminished, and people felt that in their Philadelphia bones.

Not every piece of art or historic building is likely to bring people out in the streets. Had Alice Walton wanted to buy a Cézanne, or had the original Treasury Department been located at the entrance to the new Liberty Bell Center, I doubt many people would have cared all that much. But the lesson of *The Gross Clinic* is that clearly there are some cultural objects that resonate well beyond the walls of the institutions that hold them. Cultural institutions around the country ought to take notice of that and think about how they can harness and nurture a sense of civic identity in their own locales. Americans yearn for a sense of place—and art, history, music, and architecture are all uniquely positioned to help them find it.

Eakins immortalized Dr. Gross in the process of removing an infected bit of bone from an adolescent's femur. In the end, however, reminding Philadelphians of our civic sense of self turns out to be the last great operation the eminent surgeon performed.

1. I have offered my own analysis of repatriation in the United States in my book *Do Museums Still Need Objects?* (Philadelphia: University of Pennsylvania Press, 2010), chap. 2.

2. Kwame Anthony Appiah, "Whose Culture Is It?" *New York Review of Books*, February 9, 2006.

3. Amartya Sen, *Identity and Violence: The Illusion of Destiny* (New York: W. W. Norton, 2006).

4. Peter Linett of Slover Linett Strategies, a cultural consulting firm, conversation with the author.

5. Quoted in Thomas LeClair, "'The Language Must Not Sweat': A Conversation with Toni Morrison," *New Republic*, March 21, 1981, p. 28.

6. Robert Wiebe, *The Search for Order, 1877–1920* (New York: Hill and Wang, 1967).

7. See Robert D. Putnam, *Bowling Alone: The Collapse and Revival of American Community* (New York: Simon and Schuster, 2000); William Leach, *Country of Exiles: The Destruction of Place in American Life* (New York: Vintage, 1999); James Howard Kunstler, *The Geography of Nowhere: The Rise and Decline of America's Man-Made Landscape* (New York: Simon and Schuster, 1993).

8. "Chicago Doing It First," *New York Times*, August 19, 1926.

9. See Edward Lawler, Jr., "The President's House in Philadelphia: The Rediscovery of a Lost Landmark," *Pennsylvania Magazine of History and Biography*, vol. 126 (2002), pp. 5–95.

10. For my review of the exhibit, see Steven Conn, "Our House? 'The President's House: Freedom and Slavery in the Making of a New Nation,'" *Pennsylvania Magazine of History and Biography*, vol. 135, no. 2 (2011), pp. 191–97.

Mark S. Schreiner, MD

Eakins as Witness: The Birth of Modern Surgery, 1844–89

Within the last twenty-five years, especially, there has come what might be called pre-eminently the era of the operative surgeon, due more especially to the introduction of anæsthesia and later of antisepsis. By making it possible to perform an operation without pain, and almost without danger, organ after organ of the body has been made accessible to the modern surgeon with almost invariable success.

WILLIAM W. KEEN, 1897[1]

AT THE TIME OF THOMAS EAKINS'S BIRTH in 1844, surgery was rare, limited in scope, and agonizing. Surgeons dared do little more than lance an abscess or treat traumatic injury, and their procedures were inevitably accompanied by overwhelming pain (fig. 3.1). If the patient survived the operation, the complications of infection—fever, inflammation, and pus—were so common that they were considered a necessary and natural part of healing. Surgery was a last, desperate measure, and many preferred to face certain death rather than endure the consequences of the surgeon's knife. Given the rarity of operations and the requisite steeliness of character needed to willingly inflict torturous insult upon others, few physicians considered themselves to be surgeons.

The first forty-five years of Eakins's life would see more progress and innovation than the preceding two millennia, as a remarkable series of discoveries transformed the practice of surgery—and the artist, through two monumental paintings, would serve as witness to these great events. *Portrait of Dr. Samuel D. Gross (The Gross Clinic)*, completed in 1875 (see frontispiece), just three decades after the discovery of anesthesia, documents the rapid growth of the specialty, while *The Agnew Clinic*, painted fourteen years later (see fig. 7.1), presents the field on the cusp of modernity. Understanding the medical advances achieved during Eakins's lifetime, and especially in the

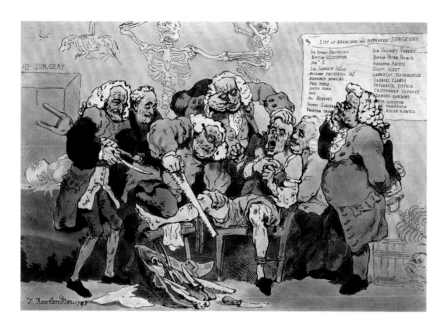

Fig. 3.1. Thomas Rowlandson (English, 1756–1827), *Amputation*, 1793. Aquatint, 11 × 15⅞ inches (27.8 × 40.3 cm). Courtesy Wellcome Library, London

period bracketed by these two great paintings, enhances our appreciation of the works themselves and of this remarkable epoch in the history of medicine.

The Discovery of Anesthesia

Surgical anesthesia ranks as one of the most important discoveries in the history of medicine. Before 1846, when ether was first used for this purpose, operations were limited to either superficial procedures or amputations. A surgeon's skill was judged solely by speed rather than technique; amputations were performed in as little as thirty seconds, without regard for anatomy or future function. Opium, laudanum, morphine, and other narcotics could dull pain but were insufficient to relieve the agony of surgery without risking death from overdose. Anesthesia, by contrast, rendered a patient unconscious and pain-free, allowing surgeons to proceed with care rather than haste. Previously unimagined operations, not just on the body surface but in every cavity and on any organ, now became possible.

In a vivid account of surgery prior to anesthesia, the English writer Frances (Fanny) Burney (1752–1840) recalls the agony of her mastectomy, performed by the renowned French surgeon Dominique Jean Larrey

(1766–1842): "Yet, when the dreadful steel was plunged into my breast—cutting through veins-arteries-flesh-nerves—I needed no injunctions not to restrain my cries. I began a scream that lasted unremittingly during the whole time of the incision— & I almost marvel that it rings not in my ears still! so excruciating was the agony."[2] After reading this description, it is easy to understand why few chose to undergo anything other than minor surgery.

Serendipity rather than rigorous science played the principal role in the discovery of anesthesia. In 1844 (the year of Eakins's birth), Horace Wells (1815–1848), a dentist from Hartford, Connecticut, attended a demonstration of nitrous oxide by the medical student turned showman Gardner Q. Colton (1814–1898). "Nitrous frolics" were then a popular form of entertainment; people would inhale the gas and their antics provided amusement for the crowd. During the performance, Wells noticed that an acquaintance injured himself without apparent awareness of his wound. The following day, with Colton's help, Wells had himself placed under the influence of nitrous oxide while his partner removed one of Wells's teeth, marking the advent of surgical anesthesia.[3] Although nitrous oxide is a general anesthetic, it did not prove potent

enough for major surgery. Furthermore, it wasn't always reliable even for extractions; when Wells was invited to demonstrate its use at Massachusetts General Hospital in Boston the following year, both he and nitrous oxide were judged failures when the anesthetized patient cried out during a tooth extraction.

William T. G. Morton (1819–1868), a Harvard medical student and one-time partner in Wells's dental practice, had helped to arrange the failed demonstration at Massachusetts General. Afterward, Morton devoted his energy to identifying a more potent alternative to nitrous oxide. The exact chain of events is still somewhat controversial, but it appears that Morton sought the advice of Charles T. Jackson (1805–1880), a chemistry professor at Harvard, who suggested that he try diethyl ether (also known as sulfuric ether). After a few experiments on animals and on himself, Morton began using ether in his dental practice. His success led him to approach Dr. John Collins Warren (1778–1856) of Massachusetts General, and on October 16, 1846, now known as Ether Day, Morton gave the first successful public demonstration of what he called "Letheon" (fig. 3.2). Many in the crowd, anticipating another failure, had come to jeer, but at the end of the operation Dr. Warren famously proclaimed, "Gentlemen, this is no humbug."[4] Hoping to capitalize on the discovery, Morton tried to conceal the composition of

Fig. 3.2. Robert C. Hinckley (American, 1853–1941), *Ether Day*, 1882–93. Oil on canvas, 8 feet × 9 feet 7 inches (274 × 292 cm). The Boston Medical Library in the Francis A. Countway Library of Medicine

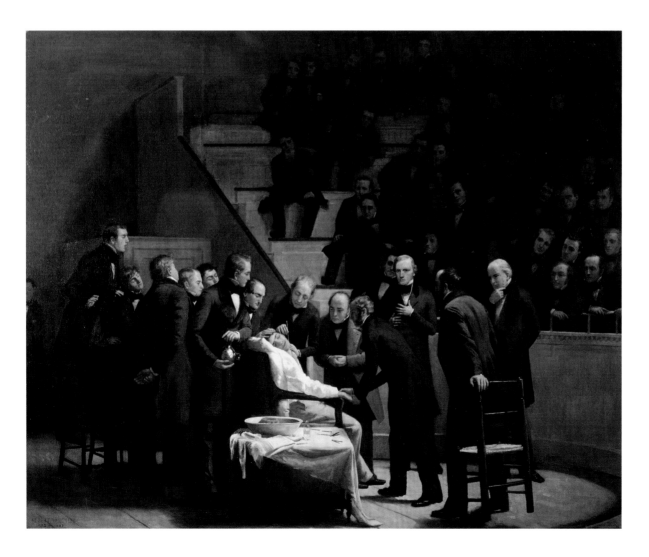

Letheon, but prior to his second demonstration, on November 7, Warren compelled him to reveal that it was common sulfuric ether. The news of the discovery of anesthesia (a term coined a few weeks later by Oliver Wendell Holmes) spread rapidly throughout the United States, to Great Britain, and throughout Europe.[5]

While Morton, Jackson, and Wells fought bitterly to claim sole credit for surgical anesthesia, British physician John Snow (1813–1858) helped popularize and establish a sound scientific basis for its use in England.[6] Dr. James Young Simpson (1811–1870), a prominent obstetrical surgeon from Scotland, introduced ether for pain relief during childbirth but became dissatisfied with its side effects. Ether had a noxious smell, caused nausea and vomiting, greatly increased saliva production, and was slow (approximately 5 to 20 minutes) to take effect. Furthermore, it was known to be explosive. Simpson reasoned that other volatile compounds might serve as anesthetics, and along with two colleagues he spent his evenings inhaling various chemicals in the hopes of discovering a viable alternative.[7] On November 4, 1847, after considerable experimentation, Drs. Simpson, Keith, and Duncan tried chloroform. As one biographer describes the event:

> [T]hey became brighteyed, very happy, and very loquacious—expatiating on the delicious aroma of the new fluid. The conversation was of unusual intelligence, and quite charmed the listeners—some ladies of the family and a naval officer, brother-in-law of Dr. Simpson. But suddenly there was a talk of sounds being heard like those of a cotton mill louder and louder; a moment more and then all was quiet—and then crash! On awakening Dr. Simpson's first perception was mental—"This is far stronger and better than ether," said he to himself. His second was to note that he was prostrate on the floor, and that among the friends about him there was both confusion and alarm. Hearing a noise he turned round and saw Dr. Duncan beneath a chair—his jaw dropped, his eyes staring, his head bent half under him; quite unconscious, and snoring in a most determined and alarming manner.[8]

Chloroform indeed has a pleasant smell; it is much more potent than ether, faster in onset, and rarely causes vomiting. Its greater potency made it more practical to transport than ether, since much smaller volumes were needed. Unfortunately, chloroform's faster action also made accidental overdose and death a genuine hazard. Even more ominously, it provoked abnormal heart rhythms that could rapidly prove deadly. Less than a year after the introduction of chloroform as an anesthetic, a fifteen-year-old British girl named Hannah Greener became its first reported fatality—probably due to a heart arrhythmia—during an operation to remove a toenail.[9]

Despite its risks, Snow soon came to prefer chloroform to ether for all patients except children, publishing books and articles based on his observations and including drawings for vaporizers and breathing circuits to improve the predictability of its administration.[10] Even so, by 1852 Snow had identified twenty-one deaths due to improper administration of chloroform.[11] Ether appeared to be the safer, if somewhat less effective, choice, since its administration was relatively easy and required little special training. The use of chloroform, on the other hand, required considerable skill to avoid complications. Despite Snow's early technical advances in delivery systems and the popularity of inhalers in Britain, the most common mode of administration for both substances in the United States was simply to pour the anesthetic into a handkerchief or towel, as shown in *The Gross Clinic*.

Many physicians initially resisted and even decried the use of anesthesia, believing that pain and suffering were essential and natural components of surgery and childbirth. Perhaps no act did more to promulgate its use than Snow's widely publicized administration of chloroform to Queen Victoria during the delivery of her son Leopold in 1853, an event that helped bring about the general acceptance of surgical anesthesia.[12]

The Development of Antisepsis

Ether and chloroform could now be used to prevent pain, but deadly infection still slowed the progress of surgical practice. At the time, the dominant theory for the origin of infection was spontaneous generation, the process by which life was thought to arise from

inanimate matter. Microscopes were rarely used in medical settings, so few doctors were even in a position to make the connection between transmissible micro-organisms and disease.

Whereas surgery is elective, childbirth is inevitable. A devastating postpartum infection called puerperal or childbed fever was all too common in the mid-nineteenth century. Oliver Wendell Holmes observed in 1843 that the infection was more prevalent in hospitals than in deliveries at home, suggesting that puerperal fever must be due to a transmissible agent.[13] However, his careful observations and reasoning had no apparent immediate impact on medical practice, nor did they dislodge spontaneous generation as the dominant theory for the origin of infection.

In 1847 in Vienna, the Hungarian physician Ignaz Semmelweis (1818–1865) made two seminal observations that suggested a transmissible source for puerperal fever. First, he noted that a colleague who died from an infection that developed after he cut his finger during an autopsy had symptoms identical to those seen in puerperal fever. He also noted a much higher incidence of infection in the wards of the city's First Division, staffed by physicians and medical students, compared to those of the Second Division, staffed by nurse-midwives. Semmelweis reasoned that puerperal fever was caused by "cadaverous particles" carried from the autopsy room on doctors' hands. To make matters worse, laboring women were examined repeatedly by trainee after trainee. He instituted a strict policy of hand-washing with chlorinated lime prior to each examination, and thereby reduced the infection rate from 12 percent to close to 1 percent. Unfortunately, Semmelweis did not publish his findings for more than a decade and failed to win many converts. His descent into psychosis (or perhaps early-onset Alzheimer's disease) ensured that his work was rapidly forgotten.

ORGANIZED NURSING AND HOSPITAL SANITATION

The Crimean War of 1853–56, fought between the Russian Empire and an alliance that included Britain, France, the Austrian Empire, and the Ottoman Empire, is often considered the first modern war. Thanks to the use of telegraphs and photographs, it was also the first war reported directly to the public by the press, unfiltered by the government. The London papers widely publicized the abysmal state of the care of wounded British troops and blamed those responsible for running the war.

Florence Nightingale (1820–1910) stepped in to address the problems on the Crimean front. Over the objections of her upper-class family, Nightingale had sought a career as a nurse. Her experiences in the fever wards during the London cholera epidemic of 1854 had convinced her of the need for hospital sanitation and clean air. As a result of her political connections, which included a personal acquaintance with Queen Victoria, the British government requested Nightingale's assistance in responding to the reports of horrible conditions for wounded soldiers.

Upon her arrival at Scutari Hospital in Crimea, the conditions were indeed horrific; sewage didn't drain, the soldiers languished without care, and the rooms lacked ventilation. Several men would occupy the same bed, and their wounds would be cleaned with the same cloth, directly transmitting infection from one patient to the next.[14] Nightingale imposed her philosophy of nursing and hospital management, including her penchants for fresh air, cleanliness, warmth, and nutrition. All of the wounded were bathed on arrival, and practices that would seem inconceivable now were suspended.

After the war, the royal commission set up to investigate the causes for the high casualty rate among British soldiers sought Nightingale's input. Her statistical analyses proved that most of the illnesses and deaths resulted from poor sanitary conditions and could largely have been prevented by good hygiene. Even though new weapons inflicted horrendous injuries, only a fifth of British fatalities were caused directly by wounds received in battle; most died from postoperative infections and diseases such as typhus, typhoid, and infectious diarrhea.[15] Nightingale used her insights and position to influence hospital design and administration, the care of soldiers, and the training of nurses,[16] establishing the beginnings of modern hospital infection-control practices.

LISTERISM

While Nightingale's work had demonstrated the need for cleanliness, sanitation, isolation of infected patients, and clean air in hospitals, the concept that infection was due to anything other than impure air or could be transmitted from a doctor or nurse to patients, and from an infected patient to other patients, was still unknown. The breakthrough came from the work of Louis Pasteur (1822–1895), who demonstrated in the early 1860s that yeast, rather than simple exposure to air, caused grape juice to ferment into wine. Dr. Joseph Lister (1827–1912), a young surgeon in Edinburgh, was the first to grasp the relevance of Pasteur's work to surgical practice and the infection of wounds. Lister repeated Pasteur's experiments, substituting urine for grape juice. He confirmed that microorganisms (bacteria)—not air—turned the urine cloudy. Lister's observation became known as the germ theory of infection, which launched the field of bacteriology.

Lister reasoned that carbolic acid, which had been used to decontaminate sewage, might also prevent infection by killing the bacteria in wounds.[17] After further refining his technique for treating wounds, he developed a system of antiseptic surgery that included hand-washing for doctors and their assistants, skin preparation for patients, instruments washed and maintained in a solution of carbolic acid, dressings soaked in carbolic acid, catgut (rather than silk) sutures soaked in carbolic acid, and a carbolic acid spray aimed at the surgical field. By 1870 he had demonstrated that his antiseptic system could prevent most infectious complications of surgery. Predictably, despite Lister's dramatic results doctors continued to reject antisepsis, particularly in Great Britain and the United States, and it would be another twenty to thirty years before Listerism was adopted universally.

Eakins's Clinics

DR. GROSS AND HIS CLINIC

In 1875, when Eakins painted his celebrated portrait, Samuel D. Gross (1805–1884; fig. 3.3) was America's preeminent physician and surgeon. Born near Easton,

Fig. 3.3. David Lothrop (American, active 1870s), *Samuel David Gross, M.D.*, c. 1870–80. Albumen print, 6½ × 4 inches (16.5 × 10.2 cm). Thomas Jefferson University Archives and Special Collections, Scott Memorial Library, Philadelphia

Pennsylvania, Gross grew up speaking the English-German hybrid of the Pennsylvania Dutch and didn't learn English until he was fifteen. He began his study of medicine at seventeen as an apprentice to a country doctor but abandoned this for a more formal education, ultimately graduating from Jefferson Medical College in Philadelphia at age twenty-three.

Despite his modest beginnings, after only a few years in practice Gross became a demonstrator of anatomy and then professor of pathological anatomy at the University of Cincinnati. He was later appointed professor of surgery at Louisville University and finally, in 1856, returned to his alma mater to become professor and chair of the Surgery Department at Jefferson.[18] His first book, *Elements of Pathological Anatomy*, was published in 1839 and became the first American medical text to gain renown in Europe.[19] Gross went on

to produce more than twelve hundred original scientific papers[20] and numerous books, including revised editions of *Pathological Anatomy* and, most famously, the six editions of the massive *System of Surgery*, first published in 1859.[21] He was very active politically, cofounding and serving as president of both the American Medical Association and the American Surgical Association, whose journal *Annals of Surgery* served as the fulcrum for the scientific development of the field. In acknowledgment of his contributions, Gross received honorary degrees from all three major British universities—Oxford, Cambridge, and Edinburgh—a remarkable achievement for an American.[22]

Gross considered himself a conservative surgeon, performing operations only as a last measure and to minimize harm to his patients. At the outbreak of the Civil War, he rapidly wrote and published a pocket-sized manual on the treatment of wounds that served as the definitive guide for both Union and Confederate battlefield surgeons.[23] In the preface, he exhorts the physician to practice conservative surgery to preserve not only the lives but also the limbs of soldiers.

The Setting of "The Gross Clinic"

The operation we witness in Eakins's painting takes place under natural light in the surgical amphitheater at Jefferson Medical College. While gas lamps were available in 1875, long-lasting electric lightbulbs were not. Chloroform was Gross's preferred anesthetic, but when ether was used gas lamps or candles would have added the risk of explosion. To ensure adequate light, Gross preferred to operate between eleven in the morning and two in the afternoon. Since at the time only about four operations per day were performed at Jefferson Hospital, restricting surgery to midday and to sunny days was not a major handicap.[24]

Operations and dissections of cadavers had been public spectacles for centuries, but by 1875 access to such demonstrations was limited, and medical students were required to pay for the privilege of attending Gross's anatomy and surgical lectures (fig. 3.4). In fact, medical education consisted primarily of attending a course of lectures over a two-year period, with little if

Fig. 3.4. Admittance card for lectures on surgery by Samuel D. Gross, Jefferson Medical College, 1869. Dr. Michael Echols Collection

any contact with actual patients. Students spent their afternoons performing anatomical dissection as their only means to gain and practice skills. While public operations were a great spectacle and Gross was a superb lecturer, the process was an extremely inefficient one for teaching surgery. An 1888 illustration of surgery at Massachusetts General Hospital shows an attendee viewing the procedure through binoculars, emphasizing the limited perspective from the amphitheater seats (fig. 3.5). My own experience in the operating room as a practicing anesthesiologist is that unless one is standing directly over the incision, it usually is not possible to see much of what is taking place during an operation. In Eakins's painting, Gross is shown backing away, not only to lecture on an important point but also to allow the audience a glimpse of the procedure.

Anesthesia

Although ether was the dominant anesthetic in the United States, the patient before us in *The Gross Clinic* is receiving chloroform. In the 1862 edition of *System of Surgery*, Gross described his preference for the latter:

It is somewhat singular that the two countries in which the anæsthetic virtues of ether and chloroform were discovered should each, respectively, prefer its own remedy; America,

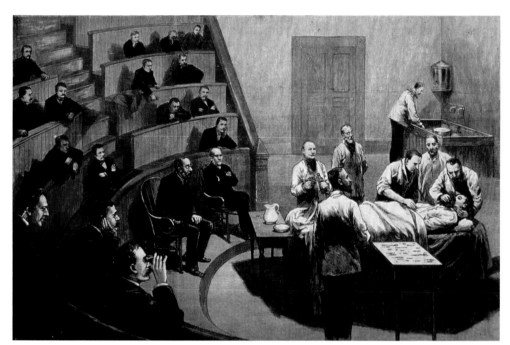

Fig. 3.5. *Instruction in Surgery. – Scene in the Operating Room Amphitheater of the Massachusetts General Hospital, Boston Administering Ether to a Patient*, 1888. Wood engraving. Courtesy U.S. National Library of Medicine, National Institutes of Health, Bethesda, Maryland

ether, and Great Britain chloroform. There are, however, in the United States, numerous practitioners who prefer the latter article, both in surgical and obstetrical practice, and I have myself constantly used it ever since its introduction among us in 1848, believing it to possess decided advantages over ether, although its administration unquestionably requires greater care and attention.[25]

By 1875, mounting evidence showed ether to be the safer choice. Gross accepted that ether might be safer for the novice, but he attributed his comparative success with chloroform to the purity of the form he used and to "the extraordinary care with which it has been administered in my practice."[26] The predominant factor in that care was the skill of Dr. W. Joseph Hearn (1842–1917), who is pictured by Eakins at the head of the bed. Although Hearn was an outstanding surgeon in his own right—particularly in neurosurgery—he was the sole anesthetist for Gross's cases from 1870 onward. Snow had earlier developed vaporizers to control the administration of both ether and chloroform, but these devices were not in common use by the 1860s due to their inconvenience and concern about "insufficiency of atmospheric air." Hearn is shown

following Gross's preferred method, which was "to pour the fluid upon a napkin or handkerchief, previously folded into a kind of cup-shaped hollow, and held securely in the hand."[27]

The Procedure

The surgical procedure Eakins depicts was one that Gross innovated and championed: the removal of a sequestrum—a piece of necrotic or dead bone that develops after osteomyelitis (acute bone infection)—in this case from the femur of a young man. This extremely painful lesion would have harbored chronic infection, causing general debilitation and even death. Prior to the advent of general anesthesia, the only surgical option would have been amputation; the prolonged and careful dissection needed to remove a sequestrum would have been intolerable to the patient. In 1875, the mortality rate from amputation at mid-femur would have been very high, perhaps 50 to 75 percent; from amputation near the hip, it would have been close to 100 percent. By limiting the operation to removal of the sequestrum, Gross literally was preserving both the patient's life and his limb.

Fig. 3.6. Detail of *The Gross Clinic* showing the surgical instrument case

Operating-Room Hygiene Prior to Antiseptic Technique

Gross, his assistants, and everyone in the gallery are shown wearing street clothes. Surgical gowns, masks, and gloves were unheard of in 1875. Surgeons of the day reserved one of their black frock coats just for surgery. A coat stiff with blood and pus would have been a source of pride, marking the wearer as an important and successful surgeon.[28]

Gross's instrument cases lie open in the foreground (fig. 3.6). Each surgeon purchased and maintained his own instruments, which came in fine wooden box sets with all of the tools needed for a specific type of surgery (fig. 3.7). The instruments would be wiped off (or not) after each procedure, but otherwise they were rarely cleaned. In a lecture in 1915 comparing surgical practices during the Civil War to those during World War I, Dr. William W. Keen made specific reference to Gross's technique, noting that

sponges then used were washed in ordinary water after an operation and if one fell to the floor during an operation it was again used. What we did in the pre-Listerian days seems now almost incredible. Before an operation nothing was rendered "sterile." I have seen my old teacher, Prof. S. D. Gross, give a last fine touch to his knife on his boot,

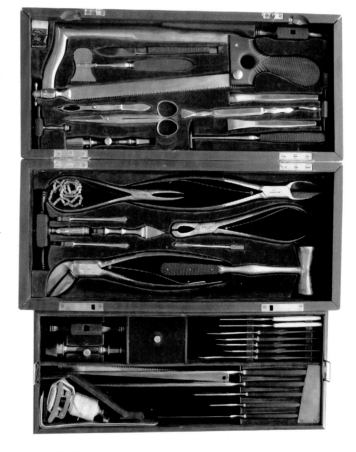

Fig. 3.7. Civil War–era surgical instrument set, manufactured by H. Hernstein, New York. Dr. Michael Echols Collection

even on the sole, and then at once use it from the first cut to the last. When threading a needle we all pointed the silk by wetting it with germ-laden saliva, rolling it between germ-laden fingers.[29]

We can only hope that by 1875 Gross had abandoned the use of his boot to sharpen his scalpel. From his writing, we know that he was extraordinarily well read and up to date on advances in all areas of medicine and surgery from around the world. He was conversant with and admired Nightingale's work related to the Crimean War and her theories on ideal hospital construction. In his own writings, Gross emphasized the importance of cleanliness, ventilation and pure air, nursing care, and the separation of patients to prevent contagion.[30]

Yet Gross's hesitance to adopt antisepsis was the one major blot on a stellar career. As the country's most famous surgeon, Gross helped stall the widespread adoption of antiseptic surgery in the United States. Although he visited Lister's hospital in 1868 and was thoroughly versed in the Edinburgh surgeon's numerous papers demonstrating the efficacy of antiseptic surgery using carbolic acid, he could not conceive or accept the idea that invisible microorganisms cause disease. In fact, by 1875 Gross stood as the leading opponent of and obstacle to the adoption of Listerism in the United States.

When Gross presided over the 1876 International Medical Congress, which met in Philadelphia coincident with the Centennial Exhibition (where *The Gross Clinic* was first shown to the public), he was still confident that impure air (referred to variously as *miasma* or *hospitalism*) was responsible for infection. Even so, he invited Lister to present a paper on "Antiseptic Surgery" at the Congress. Lister's lecture was long and impassioned, highlighting the scientific evidence and the results of his methods.[31] Gross did not respond directly, but others stood in his place to oppose and reject Lister's explanations.[32] Fortunately, Lister's remarks were not totally without effect; sitting in the audience were Gross's son, Samuel W. Gross (seen standing in the darkened archway in *The Gross Clinic*), D. Hayes Agnew (of *The Agnew Clinic*), and

Keen, all of whom listened with open minds and within months became early adopters of antisepsis.

Surgeon and author Sherwin B. Nuland recently proposed that Eakins would have been familiar with Listerism and therefore intended his portrait as a condemnation of Gross and his antiquated surgical practices.[33] Eakins was working in Europe at the time of Lister's initial findings, which were published in *The Lancet*—then probably the most important and widely read medical journal in the world—and would have been discussed widely. In a fascinating article written from a surgeon's perspective, Clyde F. Barker explores the evidence to see if there is any basis for Nuland's hypothesis. Although Barker does find additional context and corroborative support for Nuland, he nonetheless concludes: "It seems more likely to me that, whether or not Eakins shared the admiration most Philadelphians had for Gross, the painter's intent was to depict Gross as a heroic figure in the big picture he hoped would make him famous."[34]

DR. AGNEW AND HIS CLINIC

> He was beloved by every one; his words, deeds, and thoughts were quoted and copied everywhere as almost infallible. To the American world, who dearly loves a hero, he stood the ideal of the prowess of the American surgeon. The name of Agnew has always been associated with the description of the great Larrey, the French surgeon, by Napoleon: "He was the best man I ever knew."
>
> J. HOWE ADAMS, 1892[35]

David Hayes Agnew (1818–1892; fig. 3.8) grew up in considerably different circumstances from Gross. His father was a college-educated physician and surgeon, and Agnew knew from early childhood that he wanted to become a doctor. After graduating from the Medical Department of the University of Pennsylvania in 1838, Agnew became a country doctor in his hometown of Nobleville (now Christiana), Pennsylvania, about fifty miles west of Philadelphia. After five years, he briefly abandoned medicine to become a partner in his father-in-law's iron foundry. When the business failed

D Hayes Agnew

1892

Fig. 3.8. D. Hayes Agnew. Courtesy University of Pennsylvania
Archives, Philadelphia

in 1846, Agnew reentered medical practice and, per-
haps energized by the recent discovery of anesthesia,
set out to become a surgeon.

Like Gross before him, Agnew believed that a
successful surgeon needed a thorough grounding in
anatomy, and he became renowned for his ability and
willingness to scavenge corpses for dissection, obtain-
ing bodies from pauper's fields and even risking cholera
during an epidemic to procure specimens.[36] Agnew's
biographer, J. Howe Adams, relates a story about the
doctor's arrangement to dispose of his dissected corpses
in a nearby farmer's pond. A local fisherman soon
became known for eels "famed for their size and

fatness"; when the source of their enormity was eventu-
ally revealed, Agnew faced a backlash and relocated to
Philadelphia in 1848 in part to escape the notoriety.[37]

Agnew's reputation as an anatomist and surgeon
grew, and in 1863 he was appointed demonstrator in
anatomy and lecturer in clinical surgery at the University
of Pennsylvania. It was not until 1870, at the age of
fifty-two, that Agnew was finally appointed professor of
clinical surgery. The following year he was honored as the
first John Rhea Barton Professor of the Principles and
Practice of Surgery at the University of Pennsylvania.[38]

The Civil War, which furnished the first opportu-
nity for American surgeons to gain wide experience
with trauma surgery, played a major role in Agnew's
development and subsequent prominence as a surgeon.
Philadelphia's relative proximity to battlefields made it
an ideal central locale for treating wounded soldiers,
providing learning opportunities for the growing cadre
of young Philadelphia surgeons, including Agnew.
Early in the war Agnew was placed in charge of surgery
at the Hestonville Hospital in West Philadelphia, and
in 1863 he became consultant surgeon at the Mower
Hospital in nearby Chestnut Hill, which housed more
than five thousand men at a time. He treated wounded
soldiers from both armies at the Gettysburg battlefield,
including Union general Winfield Scott Hancock, who
in 1880 would lose the closest presidential election in
U.S. history to James Garfield.[39]

As a result of these experiences, Agnew developed a
reputation as the country's leading expert on the
management of gunshot wounds. When President
Garfield was shot on July 2, 1881, doctors immediately
tried to retrieve the ball. Over the course of the next
day and a half, sixteen surgeons repeatedly probed the
wound with unwashed fingers and surgical instruments
in unsuccessful attempts to remove the bullet. By the
time Agnew was consulted thirty-six hours later,
Garfield had a high fever and the wound was grossly
contaminated, ultimately proving fatal. Agnew made
no attempt to locate the bullet, but rather focused on
draining the president's abscesses, utilizing antiseptic
technique. Had Agnew been present from the begin-
ning, the outcome might have been very different. In
his *Principles and Practice of Surgery* (1889), he wrote,

"A great deal of unnecessary importance has been attached to the extraction of balls, and a great deal of harm done by a prolonged search for these missiles. Penetrating shot-wounds are believed to be aseptic, and become septic only by the measures used in exploration and extraction."[40]

Although he was a great teacher, mentor, medical doctor, and clinical surgeon, Agnew could not compete with Gross as an innovator. Rather, he was adept at assessing new techniques and ideas and adopting those he deemed most worthy. His approach was scientific, flexible, and open. "At a time when many of his juniors were skeptical as to the merits of antisepsis, or were even openly antagonistic," wrote his former student and longtime colleague J. William White, "he gave it a thorough trial and at once discarded in its favor the methods which he had employed for forty years."[41] His chapter on antisepsis in *Principles and Practice of Surgery* was the first in any major textbook.[42]

By the 1880s anesthesia and antisepsis had dramatically reduced surgical mortality, permitting much more prolonged operations and procedures on every organ of the body, but bleeding remained a major cause of operative death. Since doctors had no means to administer intravenous fluids or blood during surgery, absolute control and prevention of bleeding were essential. The control of hemorrhage was one area where Agnew's inventiveness advanced the field of surgery. He performed laboratory experiments to study the process of blood clotting and developed an arterial vessel clamp that helped limit and control bleeding.[43] As Keen noted in 1897, "Not a little of this lessened mortality [of surgery] is due to our improved methods of hæmostasis, especially by the use of the hæmostatic forceps."[44] Agnew insisted that Eakins minimize the amount of blood visible on his hands and in the surgical field.[45] This may have had as much to do with the surgeon's pride in his ability to control hemorrhage as with his awareness of the public reaction to the blood on Gross's hands in the earlier painting.

The ability to clamp bleeding arteries and tie off major veins (Gross's son Samuel W. was the first to tie off the major veins in the chest) allowed surgeons access to every part of the body.[46] The control of hemorrhage made possible more invasive operations such as the breast surgery depicted in *The Agnew Clinic* (see fig. 7.1). By the end of his career, Agnew's practice incorporated all the elements of modern surgery: extensive knowledge of anatomy, use of safe surgical anesthesia, antisepsis and asepsis, and control of hemorrhage.

The Setting of "The Agnew Clinic"

While *The Gross Clinic* shows a man at the peak of his powers, *The Agnew Clinic* of 1889 presents someone transferring his legacy to the next generation. Agnew stands several steps from the surgical table, leaning back and holding a scalpel in his left hand, demonstrating his famous ambidexterity.[47] White, the mustached surgeon working to control the patient's bleeding in the painting, described Agnew's operating room ritual this way:

> His habit at his clinic was to precede his operation by a brief statement of the history of the case, and by some remarks upon diagnosis and prognosis, and upon his reasons for choosing the particular operative method he was about to employ. During the operation itself he said but little. Afterward he would usually leave some of the final details, the arrest of hemorrhage, insertion of sutures, application of dressings, etc., to his assistant, while he explained more fully what he had just done, and described what he had observed.[48]

The operating theater is bathed in light from long-lasting electric bulbs, patented by Thomas Edison in 1879. With the advent of electric lights, surgery was no longer restricted to peak daylight hours and sunny days. The surgical instruments, rather than being housed in a wooden case owned by the surgeon, as in *The Gross Clinic*, are contained in a closed case under the watchful eye of the nurse to protect their sterility.

Demonstration of Antiseptic Technique

Agnew and his assistants are shown wearing surgical gowns, while the students, at a distance from the operating table, wear street clothes. In his textbook, published

Fig. 3.9. George Chambers (American, active 1880s), *Agnew Clinic*, 1886. Albumen print. Courtesy University of Pennsylvania Archives, Philadelphia

the same year the painting was executed, he advised that "both surgeon and assistants should divest themselves of the coat ordinarily worn, substituting for the same a white linen apron, with sleeves which button closely round the wrists. These aprons ought never to be worn in a subsequent operation without having been previously washed."[49] Sterilized instruments and freshly laundered gowns reserved for the operating room seem obvious today, but at the time the concept was revolutionary. In fact, in a photograph taken only three years earlier (fig. 3.9), Agnew and White can be seen wearing black coats, without a nurse present. In the photograph, a carbolic acid sprayer is aimed at the patient's leg; although none is shown in Eakins's painting, undoubtedly such a sprayer would have been used in 1889 to maintain antiseptic technique.

The surgical gowns, which did not become standard until the early twentieth century, give *The Agnew Clinic* a much more modern feel than *The Gross Clinic*. In fact, the painting is almost an advertisement for the modernity of the innovative practices at the University of Pennsylvania. Gloves didn't appear in surgery until

1890, when William Stewart Halsted of Johns Hopkins Hospital had Goodyear make rubber gloves to protect the sensitive hands of his nurse (later his wife) from carbolic acid.[50] Like antisepsis, masks and gloves did not catch on immediately; they did not emerge as standard attire until the influenza epidemics of 1917–18—and even then, the goal was to protect the surgeon, not the patient.

Agnew and the Advent of Professional Nursing

Agnew's views on women were strictly Victorian. He strongly opposed education for young women and initially refused to participate in the process, even to the point of resigning from Pennsylvania Hospital in 1872 rather than teach mixed classes of men and women. He eventually relented, allowing women to attend his lectures when he returned to the hospital faculty in 1877.[51] White reported, however, that Agnew's personal belief remained that a woman belonged in the home: "He admired the domestic virtues, and at one of the last dinners he ever gave,

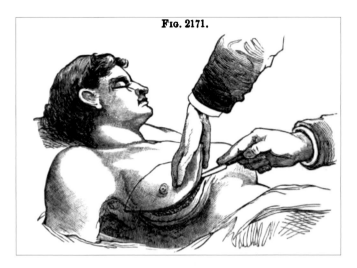

Fig. 2171.

Fig. 3.10. "Breast incision," illustration from D. Hayes Agnew, *Principles and Practice of Surgery*, 2d ed. (Philadelphia: J. B. Lippincott, 1889), vol. 3, p. 716, fig. 2171. Courtesy The College of Physicians of Philadelphia

remarked that a woman should be taught housekeeping, hygiene and belles-lettres. After that, he said, the more she knew the worse off she was."[52]

Agnew nonetheless supported an expanded role for nurses in the care of patients, recognizing that advances in medicine and surgery made public and university hospitals places for all to receive care, not just the indigent. With a growing patient population came the need for trained personnel to care for the sick. The professionalization of nursing begun by Nightingale provided the dedicated individuals needed to ensure both the care of patients and the technical needs of the surgeon. The introduction of antisepsis in the operating room meant that not just the instruments but the room and all of its contents needed careful and thorough cleaning. Then as now, the operating room nurse served as the vigilant guardian and enforcer of antiseptic technique, ever watchful of contamination of a surgeon's sleeve or instrument.

The University of Pennsylvania began organizing its School of Nursing in 1886, with the help of Nightingale and under the direction of one of her graduates, Alice Fisher. Mary V. Clymer, the nurse portrayed at the far right in *The Agnew Clinic*, was a member of the second graduating class in 1889 and winner of the first

Florence Nightingale Medal as the outstanding student in her class. Her lecture notes, preserved in the archive at the University of Pennsylvania School of Nursing, provide insight into the beginnings of organized nursing in America. Clymer's serious demeanor and "military stance" are in keeping with the standards expected by her teachers.[53] She wrote in 1888 that one "should always be dignified & grave during operations. Avoid levity & grief."[54] Given that the mortality rate from breast surgery (primarily from blood loss) cited by Agnew ranged from one in ten to one in thirty, depending on the extent of the required dissection, the opportunities to display grief during such procedures would not have been infrequent.[55]

Some authors have used Clymer's notes on breast surgery to suggest that the exposed right breast shown by Eakins represented artistic license rather than accurate observation;[56] certainly its inclusion was a source of controversy and condemnation at the time.[57] Clymer's notes from a lecture by Professor Ashurst in 1889 state the following: "Having clothing loose & if necessary cut out the sleeve. For a breast case only put one arm in the night dress & be sure to have one exposed that is to be operated on."[58] In *Principles and Practice of Surgery*, Agnew states that "[p]revious to the administration of the anæsthetic the body and arm on the affected side should be entirely disrobed of the underdress, and a light blanket thrown over the exposed portion";[59] however, the next page includes an illustration of the incision for breast excision in which both breasts are revealed, with the blanket adjusted in the same position as in the painting (fig. 3.10).[60] Whether the naked right breast accurately reflected Agnew's surgical practice or was Eakins's artistic choice remains uncertain.

Anesthesia

At the head of the bed, Dr. Elwood R. Kirby can be seen holding a towel to administer ether (fig. 3.11), configured in the same cone shape as shown in Agnew's textbook (fig. 3.12). We know that the anesthetic is ether rather than chloroform because Kirby is clutching the distinctive Squibb ether container (fig. 3.13) in his right

Fig. 3.11. Detail of *The Agnew Clinic* (see fig. 7.1) showing Dr. Elwood R. Kirby administering Squibb ether to the patient through a cone

Fig. 3.12. "Cone formed out of a towel for inhaling ether," illustration from D. Hayes Agnew, *Principles and Practice of Surgery*, 2d ed. (Philadelphia: J. B. Lippincott, 1889), vol. 2, p. 225, fig. 1125. Courtesy The College of Physicians of Philadelphia

Fig. 3.13. Squibb ether container, manufactured by E. R. Squibb & Sons, New York. Courtesy Science Museum / Science and Society Picture Library, London

arm. Kirby was an intern in 1889 and inexperienced as an anesthetist compared with Hearn. There is little evidence of his administering anesthesia again in his career.[61] In the moment captured by Eakins, Kirby holds the cone away from the patient's face. This may have been an artistic choice to allow Eakins to humanize the anonymous patient, but it was also the means by which the depth of anesthesia could be adjusted by adding more ether to the cone or allowing the patient to breathe more or less room air.

Even in the final edition of his textbook, published in 1882, Gross continued to adhere to his personal preference for chloroform despite evidence of its dangers.[62] Agnew, however, did not mince words. After a review of the medical literature up to 1872 in which he found 405 reports of death from chloroform compared to only 6 from ether, he stated that "a surgeon who, in the face of such evidence, will continue to employ chloroform, assumes a tremendous responsibility." Going a step further, he concluded: "No man has any right to jeopardize unnecessarily the life of a fellow-being. Chloroform, except in the few cases where ether fails to produce decided anaesthesia, should be banished from surgical practice."[63]

The Procedure

Surgical mastectomy may have been Agnew's least favorite operation. The evidence at the time showed a one-year survival advantage for those who underwent surgery compared to those who did not. As a rigorous scientist, Agnew recognized that the data was heavily biased and was disinclined to believe it. He even thought that surgery might shorten rather than lengthen the patient's life. Agnew reflected that his own results likely failed to match the 9.05-percent long-term survival rate reported by "Gross the younger" (Samuel W. Gross), stating, "[I]ndeed, I should hesitate, with my present experience, to claim a single case of absolute cure where the diagnosis of carcinoma had been verified by microscopic examination."[64]

So why did Eakins choose to portray Agnew performing this very operation? Art historians and critics have made much of this choice.[65] Perhaps Eakins

is showing us the future of surgery rather than its past. By 1889, surgery for breast cancer was becoming more aggressive, shaking off the conservative tendency in the hope of effecting a cure. In 1882, W. Mitchell Banks noted that although few women died from surgery, they all "died at a little later period from a want of a little more of it."[66] Instead of a simple mastectomy, surgeons began performing a more extensive excision with a clearing out of the axillary lymph nodes, even when the nodes felt normal. Banks reported a nearly 40-percent survival rate at one year and nine months after more radical surgery.[67] Although Agnew had adopted this approach (see fig. 3.10), the first major surgical advance wasn't reported until after his death, when Halsted published his experiences at Johns Hopkins with what is now known as radical mastectomy.[68] Even so, Agnew's assessment of the role of surgical treatment alone in effecting a cure would prove prophetic: "I do not despair of carcinoma being cured somewhere in the future, but this blessed achievement will, I believe, never be wrought by the knife of the surgeon. We may hope, however, for the discovery of some drug which, operating through the general system, will follow and destroy the vagrant cells."[69]

SURGERY AFTER THE CLINICS

Gross and Agnew were surgical generalists whose careers began when the number of types of operations could be counted on two hands. Both men went on to perform every type of surgery imaginable and produced thousands of pages of medical texts detailing these procedures for others. After Agnew, no one would ever again possess such a complete knowledge of anatomy, medicine, and surgery or write a single-author text encompassing the entirety of the field. As Agnew's colleague White noted, "It is not likely that there will ever again be any one who will combine the enormous experience, embracing every department of surgery, the clear judicial intellect, and the patient, untiring energy . . . to produce this remarkable exposition of his work and views."[70] By the end of the century, specialization had become inevitable, a byproduct of the increasingly complex and diverse surgeries made

possible by the combined advances of anesthesia and antisepsis. Breast surgery was the prime field where surgical specialization was beginning to emerge and from which the generalist would soon retreat. Rarely has a field witnessed as much progress in such a short span of time, going from infancy to the threshold of adulthood in forty-five years, along with the life and career of Thomas Eakins.

1. William W. Keen, "Semicentennial Address in Surgery before the American Medical Association," in *Addresses and Other Papers* (Philadelphia: W. B. Saunders, 1905), p. 259.

2. *Fanny Burney, Selected Letters and Journals*, ed. Joyce Hemlow (New York: Oxford University Press, 1986), pp. 127–41; quotation on pp. 138–39.

3. Peter H. Jacobsohn, "Horace Wells: Discoverer of Anesthesia," *Anesthesia Progress*, vol. 42 (1995), pp. 73–75.

4. Warren quoted in H. Laing Gordon, *Sir James Young Simpson and Chloroform (1811–1870)* (London: T. Fisher Unwin, 1897), p. 102. See also Francis D. Moore, "John Collins Warren and His Act of Conscience," *Annals of Surgery*, vol. 229, no. 2 (1999), pp. 187–96.

5. See, for example, Henry Jacob Bigelow, "Insensibility during Surgical Operations Produced by Inhalation," *Boston Medical and Surgical Journal*, vol. 35, no. 16 (1846), pp. 309–17.

6. By 1847, Snow had produced numerous scientific journal articles and a book on the actions and administration of ether. See John Snow, *On the Inhalation of the Vapour of Ether in Surgical Operations: Containing a Description of the Various Stages of Etherization and a Statement of the Result of Nearly Eighty Operations in Which Ether Has Been Employed in St. George's and University College Hospitals* (London: John Churchill, 1847); John Snow, "A Lecture on the Inhalation of Vapour of Ether in Surgical Operations," *The Lancet*, vol. 49, no. 1239 (1847), pp. 551–54; "Westminster Medical Society," *The Lancet*, vol. 49, no. 1226 (1847), pp. 227–28.

7. S. M. Rae and J. A. W. Wildsmith, "Editorial: So Just Who Was James 'Young' Simpson?" *British Journal of Anaesthesia*, vol. 79, no. 3 (1997), pp. 271–73.

8. Gordon, *Sir James Young Simpson and Chloroform*, p. 107.

9. See Paul R. Knight III and Douglas R. Bacon, "An Unexplained Death: Hannah Greener and Chloroform," *Anesthesiology*, vol. 96 (2002), pp. 1250–53.

10. John Snow, "On the Inhalation of Chloroform and Ether with Description of an Apparatus," *The Lancet*, vol. 51, no. 1276 (1848), pp. 177–80.

11. John Snow, "On the Cause and Prevention of Death from Chloroform, Part 3," *London Journal of Medicine*, vol. 4 (June 1852), pp. 564–72.

12. *The Case Books of Dr. John Snow*, ed. Richard H. Ellis, Medical History Supplement No. 4 (London: Wellcome Institute for the History of Medicine, 1994), p. 471.

13. Oliver W. Holmes, *The Contagiousness of Puerperal Fever* (Boston: Boston Society for Medical Improvement, 1843).

14. Christopher J. Gill and Gillian C. Gill, "Nightingale in Scutari: Her Legacy Reexamined," *Clinical Infectious Diseases*, vol. 40 (2005), pp. 1799–1805.

15. See Florence Nightingale, *A Contribution to the Sanitary History of the British Army during the Late War with Russia* (London: John W. Parker and Son, 1859); R. Hall Bakewell, "Notes on the Diseases Most Commonly Treated at the Scutari Hospitals," *Medical Times and Gazette*, November 3, 1856, pp. 441–42.

16. See Florence Nightingale, *Notes on Nursing: What It Is, and What It Is Not* (New York: D. Appleton, 1860); Florence Nightingale, *Notes on Hospitals*, 3d ed. (London: Longman, Green, Longman, Roberts, and Green, 1863).

17. See Joseph Lister, "On a New Method of Treating Compound Fracture, Abscess, Etc., with Observations on the Conditions of Suppuration, Part I," *The Lancet*, vol. 89, no. 2272 (1867), pp. 326–29; Joseph Lister, *Introductory Lecture Delivered in the University of Edinburgh, November 8, 1869* (Edinburgh: Edmonston and Douglas, 1869); S. W. B. Newsom, "Review: Pioneers in Infection Control—Joseph Lister," *Journal of Hospital Infection*, vol. 55 (2003), pp. 246–53.

18. William W. Keen, "Address at the Unveiling of the Statue of the Late Professor Samuel D. Gross, M.D., Washington, D.C., May 5, 1897," in *Addresses and Other Papers* (Philadelphia: W. B. Saunders, 1905), pp. 233–36.

19. Samuel D. Gross, *Elements of Pathological Anatomy*, 2 vols. (Boston: Marsh, Capen, Lyon, and Webb, 1839).

20. Clyde F. Barker, "Thomas Eakins and His Medical Clinics," *Proceedings of the American Philosophical Society*, vol. 153, no. 1 (March 2009), p. 11.

21. Samuel D. Gross, *A System of Surgery: Pathological, Diagnostic, Therapeutic, and Operative*, 2 vols. (Philadelphia: Blanchard and Lea, 1859).

22. Keen, "Address at the Unveiling," p. 238.

23. Samuel D. Gross, *A Manual of Military Surgery; or, Hints on the Emergencies of Field, Camp and Hospital Practice* (Philadelphia: J. B. Lippincott, 1861).

24. Annual Announcements, Jefferson Medical College, 1875–76, Thomas Jefferson University Archives.

25. Samuel D. Gross, *A System of Surgery: Pathological, Diagnostic, Therapeutic, and Operative*, 2d ed. (Philadelphia: Blanchard and Lea, 1862), vol. 1, p. 577.

26. Samuel D. Gross, *A System of Surgery: Pathological, Diagnostic, Therapeutic, and Operative*, 6th ed. (Philadelphia: Henry C. Lea's Son, 1882), vol. 1, p. 549.

27. Gross, *A System of Surgery* (1862), vol. 1, p. 580.

28. See *A Surgeon's Life: The Autobiography of J. M. T. Finney* (privately printed, 1940), p. 75; cited in Elinor S. Schrader, "From Apron to Gown: A History of OR Attire," *AORN Journal*, vol. 24, no. 1 (July 1976), p. 54. See also Barker, "Thomas Eakins and His Medical Clinics," p. 15; Harold Laufman, Nathan L. Belkin, and Kenneth K. Meyer, "A Critical Review of a Century's Progress in Surgical Apparel: How Far Have We Come?" *Journal of the American College of Surgeons*, vol. 191, no. 5 (November 2000), p. 555.

29. "Philadelphia—March, April," *Pennsylvania Medical Journal*, vol. 18, no. 9 (June 1915), pp. 744–45.

30. See Gross, *A Manual of Military Surgery*, especially pp. 27–45, 139–51.

31. Joseph Lister, "Antiseptic Surgery," in *Transactions of the International Medical Congress, Philadelphia*, ed. John Ashhurst (Philadelphia: International Medical Congress, 1877), pp. 535–44.

32. Even in the sixth and final edition of *A System of Surgery* (1882), in which he acknowledged Lister's great contribution to medicine, Gross continued to reject germ theory, offering instead that "the atmosphere of ill-ventilated and long-occupied hospitals contains a noxious, invisible, permeable dust," which is responsible for "inducing putrefaction, suppuration, and their evil consequences, and also of giving rise to the phenomenon of blood-poisoning" (vol. 1, p. 467). Keen's interpretation on this point is generous. He lauds Gross for the ability to "throw aside all his strong prejudices and accept the then struggling principles and practice of Listerism," which demonstrated "the progressive

character of his mind and his remarkable willingness to accept new truths." See Keen, "Address at the Unveiling," p. 236.

33. Sherwin B. Nuland, "The Artist and the Doctor," in *The Uncertain Art: Thoughts on a Life in Medicine* (New York: Random House, 2008), pp. 148–56.

34. Barker, "Thomas Eakins and His Medical Clinics," p. 23.

35. J. Howe Adams, *History of the Life of D. Hayes Agnew* (Philadelphia: F. A. Davis, 1892), p. 364.

36. Ibid., pp. 88–89.

37. Ibid., p. 71.

38. De Forest Willard, *D. Hayes Agnew, M.D., LL.D.: Biographical Sketch* (Philadelphia: Philadelphia Medical County Society, 1892), p. 6.

39. Adams, *History of the Life of D. Hayes Agnew*, pp. 131–35.

40. D. Hayes Agnew, *The Principles and Practice of Surgery*, 2d ed. (Philadelphia: J. B. Lippincott, 1889), vol. 1, p. 302.

41. J. William White, *Memoir of D. Hayes Agnew* (Philadelphia: College of Physicians, 1893), pp. 19–20.

42. Agnew, *Principles and Practice of Surgery* (1889), vol. 1, pp. 43–51.

43. Adams, *History of the Life of D. Hayes Agnew*, p. 175.

44. Keen, "Semicentennial Address," p. 257.

45. Lloyd Goodrich, *Thomas Eakins* (Cambridge, MA: Harvard University Press for the National Gallery of Art, 1982), vol. 2, p. 45.

46. Keen, "Semicentennial Address," p. 264.

47. See Willard, *D. Hayes Agnew*, p. 6; White, *Memoir of D. Hayes Agnew*, p. 376.

48. White, *Memoir of D. Hayes Agnew*, p. 10.

49. Agnew, *Principles and Practice of Surgery* (1889), vol. 1, p. 50.

50. See John L. Cameron, "William Stewart Halsted: Our Surgical Heritage," *Annals of Surgery*, vol. 225, no. 5 (1997), pp. 445–58.

51. See Adams, *History of the Life of D. Hayes Agnew*, pp. 144–47. Adams attributes this change to Agnew being too polite to raise objections to the presence of women, who would not have known his preferences on the matter.

52. White, *Memoir of D. Hayes Agnew*, p. 24.

53. Bridget L. Goodbody, "'The Present Opprobrium of Surgery': *The Agnew Clinic* and Nineteenth-Century Representations of Cancerous Female Breasts," *American Art*, vol. 8, no. 1 (Winter 1994), pp. 32–51 (quotation on p. 40).

54. Mary V. Clymer Papers, Center for the Study of the History of Nursing, School of Nursing, University of Pennsylvania, Philadelphia.

55. See D. Hayes Agnew, *The Principles and Practice of Surgery* (Philadelphia: J. B. Lippincott, 1883), vol. 3, p. 712. Samuel W. Gross reported that,

based on his research, "about one in six . . . of the patients die of the operation itself"; Samuel W. Gross, *A Practical Treatise on Tumors of the Mammary Gland* (New York: D. Appleton, 1880), p. 198; cited in Goodbody, "The Present Opprobrium of Surgery," p. 43.

56. See Margaret Supplee Smith, "*The Agnew Clinic*: 'Not Cheerful for Ladies to Look At,'" *Prospects*, vol. 11 (1986), pp. 161–83; Diana E. Long, "The Medical World of *The Agnew Clinic*: A World We Have Lost," *Prospects*, vol. 11 (1986), pp. 185–98; Goodbody, "The Present Opprobrium of Surgery," pp. 32–51.

57. For the painting's troubled reception, see Goodrich, *Thomas Eakins*, vol. 2, pp. 45–51; Smith, "*The Agnew Clinic*," pp. 161, 178; Michael M. Frumovitz, "Thomas Eakins' *Agnew Clinic*: A Study of Medicine through Art," *Obstetrics and Gynecology*, vol. 100, no. 6 (December 2002), p. 1299. Eakins tried for three years in a row to have it exhibited, without success. Smith quotes the directors of the Pennsylvania Academy of the Fine Arts as saying, "Some thought the picture not cheerful for ladies to look at" (p. 161). Goodrich reports that Eakins lamented, "They call me a butcher, and all I was trying to do was picture the soul of a great surgeon" (p. 46).

58. Mary V. Clymer Papers, Center for the Study of the History of Nursing, School of Nursing, University of Pennsylvania, Philadelphia.

59. Agnew, *Principles and Practice of Surgery* (1883), vol. 3, p. 715.

60. Ibid., p. 716.

61. James E. Eckenhoff, "The Anesthetists in Thomas Eakins' 'Clinics,'" *Anesthesiology*, vol. 26, no. 5 (1965), p. 666.

62. See Gross, *A System of Surgery* (1882), vol. 1, p. 549.

63. Agnew, *Principles and Practice of Surgery* (1889), vol. 2, p 291.

64. Agnew, *Principles and Practice of Surgery* (1883), vol. 3, p. 711.

65. See Goodbody, "The Present Opprobrium of Surgery"; Smith, "*The Agnew Clinic*," pp. 161–62, 166–67.

66. W. Mitchell Banks, "On Free Removal of Mammary Cancer, with Extirpation of the Axillary Glands as a Necessary Accompaniment," *British Medical Journal*, vol. 2, no. 1145 (1882), p. 1139.

67. Ibid., pp. 1140–41.

68. William S. Halsted, "The Results of Operations for the Cure of Cancer of the Breast Performed at the Johns Hopkins Hospital from June, 1889, to January, 1894," *Annals of Surgery*, vol. 20, no. 5 (1894), pp. 497–555.

69. Agnew, *Principles and Practice of Surgery* (1883), vol. 3, p. 711.

70. White, *Memoir of D. Hayes Agnew*, pp. 16–17.

Kathleen A. Foster

A Portrait of Ambition: Eakins, *The Gross Clinic,* and the American Centennial

IN THE SPRING OF 1875, Thomas Eakins lived with frustration and hope. Thirty years old, he had returned from his training in Paris almost five years earlier, but his career as an artist had stalled. The old guard at the National Academy of Design in New York refused to show his work. The Pennsylvania Academy of the Fine Arts in Philadelphia, where he studied in the early 1860s, had sold its building and suspended the annual exhibitions that offered young artists a chance to get work seen locally. Since 1870, he had produced some thirty-seven paintings, but sold only one (a watercolor) in the United States. Most successful exhibiting work with the young American Society of Painters in Water Colors in New York, he had shown a grand total of two paintings in Philadelphia—an unidentified portrait and *The Champion Single Sculls* (Metropolitan Museum of Art, New York)—at a four-day installation at the Union League in the spring of 1871. Otherwise, he could compete for an invitation from one of the two commercial galleries in town, Earle's and Haseltine's, or hope for space in a couple of display windows at high-end stores on Chestnut Street. He must have been elated, at last, by good news from Paris in April 1875, when he learned that his work had been accepted at the Salon and (for the second time) at the Goupil Gallery, where Eakins had sold a hunting picture the previous year.[1]

Buoyed by this news, his spirits—and his ambition—must have risen along with the flamboyant new Academy building on the corner of Broad and Cherry streets, designed by the up-and-coming architect Frank Furness (1839–1912), which promised to be the most splendid institution of its kind in the country (fig. 4.1). Eakins surely looked forward eagerly to the completion of this building, with its elegant new exhibition spaces and premier educational facility, scheduled to open in the spring of 1876. The building committee had consulted with him on the layout of the studios, drawing on his knowledge of Parisian art schools; certainly he was angling for a place on the faculty.[2] His old professor, Christian Schuessele (1824–1879), was ailing, and

Fig. 4.1. Frederick Gutekunst (American, 1831–1917), *The Pennsylvania Academy of the Fine Arts*, 1876. Albumen print. Archives, Pennsylvania Academy of the Fine Arts. The exuberant Frank Furness–designed building at the corner of Broad and Cherry streets in Philadelphia opened on April 22.

Eakins—unquestionably the best-trained and most talented young figure painter in the city—had positioned himself as a logical assistant and successor by volunteering critiques at the informal life school established by the Philadelphia Sketch Club after the Academy closed for renovation.[3]

Even more enticing would have been the building rising in west Fairmount Park as the centerpiece for the city's planned celebration of the centennial of American independence (fig. 4.2). Although a late start and a gloomy financial climate made some doubt that Philadelphia would ever pull off the nation's first world's fair, by 1875 work had begun on Memorial Hall, destined to hold the international display of fine arts. Among the array of temporary exhibition pavilions, Memorial Hall was one of the few buildings constructed in stone to outlast the fair, demonstrating for the first time a now-familiar stratagem to bolster the argument for municipal investment in such an exposition. Designed by the German-born Hermann Schwarzmann (1843–1891), the majestic gallery spaces would become the first home of the Pennsylvania Museum (later the Philadelphia Museum of Art) when the fair concluded. Eakins

had visited the Exposition Universelle in Paris in 1867; he understood exactly the scale and caliber of international attention that such a fair would draw. As the many punches in his exhibitor's pass indicate (see fig. 4.4), he was to be an enthusiastic visitor.[4] Contemplating Memorial Hall and the opportunity it presented to show his work alongside colleagues from the United States, France, Great Britain, and elsewhere to legions of visitors (ultimately more than nine million), Eakins must have shuddered with anticipation.

Memorial Hall also was to house the first historical survey of American art ever gathered, documenting—like the Centennial Exhibition overall—a century of progress in the United States. Determinedly patriotic and positive, the Centennial's program intentionally underscored themes of post–Civil War unity, prosperity, and productivity. The juried show of contemporary art from across the nation was expected to demonstrate the same upbeat message of accomplishment and promise. Naturally, Philadelphia's artists hoped to be front and center at such a celebration, and the Sketch Club's members eagerly volunteered their services to the art department of the upcoming fair. Following a

Fig. 4.2. Memorial Hall, Fairmount Park, Philadelphia. Opening ceremonies of the Centennial Exhibition, May 10, 1876. Courtesy Free Library of Philadelphia. Designed by Hermann Schwartzmann to house the international display of paintings and sculpture at the fair, the building became the first home of the Pennsylvania Museum (later the Philadelphia Museum of Art).

meeting on March 27, 1875, the club issued its "Address to the Artists of the United States," calling for entries that "will do honor to the country and to the occasion." Noting that "patriotism demands . . . their utmost efforts," the Sketch Club exhorted fellow artists to "show the advancement of art in the United States during the past hundred years, and display to the best advantage the peculiar characteristics of American art."[5]

Two weeks after this circular went out, Eakins wrote to his friend Earl Shinn, an art critic in New York who had been a founder of the Sketch Club in 1860 and an art student with Eakins in Paris a few years later. Grumpy about the rejection of his work that spring by the exhibition jury at the National Academy of Design, Eakins was nonetheless cheered by the recent response to his works in Paris. "But what elates me more," he continued, "is that I have just got a new picture blocked in & it is very far better than anything I have ever done. As I spoil things less & less in finishing I have the greatest hopes of this one."[6] The timing of his remarks and his sense of the promise of this new work suggest that he had launched *The Gross Clinic*, a painting that, judging by its scale and subject matter,

surely was intended for the Centennial. Based on a theme of American progress, and the largest and most complex painting he had ever undertaken, this picture was meant for a grand space and a cosmopolitan audience, to demonstrate his worth as a painter and the excellence of Philadelphia's—and thereby the nation's—modern, scientific culture.

The subject of his ambitious canvas made sense to Eakins for many reasons, starting with the fact that Samuel D. Gross (1805–1884; fig. 4.3) was one of the most famous surgeons in the world. A star of Jefferson Medical College (now part of Thomas Jefferson University), Gross was one of the school's first graduates and among its greatest professors. Born on a farm near Easton, Pennsylvania, he received his medical degree in 1828 with the third graduating class of the new college, chartered in 1824. His expertise as an anatomist led to teaching appointments in Cincinnati and Louisville until 1856, when his alma mater invited him to take the post of professor of surgery. By 1875, when Eakins painted him surrounded by his "clinic" of other doctors, he was a beacon of learning at the largest medical school in the country, revered as a teacher, admired as a surgeon,

Fig. 4.3. Samuel Bell Waugh (American, 1814–1885), *Portrait of Dr. Samuel Gross*, 1874. Oil on canvas, mounted on wood; 30 × 25 inches (76.2 × 63.5 cm). Thomas Jefferson University Archives and Special Collections, Scott Memorial Library, Philadelphia

and respected as a founder of many local, national, and international medical societies. Referred to in his day as "The Emperor of American Surgery," Gross innovated many surgical techniques and instruments, and he was a prolific and influential author. Among his publications were the textbook *A System of Surgery* (first published in 1859), which was translated into many languages, and the pocket-sized *Manual of Military Surgery* (1861), which served as a handbook for doctors on both sides of the battlefields of the Civil War.[7]

In Eakins's portrait, Gross models the new image of the surgeon described in his first address at Jefferson in 1856. "Unjustly regarded as a very humble branch of medicine," he declared, the art and science of surgery in fact required exceptional courage and skill: "To operate well demands a rare combination of qualities, which only a few favored men possess. . . . To a profound knowledge of surgical anatomy, or of the relations which one part of the body bears to another, must

be added extraordinary manual dexterity, the most perfect coolness and self-possession, great foresight, and an eye that is never appalled by the sight of blood." With the focus "that a great general displays during the progress of a battle," the good "operator" remains undeterred by "the shrieks of his patient, the sight of the vital fluid as it issues, in bold and rapid streams, from the purple channels of the body, and the fear and agitation of the bystanders."[8] Illustrating precisely this composure and expertise, Eakins depicts Gross absorbed in his work, majestically in control, a hero of modern surgery.

The operation shown in *The Gross Clinic* illustrated one of the surgeon's areas of special expertise: "the removal of dead bone from the femur of a child" suffering from osteomyelitis.[9] With his small, sock-clad feet and legs held in place by an attending doctor, the patient lies on his right side, with knees bent, his head invisible beneath the gauze cloth clasped by the anesthetist at the far end of the table. The advent of anesthesia in the 1840s liberated surgeons to perform more delicate, lengthy, and novel treatments such as this operation, which by 1875 was a routine, non-life-threatening procedure for Gross and his team (see Schreiner's essay in this volume). His clinic also demonstrates the recent revolution in the treatment of this disease, achieved by a new understanding of anatomy and the body's ability to heal itself. An infection of the bone that in the recent past would have been brutally handled with amputation was now treated with elegant, minimally invasive surgery—a triumph of applied research and conservative practice. In a famous introductory "Then and Now" lecture, Gross thrilled new medical students with such examples to illustrate the astonishing progress in medicine and surgery that had unfolded at Jefferson during his lifetime. "There is no city in the world, Paris and Vienna not excepted," said Gross, "where the young aspirant after the doctorate may prosecute his studies with more facility or advantage than in [Philadelphia]."[10] Watching from the amphitheater, at the far right of the painting, Eakins appears as an eager participant in this vanguard scientific community, leaning forward to witness and document the city's—and the nation's—exhilarating "now."

Fig. 4.4. Circle of Thomas Eakins, *Thomas Eakins Leaning against Building*, 1870–76. Albumen print, 10⁹⁄₁₆ × 5¹⁵⁄₁₆ inches (26.8 × 15 cm). Pennsylvania Academy of the Fine Arts, Philadelphia. Charles Bregler's Thomas Eakins Collection, purchased with the partial support of the Pew Memorial Trust, 1985.68.2.33. This print has been ruled with graphite lines, suggesting, along with the odd pose, preparation for an unidentified project.

Fig. 4.5. Thomas Eakins's exhibitor pass to the Centennial Exhibition, 1876. Hirshhorn Museum and Sculpture Garden Archives, Smithsonian Institution, Washington, DC. Gift of Joseph H. Hirshhorn, 1966. Eakins used the portrait seen in fig. 4.4 (printed in reverse) for his photograph on the pass.

Eakins's admiration for the charismatic surgeon may have been fired by his attendance at Gross's lectures in the spring of 1874, but the artist's self-portrait in the painting (evidently based on a photograph similar to fig. 4.4, which was printed in reverse for his exhibitor's pass to the Centennial; fig. 4.5) also reflects a long relationship with Jefferson and its faculty. Eakins's father, the calligrapher and writing master Benjamin Eakins (1818–1899), had been inscribing the diplomas at Jefferson since his son was a toddler. Eakins registered to attend anatomy lectures at the school in 1864–65, a few years after graduating from Central High School. At this same time, his former chemistry teacher at Central, Dr. Benjamin Rand, joined the faculty at Jefferson. After returning from Paris, where he may have continued to study anatomy and dissection, Eakins acquired an admission ticket to Jefferson lectures again in 1873 and 1874–75. His ability to persuade the busy Dr. Gross to pose in 1875 may tell us something about the social skills of an otherwise untested and little-known young painter, but surely it also suggests that he was part of the Jefferson community.[11]

As a student among others in the amphitheater, Eakins also takes part in the teaching moment that is the second significant subject of his painting. Jefferson Medical College educated one out of every four doctors in the United States at this time, showing a productivity and democratic accessibility to applicants made possible by the clinic system of teaching, which—unlike older models of individual mentoring—allowed many students to learn from one professor and his assistants during surgery.[12] The distinguished surgeon Jacob M. Da Costa studied with Gross and remembered the impact of his lecture-demonstrations: "As a speaker he was fluent, deliberate, clear, and emphatic. . . . His tall commanding figure, his clear voice, his features beaming with intelligence and animation, his zealous manner—all contributed to rendering his teaching effective."[13] The students and the clinical amphitheater itself, located on the top floor of the college's Ely Building, thus add meaningful context to the painting, and the particular clinic personnel are important to the story. Five young doctors (one of whom is obscured by Dr. Gross) circle the young patient. Chief of Clinic Dr. James M. Barton, age twenty-nine, bends over the patient, probing the incision, while the twenty-four-year-old junior assistant Dr. Charles S. Briggs grips the patient's legs and Dr. Daniel M. Appel—at twenty-one, the newest graduate of the school—holds the incision open with a retractor. The anesthetist (Dr. W. Joseph Hearn, age thirty-three) holds a folded napkin soaked with chloroform above the patient's face, while the clinic clerk (Dr. Franklin West, about twenty-five) records the proceedings. In the shadowy tunnel leading out of the amphitheater, Dr. Gross's thirty-eight-year-old son, Dr. Samuel W. Gross, leans casually against the wall, while the clinic's orderly, Hughey O'Donnell, stands ready to assist. Illuminated by the skylight above as well as lesser light from windows to the left, Dr. Gross turns majestically from his work to lecture to his audience of students.[14]

The clinic's story of modern science, teamwork, and teaching turns on the authority of Gross, who dominates the ring of doctors, commands the attention of the spectators, and rules the composition of the painting, reminding us that Eakins first titled it simply *Portrait of Professor Gross*.[15] As such, it was presented as

a grand manner portrait that the artist surely hoped would win the attention of patrons seeking such monumental, commemorative imagery. Like Eakins's first painting of a scientist, *Professor Benjamin Howard Rand* of 1874 (see fig. 6.2), which he also submitted to the Centennial Exhibition, *The Gross Clinic* was calculated to build a reputation for large, dignified, and inventive—even edgy—portraiture, which Eakins foresaw in his student days in Paris as the bedrock of a lucrative career in America.[16] He surely knew that the Jefferson Alumni Association recently had been commissioning portraits of the college's most celebrated faculty, including uninspired images of Gross (see fig. 4.3) and Dr. Joseph Pancoast by the venerable Samuel Bell Waugh (1814–1885) in 1874. Gross, as founder and first president of the alumni group, had launched the campaign himself in 1871 as a way to increase the school's self-esteem, and on April 15, 1875—two days after Eakins crowed about his newly blocked-in painting—Gross stepped up the pace, appointing a committee to procure additional portraits. Eakins, who had approached Gross and convinced him to pose with (one imagines) a flattering argument on the merits of celebrating his clinic and the Jefferson teaching method, stood to acquire other commissions if the painting succeeded. As he would say two years later about his portrait of the new president Rutherford B. Hayes, his ambition was to make a picture "which may do me credit in my city and which if I may be allowed to exhibit in France may not lessen the esteem which I have gained there."[17] The strategy was not without risks. Gross might not like the painting, and Waugh—who, alas, would turn up on the Centennial jury—might not fancy being eclipsed.[18] But Eakins had much to gain: local, national, and international attention and a chance to apply the lessons he had learned in Paris to figure painting that would put modern American subjects firmly in the tradition of the greatest European Old Masters. When he began his painting in 1875, he could not have anticipated the storm of criticism that it would receive when first exhibited in Philadelphia and New York, but he would live to see *The Gross Clinic* declared a masterpiece, winning for him a reputation that would surpass his most ambitious dreams.

1. See Elizabeth Milroy, with Douglass Paschall, *Guide to the Thomas Eakins Research Collection, with a Lifetime Exhibition Record and Bibliography* (Philadelphia: Philadelphia Museum of Art, 1996), p. 19. Eakins had produced about twenty-eight finished oils and ten watercolor paintings, beginning with *Street Scene in Seville* in 1870, before beginning *The Gross Clinic*. New Yorkers knew him only from his watercolors: nine had appeared at the American Society of Painters in Water Colors or at the Brooklyn Art Association in 1874–75. He sold his first painting at the watercolor exhibition of 1874, and his first oil through Goupil Gallery in Paris the same year. See Lloyd Goodrich, *Thomas Eakins: His Life and Work* (New York: Whitney Museum of American Art, 1933), pp. 164, 166. Eakins's friend Earl Shinn noted the discouraging situation in Philadelphia and the resulting drain of artistic talent; "Fine Arts: The Pennsylvania Academy," *The Nation*, vol. 22 (May 4, 1876), pp. 297–98. David Sellin described these artistic "doldrums" and the run-up to the Centennial in *The First Pose, 1876: Turning Point in American Art; Howard Roberts, Thomas Eakins, and a Century of Philadelphia Nudes* (New York: W. W. Norton, 1976), p. 7. The text of Eakins's letter to Shinn in April 1875 describing the news from Paris is included in the Appendix to the present volume.

2. Shinn, "Fine Arts," pp. 297–98, quoted in Sellin, *The First Pose*, p. 53.

3. From 1874 to 1876 Eakins conducted "large and interested" life classes packed with "diligent" students every Wednesday and Saturday evening for the Philadelphia Sketch Club; *Philadelphia Press*, January 7, 1876, quoted in Gordon Hendricks, "Thomas Eakins's *Gross Clinic*," *Art Bulletin*, vol. 51, no. 1 (March 1969), p. 58. On Eakins's Sketch Club experience, see Sellin, *The First Pose*, pp. 53–54. Eakins's pupils gave him an engraved brass porte-crayon in 1875 as thanks for his services; Kathleen A. Foster, *Thomas Eakins Rediscovered: Charles Bregler's Thomas Eakins Collection at the Pennsylvania Academy of the Fine Arts* (Philadelphia: Pennsylvania Academy of the Fine Arts; New Haven, CT: Yale University Press, 1997), cat. 265, p. 450. The plan worked: in October 1876, Eakins began to teach evening life classes at the Academy as an unpaid assistant to Schuessele (who also spelled his name *Schussele*).

4. The outer edges of his pass have lost the continuous double row of dates originally printed on these cards, making it impossible to calculate how many times Eakins visited the Centennial during June, July, and August. The absence of punchmarks between the May 10 opening (along the left border) and his first apparent visit on May 28 suggests that he stayed away until the Art Gallery was installed, or, more likely, that he was not given an exhibitor's pass until the art exhibition was nearing completion. Following the general contour of attendance at the exposition, Eakins visited more often as the end of the show approached and the weather cooled. On the design of Memorial Hall and the experience of the Centennial Exhibition, see Bruno Giberti, *Designing the Centennial: A History of the 1876 International Exhibition in Philadelphia* (Lexington: University Press of Kentucky, 2002).

5. From *Report of the Director-General, including the Reports of Bureau of Administration, United States Centennial Commission, International Exhibition, 1876* (Philadelphia: J. B. Lippincott, 1879), vol. 1, pp. 148–49, quoted in Sellin, *The First Pose*, p. 45; see also Ellwood C. Parry III, "Thomas Eakins and *The Gross Clinic*," *Jefferson Medical College Alumni Bulletin*, vol. 16, no. 4 (Summer 1967), pp. 5–6.

6. Eakins to Earl Shinn, April 13, 1875, Cadbury Collection, Friends Historical Library, Swarthmore College, Swarthmore, Pennsylvania (see the Appendix for the full text of this letter). Many other scholars have concurred that this letter refers to *The Gross Clinic*; the first seems to have been Ellwood C. Parry III, "*The Gross Clinic* as Anatomy Lesson and Memorial Portrait," *Art Quarterly*, vol. 32, no. 4 (Winter 1969), p. 375.

7. The first modern studies of the painting begin with Goodrich, *Thomas Eakins: His Life and Work*, pp. 49–53, revised and expanded in Lloyd Goodrich, *Thomas Eakins*, 2 vols. (Cambridge, MA: Harvard University Press

for the National Gallery of Art, 1982), vol. 1, pp. 123–38. More detailed articles have identified the portrait subjects and the medical context of the work: see Parry, "Thomas Eakins and *The Gross Clinic*," pp. 3–12; Parry, "*The Gross Clinic* as Anatomy Lesson," pp. 373–91; Hendricks, "Thomas Eakins's *Gross Clinic*," pp. 57–64. The medical and art-historical context was usefully enlarged by Elizabeth Johns in *Thomas Eakins: The Heroism of Modern Life* (Princeton, NJ: Princeton University Press, 1983), pp. 46–81; she cites (p. 62) I. M. Hays, who in 1887 asserted, "It is safe to say that no previous medical teacher or author on this continent exercised such a widespread and commanding influence as did Professor Gross" (quoted from "Memoir," in *Autobiography of Samuel D. Gross, M.D.*, 2 vols. [Philadelphia: George Barrie, 1887], vol. 1, p. xxix). Drawing on the collections at Thomas Jefferson University, Julie S. Berkowitz presents the most thorough account of Gross's career and Eakins's painting in *Adorn the Halls: History of the Art Collection at Thomas Jefferson University* (Philadelphia: Thomas Jefferson University, 1999), pp. 141–211. She comments on Gross's epithets as the "Emperor" or "Nestor" of American surgery (p. 141). We are also grateful to Berkowitz for sharing her research files. See also Mark Schreiner's essay in the present volume, which surveys the medical literature relating to Dr. Gross.

8. *An Inaugural Address Introductory to the Course on Surgery in the Jefferson Medical College of Philadelphia, Delivered on October 17, 1856, by Samuel D. Gross, M.D.* (Philadelphia: Jefferson Medical College, 1856). Thanks to F. Michael Angelo, Archivist at Thomas Jefferson University, for sharing this text. The theme of Gross as a paragon of modern science is developed in Johns, *Thomas Eakins*, pp. 46–70.

9. This description was given when the painting appeared at the Centennial; see *Report of the Board on Behalf of the United States Executive Departments at the International Exhibition Held at Philadelphia, Pa., 1876, under Acts of Congress of March 3, 1875, and May 1, 1876* (Washington, DC: Government Printing Office, 1884), "The Medical Section," vol. 1, cat. 15, p. 137. On this surgical procedure, see Parry, "Thomas Eakins and *The Gross Clinic*," pp. 2–12; Johns, *Thomas Eakins*, pp. 48–66; Berkowitz, *Adorn the Halls*, pp. 184–86.

10. Gross, *Inaugural Address*, quoted in Johns, *Thomas Eakins*, p. 63. On Eakins as witness, see Schreiner's essay in this volume. On the "Then and Now" lecture of 1867, which was reprinted for new students, see Berkowitz, *Adorn the Halls*, pp. 142–43.

11. Goodrich, *Thomas Eakins*, vol. 1, p. 27, noted that Eakins continued his anatomical studies in Paris and may have taken opportunities to dissect or attend surgery at local hospitals. On Eakins's affiliation with Jefferson, see Parry, "Thomas Eakins and *The Gross Clinic*," pp. 4–5. Parry, "*The Gross Clinic* as Anatomy Lesson," p. 384, notes that Jefferson was conveniently close to the Pennsylvania Academy, where Eakins was also taking classes. See also Hendricks, "Thomas Eakins's *Gross Clinic*," p. 57; Berkowitz, *Adorn the Halls*, pp. 122–28 (drawing on extant annotated admission tickets at the Hirshhorn Museum). When Lloyd Goodrich asked the painter's widow, Susan Macdowell Eakins, if (as had been rumored) the artist had considered becoming a doctor, she replied: "He was so serious about study that he likely contemplated both professions." Susan Macdowell Eakins to Lloyd Goodrich, August 24, 1931; Lloyd and Edith Havens Goodrich, Record of Works by Thomas Eakins, Philadelphia Museum of Art (hereinafter cited as Goodrich Archive, PMA).

12. On the clinic system and American medical schools, see Johns, *Thomas Eakins*, pp. 63–64. The drawbacks of this style of teaching are described in Schreiner's essay in this volume.

13. Hendricks, "Thomas Eakins's *Gross Clinic*," p. 59n20, quoting the *Autobiography of Samuel D. Gross, M.D.* Berkowitz quotes extensively from Da Costa's recollections of Gross's demeanor as a teacher; see *Adorn the Halls*, pp. 181, 187.

14. On the personnel in the painting, see Berkowitz, *Adorn the Halls*, pp. 176–79; Robert W. Ikard, "Dr. Gross's Assistants in *The Gross Clinic*," *Journal of the American College of Surgeons,* vol. 211, no. 3 (September 2010), pp. 424–30. No other images of the interior of the lecture hall survive; Berkowitz (pp. 84, 175–76) describes it as a large, octagonal amphitheater, seating six hundred. The secondary light, evidently from a window at the left, defines most of the figures in the background. Typically, Gross conducted surgery at 12:30 p.m., when the light from overhead was strongest (ibid., p. 181).

15. The painting was irregularly titled in its early years. The first record of its display at the U.S. Army Post Hospital at the Centennial gives a descriptive paragraph rather than a title. Reviews that year (see Appendix) refer to it as "Portrait of Dr. Gross," as does Eakins's pocket exhibition record book (now in the Philadelphia Museum of Art Archives). When the painting appeared at the Pennsylvania Academy in 1879, it was listed as *Portrait of Professor Gross.* It was not called *The Gross Clinic* until the retrospective exhibitions of 1916–17; see Goodrich, *Thomas Eakins*, vol. 1, p. 323; Berkowitz, *Adorn the Halls*, p. 188.

16. "One terrible anxiety is off my mind. I will never have to give up painting, for even now I could paint heads good enough to make a living anywhere in America." Thomas Eakins to Benjamin Eakins, June 24, 1869; Charles Bregler's Thomas Eakins Collection, Pennsylvania Academy of the Fine Arts (hereinafter cited as Bregler Collection, PAFA); reprinted in *The Paris Letters of Thomas Eakins*, ed. William Innes Homer (Princeton, NJ: Princeton University Press, 2009), p. 266.

17. Eakins to George D. McCreary, June 13, 1877; Bregler Collection, PAFA.

18. Parry speculates that Eakins found fault with Waugh's portrait of Gross and wished to do better, and suggests that Waugh may have been an unsympathetic Centennial juror; see Parry, "Thomas Eakins and *The Gross Clinic*," pp. 3–4, 12; Parry, "Thomas Eakins's *Gross Clinic*," pp. 373–74, 383. See also Berkowitz, *Adorn the Halls*, pp. 24–25; William H. Gerdts, *The Art of Healing: Medicine and Science in American Art*, exh. cat. (Birmingham, AL: Birmingham Museum of Art, 1981), p. 60.

Kathleen A. Foster and Mark S. Tucker

The Making of *The Gross Clinic*

By April of 1875, Eakins had begun work on *The Gross Clinic*, embarking on a creative process that expresses much about his training, his ambition, and the idiosyncratic method that would become a signature of his art making. Larger and more complex than any composition he had ever made, *The Gross Clinic* inspired some striking improvisational moments and significant changes, which were revealed in our close examination of the painting prior to its conservation in 2010. Eakins drew from the academic naturalism popular in Paris when he was a student there in 1866–69, and he was inspired by the Spanish and Dutch baroque painting he encountered in Europe, but he produced *The Gross Clinic* in a very personal and unconventional way.

Eakins had attended the atelier of Jean-Léon Gérôme (1824–1904) at the École des Beaux-Arts in Paris for three years, with supplemental sessions in the studio of the Spanish-trained painter Léon Bonnat (1833–1922), but nothing he learned in those life classes prepared him for the construction of a monumental figure painting. The French teaching method assumed, in fact, that "school" was for the mechanics of drawing and modeling form; composition, on the other hand, could not be taught. Students learned to make pictures by studying the works of other artists—in museums and galleries or at the annual salons—and then struggled on their own to create new work from imagination or observation. Eakins's first original composition, *A Street Scene in Seville* (private collection), painted in Spain in the spring of 1870, bravely tackled a subject with multiple figures in outdoor light. Floundering amid unknown, unstable components, Eakins struggled through a painful trial-and-error learning period that taught him, as he noted in his pocket journal, to conquer problems by a principle of division, reducing his difficulties to small, manageable steps.[1]

Returning to Philadelphia that summer, Eakins began his first outdoor subject in the United States that fall—*The Champion Single Sculls* (Metropolitan Museum of Art, New York)—which consolidated, for the first time and to brilliant effect, a

process that soon became his standard working method. Part French academic technique, part personal invention, this practice would be amplified by the extraordinary challenges of *The Gross Clinic*. Following Eakins through the development of this painting and its sometimes quirky and experimental construction, we are reminded that he was fundamentally alone in Philadelphia with a work of this ambition—without the mentors or collections he had known in Paris—and we can bring to life the struggles of a young painter with a powerful vision and an astonishing will to control and refine his work.

Only three oil sketches or studies remain to tell the story of the artist's early preparatory phases for *The Gross Clinic* (see figs. 5.6, 5.13, 5.16). Perhaps there never were many such sketches; convinced that oil studies could be a waste of time, he preferred to develop the details of his image on the final canvas.[2] Completely gone, however, is the record of his earliest compositional ideas, typically made in pencil on paper. Surely the complex placement of the figures in this picture needed careful thought to arrive at maximum impact and legibility. The final scheme, with one doctor completely hidden from sight behind Dr. Gross and the surgery itself confusingly foreshortened, must have been deemed the best of many alternatives.[3] We can regret the disappearance of the artist's preliminary planning sketches, but extant drawings for his other paintings of this period allow us to surmise that they would have been very schematic, focusing on the spatial layout, the general location of the figures, and perhaps the framing edges of the canvas. It is unlikely that there were detailed, highly modeled drawings of Gross or any of the other principals; Eakins didn't make such studies on paper. Conceptual rather than observed from life, functional rather than beautiful, Eakins's other extant pencil sketches demonstrate the role assigned to drawing in his compartmentalized method.[4]

The eccentricity of Eakins's habits as a draftsman emerges in the famously elaborate perspective drawings that preceded his rowing, hunting, and genre paintings between 1872 and 1876, including *The Chess Players*, a painting of 1876 that also appeared at the Centennial

(figs. 5.1, 5.2). No other American artist seems to have produced such drawings; certainly few of his contemporaries shared his skill or concern. Again, no perspective drawings for *The Gross Clinic* survive, but their existence is suggested by the pattern of his preparatory work for other compositions, the masterful illusion of space created in the painting, and the traces of a transfer grid beneath the paint on the canvas.

Eakins lectured to his students annually on the subject of perspective, and in the early 1880s he prepared a drawing manual (never published during his lifetime)[5] that describes in plain language the mechanics of the system he taught and helps us deduce its importance to *The Gross Clinic*. As his text noted, "A ground plan is a map of anything looking down on it, drawn to any convenient scale, and should almost always be drawn on paper before putting things into perspective."[6] We can assume, for such an important project, that once the general organization of the subject had been determined, he mapped out the placement of his principal figures on the imaginary floor of the surgical amphitheater of Jefferson Medical College. Eakins was known to borrow mechanical drawings from boatbuilders to make sure he got the details right in his outdoor scenes, and perhaps he had plans or photographs of the lecture hall. Unfortunately, the amphitheater he depicts was superseded by a new facility in 1877, and no images (perhaps excepting two humorous photographs made about 1879 by friends of the artist in an octagonal theater; see figs. 6.6, 6.7) survive to tell us exactly what it looked like.[7] As we shall see, the actual details of the room mattered to Eakins only insofar as he could convince viewers—as he clearly did—that they were seeing Dr. Gross in surgery, at Jefferson.

The ground plan informed the perspective drawing, which in turn established the system of recession that allowed Eakins to calculate precisely how the operating table must be foreshortened, or more distant figures diminished in size, to give the most convincing illusion of space. The perspective drawing for *The Chess Players* (see fig. 5.2), which contains figures grouped around a table as in *The Gross Clinic*, illustrates the three major decisions in a perspective set-up: the

station point of the artist (and by extension, the spectator), the placement of the picture plane (the "window" through which the subject is seen, corresponding to the plane of the canvas), and the location of the object to be depicted, in relation to the artist and the canvas. All three points, once chosen, must remain constant while constructing the space within the picture; as Eakins warned in his textbook, changes to any one will alter the scale of the figures within the painting and the recession of the space. The system demands consistency from the artist and then subtly coerces the viewer: as Eakins noted, the illusion of space will appear correct "from one point only, and the spectator should have a care to place himself at that point."[8] From that vantage, the artist's choices of station point, picture plane, and the location of the components of the composition create a specific—in fact unique—relationship between the viewer and the objects depicted that can serve subtle symbolic and psychological ends.

The first and simplest reference point to be determined is the vertical center line, which delineates what Eakins called the "middle of your field of vision" as you look at the subject. This line "down the exact middle of your canvas" can be imagined as continuing down the wall and forward to the feet of the artist, establishing the side-to-side position of the spectator relative to the subject.[9] In *The Chess Players*, the middle line falls, significantly, through the right eye of Eakins's father, Benjamin, standing between his two friends seated at the table, and then drops through the center line of the chess board itself. Both intersections underscore the importance of Benjamin Eakins and his role as observer of the game, mirroring both the physical position and the work of the artist.

In *The Gross Clinic* the middle line—visible in some places in the lower half of the composition as a faint graphite line beneath the paint—also runs down the exact center of the painting, but the focus of our attention here is not so simple. The line drops through two especially intent student faces, intersects Gross's left shoulder, and continues down the empty space between his jacket and sleeve (fig. 5.3). Although nothing important is happening along this line, it falls exactly halfway between Gross's own spine and the midpoint of the surgical incision, establishing an axis around which the two great focal points of the painting are balanced.

Once the center line has been drawn, the second decision affecting the way space is created in the perspective scheme involves the eye level of the artist, or the "horizon line." In *The Chess Players*, the horizon is sixty inches from the floor, a conventional height in portraiture, being about the distance from the ground to the eyes of a standing person of middling height (about five-foot-six, perhaps like Benjamin Eakins), and an easy number to reduce into fractions when calculating a picture smaller than life scale. Seeking his father's exact eye level, Eakins established Benjamin as the center of the universe of this painting, looking down on his friends at the table, and also as equal in stature to the painter—although we know that Eakins actually was about four inches taller than his father. Signing the work BENJAMIN EAKINS FILIUS PINXIT (Benjamin Eakins's son painted this), the artist also honored his father by effectively bending his knees and respectfully dropping his eye level as he composed the scene. Such deliberate and meaningful eye levels occur throughout Eakins's work in the 1870s. Crouching low opposite a hunter squatting in the marshes, or high above an oarsman or sailor, his vantage can be understood as driven by the wish to find the most informative and engaging viewpoint. Stressing his own embodied point of view, Eakins creates a sense of involvement, a you-are-there immediacy that will carry the painter's subjective experience directly to the viewer.[10]

In life-size portraiture such as *The Gross Clinic*, artists typically choose a horizon that expresses their own position, either when seated (often at four feet, close to an average eye level, and also easy to calculate with) or standing (often at five feet). Both of Eakins's full-length, life-size portraits executed before 1875 (*Kathrin* of 1872, Yale University Art Gallery, New Haven; and *Professor Benjamin Howard Rand* of 1874 [see fig. 6.2]) had taken a seated perspective; until *The Gross Clinic*, he had never tried a standing, life-size subject, much less one with multiple figures at different distances. With *Kathrin*, he placed himself slightly above his dainty fiancée, creating a sense of intimacy as

we look down on her, and embodying his own sense of protectiveness and superiority. Rand is also encountered intimately, at home among personal belongings, but from a slightly lower, deferential eye level, his privacy protected by an averted gaze and intervening obstacles.[11] Gross also rises above the artist. The horizon line appears as a faint incised groove in the paint surface of *The Gross Clinic*, running just below the surgeon's left ear and above his lip (see fig. 5.3). Judging from the

Fig. 5.1. *The Chess Players*, 1876. Oil on wood, 11¾ × 16¾ (29.8 × 42.6 cm). The Metropolitan Museum of Art, New York. Gift of the artist, 1881 (81.14). Courtesy Art Resource, New York

OPPOSITE: Fig. 5.2. *Perspective Drawing for "The Chess Players,"* 1875–76. Graphite and ink on cardboard, 24 × 19 inches (61 × 48.3 cm). The Metropolitan Museum of Art, New York. Fletcher Fund, 1942 (42.35). Courtesy Art Resource, New York. In the empty space at the top of his drawing paper, Eakins redrew the chairs and side table that circle the chess table placed at the center of his perspective elevation, below.

height of the doctor (known to be six-foot-two, but probably closer to six feet, taking into account his age and his slightly leaning posture), the horizon is about sixty-six inches from the floor.[12] Although departing from the more conventional sixty inches, this was a naturalistic choice for Eakins, probably very close to his own eye level facing Gross, who was a tall man for this era and at least four inches taller than the artist. Knowing that Eakins could either flatter his sitters (as he did in *The Chess Players*) or subtly condescend, his choice to put his own eye level close to but slightly below Gross's conveys both his identification with and respect for the surgeon and his wish to make viewers acknowledge the surgeon's authority. Even more subtly, he also put himself in the picture, as witness.

The horizon line intersects the vertical center line at the point of sight, where—as seen in the drawing for *The Chess Players*—all lines at right angles to the picture plane will seem to converge. The rate of recession (from dizzyingly fast to imperceptibly slow) of objects like the

Perspective drawing for the
painting of the "Chess players"
by Thomas Eakins 1876
painting is in the Metropolitan Museum
New York City

Horizon 60 inches
Distance picture 30 inches

Fig. 5.3. A one-foot grid that can be inferred from segments of incisions in the paint and faint lines drawn on the canvas before painting. The grid establishes the plane of life scale on which Dr. Gross is placed. Anything in that plane appears actual size; nearer forms are larger and those more distant are smaller. The grid contains the middle line of the painting, just to the right of Gross's head, and the horizon line, just below his nose. Diagram by Allen Kosanovich, Conservation Department, Philadelphia Museum of Art

chess table or the operating table will depend on the third and most crucial factor in the perspective set-up: the viewing distance, or the distance of the ideal spectator from the canvas or "picture plane." Although the artist may move around and work very close to the picture as it is painted, the viewing distance is a fixed spot, established at the outset as the basis of the perspective scheme. A conscientious viewer should stand in this spot to recover the artist's viewpoint, and experience the spatial construction most convincingly. For small paintings such as *The Chess Players*, where the figures are about one-eighth life-size, the viewing distance is the basis for calculating the relative diminu-

tion of objects appearing on the picture plane, according to their placement in space on an imaginary checkerboard of the floor. The relationship between the size of a painted image of a figure and the actual size of the figure varies with the viewing distance, according to a simple scale-change ratio that Eakins called "the one and only law of perspective."[13] Eakins conveniently annotated his *Chess Players* drawing "Distance picture 30 inches," indicating how far a spectator should stand from the painting, so that all the spatial relationships will appear correct. Because his tiny painting represented the scene at a reduced scale (1/8), the *actual* distance between the artist and his father, according to

the perspective layout shaped by Eakins's "one and only law," was eight times farther away, or twenty feet. That this distance seems surprisingly long, given the context of the cozy Victorian parlor depicted in the painting, hints at the artifices of the pictorial construction of space in Eakins's work.

For a portrait painting at life scale, the viewing distance for the artist (or spectator) considering the canvas is the same as the distance from the artist to his principal subject: Gross and his figure on the canvas are both life-size, and therefore equidistant from Eakins. However, everything behind Gross in the picture still must be scaled smaller than life-size, just as things in front of him will seem to get larger. So the viewing distance must be fixed and a perspective layout calculated to project the foreshortening of the operating table and the scale of every figure other than Dr. James M. Barton, the figure to the right who is probing the incision, and who shares the same distance plane with Gross. Judging by the immediacy of the scene, which seems to take place only a few feet away, we might guess that the near doctors, Charles S. Briggs and Daniel M. Appel, are within arm's reach, and Gross and Barton are about five feet distant. However, without the original perspective drawing and with no clear visual cues (such as objects on the floor, receding lines, or items of known dimensions), we can only estimate the viewing distance based on the relative recession of the objects within the space and Eakins's practice in his surviving perspective drawings from the 1870s.

These drawings, such as the one for *The Chess Players*, tell us that Eakins almost never placed figures at a viewing distance closer than twelve feet, and for good reason. The surviving perspective drawing for Eakins's full-length, life-size portrait of Dr. John H. Brinton, painted in 1876,[14] shows the sitter seated on the sixteen-foot line, and extant drawings for other life-scale portraits use viewing distances between thirteen and sixteen feet. His rowing subjects (all at half life-size or smaller) set his figures even deeper in space—between thirty-five and seventy feet away— while maintaining the same uncanny effect of immediacy.[15] Because Eakins couldn't actually stand sixteen feet from his canvas while painting a portrait, these

drawings expose the strange artifices of linear perspective employed in the name of realism by many painters since the Renaissance. They also teach us that the viewing distance was a game that Eakins played like a master, seeking—as with his choices for the horizon—a variety of solutions that demonstrate his command of the effects of illusion, his pleasure in problem-solving, and his wish to cover the tracks of his machinery.

The challenge (and the fun) of these calculations involves finding a distance for his doctors—or his sailboats and rowing shells—that gives maximum legibility, minimum distortion, and an effective two-dimensional design. Being either too close or too far has perils. At long distances the foreshortening of objects (such as the operating table) becomes very compressed and hard to track, while at close range distortion takes over as objects in the foreground grow supernaturally larger in front of the plane of life scale. Look again at the perspective of *The Chess Players* and imagine the grid of the floor projected toward the viewer, from twenty feet at the table to zero beneath your own toes. The squares of the floor close to us expand with unsettling speed, such that if Benjamin Eakins were to walk toward us, his seven-inch figure would double in size by the ten-foot line, reach half life-size about five feet from us, and then double again to life-size in just the last few feet. If we were actually five feet from Dr. Gross, we would see the table zoom down toward us and doctors in the foreground expand grotesquely; although only two feet closer to us, they would look fully 25 percent larger than Gross. We witness and quickly accommodate to similar scale changes every day walking down the sidewalk or seated at the end of a dinner table; the photograph of Eakins's friends clowning in a parody of *The Gross Clinic* (see fig. 6.6) illustrates how a natural viewing distance, if applied to Eakins's composition, would produce a distorted appearance. But such effects projected onto the two-dimensional plane of a painting seem awkward, unreal, and—to eyes accustomed to Western perspective systems—wrong. Vincent van Gogh, backed up against the wall of his bedroom at Arles in 1889, painted the space as he saw it, with his bed rushing forward into an active foreground zone that all

Fig. 5.4. Vincent van Gogh (Dutch, 1853–1890), *The Bedroom at Arles*, 1889. Oil on canvas, 22⅝ × 29⅛ inches (57.5 × 74 cm). Musée d'Orsay, Paris. Courtesy Art Resource, New York

perspective teachers, including Eakins, would have advised him to avoid (fig. 5.4). Expressively exploiting bad practice, Van Gogh reached for a realism that actually captured an aspect of visual experience. Eakins, steeped in the naturalistic conventions of perspective that have conditioned Western spectators since the Renaissance, moved his figures back into a zone where the pace of scale change was not so surprising—usually beyond twelve feet—and then cropped the foreground to pull the whole scene forward, as if it were happening under our noses.

Leonardo da Vinci advised his students to choose a viewing distance at least three times the height of the principal figures in a life-scale painting, to stay clear of the weirdly distorting foreground zone. For *The Gross Clinic*, calculating from Dr. Gross's height, Leonardo would have suggested a viewing distance of eighteen or nineteen feet. More likely, Eakins played it safe: given the scale changes of the distant figures (such as the clerk, who is evidently three-quarters life-size; Dr. Samuel W. Gross, two-thirds life-size; and clinic orderly Hughey O'Donnell, exactly half life-size; fig. 5.5), the "one and only law" suggests that his viewing distance is twenty feet or more. This is longer than any portrait in

his oeuvre for which drawings survive to tell us the system, but *The Gross Clinic* was a larger canvas, with more figures to be embraced from side to side.[16] At this distance, the floor plan allows plausible spaces between the figures, a reasonable pace of recession for the operating table (the most charged and confusing zone in the painting), and a degree of expansion for the two foreground doctors—about 6 percent—that most viewers will accept as natural, if they notice it at all.[17]

A critic who spent considerable time interviewing Eakins in 1879 about his teaching methods did notice, perhaps after coaching, such "difficulties of a practical nature" in *The Gross Clinic*, observing that "the figures in the foreground were a little more, and those in the background a little less, than life size, but so ably was the whole depicted that probably the reason why nine out of ten of those who were startled or shocked by it were thus affected, was its intense realism."[18] Like Caravaggio and countless other masters of perspective, Eakins engineered this illusion by cropping the scene to deny us any clues from the floor, to mask the long viewing distance, and seemingly to pull the whole tableau forward. As a final feint, he blurred the instruments in the foreground, as if imitating a camera lens with a limited depth of field. The effect sharpens our attention on the central group and creates the theatrical sense, as his friend from the Philadelphia Sketch Club, William J. Clark, Jr., remarked in 1876, that "the artist has taken a point of view sufficiently near to throw out of focus the accessories, and to necessitate the concentration of all his force on the most prominent figure."[19]

It is hard to know if Eakins had fully worked out this perspective scheme when he quickly sketched in oil the overall composition of his painting (fig. 5.6). Evidently, the horizon line had already been determined, as indicated by a dark red stroke extending in from the left margin. The decisiveness of the painting, as well as its close correlation to the finished picture, indicates that he had already given much thought to the composition. Many such small, quick drafts in oil for Eakins's larger paintings survive, demonstrating his habit of recording an image held in his imagination or quickly sketching from a model to confirm the basic composition, the light source, the tonal organization

Fig. 5.5. A horizon of 66 inches, established by Dr. Gross's height and the grid seen in figure 5.3, allows us to re-create the plane of the floor beginning from an imaginary line under his feet, about 14 inches below the lower edge of the painting. A hypothetical reconstruction of the figure placement on such a floor demonstrates an orderly recession of space and diminution of figures suggesting a viewing distance of about 20 feet. Eakins's careful cropping of the composition, arrangement of figures, and foreground blurring removes all clues to this calculation, leaving an impression of startling closeness. Diagram by Allen Kosanovich and Mark S. Tucker

and palette, and the relationship between the image and the framing edge. As his student Charles Bregler noted, Eakins stayed remarkably true to these initial compositional sketches as he moved forward. Unlike other artists, who revise extensively as they work, Eakins seems to have fixed the image in his mind's eye very firmly before reaching for a larger canvas; the execution of the painting strove to realize that image, refined and corrected by observation.[20]

Significantly, the *Sketch for "The Gross Clinic"* is Eakins's largest surviving compositional sketch, as well as the earliest extant example of this type of work in his practice, demonstrating the launch of a method that would last until the end of his career. To block out his idea in color, Eakins picked up a used canvas, somewhat larger than the current sketch (which was cut down and restretched sometime before 1929, when his widow, Susan Macdowell Eakins, gave the painting to the Philadelphia Museum of Art). This canvas had been used for some rowing studies, their impasto still visibly disrupting the forms of the central figure group with bright flecks of orange, blue, and lime green.[21] Painted quickly with brushes and palette knife, the clinic sketch captures the basic ideas: the principal highlights on Gross, the exploding petals of white around the surgical site, and two strong notes of blood red—on Gross's hand holding the glinting scalpel, and on the incision—that leap out to underscore the primary organization of tone and color in the painting. Eakins left the background and margins of the sketch undeveloped: the students' faces are suggested by a few dabs of dark red, and the woman on the left remains a vague, slumping profile. There is no sign yet of the clerk with his white lectern or of the two figures in the doorway, and the foreground is an uninterrupted band of warm gray. He vaguely suggests the upward sweep of a railing at the right, and summarily knifes on a patch of black to indicate a small, dark, empty doorway in the distance, centered behind the group.

The later arrival or movement of many peripheral elements in the finished composition indicates several things: that Eakins worked from the most important figures at the center of his subject, adjusting the margins to suit; that, notwithstanding the striking realism

of the final painting, there was no organizing sketch or photograph of the entire scene; and that much of the background and foreground was altered or invented at a later stage. However, certain features that are consistent from the sketch to the finished painting, including some oddly precise details of light fall, such as the bright line of the part in Dr. W. Joseph Hearn's hair, the glinting anchor-pin of the watch chain threaded through a buttonhole on Gross's vest, and some eccentric highlights in the flesh and hair of the figures, imply direct observation or, more likely, the use of photographs, now lost. Although some scholars have assumed that Eakins painted this large sketch on the spot at Jefferson—a remarkable bit of cooperation from the staff, it would seem—he was more probably working in his studio from one or more photographic studies of the principal group.

The casual reuse of an old canvas, like the red stroke indicating the horizon line and the confident summary of the figures, hints at work done in the studio, with preexisting drawings or photos at hand. The purpose of the sketch, then, would have been to confirm the organization of the principal lights and darks in the painting and establish the Rembrandt-esque palette: warm grays, reddish brown, black, white, and two startling notes of blood red. As a last gesture, Eakins marked the cropping of his picture decisively with strokes of dark red and laid in a broad "frame" in dark yellow, perhaps to test the impact of gold against his color scheme. From these choices, responding to the image he had constructed, would come the proportions of the large canvas (typically a custom size) and perhaps even the visual qualities of the frame.[22] Already, he was imagining his painting in the Art Gallery at the Centennial.

OPPOSITE: Fig. 5.6. *Sketch for "The Gross Clinic,"* 1875. Oil on canvas, 26 × 22 inches (66 × 55.9 cm). Philadelphia Museum of Art. Gift of Mrs. Thomas Eakins and Miss Mary Adeline Williams, 1929-184-31. Some of the bright colors of earlier, unrelated sketches, originally fully hidden, were uncovered in the area of the surgical team during an early attempt to clean *The Gross Clinic* sketch.

If he had not previously prepared a schematic ground plan and perspective elevation, he must have done so now, to construct his image on the final canvas. The exhilarating moment of blocking in his painting, referred to in a letter to his friend Earl Shinn in April 1875,[23] can be recovered from study of the X-radiograph of the painting, which reveals the early layers of the painting (fig. 5.7). Long, excited strokes, troweled on with a blade, arc across the top half of the painting, recording the speed with which Eakins eagerly buried the white ground on his new canvas with a deep, warm gray meant to cast a background shroud of darkness and space behind his figures. The breadth of this first painting stage vividly recalls notes made to himself in his student days, when he vowed to cover his canvas very quickly at the outset, with bold assurance, disregarding details.[24] Broad, painterly handling and palette-knife work in the lay-in of the foreground doctors, ultimately veiled on the carefully modeled surface, show a freedom and speed more often displayed at this date by Édouard Manet than by Eakins, embodying the artist's excitement as he tackled this big composition (fig. 5.8).

Most unconventional, however, is the heavy overall build-up of paint beneath the principal heads. Academic practice, sanctioned by generations of European masters, usually kept dark zones thin while progressively increasing the thickness of midtones and highlights (fig. 5.9). Because of the frequent incorporation of dense lead white pigment and the increased paint thickness in these selectively built-up areas, they typically show as correspondingly lighter zones in the X-radiograph, so that the distribution of light and dark usually resembles the visible surface of the painting. Eakins surely knew the convention of thin darks and built-up lights, as surviving figure studies from his student days in Paris demonstrate, but the X-radiograph of *The Gross Clinic* shows an idiosyncratic new practice. For the heads, he blocked in a masklike base that would run below both daylit and shadowed areas on his principal figures, almost as if, like his master Bonnat, he wished to "model" his painting like a sculptor, building each form physically in paint to establish a foundation on the canvas that literally stood

in relief (fig. 5.10).[25] Working from a more generalized base of higher-key local tone, he then modeled the shaded version of that tone by superimposing darker paints and glazes over his base.

Eakins looked for and found validation of this system while puzzling over the masterpieces in the Prado in 1869. Analyzing the modeling in Diego Velásquez's *Las Hilanderas* (*The Spinners*)—which he proclaimed "the most beautiful piece of painting I have ever seen"—Eakins insistently concluded that Velásquez "glazes a lot with colors entirely transparent in the shadows, but that which is underneath is already solidly painted."[26] Reinventing this practice for himself in Philadelphia, Eakins would achieve chiaroscuro predominately by layering, in preference to the more direct juxtaposition and blending of tones representing lights and shadows. *The Gross Clinic* stands as a breathtaking display of his resourcefulness in re-creating, in his own fashion, the powerful chiaroscuro of the Old Masters that he had admired and struggled to understand in Europe.[27] Few looking at this painting would suspect that its evocation of Velásquez was willed into being using technical means, especially in flesh painting, quite at odds with tradition.

Eakins must have outlined his figures before beginning to build their forms, but the underdrawing on his canvas is often difficult to detect, even with modern examination techniques such as infrared reflectography (IRR). His pencil lines tend to be light and wiry, easily masked by overlying paint and the common admixture of black in his paint. Although the ruled pencil grid on *The Gross Clinic* can be seen with IRR in a number of places, freehand drawing of contours and details is only rarely and faintly detectable. However, a telltale feature of the underpainting in the faces, seen in figure 5.10, reveals the presence on the canvas of a precise preparatory drawing that laid out

OPPOSITE: Fig. 5.7. X-radiograph composite of forty-eight separate plates of *The Gross Clinic* made in July 2009 by Joe Mikuliak. Composite produced by Steven Crossot. Conservation Department, Philadelphia Museum of Art

5.8

5.9

5.10

Fig. 5.8. X-radiograph detail of Dr. Briggs showing rapid palette knife lay-in of forms in the face, hair, and along the line of the shoulder

Fig. 5.9. X-radiograph detail of Rembrandt Harmensz. van Rijn (Dutch, 1606–1669) and studio, *Head of Christ*, c. 1648–56. Oil on canvas. Philadelphia Museum of Art. John G. Johnson Collection, cat. 480. This example shows the more typical direct correlation between the distribution of lights and darks in an Old Master painting and the way they are rendered in an X-radiograph. Conservation Department, Philadelphia Museum of Art

Fig. 5.10. X-radiograph detail of Dr. Gross's head showing Eakins's idiosyncratic buildup of paint in shaded areas of flesh. This characteristic is also apparent in fig. 5.8.

contours and divisions between zones of light and dark. Distinct, dark linear boundaries visible around many contours and along divisions between lights and shadows show that Eakins was building up to either side of his lines but not obscuring them with paint until those forms were well established, producing a sort of "stained-glass" appearance in the X-radiograph that has also been observed in other paintings by the artist, such as *The Crucifixion* of 1880 (fig. 5.11).

The X-radiograph also reveals, for the first time, Eakins's process of critiquing and improving his composition (fig. 5.12). Some adjustments were small: at the very center, Dr. Barton's probe is seen to have been longer at first, extending above Dr. Hearn's fingers; made shorter, it keeps to the midground plane and allows Hearn's face to fall back into space. More significantly, the figure of the clinic clerk at the upper left, Dr. Franklin West, was initially blocked in at a lower position, sharing Gross's eye level. Eakins moved him and his desk up six inches to avoid a dull and slightly uncomfortable juxtaposition, finding a much more dynamic position for West at the top of a long diagonal that unites the composition from the upper left to the lower right. In tandem with this change, Dr. Appel (in the lower right foreground) was first blocked in as he appears in the sketch (see fig. 5.6), but then revised to appear somewhat lower and looking more to his left, so that his profile is fully described. Dr. Appel was at first a mirror of Dr. Briggs (on the other side of the table), but this change made him more recognizable and also more effective as the figure receiving and redirecting the energy of the main diagonal of the composition. His right arm also drops slightly, revealing both buttocks of the patient and thereby making the pose slightly more comprehensible (and to some, no doubt, offensive).

Most interesting of all is the broad stripe across the foreground, visible in the X-radiograph, which the artist decisively laid down with a palette knife and later covered over in a major revision of the lower foreground. The mystery of this line falls away with the realization that it is indicated on the sketch, where it represents the wall and railing encircling the doctors in the surgical "pit." Eakins first imagined the figures enclosed by this wall, thereby suggesting the viewer's

Figs. 5.11a, b. Detail (a) and corresponding area of the X-radiograph (b) of *The Crucifixion*, 1880. Oil on canvas. Philadelphia Museum of Art. Gift of Mrs. Thomas Eakins and Miss Mary Adeline Williams, 1929-184-24. The dark margins in the X-radiograph indicate thinner paint over initial drawn lines defining contours and divisions between the lit and shaded areas of forms. Such indications of painting within zones defined by preliminary drawing can be seen in the ear and jaw in fig. 5.8; in the forehead, nose, and chin in fig. 5.10; and in many other places throughout the foreground in fig. 5.7.

Fig. 5.12. X-radiograph composite of *The Gross Clinic* with lines indicating the initial placement of compositional elements. Diagram by Allen Kosanovich and Mark S. Tucker

placement (notwithstanding the twenty-foot viewing distance used to calculate the perspective) in the first row of the seating. Such a dynamic idea of involvement was also used by his contemporaries Edgar Degas and Mary Cassatt in the 1870s to give a sense of layered spaces and modern spectatorship in cafés and theaters. Eakins's compositional sketch shows that this concept was present at the outset.[28] He evidently decided that this solution deadened the foreground, however, and opted for a better one: allowing a view under the table, to give a sense of space, and spreading

the surgeon's kit across the foreground, glittering and slightly ominous, to give the viewer an even more powerful sense of participation. Rather than being outside the railing among the students, we are now at the foot of the table, within reach of the instruments, the seventh doctor in the clinic.

To accomplish this effect of immediacy, Eakins seems to have introduced a second, lower eye level that encompasses the new table and trays of tools from the vantage of a seated observer. Eakins's student J. Laurie Wallace remarked on this inconsistency in 1936,

concluding that "evidently he did not want to show the table with the instruments sliding off," as they might have appeared from a higher point of view. Veiled by the raked and jumbled positions of the trays and a scarf that conveniently masks the corners of the instrument and operating tables, this inconsistency was deliberately introduced to avoid the unnatural distortion of a rigidly applied perspective scheme. Perhaps not coincidentally, this lower horizon would have aggressively intersected the incision, reinforcing the alternate focus of the painting.[29]

All these changes are inherently interesting at the level of detail and strategy, but taken together they reactivate our sense of the artist at work, in the process of inventing an image that had not completely fallen into place. By raising the clerk and the wall beneath him, Eakins shows his willingness to toss his perspective plan and alter whatever he may have observed in the Jefferson amphitheater if it did not suit his composition. Likewise, the construction and then vaporization of the foreground wall demonstrates his role as architect of the scene before him, seeking an ever more dramatic effect. Suddenly, it no longer matters what the Jefferson amphitheater really looked like, or whether photographs were used at the outset; clearly Eakins is revising the space to suit his search for maximum compositional and emotional impact. Like the choices within the perspective layout, his compositional tinkering reminds us of the artful stage-managing of the entire scene. Astonishingly convincing, and now familiar to us after more than a century of fame, the composition seems natural and inevitable; the X-radiograph reminds us that it was artful.

Once the composition had been blocked in, Eakins turned to the development of the figures. By the late summer of 1875 he was in the midst of appointments with Gross, painting him from life on a separate canvas that was more conveniently carried to sittings (fig. 5.13), and then from life on the big canvas, in the top-floor studio in the Eakins home at 1729 Mount Vernon Street, where a skylight reproduced the illumination in the amphitheater. In the bust-length study, Eakins focused on the modeling of Gross's head in this strong downward light, which transforms the doctor's hair into an

aureole and casts his eyes into almost impenetrable dark—effects that give Gross a mysterious, otherworldly authority. Seeking a record of color hues and values in daylight, Eakins tracked the play of light across the doctor's face in broad, unblended touches of pink and beige, noting the glinting opal shirt stud and the deep black velvet of his collar against the duller black of his wool jacket. Eakins took his life sketch and scored lightly into the paint a grid that matches a similar network of lines on his final painting, made to speed the transfer of his observations to the main canvas. Most likely, more life sessions ensued as he polished this image; evidently they went on so long that the busy Gross exclaimed, "Eakins, I wish you were dead!"[30] Surely he chased the other doctors in the clinic for modeling sessions, too, but none of these studies—if they were made on separate supports—survives.

Based on the evidence of his compositional sketch and the X-radiograph, it seems likely that Eakins brought the central group to a level of convincing solidity before tackling the secondary characters and the background.[31] The build-up of paint in the principal foreground figures, which makes their forms so prominent in the X-radiograph, is not seen in the peripheral figures—most of whom do not appear in the compositional sketch—demonstrating that they were painted more thinly, and with paint mixtures short on pigments, such as lead white, that strongly absorb X-rays. All are bystanders who reflect on the action, adding different emotional notes. The students, in various postures of attentiveness, establish the context of lecturing and learning. The woman on the left (fig. 5.14), identified by reviewers as early as 1876 as "a female relation of the patient" and by 1879 as the "mother" (though her true identity, like the patient's, remains unknown), expresses the blind ignorance of a layperson, too frightened to watch.[32] She wears an old-fashioned "spoon" bonnet and a modest, similarly outdated black silk dress, perhaps suggesting widowhood and poverty, as well as a resolution to dress with dignity for the occasion. Her hair seems to be gray, and all of her face save a glimpse of her nose is concealed behind her clawlike left hand. The carefully recorded peculiarities of that contorted hand mark her as a very

Fig. 5.13. *Study of the Head of Dr. Gross*, 1875. Oil on canvas, 24 × 18¼ inches (61 × 46.4 cm). Worcester Art Museum, Massachusetts, Museum Purchase, 1929.124

particular person, closely studied by the painter.[33] More importantly, her shielded face and tormented gesture make her an anonymous surrogate for the average, unprepared viewer, if not an allegory of fearfulness and female weakness.[34] The only woman in the room, she is evidently small and seems incapacitated by her emotions. For some early viewers of the painting, her "scream of horror" was unbearably intense.[35] Her reaction, expressing the response of a layperson, shows that—however surprised or disappointed he might have been by the revulsion of his critics—Eakins

foresaw the public reaction to this subject and exploited the contrast between the different types of spectators for transparently theatrical effect. He would never again paint such a melodramatic figure. Her cringing pose serves as a foil to the calm, upright, open stance of Gross, who professionally rises above "the fear and agitation of the bystanders"[36] to lead an intently watchful clinic and audience of men. In the doorway, Hughey O'Donnell and young Dr. Gross strike relaxed poses that tell us they have witnessed this scene often. Like the students and the clinic doctors, they instruct

the viewer, conveying focused attention, skill, and manly confidence.

That these peripheral figures function as theatrical commentators, like a chorus that arrives onstage after the main actors in the drama have been established, might be read in their absence in the compositional sketch (see fig. 5.6), in their comparatively direct and rapid execution, or in the evidence of a distinct campaign on the background. Following the practice documented in drawings for other life-size portraits, Eakins seems to have constructed his background after the principal figures were firmly in place.[37] Although he envisioned amphitheater seating in his original concept, the invention of the space and the distribution of secondary figures show a new, responsive phase of planning, when detail was added and the background adjusted to enliven his composition. The tunnel, very broadly painted behind Gross in the study, was enlarged and shifted to the right, adding asymmetrical balance and a breath of space. The tiers of benches were also subtly skewed, so that the figures at the left, seated along a diagonal joint in the plan, face inward and are slightly more distant (fig. 5.15). Conscientiously masking this "seam" in the seating with the figures of the clerk and Dr. Gross, Eakins nonetheless added a characteristic tension to his composition with this twist to the space. The slight slope of the railing below the clerk and the rake of the benches on the right (evidently parallel to the original foreground railing, visible in the X-radiograph; see fig. 5.7) also give evidence of the octagonal plan of the room, like the amphitheater shown in the parody photographs (see figs. 6.6, 6.7). The recognition of this plan confirms the viewing height (low) and distance of the spectator (close) suggested by the foreshortening of this octagon and the proximity of the railing. Suddenly we have another reason why Eakins painted out the wall in the foreground: it gave away clues to the separate perspective on the amphitheater itself.

Perhaps based on a perspective drawing or projected from a photograph, this background of benches has a logic of its own that occasionally fails to merge with the world of the foreground doctors. Notwithstanding his careful masking of edges and corners to

Fig. 5.14. Detail of the female figure in *The Gross Clinic*

suppress clues or glide over the seams between his three different perspectives—foreground instruments, midground figures, and background audience—the odd sense of spatial disjunction resulting from Eakins's composite method is exposed in the elusiveness of the figures placed in the transitional zones. In the sketch (see fig. 5.6), the woman appears as a limp figure seated just behind Dr. Briggs in the left foreground. When Eakins finally came to consider her role, pose a model, and insert her petite figure in the composition, he pushed her back into the middle distance, where she obscures the angle of the floor and the wall, but seems too small for her location.[38] Likewise, O'Donnell and young Dr. Gross seem to be positioned as landmarks, mapping the space of the tunnel, but they are difficult

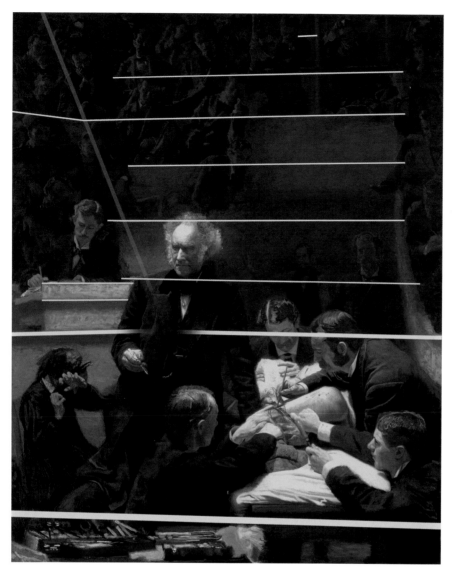

Fig. 5.15. *The Gross Clinic* with lines that follow or are projected from linear features of the architecture. Highlighting tiers of benches, the clerk's desk, and the surgical pit's railing (the bottom section of which is visible in the X-radiograph, but omitted from the finished painting) clarifies the octagonal space of the amphitheater. The portion of the composition to the left of the diagonal gray line represents another facet of the octagon, and the figures in this section sit facing the center of the composition, not forward as elsewhere. The horizontal lines to the right of the diagonal, as well as the railing across the bottom, subtly converge to a far-distant vanishing point to the left, indicating that the viewer and the picture plane are oriented at a slight angle to the axes of the octagon. Diagram by Mark S. Tucker

to place on a plan that credibly integrates the foreground surgical group and the amphitheater backdrop, perhaps because they inhabit a zone of overlapping perspective grids, or because their principal job is solely pictorial: to block further recession and, by their gazes, return interest to the foreground.[39]

Above the central group float the faces and dim forms of the students in the audience, leaning left and right to gain a good view. Clearly individuated, they have never been identified as portraits of particular students at Jefferson. Only a tiny, lively oil sketch of Robert C. V. Meyers (fig. 5.16), who appears above the tunnel in the upper right corner of the painting,

survives to represent the preparatory work for these secondary figures. Not a medical student, Meyers was a writer and friend of the artist who seems to have been pressed into service as a model. Dated October 10, 1875, and also lightly incised with a grid, this sketch serves as a marker of Eakins's progress by the fall, when such minor figures were being dropped into the amphitheater seating, which had been drafted on the canvas to receive them.[40]

Such life studies seem to have been augmented by photographs of the major figures in the painting. Eakins did not own a camera until 1880, but he knew professional photographers, including Frederick Gutekunst

and the Schreiber family, and the use of photographic sources is evident in his work as early as 1872. A photograph of Eakins in an enigmatic, contrived pose (see fig. 4.4), scored with pencil lines suggesting a vertical axis and horizon line of some unidentified project, is one of the earliest surviving prints documenting his creation of camera studies prior to the Centennial. Following the discovery in 1985 of hundreds of previously unknown photographs relating to Eakins's subjects of the late 1870s and early 1880s, Philadelphia Museum of Art conservators detected in a number of his paintings a system of tiny incised lines used to transfer registration points from photographs projected with a "magic lantern" onto the canvas to guide his painting. As in a number of Eakins's pictures from 1874 to 1885 (figs. 5.17a, b), these delicate lines are also found on *The Gross Clinic* (figs. 5.18a–e).[41] Predictably, these minute reference marks in the paint are concentrated in and around the portrait heads of the principal clinic doctors, telling us that Eakins had photographs of the busiest sitters, particularly the impatient Gross, but probably not the background figures.

A celebrity, Gross often posed for the camera, but no photographs survive showing him exactly as he appears, lit from above, in *The Gross Clinic*. However, professional portraits by Gutekunst (who also photographed Eakins and his family) and others (see fig. 3.3) show many similarities with Eakins's painting.[42] The existence of more camera studies was confirmed by the sculptor Alexander Stirling Calder (1870–1945), who noted that Eakins "had made some very fine photographs of Dr. Gross for his own use," which Calder borrowed from him in the 1890s for the preparation of a posthumous portrait statue, now installed on the campus of Thomas Jefferson University.[43] Probably Eakins had a portfolio of such photographs, which he used to create a convincing composite, as in his luminous *Mending the Net* of 1881 (Philadelphia Museum of Art), for which he drew upon more than thirty photographs of landscape, fishermen, and geese along the shores of the Delaware River (see figs. 5.17a, b). Certainly, the result was convincing to Gross's contemporaries: "One can hardly conceive of a more perfect resemblance," wrote a correspondent for the *Boston Medical and Surgical Journal*.[44]

Fig. 5.16. *Study of the Head of Robert C. V. Meyers*, 1875. Oil on paper, mounted on board; 9 × 8½ inches (22.8 × 21.6). Collection of Daniel W. Dietrich II

In capturing likeness, costume, and gesture, photographs also taught Eakins ways of seeing and depicting forms in light. Flickering, diffused contours of the foreground figures (see fig. 8.16b) emulate a decidedly photographic effect: in the most important plane of the painting, where detail and interest are focused, Eakins was carefully evoking "halation," the spreading of a light tone beyond its proper boundaries, caused by scattered reflection of light from the back of the photographic plate into surrounding emulsion. The painted effect, whether produced as a direct reference to photographs consulted or simply as a suggestion of photographic verity, appears in other paintings such as *The Pair-Oared Shell* of 1872 (Philadelphia Museum of Art) and *Mending the Net*. Like his artful use of camera studies, such references to visual properties specific to photographs in Eakins's paintings went undetected until recently. This was largely because Eakins, unlike so many of his academic contemporaries who were also appropriating photographic imagery, was truly adept at translating such "objective" source material as photographs and perspective studies into the distinct visual and tactile

a b

Figs. 5.17a, b. Eakins's source photographs (a) for the figure group in the detail (b) of *Mending the Net*, 1881. Oil on canvas. Philadelphia Museum of Art. Gift of Mrs. Thomas Eakins and Miss Mary Adeline Williams, 1929-184-34. Diagrammed in red are the tiny reference incisions Eakins made while projecting the photographs onto the surface during painting. Source photographs courtesy Pennsylvania Academy of the Fine Arts, Philadelphia. Charles Bregler's Thomas Eakins Collection, purchased with the partial support of the Pew Memorial Trust. Diagram by Mark S. Tucker and Nica Gutman

terms of traditional painting. Surely he must now be recognized for his creative interaction with photography at many levels—from quasiscientific motion studies and comparative anatomical projects to compositional and formal elements—which was more varied, imaginative, and almost invisibly assimilated than that of any other artist of his generation.

With the detail and portrait likenesses of his figures secured from life study and photographic aids, Eakins could move on to the finishing stages, seeking his final effects with toning glazes, sometimes added with remarkable breadth (fig. 5.19). We know from his other paintings of the 1870s that he was committed to his own system of painting a foundational base with strong colors and contrasts, which was then darkened with subsequent layers of paint and glazes to achieve a balance of strength and delicacy.[45] Glinting beneath the oil sketch for *The Gross Clinic*, bright spots of blue, orange, and lime green record the vibrant base colors of

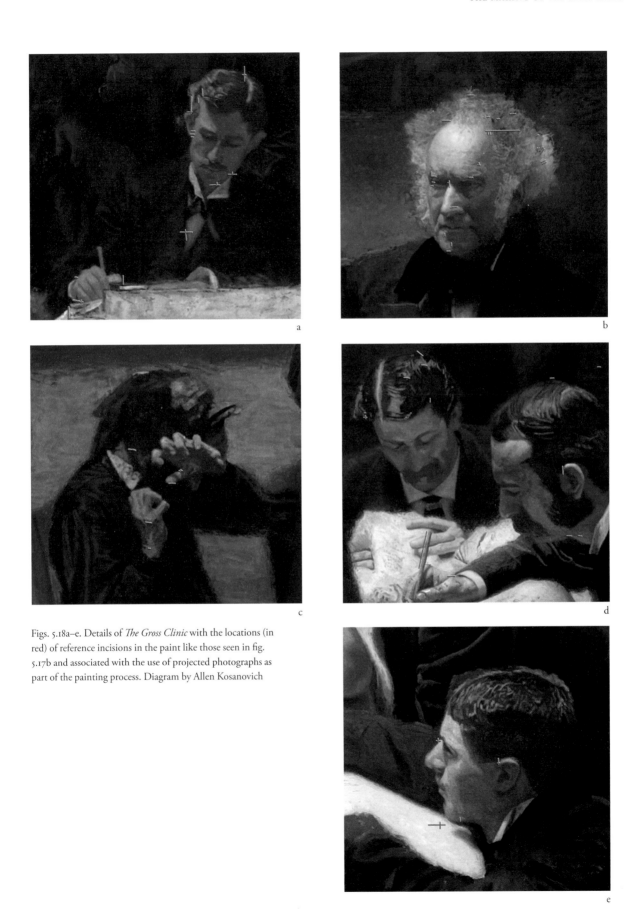

Figs. 5.18a–e. Details of *The Gross Clinic* with the locations (in red) of reference incisions in the paint like those seen in fig. 5.17b and associated with the use of projected photographs as part of the painting process. Diagram by Allen Kosanovich

Fig. 5.19. Detail of *The Gross Clinic* showing broad strokes of a black finishing glaze extending upward onto the background above Gross's shoulder

the earlier rowing sketches painted on the same panel. On top of this brilliant base, successive layers of refinement drew closer to his sense of truthful observation and unity of effect. He was seeking nothing less than the rich, harmonious modeling and depth of the Old Masters, whose techniques had been lost to modern painters. Modeling with dark glazes also gave Eakins the precise kind of control he sought to suggest forms turning in space with great subtlety, and to create such strong illusions of mass, distance, and the fall of light. In a larger sense, this technique also gave

him a kind of incremental control over each area of the painting, which could be slowly glazed until the desired color and tonal relationships were achieved. Never drawn to the bravura effects of painting *au premier coup* (spontaneously and directly) or very confident about his ability to capture an effect so directly, Eakins chose to work methodically, step by step, to reach his goal.

Suited to his personality, this technique also served the ultimate artistic goal for a naturalist painter of Eakins's generation: the final balancing of the overall composition of lights and darks, or "values," to give the illusion of truth. For such an artist, a challenge waited between the pigments of black and white on the palette, which must be pressed to conjure the far wider range of dark and light in the natural world. His mission was to construct an artificial, self-contained system of value relationships—"true tones"—within the painting that would echo nature while expressing the meaning, skill, and individual sensibility of the artist.[46] Although history would come to associate the 1870s largely with the ascendance of the highly keyed palette and bright colors of the Impressionists, for mainstream academic painters and connoisseurs of this generation it was the control of tone—of values of light and dark in paintings often admired for their coloristic sobriety and restraint—that was viewed as a critical measure of visual truthfulness. Bonnat reduced painting to a pithy formula along these lines in his teaching; as Edwin Blashfield (1848–1936), an Eakins contemporary in the atelier, said of Bonnat's instruction, "Construction and values, values and construction, how often did the student hear those mysterious words."[47] Eakins's work demonstrates his complete embrace of these priorities and, throughout the early 1870s, his will to plumb their mysteries. *The Gross Clinic* stands as testament to his hard-won mastery of values and construction, a remarkable example of the illusionistic and expressive power he was able to draw from the fundamentals of academic vision he absorbed in Paris. Blashfield's admiring appraisal of Bonnat's achievement, in fact, could equally describe Eakins's: "Truth and logic were the basis of everything he did. His pictured people were round and stood out, they had air to breathe and move in, you could walk behind

them."[48] Even now, one cannot stand before Eakins's youthful masterpiece without an overwhelming sense of the hush of the operating amphitheater and the uncannily animate presence of the doctors of that now-distant time, whose noble work, intelligence, and expertise he took as his subject.

1. Kathleen A. Foster, *Thomas Eakins Rediscovered: Charles Bregler's Thomas Eakins Collection at the Pennsylvania Academy of the Fine Arts* (Philadelphia: Pennsylvania Academy of the Fine Arts; New Haven, CT: Yale University Press, 1997), p. 50, citing Eakins's so-called Spanish notebook, now in Charles Bregler's Thomas Eakins Collection, Pennsylvania Academy of the Fine Arts (hereinafter cited as Bregler Collection, PAFA). On his training in Europe, see ibid., pp. 32–48; H. Barbara Weinberg, "Studies in Paris and Spain," in Darrel Sewell et al., *Thomas Eakins*, exh. cat. (Philadelphia: Philadelphia Museum of Art, 2001), pp. 13–26.

2. Some studies may have been painted over, such as the rowing sketches underneath Eakins's preparatory oil sketch for *The Gross Clinic* (see fig. 5.6). Careless with his preparatory material, he may have discarded or damaged his work, and he gave many studies away to his sitters and students, such as *Sketch of R. C. Meyers* (see fig. 5.16). On his habits sketching in oil, see Foster, *Thomas Eakins Rediscovered*, pp. 72–80.

3. Some scholars, including Lloyd Goodrich and Elizabeth Johns, have assumed that these awkwardnesses demonstrate Eakins's fealty to an observed event. See Goodrich, *Thomas Eakins*, 2 vols. (Cambridge, MA: Harvard University Press for the National Gallery of Art, 1982), vol. 1, p. 124; Johns, *Thomas Eakins: The Heroism of Modern Life* (Princeton, NJ: Princeton University Press, 1983), pp. 51–52. Indeed, the placement of the figures must have followed the clinic's practice. However, much variety was possible within these constraints, and his other adjustments to the composition, described below, demonstrate his manipulation of the scene.

4. Michael Fried, in *Realism, Writing, Disfiguration: On Thomas Eakins and Stephen Crane* (Chicago: University of Chicago Press, 1987), launched the first discussion of Eakins's conceptual drawing practice in relation to the power of instruments of investigation (scalpels, probes, pencils) depicted in *The Gross Clinic*. This thesis was developed in Foster, *Thomas Eakins Rediscovered*, pp. 51–59, 69–71, which gives examples of compositional drawings for early projects such as *Street Scene in Seville* and the sporting paintings of 1872–76, and discusses the survival rate of drawings and their compartmentalized uses in Eakins's method. Famous in his lifetime for his drawing skills, he actually seems to have sketched in pencil or pen very little, preferring to work as soon as possible in oil paints, to develop color and modeling of form at once.

5. Eakins's manuscript eventually entered the collection of the Philadelphia Museum of Art in 1963, and the drawings he made for it were acquired by the Pennsylvania Academy of the Fine Arts in 1985. The text and illustrations were published in 2005 as *A Drawing Manual by Thomas Eakins*, ed. Kathleen A. Foster (Philadelphia: Philadelphia Museum of Art).

6. Thomas Eakins, "Linear Perspective," in ibid., p. 58. For examples of such ground plans, see Foster, *Thomas Eakins Rediscovered*, pp. 204, 362.

7. Ellwood C. Parry III, "*The Gross Clinic* as Anatomy Lesson and Memorial Portrait," *Art Quarterly*, vol. 32, no. 4 (Winter 1969), p. 386, published a speculative ground plan of the painting that demonstrates, in its errors, the difficulty of coordinating the placement of the figures to reflect their proper recession in space, as discussed below. On the history of the teaching amphitheaters at Jefferson Medical College, see Julie Berkowitz, *Adorn the Halls: History of the Art Collection at Thomas Jefferson University* (Philadelphia: Thomas Jefferson University, 1999), pp. 86–89, 180–183, 228–29. See also Mark Schreiner's illustrations of similar surgical theaters in his essay in this volume.

8. Eakins, "Linear Perspective," p. 47.

9. Ibid., p. 51.

10. About two years earlier, in *The Artist and His Father Hunting Reed Birds in the Cohansey Marshes* of 1873–74 (Virginia Museum of Fine Arts, Richmond), Eakins used a horizon of sixty-three inches, finding the eye level of his self-portrait, with bent knees. From such evidence and period sources, including the artist's passport, it seems that Eakins was five-foot-ten; see transcript in the Merl Moore Research Files at the Smithsonian American Art Museum Library, Washington, DC. In this painting, Benjamin Eakins appears to brush the horizon, evidently standing about five-foot-four or -five plus the inch or two lost by his position on the floor of the skiff, slightly below water level; see Foster, *Thomas Eakins Rediscovered*, pp. 134–35. Other paintings from this period include the watercolor *Baseball Players Practicing* of 1875 (Museum of Art, Rhode Island School of Design, Providence; see fig. 10.3), with a horizon of sixty-four inches; *Rail Shooting in the Delaware* of 1876 (Yale University Art Gallery, New Haven, Connecticut), sixty inches; *La Chasse* of about 1873–75 (current location unknown), fifty-eight inches; *Starting out after Rail* of 1874 (Museum of Fine Arts, Boston), eighty-four inches; and a sequence of seven rowing pictures between 1871 and 1874, with horizons ranging from thirty-six to sixty inches. See Foster, *Thomas Eakins Rediscovered*, pp. 60–61, 126.

11. The middle line in the Rand portrait can be seen in the lower part of the canvas; as in *The Chess Players*, it intersects something significant: the fold of the book that Rand is reading. The horizon line cannot be detected on the canvas; judging from the upper surfaces barely visible on the scientific instruments at the left, the eye level is slightly below his mouth.

12. Gordon Hendricks, *The Life and Works of Thomas Eakins* (New York: Grossman, 1974), p. 88, describes Gross as having been six-foot-two and two hundred pounds. The sixty-six-inch horizon is deduced from Gross's height and the twelve-inch grid on the canvas, which (following Eakins's usual practice) we can assume was generated by some even relationship to the floor. The first graphite line found on the canvas (about four inches above the lower edge) represents a line eighteen inches above the floor. Subsequent lines on the grid record distances of thirty, forty-two, fifty-four, and sixty-six inches from the floor at the line of life scale, where Gross stands. Because, as explained below, the foreground expands to larger than life scale, Eakins cropped this zone so that we cannot see Gross's feet (fourteen inches below the lower edge of the canvas) or the floor below the table legs, which are closer and even lower. On Eakins's use of the horizon line and the grid in another life-size portrait (of Dr. John H. Brinton) from this moment, see Foster, *Thomas Eakins Rediscovered*, pp. 203–8.

13. Eakins, "Linear Perspective," p. 49. With every doubling of distance from the eye to an object, its apparent size diminishes by half, just as with every halving of the distance to an object, its size will appear to double. For discussion of the "one and only law" and additional examples of Eakins's manipulation of the distance point, see Foster, *Thomas Eakins Rediscovered*, pp. 61–66.

14. The finished painting is now at the National Gallery of Art, on deposit from the National Museum of Health and Medicine of the Armed Forces Institute of Pathology, Washington, DC; see Sewell et al., *Thomas Eakins*, pl. 17, p. 56. The perspective drawing is in the Bregler Collection, PAFA; see Foster, *Thomas Eakins Rediscovered*, p. 205.

15. For other examples, see Foster, *Thomas Eakins Rediscovered*, pp. 126, 214. Beyond about fifty feet, another kind of problem arises, for the scale

change has slowed so much that even substantial distance between figures is difficult to reckon.

16. A longer viewing distance also creates a more comfortable visual grasp of a wide canvas, so that the subject is easily bracketed within a 20-degree angle, beyond which other types of distortion increase along with a general loss of focus. On this visual angle and Leonardo's rule, see ibid., p. 207. In 1944, George Barker, a student of Eakins's student J. Laurie Wallace, tried to work out the viewing distance for the painting as part of his own study of *The Gross Clinic*. Showing familiarity with Leonardo's advice, he noted: "If Eakins was three times the height of Gross away from Gross, he must have been 18 feet." George Barker to Charles Bregler, July 30, 1944. Lloyd and Edith Havens Goodrich, Record of Works by Thomas Eakins, Philadelphia Museum of Art (hereinafter cited as Goodrich Archive, PMA).

17. The viewing distance impacts the rate of recession as well as the amount of space separating figures that, by their change in scale, express different positions in depth. Calculating backward from these scale relationships to find Eakins's viewing distance is imprecise, because Eakins gives so little from which to measure: bodies are obscured, faces are foreshortened, the floor level has been cropped, and the corners of the operating table are blurred or hidden. Nonetheless, rough scale relations can be deduced by measuring the figures' foreheads and faces. Knowing Eakins's practice, we have assumed that he had a ground plan that placed his figures around a real operating table in a functional arrangement. In this scheme, the operating table is the unknown, but most likely it approximated the dimensions of Jefferson's surviving 1880s operating table, which is twenty-four inches wide, sixty-five inches long (with wings to extend it if needed), and thirty-two inches high, and is supported by pillars (rather than four legs, as in *The Gross Clinic*). Indeed, measured at Gross's position of life scale, the table seems to be about thirty-four inches high (including the mattress) and twenty-four inches across, between Gross and Barton. See Berkowitz, *Adorn the Halls*, pp. 183–84. The parody photos (see figs. 6.6, 6.7), possibly taken in the old amphitheater, show an earlier table, evidently also on a single pillar. Although this kind of table was suited to surgery, we might speculate that Eakins saw another table at Jefferson, substituted a table at hand, or—most likely—invented somewhat elusive corner legs to give visual support to a surface that otherwise would have seemed to float inexplicably when seen from his chosen viewpoint. This table must have been at least sixty inches long to accommodate a small figure posed, like the patient, with knees bent. Given the scale relationships visible on the canvas (for example, that O'Donnell is half the size of Gross), different maps of the floor can be drawn that support these scale relationships at alternate viewing distances. Wherever Gross is positioned (as the base for life scale), O'Donnell will always be half his size and, according to the "one and only law," twice as far away. As the viewing distance lengthens, O'Donnell is likewise pushed farther into the distance, and more space opens up between all the other figures in the plan. For distances shorter than sixteen feet, the plan shrinks too much to allow room for the operating table. Beyond twenty-four feet, the figures become very far-flung (O'Donnell would be at least forty-eight feet away), exceeding the reasonable dimensions of a hypothetical surgical amphitheater. At this longer distance, the foreshortening of the table would also become even more difficult to read. In our calculation of the distance point, we were grateful for the advice and earnest efforts of Thomas O. Halloran, who has devised a remarkable system for determining viewing distance from internal measurements in a painting. Ultimately, the changes in the painting, the evidence of multiple viewpoints, and the maddening absence of measuring points made Halloran's method inapplicable, though the effort taught us much about Eakins's deliberate veiling of the machinery of his composition. See Thomas O. Halloran, "Finding a Picture's Station Point: Reconstructing Virtual Space When the Usual Way

Will Not Work," *Behavior Research Methods*, vol. 38, no. 1 (2006), pp. 107–16. Two other individuals devoted substantial time and effort to the study of the painting's perspective. Philadelphia Museum of Art conservator Allen Kosanovich generated graphic analyses overlaying on the image of the painting the grid of the life-scale plane and projecting from that grid ground plans for different viewing distances. In his investigation of the dimensions of the operating pit and the orientation of the railing surrounding it, he received helpful assistance from Jeffrey Sitton, installation design assistant at the Philadelphia Museum of Art, using a computer-aided drafting (CAD) program. Eric N. Tucker derived cross-sectional elevations of the scene from likely dimensions of the architecture of the operating theater, the ratio of diminution of the apparent height of the tiers of amphitheater benches with distance, and apparent sizes and positions of foreground forms relative to the background. He also produced supplementary CAD images of the amphitheater, which while convincingly evocative of the architecture, were ultimately difficult to reconcile with Eakins's rendering of the space. In the end, the various investigations were limited and rendered inconclusive by their necessary basis in approximations of the actual dimensions of depicted forms, and by the artist's concealment of key intersections or converging lines that would establish a single consistent viewing point distance for every part of the painting.

18. William C. Brownell, "The Younger Painters of America," *Scribner's Monthly*, vol. 20, no. 1 (May 1880), p. 4. Brownell's important interview with Eakins was published nine months earlier; see "The Art Schools of Philadelphia," *Scribner's Monthly*, vol. 18, no. 5 (September 1879), pp. 737–50. Another newspaper critic felt that although "the perspective is too violent, that the figures diminish too rapidly, that is a technical point on which the artist ought to know more than we, and on which so careful a draughtsman as Mr. Eakins must have used his knowledge, so we yield, with a protest." "Some Recent Art," clipping from an unidentified newspaper, Bregler Collection, PAFA; see Appendix.

19. William J. Clark, Jr., "The Fine Arts: Eakins' Portrait of Dr. Gross," *Philadelphia Evening Telegraph*, April 28, 1876, p. 4. Artists used this kind of selective focus as a device long before the advent of the camera, and it is in some respects more like natural vision. Eakins interacted with photography in many ways; on his use of selective focus as an artistic rather than a photographic choice, see Foster, *Thomas Eakins Rediscovered*, pp. 175–76.

20. Charles Bregler, "Thomas Eakins as I knew him," Bregler Collection, PAFA; cited in Foster, *Thomas Eakins Rediscovered*, p. 74.

21. For an X-radiograph of the painting showing the rowing figures beneath the surface, see Theodor Siegl, *The Thomas Eakins Collection* (Philadelphia: Philadelphia Museum of Art, 1978), p. 173 and cat. 21, p. 64. Siegl notes that Eakins's student in later years, Tom Eagan, recalled that Eakins especially liked this sketch. Early cleanings have exposed in a few places the extremely bright colors of his earlier plein air studies.

22. Marc Simpson interpreted this border as a frame; see "The 1870s," in Sewell et al., *Thomas Eakins*, p. 32. The custom size of *The Gross Clinic*, generated by the necessities of the composition, is typical of Eakins. For compositions other than conventional bust-length portraits, Eakins rarely used conventional prestretched canvases. See Foster, *Thomas Eakins Rediscovered*, pp. 75, 200.

23. Eakins to Earl Shinn, April 13, 1875, Cadbury Collection, Friends Historical Library, Swarthmore College, Swarthmore, Pennsylvania (see the Appendix for the full text of this letter).

24. "Try to construct so little form at the beginning that it would be possible to paint my entire picture in a single day. Make [it] solid right away." Eakins, Spanish notebook, Bregler Collection, PAFA (translation by Mark Tucker and Nica Gutman).

25. Eakins's friend William Sartain, writing to their mutual friend Charles Fussell from Paris in July 1870, described his teacher's method: "A word about

Bonnat. I said he was so *solid* in his work. I will tell you *how* he paints. He draws the large divisions true as possible, omitting such details as eyes mouth &c. Then he paints the thing as a round mass, giving all the tones and values. After completing this painting of the general masses, he then goes over it and puts in the nose mouth &c. . . . Bonnat as it were '*models*' the painting like a sculptor." Sartain to Fussell, July 4 (mailed July 11), 1870; Eakins Archives, American Art Department, Philadelphia Museum of Art.

26. Eakins, Spanish notebook, Bregler Collection, PAFA (translation by Mark Tucker and Nica Gutman).

27. Eakins's references to this approach, his search for it in the paintings he admires, and his disdain for *au premier coup* (direct) painting are scattered throughout the Spanish notebook. See also Mark Tucker and Nica Gutman, "The Pursuit of 'True Tones,'" in Sewell et al., *Thomas Eakins*, pp. 353–66; Foster, *Thomas Eakins Rediscovered*, pp. 46–47.

28. Parry, "*The Gross Clinic* as Anatomy Lesson," p. 381, noted the psychological separation created by the railing.

29. Wallace also noted that "the horizon is in my estimation at the bottom of Dr. Gross's chin." His observations are quoted in a letter from George Barker to Lloyd Goodrich, October 7, 1936; Goodrich Archive, PMA.

30. Susan Eakins told this to Goodrich in 1930; see Parry, "*The Gross Clinic* as Anatomy Lesson," p. 375; Goodrich, *Thomas Eakins*, vol. 1, p. 128. Eakins wrote to his fiancée, Kathrin Crowell, on August 20, 1875, that he was having "trouble with Dr. Gross not from any unwillingness of his, but when I wanted him most he would be away or so run down with operations that he could not find me an hour. But I expect him Sunday"; Bregler Collection, PAFA. Years later, Susan Eakins wrote that Eakins was "permitted in the Clinic Room. Dr. Gross realized that he was serious in his work, and gave him every opportunity to study the color, the positions of objects and general arrangements of a Clinic. Having arranged the composition on the canvas, he made studies of each person in the picture. The important figures, Dr. Gross and his assisting surgeons, requiring more finished painting, would give as many poses as possible, probably six poses of an hour each time in the pose of Dr. Gross, the other surgeons some what less time. The students in the background, probably one or two poses." Mrs. Eakins did not know her future husband at the time. In this same letter she insisted that he never used photographs for portraits, although subsequent study has demonstrated that Eakins enthusiastically, if secretly, embraced photographic studies. Susan Macdowell Eakins to Mrs. Lewis R. Dick, c. 1930, Bregler Collection, PAFA; cited in Kathleen A. Foster and Cheryl Leibold, *Writing about Eakins: The Manuscripts in Charles Bregler's Thomas Eakins Collection* (Philadelphia: University of Pennsylvania Press, 1989), p. 299.

31. A rare unfinished full-length portrait, of the architect John J. Borie III (now in the Hood Museum of Art, Dartmouth College, Hanover, New Hampshire), illustrates the appearance of a painting by Eakins halted before the details in the sitter's environment had been completed; see Foster, *Thomas Eakins Rediscovered*, pp. 208–10.

32. Clark, "The Fine Arts," p. 4. This figure was first referred to as the "mother" when the painting was exhibited in New York in 1879; see "The American Artists: Varnishing Day of the Second Exhibition: The Venuses of Eaton and La Farge—Surgery by Eakins—Landscapes of Homer Martin," *New York Times*, March 8, 1879, p. 5. These reviews are reproduced in the Appendix to this volume. Hendricks, *Life and Works of Thomas Eakins*, p. 59, asserted that the woman represented the family of a charity patient, following the protocols of public surgery; Berkowitz, *Adorn the Halls*, pp. 167, 174–75, notes that this has never been substantiated.

33. One proposed explanation for the apparent odd protuberance at the right of the figure's foreshortened left hand is that it is a sixth finger. See Julie Berkowitz, *Jefferson Medical College Alumni Bulletin*, vol. 52, no. 3 (June 2003).

On p. 14, the author quotes Joseph Upton, MD, a specialist in the genetics of hand malformations, who speculated that if polydactyly is depicted here the model could have been from the Germantown section of Philadelphia, as this genetic trait is found more frequently in persons of Pennsylvania German descent. More recently, Cynthia Watkins, certified hand therapist at the Rothman Institute, Philadelphia, examined detailed images of the painting and its wash replica and concluded that there was no sixth finger, and that although the fall of light makes the protuberance appear to be bony, it is musculature, and that the woman's "hypothenar eminence is in an extreme state of contraction due to her clenched position." Correspondence with Mark Tucker, July 1, 2011.

34. Ellwood C. Parry III, "Thomas Eakins and *The Gross Clinic*," *Jefferson Medical College Alumni Bulletin*, vol. 16, no. 4 (Summer 1967), p. 8, notes that the woman's presence may state the "life and death" theme of the subject, or express the unsuitability of women to surgery. Parry, "*The Gross Clinic* as Anatomy Lesson," p. 382, notes art-historical precedents for such a female figure flinching at the sight of death. Amy Werbel, *Thomas Eakins: Art, Medicine, and Sexuality in Nineteenth-Century Philadelphia* (New Haven, CT: Yale University Press, 2007), p. 49, notes that this woman—the only figure in the painting not involved in teaching, healing, or learning—represents "the worst kind of viewer—a hysteric."

35. See, for example, reviews in the *New York Times* and *New York Tribune* in 1879, both objecting to the inclusion of the "mother," or Earl Shinn's more measured appreciation for the dramatic intensity in his review in the *Nation* the same year; all three are reprinted in the Appendix.

36. *An Inaugural Address Introductory to the Course on Surgery in the Jefferson Medical College of Philadelphia, Delivered on October 17, 1856, by Samuel D. Gross, M.D.* (Philadelphia: Jefferson Medical College, 1856).

37. See particularly the invention of the background in the portrait of John H. Brinton, discussed in Foster, *Thomas Eakins Rediscovered*, pp. 205–7.

38. Mariana Griswold Van Rensselaer, "The Spring Exhibitions in New York: The National Academy of Design, the Society of American Artists, etc.," *American Architect and Building News*, vol. 5, no. 176 (1879), p. 149, pointed out "faults in the perspective of the subordinate figures." The critic for the *New York Tribune* complained, "A mile or so away, at a high-raised desk, another impassive assistant records with a swift pen the Professor's remarks, and at about the same distance an aged woman, the wife or mother of the patient, holds up her arms and bends down her head in a feeble effort to shut out the horror of the scene. She is out of all proportion small compared with the other figures, and her size is only to be accounted for on the impossible theory that she is at a great distance from the dissecting table"; [Clarence Cook], "The Society of American Artists: Second Annual Exhibition," *New York Tribune*, March 22, 1879, p. 5. In fact, her pose and costume make it hard to measure her, though she seems to be about 7/8 or 8/10 scale, slightly larger than Dr. West at the podium above her, who seems about 75 percent life-size. At a viewing distance of twenty feet, she would be on the plan at about twenty-three to twenty-five feet from us (three to five feet behind Gross), with Dr. West at twenty-six and a half feet. Even though this placement can be rationalized because she may have been a petite woman, she still seems slightly out of scale.

39. Although Samuel W. Gross seems to be two-thirds life-size, he appears to be closer on the plan than he should be at that scale. O'Donnell is also difficult to locate on the plan, because he is difficult to measure; apparently, he is at half life-size. Both men are as tall as (or taller than) Gross, which would make them all remarkably tall for this period, or perhaps just conveniently so for the artist's composition. These anomalies might be explained by a sloping surface in the tunnel, or by the suspicion that two different plans have been overlaid and intuitively fudged. At the very least we can note that Eakins

deliberately makes it impossible to see the floor and measure his figures, as approximated in the diagram of *The Gross Clinic* with the figures outlined to demonstrate recession (see fig. 5.5).

40. Eakins's sketch of Meyers was made in oil on paper, which became brittle and was subsequently laid down on canvas. If other preparatory oil sketches were also on paper, their disappearance might be explained by their similar deterioration over time. On Meyers, who was not registered to attend classes at Jefferson, see Hendricks, *Life and Works of Thomas Eakins*, p. 54; William Innes Homer, ed., *Eakins at Avondale and Thomas Eakins: A Personal Collection* (Chadds Ford, PA: Brandywine River Museum, 1980), p. 46. David Sellin, *Thomas Eakins and His Fellow Artists at the Philadelphia Sketch Club* (Philadelphia: Philadelphia Sketch Club, 2001), p. 8, speculated that Eakins's friends from the Sketch Club also posed for *The Gross Clinic*, including William Sartain, Earl Shinn, and particularly William J. Clark, Jr., whose commentary in the press indicates that he had seen the painting in Eakins's studio. Meyers is about half life-size, like O'Donnell, who is on about the same plane in the distance.

41. The use of these tiny registration marks was concentrated in the initial working up of the image, although Eakins sometimes added them at intervals throughout the painting process. Because they were not used at a single stage in the making of a painting, great numbers of them are frequently buried or blurred by subsequent paint layers; on the use of photographs in this fashion, see Mark Tucker and Nica Gutman, "Photographs and the Making of Paintings," in Sewell et al., *Thomas Eakins*, pp. 225–38. On Eakins, photography, and the many Philadelphia photographers he knew, see W. Douglass Paschall, "The Camera Artist," in Sewell et al., *Thomas Eakins*, pp. 239–55. On the photographs discovered in the Bregler Collection and their relationship to various paintings, see Foster, *Thomas Eakins Rediscovered*, pp. 106–20, 163–88.

The photographs and negatives in the Bregler Collection are catalogued in Susan Danly and Cheryl Leibold, *Thomas Eakins and the Photograph: Work by Thomas Eakins and His Circle in the Pennsylvania Academy of the Fine Arts* (Washington, DC: Smithsonian Institution Press for the Pennsylvania Academy of the Fine Arts, 1994).

42. Parry, "Thomas Eakins and *The Gross Clinic*," p. 5; Parry, "*The Gross Clinic* as Anatomy Lesson," pp. 375–78. Many images of Gross are documented in Berkowitz, *Adorn the Halls*, pp. 145–49, 194.

43. On Calder's sculpture of 1895–97 and his use of photos, see Berkowitz, *Adorn the Halls*, pp. 150–54. Parry, "*The Gross Clinic* as Anatomy Lesson," p. 390, notes that the Calder sculpture, in its quotation of Gross as he appears in the painting, suggests the iconic status of *The Gross Clinic* by the mid-1890s.

44. W. H. Workman, "Letter from Philadelphia," *Boston Medical and Surgical Journal*, vol. 95 (August 3, 1876), p. 153. See the Appendix for this detailed response from a doctor.

45. See, for example, Tucker and Gutman, "The Pursuit of 'True Tones,'" p. 354.

46. Ibid.

47. E. H. Blashfield, "Léon Bonnat," in *Modern French Masters: A Series of Biographical and Critical Reviews by American Artists*, ed. John C. Van Dyck (New York: Century, 1896), p. 50.

48. Students' high esteem for Bonnat's work, method, and teaching is clear in Sartain's July 1870 letter to Fussell: "Bonnat is far the greatest painter of these later centuries, more conscientious and honest, more *solid*, more tone and color. He is underappreciated. One or two of the Old Masters only has superseded him in these qualities. . . . Bonnat is perhaps the only teacher living that does not do harm." William Sartain to Charles Fussell, July 4, 1870; Eakins Archives, American Art Department, Philadelphia Museum of Art.

Kathleen A. Foster

The Gross Clinic in Philadelphia and New York, 1875–79

"TOM EAKINS IS MAKING EXCELLENT progress with his large picture of Dr. Gross, and it bids fair to be a capital work," reported the artist's neighbor and longtime advisor, John Sartain, in August 1875. An impresario of the arts in Philadelphia, Sartain was appointed superintendent of the art display at the Centennial Exhibition a few weeks later. Taking charge of tardy and disorganized planning, he soon realized that the flood of submissions to the art department was going to require an annex to Memorial Hall. As hurried construction on this expansion began that fall, Eakins made the last of his refinements to the painting. The picture seems to have been completed by Christmas, when Eakins gave his friend Robert C. V. Meyers the small portrait sketch he had made in October (see fig. 5.16), when Meyers served as a model for one of the students in the background of the final painting.[1] Eakins signed and dated his finished canvas "1875" and began to plan for the promotion of the painting and its exhibition at the Centennial the following spring.

Anticipating publicity, he prepared an India ink and watercolor replica of the painting to send to the internationally famous publisher of art reproductions, Adolphe Braun and Company, in Alsace, which was then part of Germany. His wash replica (see fig. 8.5), doubtlessly based on a working photograph of the painting made in Philadelphia, was an economical and convenient way to spare the difficulty of shipping the canvas to Europe. In making it, Eakins also anticipated the difficulties that still plague even experienced professional photographers in lighting a very large, dark painting like *The Gross Clinic*. Moreover, he understood that the black-and-white glass plate negatives of this era could not capture color values correctly, making red tints too dark and blue tints too pale; as he said in 1881, "My drawing [of *The Gross Clinic*] was made with the intention of coming out right in a photograph."[2] Knowing that the reproduction would lack the range of tone in the oil, for clarity he made the drawing lighter overall than the painting, while painstakingly translating the painting's *relative* tones of dark and light.

His wash image becomes, then, the first record—and a critically adjusted one—of the initial appearance of the painting, not only documenting the correct relative values of the image, but also illustrating, by the extent of the artist's pains, the supreme importance for Eakins of establishing the proper balance of tones. The collotype (sometimes called an "autotype")[3] that Braun produced (fig. 6.1) would convey the impression of the painting to Eakins's friends overseas and serve as a harbinger of the work's debut.

By early March 1876, Eakins evidently had received reproductions from Europe, and he began a studied rollout of his painting, sending a photograph of *The Gross Clinic* to an art reception at the Penn Club on March 7. William J. Clark, Jr., an art critic who had nominated Eakins as visiting professor to the Philadelphia Sketch Club and oversaw the life-drawing classes the artist taught there, published a glowing review in the following day's *Philadelphia Evening Telegraph*, in which he described the painting as "a work of great learning and great dramatic power." Clark, who had probably also seen the painting in Eakins's studio, noted that "the exhibition of the photograph last night will certainly increase the general desire to have the picture itself placed on exhibition at an early day."[4]

Somewhat drained by the competing attraction of the Centennial, the Pennsylvania Academy of the Fine Arts' spring 1876 exhibition, the first since 1870, opened on April 24, just days after the ribbon-cutting for the spectacular new Academy building at Broad and Cherry streets. Eakins sent a watercolor, *The Zither Player* (Art Institute of Chicago; see Appendix, fig. 10.1), and another (or perhaps the same) framed photograph of *The Gross Clinic*.[5] Like many artists, he was saving his most important work for the Centennial jury, which conducted its deliberations April 4–8 in a building next door to the Academy. The jury's initial reaction to the painting is not recorded. What we do know is that about April 25 *The Gross Clinic* went on view at Sketch Club member Charles F. Haseltine's gallery on Chestnut Street.[6] Clark gave an insider's account of Eakins's painting when it appeared at Haseltine's, penning one of the most positive reviews the artist would receive in his lifetime:

The public of Philadelphia now have, for the first time, an opportunity to form something like an accurate judgment with regard to the qualities of an artist who in many important particulars is very far in advance of any of his American rivals. We know of no artist in this country who can at all compare with Mr. Eakins as a draughtsman, or who has the same thorough mastery of certain essential artistic principles.

Clark commented on the surprising visual qualities of the painting:

With regard to Mr. Eakins' color, however, there is this to be said—and it is a point that must be considered by those who may be disposed to regard his color as odd, not because it does not represent nature, but because it does not look like what they have been accustomed to in other pictures—his aim in color, as in drawing, is to represent, as near as is possible with the pigments at command, the absolute facts of nature, and a misrepresentation of facts for the purpose of pleasing the eyes of those who do not know what nature looks like is something that his method does not contemplate.

Clark concluded:

To say that this figure is a most admirable portrait of the distinguished surgeon would do it scant justice; we know of nothing in the line of portraiture that has ever been attempted in this city, or indeed in this country, that in any way approaches it. . . . Leaving out of consideration the subject, which will make this fine performance anything but pleasing to many people, the command of all the resources of a thoroughly trained artist, and the absolute knowledge of principles which lie at the base of all correct and profitable artistic practice, demand for it the cordial admiration of all lovers of art, and of all who desire to see the standard of American art raised far above its present level of respectable mediocrity. This portrait of Dr. Gross is a great work—we know of nothing greater that has ever been executed in America.[7]

The Centennial opened on May 10, 1876 (see fig. 4.2), with the art exhibition in disarray; the galleries were

Fig. 6.1. *Collotype of "The Gross Clinic,"* 1876. Printed by Adolphe Braun & Co., Alsace, Germany. Image 11¼ × 9⅛ inches (28.6 × 23.2 cm). Philadelphia Museum of Art. Gift of Mrs. Adrian Siegel, 1952-37-1

filled with crates and debris, and many items had not yet arrived. By June 1, two watercolors by Eakins—*Baseball Players Practicing* (Museum of Art, Rhode Island School of Design, Providence; see Appendix, fig. 10.3) and *Whistling for Plover* (Brooklyn Museum, New York; see Appendix, fig. 10.4)—could be seen in the Annex in a special display mounted by the American Society of Painters in Water Colors; by mid-June, when the American section of the main gallery neared completion, three of his oils were on view: *The Chess Players* (see fig. 5.1) in the Central West Gallery; *Elizabeth at the Piano* (Addison Gallery of American Art, Andover, Massachusetts; see Appendix, fig. 10.2), depicting his sister in a shadowy interior, in Annex

Gallery 30; and *Professor Benjamin Howard Rand* (fig. 6.2), showcased in Gallery C, the "Saloon of Honor" (fig. 6.3) at the center of the building.[8]

The Rand portrait, painted the year before *The Gross Clinic*, was the largest and most important of these three entries, and Eakins must have been pleased by its prominent placement. Benjamin H. Rand was the first doctor and scientist Eakins had depicted, as well as the first sitter not part of the artist's family or inner circle of friends. Eakins had known Rand half his life, however, as Rand had been the artist's chemistry teacher at Central High School. A graduate of Jefferson Medical College, Rand joined its faculty in 1864, the year Eakins first attended anatomy lectures and demonstrations. Disabled by an accident in his laboratory, Rand retired in 1873, so he had time to sit for a portrait when his former student approached him with the idea the following year. Eakins may have been aiming to produce a commemorative image for the recently announced portrait initiative at Jefferson, which sought paintings of esteemed faculty to hang at the college, but he was deliberately unconventional in his strategy. He depicted Rand informally, at home, caught between his life of science, represented by a gleaming microscope, test tubes, and books, and his domestic world, captured in the gray cat, flower, and mysterious jumble of papers before him. Barricaded behind a desk, fur robe, wastebasket, and magenta afghan throw, Rand is lost in reverie, expressing an introspective mood that would become a hallmark of Eakins's portraiture for more than thirty years. The unusual complexity of mood, space, and artifacts in the Rand portrait tells us that Eakins intended something more ambitious and artistic than a standard institutional likeness. The critics recognized its odd qualities. It is "a portrait which is made a picture by the many accessories introduced," noted the critic of the *Philadelphia Evening Bulletin*, who called it "one of the best contributions to the section" of American art at the Centennial.[9]

Eakins's two entries in the display of the American Society of Painters in Water Colors went unnoticed, however, and the artist must have been disappointed by the overall response to the art department. Perhaps because the galleries were confusing and exhausting, with about seven hundred paintings (a tenth of the total

Fig. 6.2. *Professor Benjamin Howard Rand*, 1874. Oil on canvas, 5 × 4 feet (152.4 × 121.9 cm). Crystal Bridges Museum of American Art, Bentonville, Arkansas

international ensemble) hung frame to frame and floor to ceiling, many journalists gave the American art on view only brief consideration. Some praised the exhibition, but others expressed disappointment, regretting the numerous mediocre pictures that eroded a coherent sense of national achievement. Open war erupted between superintendent Sartain and the New York members of the jury, who rejected most of the paintings submitted en bloc from the annual exhibition of the Pennsylvania Academy of the Fine Arts, producing a politicized installation that must have left many Philadelphia artists disgruntled. Sartain surreptitiously inserted eight of these rejected paintings in the Annex

galleries, and the situation devolved into an angry face-off between New York and Philadelphia, and between the landscape artists of the old school and the European-trained figure painters of the new generation; Sartain and the Philadelphia artists he supported (including Eakins) were not happy with the outcome.[10]

The Gross Clinic, caught up in this combative moment, was not shown in Memorial Hall, and therefore received no attention from the art press. Although the jury claimed inadequate space, other reasons were rumored. A correspondent for New York's *Medical Record* noted that "the picture has much merit, and the likeness is excellent; but the coloring is not pleasant, and the subject is so repulsive, the Professor's unnecessarily bloody hand being the conspicuous feature of the scene, that we are not surprised that, for this latter cause alone, it was refused a place in the Art Gallery by the Committee of Selection, to find a more appropriate niche in the Army Hospital."[11] Another correspondent to a Boston medical journal saw it otherwise, reporting that the painting "was originally offered to the art committee, but the details of the picture proved so shocking that two or three members of the committee actually became faint, and it was deemed wise to reject it; so that although there are in memorial hall pictures which are far more gory, this fine work of art at last found its way to the government hospital building. Let me advise those of your readers who visit the Exhibition not to miss a view of it."[12] Eakins's friend William Clark urged the same, but had darker suspicions concerning the jury:

> There is nothing so fine [as *The Gross Clinic*] in the American section of the Art Department of the Exhibition, and it is a great pity that the squeamishness of the Selecting Committee compelled the artist to find a place for it in the United States Hospital building. It is rumored that the blood on Dr. Gross' fingers made some of the members of the committee sick, but judging from the quality of the works exhibited by them we fear that it was not the blood alone that made them sick. Artists have before now been known to sicken at the sight of pictures by younger men which they in their souls were compelled to acknowledge were beyond their emulation.[13]

Fig. 6.3. The American art display in the "Saloon of Honor" of Memorial Hall at the Centennial Exhibition, 1876. Eakins's *Professor Benjamin Howard Rand* (see fig. 6.2) was shown in this gallery. Courtesy Free Library of Philadelphia

The installation site of the painting in the "Army hospital" may have seemed incongruous, but it was far from obscure. Apart from the display of medical equipment in the main exhibition hall, the U.S. Army constructed a freestanding replica of a full-scale post hospital to demonstrate the state-of-the-art medical facilities on American military bases (fig. 6.4). Although no patients had actually been treated in this building, it included a complete ward with beds covered in mosquito netting, walls decorated with framed photomicrographs of diseased colons, and windows hung with photographic transparencies of various cancers. *The Gross Clinic* appeared at the end of

Fig. 6.4. Exterior view of the Army Post Hospital from the Army Medical Department's exhibit at the Centennial Exhibition. OHA 76: International Exposition of 1876 Medical Department Photographs. National Museum of Health and Medicine, Washington, DC

this model ward, with dark fabric draped around it to give a semblance of picture-gallery dignity (fig. 6.5), setting off the ornate gilded frame (see fig. 9.1) that he had ordered, no doubt at considerable expense, anticipating a "salon" environment. It may be that Dr. Gross, who had organized an international congress of surgeons to coincide with the Centennial celebration, also engineered the display of the painting in the U.S. Army Post Hospital. Listed as the owner of the painting in the checklist of the display, he may have wished to have it on view in the building most likely to be visited by his colleagues attending the conference. As the *Philadelphia Evening Bulletin* insisted, "No visitor to the grounds should fail to see" this installation, calling the portrait of Dr. Gross "a splendid work of art in itself."[14] Certainly many doctors took this advice, and—judging by the extant reviews of the post hospital (see the Appendix)—Eakins received more complimentary attention in print from this audience of specialists than from the art critics.[15]

After the Centennial closed in November 1876, *The Gross Clinic* went back to Haseltine's gallery for an unknown interval.[16] On February 23, 1878, the account book at Jefferson Medical College recorded that Eakins

was paid two hundred dollars for a "picture of surg. Clinic," and within a few weeks a Philadelphia paper reported that the painting was now in the college's "new museum at Tenth and Sansom Streets."[17] Eakins may have given the painting to Gross, just as he had presented Rand with the portrait from the previous year. If so, perhaps Rand's transfer of his portrait to Jefferson in 1877 inspired Gross to do the same, and (in his role as president of the Alumni Association) to direct some courteous compensation to the artist for expenses such as framing. Eakins asked as much for his watercolors in this decade, so the sum of two hundred dollars was clearly a token. Susan Macdowell Eakins remembered her husband "saying he received about what it cost in materials. I suppose he had to buy the frame too."[18] Mostly a gift, the transaction was nonetheless marked with a proud "SOLD" next to the painting's title in his pocket record book.[19]

Seeking further publicity for the painting, Eakins sent his ink wash version of *The Gross Clinic* to the watercolor society's exhibition early in 1877; it was not listed in the catalogue, and received no notice in the press.[20] A year later, in the spring of 1878, he submitted a photograph of *The Gross Clinic* to the first exhibition of

Fig. 6.5. *The Gross Clinic* displayed, along with "a small photograph of the same," inside a model ward of the Army Post Hospital at the 1876 Centennial Exhibition in Philadelphia. Courtesy the Library of Congress, Washington, DC

the new Society of American Artists (SAA) in New York, and a year after that he had the painting sent to their second show, held at the Kurtz Gallery, March 10–29, 1879. Although his work had finally been accepted at the prestigious National Academy of Design in 1877, Eakins had thrown his support to the SAA, a controversial new organization composed mostly of young artists who had returned from study abroad to find, as he had, small welcome for new talent or progressive work. Basing its approach on the latest trends in Paris and Munich, the SAA drew close attention from many critics, most of whom would have missed *The Gross Clinic* at the Centennial three years earlier. Many of these New York critics, who knew Eakins only from his watercolors of sporting subjects and genre scenes, were stunned by the picture, and Eakins suddenly found himself the center of attention.

The critics varied in their responses, but were united in finding the subject somewhere on the spectrum from "unpleasant" to "ugly," "objectionable,"

"grisly," "horrible," "repulsive," "disgusting," "sickening," and "revolting" (see the Appendix). From this consensus, they discussed the appropriateness of displaying such a painting to the general public, opining that even strong persons (not to mention the weaker sex and children) found the painting hard to confront. For some, it was fit only for a medical school, or should never have left the dissecting room; even admirers such as the critic and former fellow student with Eakins in Paris, Earl Shinn, made sense of the subject by incorrectly assuming that it had been "ordered for the faculty" at Jefferson. For others, Eakins had simply gone too far in the direction of naturalism and thus left the realm of art.[21] At a moment when realism was increasingly associated with the detailed, topographical views of the midcentury landscape school and progressive critics were seeking "poetical" subjects and expressive handling, Eakins's work seemed inartistic and contrary.

Such opinions logically led to discussion of the style of the painting ("sickeningly real" to some, "startlingly lifelike" to others) and Eakins's command of technique. The shocked response to *The Gross Clinic* makes for lively reading in excerpt, but few scholars have credited the length, detail, and complexity of the commentary generated by the painting, which generally began by acknowledging the skill of the artist. Writing for the *Art Journal*, Susan N. Carter articulated the mixed opinions of many discriminating viewers: she concluded that the subject represented the "degradation of art" and found the background "black and disagreeable," but complimented the "beautiful modeling of hands," skillful composition, fine color, and admirable portraiture. In the ten known reviews the painting received during the 1879 exhibition, technical criticism focused on the portrait likeness and drawing skill (generally deemed excellent), the use of color (described with phrases ranging from "wooden and academic" and "not pleasant" to "fine"), the artist's generally low tone (characterized by one critic as "well but blackly painted"), and his various "faults in the perspective of the subordinate figures."[22] But everyone was impressed. The critic in the *Graphic* stressed the seriousness of Eakins's work, which contained "thought

and feeling of a high order" not seen elsewhere in the show, and other reviews repeatedly described an effect of strength, power, drama, intensity, and importance. "Powerful, horrible, and yet fascinating," exclaimed the *Tribune*'s critic (probably Clarence Cook), who put the painting in the company of Jacques-Louis David's *Death of Marat* and Théodore Géricault's *Raft of the Medusa*.[23] Eakins had made a reputation overnight.

Interest in the SAA show inspired the Pennsylvania Academy of the Fine Arts (perhaps at the urging of an exhibition committee that included Eakins, who was now on the faculty) to invite the entire exhibition to Philadelphia, to be shown as a separate, unjuried display within the Academy's spring annual, held April 28 to June 2, 1879. Confusion ensued, as Eakins's painting was not installed, but a large Florida landscape painting by Thomas Moran (1837–1926), rejected by the SAA in New York, was given a place of honor in the exhibition. Eakins wrote an alternately testy and conciliatory letter to the Academy's Board of Directors and to the Chairman of the Committee on Exhibitions, George Pepper, noting the "unfortunate notoriety" of both paintings and protesting the situation, characterizing the Academy's secretary, George Corliss, as a "miserable and tricky partisan." Walter Shirlaw, president of the SAA, also wrote to complain, and William Merritt Chase and William R. O'Donovan came down from New York to straighten things out, threatening to withdraw the entire installation.[24] On May 9 the Academy's Board agreed to revise the hanging; Moran's painting was removed and several other paintings were shifted into the SAA's gallery, but *The Gross Clinic* stayed outside the group, in an "obscure corner" (probably the back corridor), where it remained for the duration of the exhibition.[25]

The Gross Clinic returned to Jefferson Medical College in June 1879, at the end of the Academy's exhibition. Although battered by the press, Eakins and his circle were not daunted, if a parody photograph of the painting (fig. 6.6) made about this time can be read as a lighthearted show of support for the artist. Identifying the setting in these photographs has been complicated by the absence of images of the Jefferson amphitheater, but it may be the same octagonal space

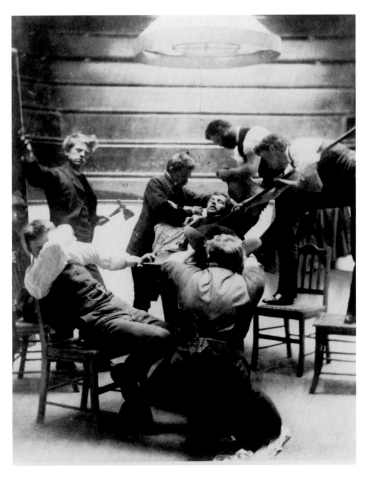

Fig. 6.6. Circle of Thomas Eakins, *Parody of "The Gross Clinic,"* c. 1879 (negative). Modern gelatin silver copy print, sheet 4¹⁵⁄₁₆ × 4 inches (12.5 × 10.2 cm). Philadelphia Museum of Art. Gift of George Barker, 1977-172-1

Fig. 6.7. Circle of Thomas Eakins, *Parody of an Anatomy Lesson*, c. 1879 (negative). Modern gelatin silver copy print, sheet 4 × 5 inches (10.2 × 12.7 cm). Philadelphia Museum of Art. Gift of George Barker, 1977-172-3

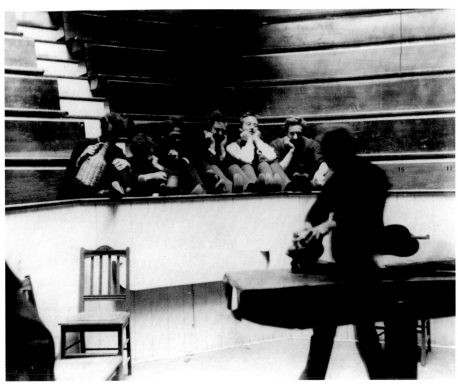

depicted in the painting.[26] The silliness of this photo and a companion tableau of a mock anatomy lecture (fig. 6.7) suggests a moment of teasing (or cheering) by Eakins's friends and students from the Sketch Club or the Academy, who feign performing surgery with a hatchet, probing with a shade pull, and delivering anesthesia with a wicker-bound wine jug, while an onlooker recoils in horror. Parodying the painting, the men also mock the attitudes of the critics who found the surgery brutal and the "mother" overwrought. The rapt chin-in-hand poses of the audience in the "anatomy lecture" also echo the figures in the background of *The Gross Clinic*, hinting that these men may have won the right to make fun of Eakins by posing for his picture.[27] Part of the unframed canvas of the actual *Gross Clinic* is visible on the left, suggesting that the group had gathered to help return the painting to Jefferson after the two exhibitions in the spring of 1879. The objections of the critics did not daunt these supporters, nor did they prevent the Jefferson community—which represented (as the critics agreed) the best-prepared, most fitting audience for such a subject—from embracing the painting. By 1884, the College reported, "The celebrated portrait of Prof. Samuel D. Gross, by Mr. Thomas Eakins" was displayed in the "Dean's Room," on the lower floor of the College building, where (particularly after Gross's death that year) it quickly became, exactly as the school's portrait committee intended, an emblem of Jefferson Medical College's proud history.[28]

1. John Sartain to Emily Sartain, August 1875, Sartain Papers, Historical Society of Pennsylvania, Philadelphia. See also Ellwood C. Parry III, "*The Gross Clinic* as Anatomy Lesson and Memorial Portrait," *Art Quarterly*, vol. 32, no. 4 (Winter 1969), p. 387; David Sellin, *The First Pose, 1876: Turning Point in American Art; Howard Roberts, Thomas Eakins, and a Century of Philadelphia Nudes* (New York: W. W. Norton, 1976), p. 45; Lloyd Goodrich, *Thomas Eakins*, 2 vols. (Cambridge, MA: Harvard University Press for the National Gallery of Art, 1982), vol. 1, p. 128. On the chaotic run-up to the Centennial, see Kimberly Orcutt, "'Revising History': Creating a Canon of American Art at the Centennial Exhibition" (Ph.D. diss., City University of New York, 2005), pp. 60–121.

2. His statement is from a letter of July 13, 1881, to the publisher S. R. Koehler in Boston, who was about to reproduce *The Gross Clinic*. Eakins sent the wash replica for use and asked for a "light proof" of the image as it was to be printed, so he could "work over it with indian ink and bring the tones to what I want, if the first [proof] don't suit me." See Kathleen A. Foster, *Thomas*

Eakins Rediscovered: Charles Bregler's Thomas Eakins Collection at the Pennsylvania Academy of the Fine Arts (Philadelphia: Pennsylvania Academy of the Fine Arts; New Haven, CT: Yale University Press, 1997), pp. 109, 256n16.

3. On Braun and the autotype, a patented photographic process improving on the collotype, see Gordon Hendricks, "Thomas Eakins's *Gross Clinic*," *Art Bulletin*, vol. 51, no. 1 (March 1969), p. 58; Phyllis D. Rosenzweig, *The Thomas Eakins Collection of the Hirshhorn Museum and Sculpture Garden* (Washington, DC: Smithsonian Institution Press, 1977), pp. 59–60; Theodor Siegl, *The Thomas Eakins Collection* (Philadelphia: Philadelphia Museum of Art, 1978), p. 65; Julie Berkowitz, *Adorn the Halls: History of the Art Collection at Thomas Jefferson University* (Philadelphia: Thomas Jefferson University, 1999), pp. 195–97. Braun's process, an early kind of photomechanical lithography, also had the advantage of greater pigment stability than the cheaper albumen process. Eakins's painting and the wash drawing register almost perfectly, telling us that Eakins projected a photograph of the painting and traced the image onto the watercolor paper. It may be that his dissatisfaction with this initial photograph made him realize that he would need to translate the values of the painting himself to get a reliable reproduction. Braun's company, world famous for art reproductions, had a Philadelphia agency, J. O. Stornay at 1516 Chestnut Street; see Berkowitz, *Adorn the Halls*, p. 213n46.

4. William J. Clark, Jr., "The Fine Arts: The Penn Club Reception," *Philadelphia Evening Telegraph*, March 8, 1876, p. 4 (excerpted in the Appendix to this volume). Clark served as the arts and culture critic for the *Telegraph* beginning in 1868. His close association with Eakins can be deduced from a letter of January 22, 1876, from the Sketch Club to the Pennsylvania Academy of the Fine Arts, petitioning for space for their life school in the new building; twenty-two members signed the letter, with Clark and Eakins heading the list. Archives, Pennsylvania Academy of the Fine Arts, Philadelphia.

5. For a review of the Academy's show, see the Appendix. According to Eakins's exhibition record book I, Charles Bregler's Thomas Eakins Collection, Pennsylvania Academy of the Fine Arts (hereinafter cited as Bregler Collection, PAFA), he also sent photographs of *The Gross Clinic* to the Centennial (seen below the painting; see fig. 6.5); to Haseltine's gallery in late 1876; to "Lindsay & Blakiston's" (a publisher and bookseller specializing in medical texts, including Agnew's work, at 25 South Sixth Street) in 1878; and "Two given to Mrs. Schuesselle's Sale," a benefit held for the widow of his professor, Christian Schuessele, in 1880. Berkowitz, *Adorn the Halls*, p. 195, also records copies sent to the first exhibition of the Society of American Artists in 1878; to a reception at the New York Art Students League in 1879; to the Chicago World's Fair in 1893; to Earle's Gallery in 1896; and to the St. Louis World's Fair in 1904. The later items on this list were probably copies of the collotype, but (judging from fig. 6.5) the photograph shown at the Centennial, and perhaps at some of the other early exhibition venues, was four times larger than the autotype, close to the size of the wash replica. Perhaps it resembled the albumen photograph of the painting, 18¼ × 13¾ inches, sold as lot 678A at Freeman's Auction, Philadelphia, on March 28, 1996. It is remarkable that Eakins so frequently sent the photograph as a surrogate or harbinger for the painting, or showed it alongside the painting, perhaps because he mistrusted the viewing conditions for his work. He also sent a copy of the collotype to the Library of Congress when he applied for copyright on April 6, 1876, and additional prints were given to friends, sometimes years later, such as those inscribed to Florence Einstein, now in the Philadelphia Museum of Art (see Siegl, *The Thomas Eakins Collection*, p. 65); to Joseph Leidy II (National Library of Medicine); to James Tyson in 1914 (College of Physicians, Philadelphia); to the ophthalmologist Dr. Thomas H. Fenton (Hirshhorn Museum and Sculpture Garden, Washington, DC; see Rosenzweig, *The Thomas Eakins Collection*, pp. 59–60); and to Dr. Edward Spitzka (Thomas Jefferson University; see Berkowitz, *Adorn the Halls*, pp. 195–97).

Walt Whitman's biographer Horace Traubel reported that Eakins gave a print to the poet; see Elizabeth Johns, *Thomas Eakins: The Heroism of Modern Life* (Princeton, NJ: Princeton University Press, 1983), p. 76. He is also reported to have given a "framed picture of the Gross Clinic" to the Lancaster County Historical Society in 1912; see "Minutes of the December Meeting," *Papers Read before the Lancaster County Historical Society*, vol. 16 (1912), p. 293. Another copy is in the collection of Julie Berkowitz.

6. Hendricks, "Thomas Eakins's *Gross Clinic*," p. 60. William J. Clark, Jr.'s review in the *Evening Telegraph* of April 28, 1876 (see Appendix), noted that the painting "until within a few days past has only been visible in the studio of the artist." Eakins's exhibition record book II, now in the Archives of the Philadelphia Museum of Art, lists only Haseltine's "after the close of the Centennial" (p. 23). See also Sellin, *The First Pose*, p. 14; Berkowitz, *Adorn the Halls*, p. 162. Goodrich, *Thomas Eakins*, vol. 1, p. 131, assumed that the exhibition at Haseltine's signaled the rejection of the painting by the Centennial jury.

7. William J. Clark, Jr., "The Fine Arts: Eakins' Portrait of Dr. Gross," *Philadelphia Evening Telegraph*, April 28, 1876, p. 4 (see Appendix for the complete review). It is not clear whether the jury had reviewed the painting or if its decision was known to Clark by this time.

8. For a complete checklist of the American art display at the Centennial and plans of Memorial Hall and the Annex, see Orcutt, "Revising History," pp. 324–25, 357–428. Orcutt notes that Gallery C (see fig. 6.3) was designated for the "largest and best" of the most eminent American artists, and publishes David Sellin's diagram identifying many of the paintings and sculptures shown. On the reception of *Elizabeth at the Piano*, see Appendix; see also Marc Simpson, "The 1870s," in Darrel Sewell et al., *Thomas Eakins*, exh. cat. (Philadelphia: Philadelphia Museum of Art, 2001), pp. 32–33.

9. "Our Great Show," *Philadelphia Evening Bulletin*, May 17, 1876, p. 2. A review in the same paper two months later complained, however, that the face of the sitter was too deeply sunk in shadow; "The Centennial Exhibition: The Fine Arts: United States Section—Paintings in Oil," *Philadelphia Evening Bulletin*, July 10, 1876, p. 2 (see Appendix). See also William J. Clark's review of June 16, 1876, in the *Philadelphia Evening Telegraph* (see Appendix). Parry, "*The Gross Clinic* as Anatomy Lesson," p. 374, notes that Eakins departed from the earlier honorific portraits at Jefferson by including properties revealing Rand's personal and professional life; he also points out that Rand served on the executive committee of the Alumni Association and could have told Eakins about the Jefferson portrait campaign (p. 387). Johns, *Thomas Eakins*, p. 54, notes the Rand portrait's role as a precursor to *The Gross Clinic* and suggests that it might have been painted to honor Rand's retirement. Berkowitz, *Adorn the Halls*, pp. 134–40, surveys Rand's career, his connections to Eakins, and the response to the painting. X-radiographs of the painting in the conservation files of the Philadelphia Museum of Art indicate many changes in the foreground where, as in *The Gross Clinic*, Eakins made major adjustments to his composition, for example, adding the bank of drawers at the left to mask Rand's right leg.

10. See the reviews in the Appendix. For additional bibliography and an analysis of the art politics of the Centennial Exhibition, see Orcutt, "Revising History," pp. 110–55. She notes that the jury accepted 850 American paintings and sculptures, rejecting about 26 percent of those submitted, including works by Eakins's close friends William Sartain and H. Humphrey Moore, who had studied with him in Paris (pp. 112, 152). The award process was likewise marred by disputes, leading to much dissatisfaction (pp. 181–89). Orcutt published a more focused account of the rejection of the Academy's display in "H. H. Moore's *Almeh* and the Politics of the Centennial Exhibition," *American Art*, vol. 21, no. 1 (Spring 2007), pp. 50–73.

11. Richard J. Dunglison, "Correspondence: Medical Centennial Affairs," *Medical Record*, vol. 11 (June 10, 1876), p. 389 (see Appendix).

12. W. H. Workman, "Letter from Philadelphia," *Boston Medical and Surgical Journal*, vol. 95 (August 3, 1876), p. 153 (see Appendix). James D. McCabe, reviewing the fair in retrospect, noted the "fine picture of Dr. Gross" in the Post Hospital as "one of the most powerful and life-like pictures to be seen in the Exhibition," adding that it "should have had a place in the Art Gallery, where it would be but for an incomprehensible decision of the Selecting Committee"; *The Illustrated History of the Centennial Exhibition* (Philadelphia: National Publishing Company, c. 1876), pp. 649–51 (see Appendix).

13. William Clark, Jr., "The Centennial: The Art Department: American Section," *Philadelphia Evening Telegraph*, June 16, 1876, p. 2 (see also Appendix). David Sellin, *Thomas Eakins and His Fellow Artists at the Philadelphia Sketch Club* (Philadelphia: Philadelphia Sketch Club, 2001), reports that the jury rejected two paintings (*The Gross Clinic* and a rowing painting) "for lack of space to accommodate the amount requested, according to the annotation on his application" (p. 8). Sellin lists the members of the jury and speculates that the New Yorkers (Samuel Huntington, Thomas Hicks, and Worthington Whittredge, all members of the National Academy) could have been Eakins's opposition. However, the Philadelphia jurors were Samuel B. Waugh, a rival painter who had executed his own portrait of Dr. Gross (see fig. 4.3), and Howard Roberts, a sculptor Eakins had known (and disliked) in Paris. Sartain was not on the jury, but his meddling with the installation and clashes with the New Yorkers might have worked against Eakins. In correspondence with another artist, Sartain noted that the jury's mandate was not to "accept" work but "*simply to reject work of insufficient merit*"; Hendricks, "Thomas Eakins's *Gross Clinic*," p. 61; see also Sellin, *The First Pose*, pp. 14, 45. Another writer commented more cryptically that "Thomas Eakins's portrait of Dr. Gross and H. H. Moore's 'Almeh, a Dream of the Alhambra'—were rejected by the committee for reasons which had nothing to do with the artistic merit of the works themselves"; "Our Great Show," pp. 1, 2 (see Appendix).

14. "The Exhibition. Medical Department U.S.A.," *Philadelphia Evening Bulletin*, May 30, 1876, p. 8 (see Appendix). See also *Report of the Board on Behalf of the United States Executive Departments at the International Exhibition Held at Philadelphia, Pa., 1876, under Acts of Congress of March 3, 1875, and May 1, 1876* (Washington, DC: Government Printing Office, 1884), "The Medical Section," cat. 15, vol. 1, p. 137. Sellin, *The First Pose*, p. 14, noted that Gross lent the painting, perhaps knowing that the organizers of the fair had urged the display of portraits of distinguished citizens within the appropriate departments.

15. Berkowitz, *Adorn the Halls*, pp. 201–6, tells the story of the Post Hospital and surveys the response in medical journals (see also the Appendix to this volume), as well as citing an "Anatomist's" diatribe concerning the inadequate anatomical knowledge shown by most American painters exhibiting in Memorial Hall. She also argues that the installation was a progressive and popular location, not "uncouth" or part of the first-aid station, as earlier scholars have presumed.

16. Ibid., p. 162. See also Eakins's exhibition record book I, p. 25; exhibition record book II, p. 23.

17. Berkowitz, *Adorn the Halls*, pp. 188–90, citing "Art and Artists," *The Press*, March 9, 1878, p. 4.

18. Susan M. Eakins to Lloyd Goodrich, October 8, 1932; Lloyd and Edith Havens Goodrich, Record of Works by Thomas Eakins, Philadelphia Museum of Art.

19. Eakins's exhibition record book I, p. 25. Parry, "*The Gross Clinic* as Anatomy Lesson," p. 384, notes that, since the painting had not been commissioned, any sale to Jefferson could be deemed a success, and certainly the transaction conferred the approval of Dr. Gross. Simpson, "The 1870s,"

p. 392n75, notes that Waugh also received $200 from Jefferson for his portrait of Dr. Gross.

20. Simpson, "The 1870s," p. 392n71, citing "Painters in Water-Colors," *New York Evening Post*, January 20, 1877, p. 3.

21. See, for example, [Earl Shinn], "Fine Arts: Exhibition by the Society of American Artists," *The Nation*, vol. 28, no. 716 (1879), pp. 206–7 (see Appendix).

22. See, e.g., M[ariana] G[riswold] Van Rensselaer, "The Spring Exhibitions in New York: The National Academy of Design, the Society of American Artists, etc.," *American Architect and Building News*, vol. 5, no. 176 (1879), p. 149 (see Appendix).

23. [Clarence Cook], "The Society of American Artists: Second Annual Exhibition—Varnishing-Day," *New York Tribune*, March 8, 1879, p. 5 (see Appendix).

24. The controversy of the 1879 Academy exhibition is recounted by Goodrich, *Thomas Eakins*, vol. 1, pp. 137–38. See Eakins's letter of April 24, 1879, to the Academy's Board of Directors (see Appendix), and his undated letter draft to George S. Pepper, Bregler Collection, PAFA. Evidently the SAA exhibition was dispersed in New York and *The Gross Clinic* was returned to Eakins's shipping agent, Haseltine's, before the Academy confirmed its plan to bring the show to Philadelphia. The New York paintings were then gathered and shipped as a group, allowing Corliss to argue that this was the complete selection. Apart from Eakins's insistence that he had explained the situation to Corliss more than once, it seems unlikely, given the extensive criticism of *The Gross Clinic* in the New York press, that Corliss did not know it was part of the SAA show.

25. Berkowitz, *Adorn the Halls*, pp. 208–10, documents this controversy and the attending criticism of the painting, drawing upon the minutes of the Committee on Exhibitions at the Academy. The Committee agreed to leave Eakins's painting undisturbed, without citing any reasons. Eakins's letter draft to Pepper dwells repeatedly on the words "notoriety" and "quarrel," demonstrating his sensitivity to his own troublesome reputation. Susan Eakins described this controversy in her notes on her husband's career, lauding the "backbone" shown by his colleagues in New York; Bregler Collection, PAFA, microfiche series II 4/A/4-5.

26. The opening of Jefferson's new hospital amphitheater in 1877 made the old Ely Building lecture room obsolete, which may explain the surprising appearance of the unframed painting and the clowning young men in this space. The white walls and chest-high wooden railing of the pit resemble those depicted in the painting. The hanging shade may have been added later, or wisely omitted by the artist. For a photograph of the 1877 amphitheater, see Berkowitz, *Adorn the Halls,* p. 180.

27. Hendricks suggested that the figures were Sketch Club members photographed at Jefferson in 1875–76. He named Meyers as among the men posing in the photograph, and also identified the foreground figure at the left (the "mother") as Eakins himself; see Gordon Hendricks, *The Photographs of Thomas Eakins* (New York: Grossman, 1972), nos. 245, 246, pp. 171–72, 209; Gordon Hendricks, *The Life and Works of Thomas Eakins* (New York: Grossman, 1974), p. 88. This identification was carried forward in Jennifer Doyle, "Sex, Scandal, and Thomas Eakins's *The Gross Clinic*," *Representations*, no. 68 (Autumn 1999), p. 25, and Henry Adams, *Eakins Revealed: The Secret Life of An American Artist* (Oxford: Oxford University Press, 2005), p. 234. Sydney D. Kirkpatrick, *The Revenge of Thomas Eakins* (New Haven, CT: Yale University Press, 2006), p. 199, went further, identifying (also without supporting evidence) the "mother" as Charles Stephens, "Gross" as Earl Shinn, and "Barton" as James Kelly. Certainly Eakins's Sketch Club friends and Academy students are likely players here, and Meyers (see fig. 5.16) may be the figure holding the head of the "patient." However, it is hard to recognize any of these figures as Eakins, and if he were behind the camera one might expect the poses to more closely parallel those in the composition. In both the extant vintage print (Woodmere Art Museum, Philadelphia) and the twentieth-century copy print now in the Philadelphia Museum of Art (see fig. 6.6), the negative has been printed in reverse (note the backward numbers on the benches and the reversed painting), perhaps deliberately to improve the resemblance to the painting. Sellin, *Thomas Eakins and His Fellow Artists*, p. 8, was the first to note the presence of the painting in the image; he also identified Eakins as "probably" present in the foreground, and unconvincingly asserted that the photo was intentionally staged in reverse "to take advantage of existing light effects." Apart from the fact that the parodists do a poor job of imitating the composition (even with the painting in the room), the sense of hijinks verging on disrespect makes it hard to imagine that Eakins was present. Both the vintage print and the copies came from the circle of the donor, George Barker, who was a student of Eakins's student John Laurie Wallace. Born in 1864, Wallace enrolled at the Academy in the fall of 1879 and does not seem to have participated in these photographs, but he did assist Eakins with camera projects in early 1880s and remained a lifelong friend.

28. Berkowitz, *Adorn the Halls*, pp. 190–93, traces the different locations of the painting at Jefferson from 1878 to 1991.

Kathleen A. Foster

The Challenge Revisited: *The Gross Clinic* and *The Agnew Clinic*

FOURTEEN YEARS AFTER COMPLETING *The Gross Clinic*, Eakins was called upon to celebrate another great teaching surgeon. Commissioned by students in honor of their beloved retiring professor, Dr. D. Hayes Agnew (1818–1892), the painting both echoed the Gross portrait and revised it in important ways (fig. 7.1). Agnew, a famed anatomist, surgeon, teacher, and textbook author, was Samuel Gross's counterpart at the University of Pennsylvania, where he served twenty-six years on the faculty of the School of Medicine. In the painting, he appears at the left, pausing to explain to his students the mastectomy that he has just concluded. His senior clinic assistant, Dr. J. William White, applies a dressing, while Dr. Joseph Leidy, Jr., bends over the patient with a sponge. Dr. Ellwood R. Kirby administers ether with a cone, nurse Mary V. Clymer hovers stoically, and Dr. Fred H. Milliken whispers into the ear of Thomas Eakins, who stands in a spot very similar to the place he occupies near the right margin of *The Gross Clinic*.[1]

Circumstances in 1889 had changed in important ways that affected the appearance of this new clinic painting. For starters, the portrait was not Eakins's idea. He was approached early that year by a committee of students from the classes of 1889, 1890, and 1891, who evidently knew his reputation for such portraits—perhaps they envied Jefferson's great painting—and who offered him $750 to paint their esteemed professor in a standard three-quarter-length portrait. The unusually fine finish of just such a portrait of Agnew by Eakins (fig. 7.2), which varies only slightly from the image of the surgeon in the larger painting, indicates that the artist was well into this standard format when he was inspired to make a large painting of the entire clinic, with all the students included, for the same fee. The students agreed to model for Eakins in his studio, where he built risers to simulate the amphitheater seating. This commitment totally altered the scale and impact of the picture by distributing importance across the clinic, the surgery, and twenty-five identifiable members of the audience. Unlike

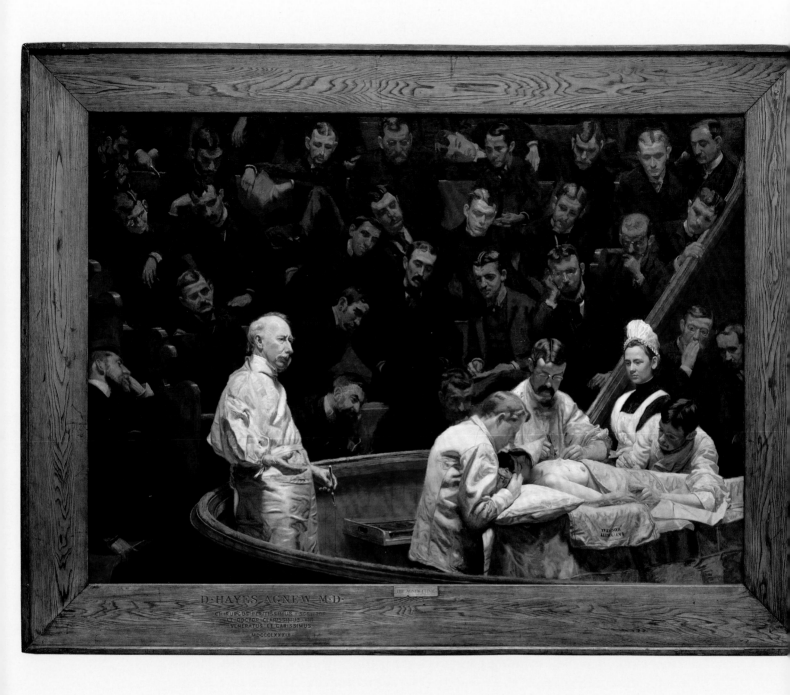

Fig. 7.1. *Portrait of Dr. D. Hayes Agnew (The Agnew Clinic)*, 1889. Oil on canvas, 7 × 10 feet (214 × 305.4 cm). University of Pennsylvania Art Collection, Philadelphia, 1889.0001

The Gross Clinic, where the spectators are anonymously cast in shadow, the students emerge as participants in the event, necessarily washed by a stronger light.[2]

By choosing to include the students, Eakins put pressure on himself, for the painting was needed for graduation ceremonies in May of 1889, leaving only three months to complete the project—perhaps a third of the time he had devoted to *The Gross Clinic*. Eakins's student and studio mate Samuel Murray remembered the hectic pace and long hours Eakins put into the painting that spring, often sitting cross-legged (and occasionally napping) on the floor while finishing the lower figures in a canvas that barely fit in his Chestnut Street studio. This accelerated schedule shows in the painting, which is more thinly painted overall and brilliantly suggestive in places, revealing the artist pushed to a bravura akin to the work of friends such as John Singer Sargent (1856–1925). More experienced and confident at age forty-five, he worked quickly, using the excitement of the commission to vault himself out of a period of retreat and depression following his forced resignation from the Pennsylvania Academy of the Fine Arts in 1886. *The Agnew Clinic* became an exhilarating challenge and a banner announcing his return to the field. With new resolve and rising ambition, his eye once again on France, he also sent three paintings that spring to the 1889 Exposition Universelle in Paris.[3]

Eakins evidently attacked the project in his typical way, attending Agnew's surgical lectures to get a sense of the doctor's characteristic demeanor, his ambidextrous use of the scalpel, and his habit of standing back to explain his procedures while assistants concluded the work. These traits shaped the pose and gesture of the first portrait, which has been characterized as a "study" for the larger painting, though it is far more developed than his life study of Gross (see fig. 5.13) or any other preparatory portrait in Eakins's work.[4] The preexistence of this image reads out in the uncanny articulation of Agnew in the small, otherwise very broad oil sketch that signals the turning point in the project, when Eakins began to imagine a much grander picture (fig. 7.3). The latter sketch reveals his bold idea to push Agnew far to the left, set powerfully in relief against a bank of students represented by dots and blurred shapes, and balanced against the nurse, in her odd cap, and a dashing patch of white representing the patient and the clinic doctors. Following his by-now established practice, he crystallized in this sketch an image to which he would hold as he developed the painting. "He always made a very definite mental picture of what he intended to do," remembered his student Charles Bregler, who witnessed the painting of *The Agnew Clinic*. "He told me exactly how he was going to compose it, the placing of the various figures and his reason for so doing. This before he had made a sketch. Then followed the sketch 10 × 14 inches, the only one made for this large picture . . . and he painted this as he planned and recorded in the small sketch."[5]

No other studies for *The Agnew Clinic* survive, and perhaps there were none. Maybe Agnew came to pose again for the final painting, because the folds of his surgical gown have been revised. One can imagine the jesting and jockeying as the students were arranged on the benches in his studio, where Eakins could study them and work directly on the large canvas. Pencil grids on the painting indicate planning drawings and perspectives that—as with *The Gross Clinic*—have been lost, but no related photographs have been discovered, nor are there signs of photographic tracing; perhaps they would have slowed him down too much.

Although Eakins's working method had not altered much since 1875, surgery had changed in ways that dramatically affected this new painting. The arrival of artificial lighting in the amphitheater allows us to see the students more clearly and illuminates the physicians' bright, sterile dress, which had replaced the street clothing worn in Dr. Gross's day. The ivory-handled scalpel has been exchanged for a steel one that could be sterilized in a tray, visible behind the surgeons; Agnew's hand gleams now with water from his knife, not blood. Along with modern aseptic techniques came the presence of women in surgery, represented by Mary Clymer, a recent, prizewinning graduate of the university's new school of nursing, who monitors the cleanliness of the instruments and procedures.[6]

Incorporating these novelties into the largest canvas of his career, Eakins compounded the changes

the operating table, who occupy more of the painting's surface. By implication, the artist underscores the teamwork of the Agnew clinic; even at a remove from their leader, the assistants perform expertly. Gross, by comparison, is more majestic and more integral to his team, who cluster tightly below him, human extensions of his will.

The change in light reinforces this change in the affect of the painting, for *The Gross Clinic* is by comparison altogether more theatrical and mysterious, with Gross lit by angelic light from the oculus above. For the Agnew portrait, responding to the critics who found *The Gross Clinic* too cold and black, Eakins told a friend, "I'll give them color," an intention he decisively forecast in the strong hues of his first sketch.[7] The brighter artificial light on Agnew spotlights him against the dark, like Gross, but also warms the painting, better explains the space, identifies the participants and draws them forward, and generally gives a greater sense of everyday immediacy. Cropping makes the space feel tighter, more intimate—perhaps representing the comparatively smaller classes at Penn—and more coherent.[8] Recovering his earlier idea about the use of the railing as a foreground wall, seen in his first sketch for *The Gross Clinic* (see fig. 5.6) and in the X-radiograph of the painting (see fig. 5.7), Eakins created a new solution, circling the wall of the surgical pit around Agnew and across the foreground. This device places us clearly in the front row, among the students, whose relationship to Agnew and to the patronage of the painting is again acknowledged. If Eakins had been saving this idea since 1875, he once again demonstrated that it was pure invention by altering it in midstream: infrared reflectographic examination of the painting shows that the wall originally dropped below the margin of the canvas near the center line, as in the sketch. Redrawing the railing to have it sweep all the way to the lower right corner made a more stable, satisfying design, but suggested a new, lower vantage point in his perspective of the oval "pit."[9] Once again, pictorial needs overrode his initial perspective scheme.

No drawings for *The Agnew Clinic* survive, so the original perspective plan is difficult to reconstruct. Obviously, the space is not as deep as in *The Gross*

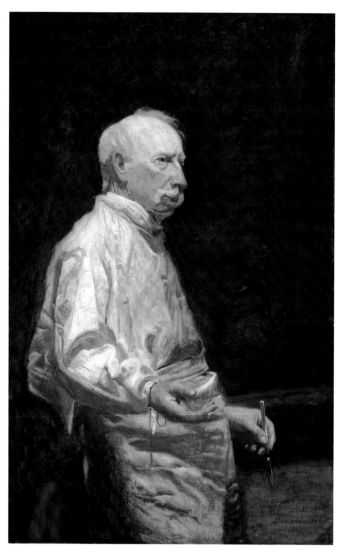

Fig. 7.2. *Dr. D. Hayes Agnew*, 1889. Oil on canvas, 49 × 31½ inches (124.5 × 80 cm). Yale University Art Gallery, New Haven, Connecticut. Bequest of Stephen Carlton Clark, BA 1903 (1961.18.16)

by recasting his earlier clinic picture in every possible way for maximum difference. His choices for *The Agnew Clinic* throw light, by comparison, on the decisions underlying *The Gross Clinic*. For *Agnew*, he began by organizing the image on a horizontal rather than vertical canvas, turning the patient to show the long side of the table and dividing the principals. The result disperses the focus of the painting, emphasizing Agnew's calm withdrawal from action in his role as teacher, and giving greater weight to the group around

Fig. 7.3. *Sketch for "The Agnew Clinic,"* 1889. Oil on canvas,
mounted on cardboard; 10⅜ × 14½ inches (26.4 × 36.8 cm).
Michael Altman Fine Art and Advisory Services, LLC.
Photograph courtesy Avery Galleries, Bryn Mawr, Pennsylvania

Clinic, and the figures have either been gathered and
distributed across the life-scale line or pressed back into
a fairly uniform distance of 75 to 90 percent of life-size.
Turning his vantage so that he looks directly into the
audience rather than out the door of the room, Eakins
avoids the deep, shadowy space and the complex,
sometimes problematic recession of figures in *The Gross
Clinic.* Typically for his paintings, the middle line is
subtle, dropping through the right eye and gray necktie
of a student, J. Howe Adams, and barely catching the

tail of Dr. Kirby's white coat. This center line invisibly
divides the two groups: Dr. Agnew firmly occupies the
center of his half of the canvas, facing the alternate pole
of interest, at Dr. White's hands and the surgical
procedure—exactly the same balance seen in the
vertically compressed *Gross Clinic.*

Young Adams at the center, who looms signifi-
cantly in the sketch (see fig. 7.3), also skims the horizon
line, which—as indicated by the flat, head-on view of
the bench backrest at that elevation (more easily seen in

the sketch)—is very high, at least eighty inches.[10] At the intersection of the horizontal and vertical axes, Adams mirrors the viewer and sends attention forward, much like the two figures in the distance of *The Gross Clinic*. As spectators, we are clearly across the room from this other figure, occupying one point of a diamond in space that connects Agnew, Adams, the surgery, and ourselves. There is no "mother" in this painting to serve as a viewer surrogate; instead, we encounter the students and become one of them. We might suspect Adams, in his discreet prominence at the vanishing point, to be one of the principal organizers of the commission, and indeed he was among Agnew's greatest admirers. Comparable to Dr. Samuel W. Gross, who stands watching his father from the background of *The Gross Clinic*, Adams was like a son to the childless Agnew. President of the newly organized "D. Hayes Agnew Surgical Society" and about to marry Agnew's niece, Adams would deliver the eulogy at Agnew's funeral in 1892 and write his professor's biography.[11] His place at the exact center of the composition would have made sense to everyone at Penn's medical school in 1889, and it reiterates the importance in *The Agnew Clinic* of the students who drove the commission as well as the artist's reconstruction of the balance of power in *The Gross Clinic*.

Adams's high vantage point allows a good view of the surgery, and it would have been easy for Eakins to paint this angle when the canvas was in his studio, resting on blocks on the floor. But it is not easy for an actual spectator to recover this position opposite the painting, as Eakins suggested in his drawing manual.[12] Matters were also confused by the insertion of his own portrait (painted by the artist's wife, Susan Macdowell Eakins, from photographic studies taken from a low vantage; fig. 7.4) at the far right, exactly halfway up the canvas, bending forward to dip respectfully below Agnew's eye level. Like Gross, Agnew appears to be seen from below (a feeling even more obvious in the first portrait; see fig. 7.2), and the alteration in the railing likewise implies another drop in the eye level. Accustomed, by 1889, to assembling images from multiple photographic sources, and working on a big canvas that he could not appraise from a distance in his tiny studio, Eakins was vulnerable to inconsistencies of viewpoint that could creep into compositions based on pastiche.[13] The variety of vantages in *The Agnew Clinic*, exceeding the multiple viewpoints in *The Gross Clinic* but more smoothly integrated, suggests that Eakins has relaxed his perspective system and is working more intuitively across the huge canvas. The diminution of figures between the foreground and back is slight— only 10 percent to Adams and his classmates—which would necessitate an enormous viewing distance to allow the spacing between foreground figures and the audience that is intellectually understood.

These shifts in content, strategy, and layout in *The Agnew Clinic* combine to create an effect quite different from that of *The Gross Clinic*. Larger, simpler, and easier to comprehend, *The Agnew Clinic* is more lucid as it is lighter and brighter. This makes the painting more accessible, even though we are set back neatly behind the railing; by comparison to *The Gross Clinic*, with its ambience of mystery, heroism, and stifled terror, the mood in *Agnew* seems serene and business-like. But Eakins has not lost his wish for drama. Against this sense of greater calm, he places volatile surprise: two women, including a militant new professional and a beautiful, bare-breasted patient suffering from cancer. The most difficult and provocative center of *The Gross Clinic* was the patient, almost impossible to read because of the foreshortened vantage point, which we could rationalize as a choice made in order to give a good view of the incision and as many doctors as possible. Although his friend William J. Clark Jr., deduced that Eakins was trying to minimize the distress of the event,[14] he actually created a confusing, ultimately shocking perspective that gained offensiveness when viewers felt a sense of shame—and ambush—upon puzzling out the view of the patient's buttocks. Showing surgery, an event that for most people in the nineteenth century took place in the privacy of one's home, was aggressive enough; teasing the viewer into an exploration of the bare flanks of a figure of indeterminate age and sex was too much to take.[15] Perhaps chastened by the response of his critics, but more likely restrained by Agnew himself, Eakins chose a more discreet view of the surgery. Agnew also

Fig. 7.4. Attributed to Susan Macdowell Eakins (American, 1851–1938), *Dr. Fred H. Milliken and Thomas Eakins in the Chestnut Street Studio: Study for "The Agnew Clinic,"* c. 1889 (negative). Modern print from glass negative, 4 × 5 inches (10.2 × 12.7 cm). Pennsylvania Academy of the Fine Arts, Philadelphia. Charles Bregler's Thomas Eakins Collection, purchased with the partial support of the Pew Memorial Trust, 1985.68.2.853

insisted on keeping his hands free of blood, surely reacting to the precedent of *The Gross Clinic* (which Gross himself found unnecessarily bloody), and so the painting is less gory as well as less confusing.[16] Stepping away from the table to comment on the surgery, Agnew leaves a clear view of the patient. With two fewer doctors present, there are no inexplicable hands emerging, and no one blocks our understanding of the grim story of breast cancer, involving far more drastic surgery than seen in *The Gross Clinic*, or the two women who add a new level of emotion to this painting.

Agnew was not a specialist in this surgery, though he discussed it in his textbook, and unlike the procedure in *The Gross Clinic*, it did not promise a happy outcome. In January 1888, just before the launch of the portrait commission, Agnew lost a patient, Mary S. Cope, the daughter of the well-known Quaker merchant Thomas P. Cope, following a mastectomy. Mary's brother Walter had studied with Eakins at the Academy, and perhaps her sad story subtly influenced his choice of surgery in the painting, though a direct reference to her case seems unlikely. The choice of breast surgery

did, however, illustrate Agnew's compassionate, palliative approach to the monstrous disease that tormented his profession. "I do not despair of carcinoma being cured somewhere in the future, but this blessed achievement will, I believe, never be wrought by the knife of the surgeon," he asserted in his textbook on surgery,[17] though younger innovators such as William Stewart Halsted and Samuel W. Gross, promoting radical mastectomy, would soon try to prove him wrong. Known as a teacher rather than an experimental researcher, and as a humane and gentle doctor, Agnew was well represented in Eakins's painting by a surgery that reveals the patient tenderly, as an individual.[18]

More probably, Eakins chose the subject because it gave him an opportunity to paint a beautiful female nude (rather than an adolescent boy, as in *The Gross Clinic*) in a plausible contemporary context. As some scholars have noted, conventional protocol would have dictated covering the patient completely for surgery, making Eakins's exposure of her healthy breast yet another "trademark element of provocation."[19] Like Gabriel von Max (1840–1915), whose painting

Fig. 7.5. Gabriel Cornelius von Max (Czech, 1840–1915), *The Anatomist*, 1869. Oil on canvas, 4 feet 5¾ inches × 6 feet 2⅝ inches (136.5 × 189.5 cm). Neue Pinakothek, Bayerische Staatsgemäldesammlungen, Munich, inv. 14680. Courtesy Art Resource, New York

The Anatomist (fig. 7.5) had hung two rooms away from Eakins's work in the Annex at the Centennial, and Henri Gervex (1852–1929), whose depiction of the surgeon Dr. Péan and his supine nude patient had appeared at the Salon in 1887 (see fig. 9.2), Eakins took liberties with his subject in order to focus on a lovely, unconscious, bare-breasted woman and her avid male observers.[20]

The passiveness and anonymity of the patient, often noted in feminist critiques of *The Agnew Clinic*, contrast with the uprightness of Nurse Clymer, the other lightning rod in the painting. The picture of discipline, she is the polar opposite of the distraught woman in *The Gross Clinic*. Clymer's presence would

have lifted many eyebrows, even in the medical community; Agnew himself had earlier resigned his appointment at Pennsylvania Hospital rather than admit women for training as nurses in the surgical clinic, but by 1889 he preferred female nurses.[21] Winner of the Florence Nightingale Prize in the second graduating class of the new nursing program at the Hospital of the University of Pennsylvania, Clymer seems resolutely planted in this world of men. Her gaze, following the line of attention from Eakins and Milliken over her shoulder and reinforced by the strong mahogany diagonal of the railing and the arrow of her apron front, looks to the patient and the surgery, but

her impassive expression invites interpretation: vigilant, is she also daydreaming about the fate of the woman on the table?

The striking differences between Eakins's two clinic paintings may be due in part to the artist's ambition, as he pressed in *The Agnew Clinic* for a fresh, distinctive solution to the challenge of depicting such a subject. They may also reflect his very different relationships with his two subjects: Eakins knew Gross personally and had studied with him as a young man; Agnew, though famous in the city for decades, was less familiar, and also less intimidating as a personality. Eakins, for his part, was no longer so impressionable as he had been at age thirty-one. Awed by Gross, whose portrait conveys, as Ellwood C. Parry III noted, "a feeling of veneration emphasized by the lighting and the composition," Eakins by 1889 could feel that his position as an artist was on a par with that of Agnew as a surgeon.[22] (Indeed, the artist would write to Gross's successor, Jacob M. da Costa, in 1893, "I presume my position in art is not second to your own in medicine."[23]) After years of teaching anatomy and dissection at the Academy, Eakins's feeling of professional kinship with doctors would have increased, along with his sense of the normality of surgery. Less theatrical and rhetorical than *The Gross Clinic*, with no participants from outside the medical school, *The Agnew Clinic* is a painting by and for the insider.[24]

Even the frame Eakins chose set *The Agnew Clinic* apart from his earlier clinic picture. In 1876, an ornate, gilded frame was required to suit the "salon" context he anticipated for *The Gross Clinic*. His preference for these complex frames persisted until the middle of the 1880s and the end of his tenure at the Academy. By 1889, however, his taste had changed, and the plain, gilt-chestnut frame he designed for *The Agnew Clinic* embodies a simpler Arts and Crafts aesthetic that also may express his new somewhat bohemian status, outside the academy; certainly it suits the sober subject of the painting. In the 1890s, such austere frames personalized with engraved detail would become a hallmark of his work, as in *The Concert Singer* (Philadelphia Museum of Art) and *Portrait of Professor Henry A. Rowland* (Addison Gallery of American Art, Ando-

ver, Massachusetts). In *The Agnew Clinic* frame, the muted tone of the gilding provides a soft backdrop for the Latin inscription carved beneath the figure of the surgeon. Composed by Eakins, it again put the student patrons forward, speaking their sentiments: "Most experienced surgeon, the clearest writer and teacher, the most venerated and beloved man."[25]

The Agnew Clinic was presented to the trustees of the University of Pennsylvania School of Medicine at the graduation ceremonies held at the Academy of Music on May 1, 1889. Unveiled before an audience that adored Agnew, it was immediately treasured by the school; Adams judged it "perfectly proper" for its audience there, though "more or less repulsive" to the general public.[26] Indeed, when it was displayed to the outside world at Haseltine's gallery, the critical response repeated the principal objection to *The Gross Clinic*: suitable for doctors, but too grisly for the public. When an artist committee invited Eakins to send a group of works to the Academy's exhibition eighteen months later, he included *The Agnew Clinic*, but the painting was rejected on the basis of its earlier display at Haseltine's—though this was widely recognized as a technicality seized upon to justify the opinion of the directors, who, as Susan Eakins put it, "thought the picture was not cheerful for ladies to look at." Not long after, probably in 1892, the jury of the Society of American Artists, who had earlier defended *The Gross Clinic*, also rejected the Agnew portrait. Feeling betrayed and insulted, Eakins resigned from the group.[27]

But the tide was turning. In 1893, *The Agnew Clinic* slipped into the Pennsylvania Academy of the Fine Arts as part of a brief preview of work being sent to the American art section of the World's Fair in Chicago. It was joined for the first time by *The Gross Clinic*, which had not been exhibited outside Jefferson Medical College since 1879. Although the press was still horrified by these surgical subjects, Eakins won a bronze medal in Chicago for his ten paintings shown there, signaling the respect and recognition that his work had begun to draw from art juries. Soon he was being invited to serve on juries, and in 1904 he was appointed to the advisory committee of the World's Fair in St. Louis. This honor seems to have inspired him to send

"the best of my pictures available," a group of seven paintings that once again included his two great clinic pictures. Almost thirty years after the disappointment of the Centennial Exhibition, Eakins was awarded a gold medal in St. Louis,[28] and *The Gross Clinic* began to rise in the estimation of observers. An article on the art collection at Jefferson in 1915 described the painting as both the artist's masterpiece and "the masterpiece of the collection"; when Eakins died the following year, the headline of his obituary remembered the portrait of Gross.[29] The memorial exhibition organized the following year by the Metropolitan Museum of Art in New York and subsequently shown at the Pennsylvania Academy of the Fine Arts centered on both of the clinic portraits and drew accolades that would form the basis of Eakins's reputation in the twentieth century. After viewing the retrospective, the critic Henry McBride declared flatly that, although Eakins's name was still "unfamiliar to the present art public," he was "one of the three or four greatest artists this country has produced and his masterpiece, the portrait of Dr. Gross, is not only one of the greatest pictures to have been produced in America but one of the greatest pictures of modern times anywhere."[30] Echoing the praise of Clark, Eakins's most fervent supporter at the time of the Centennial, McBride gave witness to the victory, forty years later, of a young artist's headiest ambitions.

1. Margaret McHenry, *Thomas Eakins Who Painted* (privately printed, 1946), pp. 83, 144–45, noted Susan Eakins's role in the painting and related anecdotes about the work and Agnew's "serene" posing. See also Lloyd Goodrich, *Thomas Eakins*, 2 vols. (Cambridge, MA: Harvard University Press for the National Gallery of Art, 1982), vol. 2, pp. 39–51. Ellwood C. Parry III, "Thomas Eakins and *The Gross Clinic*," *Jefferson Medical College Alumni Bulletin*, vol. 16, no. 4 (Summer 1967), pp. 8–9, notes Agnew's textbook instructions on this surgery and his changing opinion of women in surgery. Margaret Supplee Smith, "*The Agnew Clinic*: 'Not Cheerful for Ladies to Look At,'" *Prospects*, vol. 11 (1986), pp. 161–83, discusses the differences between the two clinic paintings, the history of breast surgery, the competition between Penn and Jefferson, and Eakins's use of nude subjects in the context of the scientific and artistic worlds of his era. The same issue of *Prospects* contains useful studies by Diana E. Long ("The Medical World of *The Agnew Clinic*: A World We Have Lost," pp. 185–98) and Patricia Hills ("Thomas Eakins's *Agnew Clinic* and John S. Sargent's *Four Doctors*: Sublimity, Decorum, and Professionalism," pp. 217–30). Both clinic paintings were displayed together and compared in an exhibition at Johns Hopkins University; see Elizabeth Johns, Jerome J. Bylebyl, and Gert H. Brieger, MD, *Thomas Eakins: Image of the Surgeon*, exh. cat. (Baltimore: Walters Art Gallery and Johns Hopkins

Medical Institutions, 1989). Amy Werbel evaluates the literature on *The Agnew Clinic* in *Thomas Eakins: Art, Medicine, and Sexuality in Nineteenth-Century Philadelphia* (New Haven, CT: Yale University Press, 2007), pp. 28–52.

2. All the figures were identified and recorded at an alumni gathering in about 1915; see "The Unidentified Student in the Agnew Painting," *Old Penn Weekly Review*, vol. 14, no. 5 (October 30, 1915), p. 171. A key to the painting appears on the website of the University of Pennsylvania's Archives, http://www.archives.upenn.edu/histy/features/1800s/1889med/agnewclinic.html (accessed May 26, 2011). Parry, "Thomas Eakins and *The Gross Clinic*," p. 119, noted the shift in orientation of the painting, compared to *The Gross Clinic*, to give greater importance to the students. Marc Simpson, "The 1880s," in Darrel Sewell et al., *Thomas Eakins*, exh. cat. (Philadelphia: Philadelphia Museum of Art, 2001), p. 119, notes the lively arrangement of the students, citing the analysis of David M. Lubin in *Act of Portrayal: Eakins, Sargent, James* (New Haven, CT: Yale University Press, 1985), pp. 27–82.

3. Eakins sent to the Exposition Universelle in 1889 his *Portrait du Professeur Geo. H. Barker* [*Portrait of Professor George H. Barker*], Mitchell Museum, Mount Vernon, Illinois; *La Leçon de danse* [*The Dancing Lesson (Negro Boy Dancing)*], Metropolitan Museum of Art, New York; and *Le Vétéran;—portrait de Geo. Reynolds* [*The Veteran (Portrait of Geo. Reynolds)*], Yale University Art Gallery, New Haven, Connecticut. These were his first works seen in Paris since 1875, and the first seen in Europe since the Munich international art exhibition in 1883; see Elizabeth Milroy, with Douglass Paschall, *Guide to the Thomas Eakins Research Collection, with a Lifetime Exhibition Record and Bibliography* (Philadelphia: Philadelphia Museum of Art, 1996), pp. 24, 26.

4. The painting is signed "STUDY FOR THE / AGNEW POR- / TRAIT EAKINS." Sally Mills discusses this painting and the Agnew portrait in John Wilmerding et al., *Thomas Eakins and the Heart of American Life*, exh. cat. (London: National Portrait Gallery, 1993), pp. 143–45. She notes (p. 145) that the painting shows many sketchy and reworked sections typical of a study, but it is not gridded for transfer. Evidently, Eakins wished to keep it as an autonomous painting, and he did exhibit it, to much acclaim, in 1913 and 1914. On Agnew's habits, see Smith, "*The Agnew Clinic*," pp. 165–66.

5. Charles Bregler, "Thomas Eakins as I knew him," undated manuscript, Charles Bregler's Thomas Eakins Collection, Pennsylvania Academy of the Fine Arts (hereinafter cited as Bregler Collection, PAFA), microfiche series IV, 13/D/14.

6. Gross stressed cleanliness in surgery, but he was outspoken in his resistance to Dr. Joseph Lister's new theories and procedures, which may explain why the newest antiseptic techniques were not adopted in Philadelphia until 1876. Sterile dress and other aseptic practices became common in the 1880s, but surgical gloves and masks were not widely adopted until after the turn of the century. See Julie Berkowitz, *Adorn the Halls: History of the Art Collection at Thomas Jefferson University* (Philadelphia: Thomas Jefferson University, 1999), p. 182; and also Mark Schreiner's essay in this volume. As Schreiner notes, Agnew probably would have been using an antiseptic sprayer in this surgery, which Eakins has evidently pushed offstage to the right.

7. Quoted in Goodrich, *Thomas Eakins*, vol. 2, p. 41.

8. A photograph of Agnew in surgery in a similar amphitheater in 1886 (see fig. 3.9) shows a large room, with a similar railing and wall, but without the gothic bench-ends, which appeared in a lower anatomical classroom in the Medical School building (later Logan Hall, now Cohen Hall). Agnew and his team are not wearing aseptic dress in this photo (University of Pennsylvania Archives). The hospital of the University of Pennsylvania also had an enormous surgical amphitheater by this time. The scale of these rooms makes it clear that Eakins chose to crop the subject to confine the space.

9. In February 2011 the painting was examined and documented using a Santa Barbara Focalplane InSb IR camera. Reflected infrared photographs

were also taken at that time with a Nikon D90 camera fitted with a #87 gelatin filter.

10. In this circular amphitheater, the bench backs below our eye level seem to curve downward; the one bench that seems perfectly horizontal is at eye level; the ones above eye level seem to curve slightly up. According to Lloyd Goodrich, Agnew was a burly, six-foot man; manuscript, Lloyd and Edith Havens Goodrich, Record of Works by Thomas Eakins, Philadelphia Museum of Art (hereinafter cited as Goodrich Archive, PMA). In the painting the top of his head seems to be about ten or twelve inches below the horizon line. Allowing some leeway for his leaning pose, this would place the horizon between eighty and eighty-four inches.

11. J. Howe Adams, *History of the Life of D. Hayes Agnew* (Philadelphia: F. A. Davis, 1892). The Agnew Surgical Society was the newest of four reading and discussion groups for upperclassmen at the School of Medicine that allowed the students to fraternize with the faculty, particularly their honored "sponsor." Another president of one of these societies, William C. Posey, is immediately to Adams's left, in a ring of graduating seniors that dominate the center of the painting. The class president (also a society president), Joseph Allison Scott, who made remarks offering the painting at the class graduation ceremonies, appears at the far left margin, in a casual, perhaps intentionally comical position immediately behind Agnew. Predictably, the first- and second-year students are crammed into the top row at the right.

12. Thomas Eakins, "Linear Perspective," in *A Drawing Manual by Thomas Eakins*, ed. Kathleen A. Foster (Philadelphia: Philadelphia Museum of Art, 2005), p. 47.

13. No horizon line is visible in the sketch of Agnew (fig. 7.3), but a four-inch graphite line skimming the doctor's chin can be detected on the painting. Other examples of composite method include *Shad Fishing at Gloucester on the Delaware* of 1881 (Philadelphia Museum of Art) and *Cowboys in the Badlands* of 1888 (private collection), both combining landscape and figures from separate photographic studies with mixed success. See Kathleen A. Foster, *Thomas Eakins Rediscovered: Charles Bregler's Thomas Eakins Collection at the Pennsylvania Academy of the Fine Arts* (Philadelphia: Pennsylvania Academy of the Fine Arts; New Haven, CT: Yale University Press, 1997), pp. 163–67, 192–93; Mark Tucker and Nica Gutman, "Photographs and the Making of Paintings," in Sewell et al., *Thomas Eakins*, pp. 225–38.

14. William Clark, Jr., "The Fine Arts: Eakins' Portrait of Dr. Gross," *Philadelphia Evening Telegraph*, April 28, 1876, p. 4 (see Appendix).

15. Berkowitz, *Adorn the Halls*, p. 175, citing medical historian Charles Rosenberg, notes that middle- and upper-class patients generally preferred to be treated at home, seeing hospitals as unclean and populated by a lower-class clientele.

16. Adams, *History of the Life of D. Hayes Agnew*, p. 333, comments on Agnew's wish to have the blood removed from the painting, demonstrating the surgeon's sense of public propriety, notwithstanding his own years of experience with such scenes. Eakins's first portrait of Agnew (see fig. 7.2) is also notably free of blood. When asked about the surgery in his portrait, Gross responded that the operation "was performed for the removal of a diseased thigh bone, seldom a bloody procedure, although so represented by the artist in my picture"; "Notes and Queries," *The Continent* (Philadelphia), vol. 3, no. 22 (May 17, 1883), p. 702 (see Appendix).

17. D. Hayes Agnew, *The Principles and Practice of Surgery* (Philadelphia: J. B. Lippincott, 1883), vol. 3, p. 711.

18. Adams's adulatory biography stresses Agnew's character as a good Christian and model human being who generated the respect and affection of his colleagues and students. On Agnew's practice, see Diana Long Hall, "Eakins's Agnew Clinic: The Medical World in Transition," *Transactions and Studies of the College of Physicians of Philadelphia*, ser. 5, vol. 7, no. 1 (1985), pp.

29–31; Smith, "The Agnew Clinic," p. 168; Judith Fryer, "'The Body in Pain' in Thomas Eakins' *Agnew Clinic*," *Michigan Quarterly Review*, vol. 30, no. 1 (Winter 1991), pp. 191–209. All of these scholars detect the paternalistic and condescending attitude toward women, typical of this period, that accompanied Agnew's celebrated compassion. Bridget L. Goodbody, "'The Present Opprobrium of Surgery': *The Agnew Clinic* and Nineteenth-Century Representations of Cancerous Female Breasts," *American Art*, vol. 8, no. 1 (Winter 1994), pp. 32–51, finds misogyny in the breast cancer treatments of this era; her approach is critiqued by Amy Werbel, *Thomas Eakins: Art, Medicine, and Sexuality in Nineteenth-Century Philadelphia* (New Haven, CT: Yale University Press, 2007), pp. 45–46. Members of the Cope family would have been well known at both the University of Pennsylvania and the Academy; Robert Alan Aronowitz tells the story of Mary Cope's treatment as a case study in *Unnatural History: Breast Cancer and American Society* (Cambridge: Cambridge University Press, 2007), pp. 74–85. He examines *The Agnew Clinic* as a bloodless, idealized statement of the ambivalence in this era, as confident expectations of scientific progress met the grim reality of surgery.

19. Werbel, *Thomas Eakins*, p. 46.

20. Smith, "The Agnew Clinic," pp. 175–78, citing Clymer's class notes, speculates that Eakins was countering criticism of the puzzling patient pose in *The Gross Clinic*, and also indulging a sensational subject under the professional rubric of science. However, the transitional aseptic procedures shown here, with doctors lacking caps, masks, and gloves, and taking place within close range of an audience, makes it difficult to know how much license Eakins took with the medical reality of this scene. Mark Schreiner's essay in this volume suggests an alternate practice. Eakins turned the patient's head away from the corridor, which contradicts the position seen in *The Gross Clinic*, as well as the photograph of Agnew in surgery in 1886 (see fig. 3.9). This reversal makes good sense for the composition, however, and follows the precedents of Max's *Anatomist* of 1869 (see fig. 7.5) and Gervex's *Before the Operation* of 1887 (see fig. 9.2). John Maas, "Surgery and Sex: New Light on Thomas Eakins" (typescript, Goodrich Archive, PMA), notes the overlapping tropes in painting of this period, with sleeping, drugged, or dead recumbent nude women in the company of fully dressed, standing men as part of a common sexual fantasy conflating sexual ecstasy and pain; he comments that reproductions of Max's painting were popular décor for doctor's waiting rooms. The visual analysis offered by Lubin, *Act of Portrayal*, p. 34, notes the eye-catching "target" of the exposed breast.

21. Diana E. Long, "Eakins's Agnew Clinic: The Medical World in Transition," *Transactions and Studies of the College of Physicians of Philadelphia*, ser. 5, vol. 7, no. 1 (1985), p. 28; Smith, "The Agnew Clinic," noted that women were not admitted to Penn's medical school until 1913; on the course of women's education as either doctors or nurses, and the contrasting story of *The Gross Clinic*, see ibid., pp. 169–71. Werbel, *Thomas Eakins*, p. 46, describes Clymer as "the most radical inclusion in the painting" and discusses Agnew's changing opinions of women in surgery.

22. Parry, "Thomas Eakins and *The Gross Clinic*," p. 9.

23. Thomas Eakins to Jacob da Costa, January 9, 1893, typescript, Goodrich Archive, PMA.

24. See Werbel, *Thomas Eakins*, pp. 49–52, on the culture of anatomy and surgery that inured both doctors and artists to messages of sexuality and violence in the human body.

25. McHenry, *Thomas Eakins Who Painted*, p. 146, wrote that Eakins "designed and carved" the frame; Goodrich's draft of his revised catalogue raisonné notes that the artist "constructed" the frame, with the phrase "and carved" crossed out of his manuscript; Goodrich Archive, PMA. On Eakins's use of Latin inscriptions, a habit he began in the 1870s, see Goodrich, *Thomas Eakins*, vol. 2, p. 196.

26. Adams, *History of the Life of D. Hayes Agnew*, p. 333. Adams also noted that "it was this work which made Dr. Agnew famous," and that it fittingly "represents the most important side of Dr. Agnew's life-work" (ibid.).

27. Susan Eakins noted that many items in the exhibition had been shown elsewhere, and many were more violent and bloody than *The Agnew Clinic*; "Notes on Thomas Eakins," Bregler Collection, PAFA. The dispute and various letters are discussed in Goodrich, *Thomas Eakins*, vol. 2, pp. 47–49; Simpson, "The 1880s," p. 119, quotes the artist's letter of resignation from the Society of American Artists, and notes the rumored opinions of *The Agnew Clinic* that called Eakins "a butcher," much to his distress.

28. On the response of journalists in 1893, see Simpson, "The 1880s," pp. 119–20, and the Appendix to this volume. The medal from Chicago was tarnished by a general dissatisfaction with the award process and the withdrawal of many artists from the judging; see Kimberly Orcutt, "'Revising History': Creating a Canon of American Art at the Centennial Exhibition" (Ph.D. diss., City University of New York, 2005), p. 297. The seven "best" paintings sent to St. Louis included the two clinics, *The Crucifixion* (Philadel-phia Museum of Art), *The Cello Player* (private collection), *Salutat* (Addison Gallery of American Art), *Cardinal Martinelli* (Armand Hammer Collection), and *Louis Kenton (The Thinker)* (Metropolitan Museum of Art, New York). He also listed the two clinic pictures among the "best" of his work in annotations on a letter from John Pickard, June 20, 1907 (Archives of American Art, Smithsonian Institution, Washington, DC). His prize documents from the St. Louis World's Fair and elsewhere are in the Bregler Collection, PAFA, including a certificate from the 1900 Exposition Univer-selle in Paris, annotated "from committees who did not know a good picture from a bad one"; see Foster, *Thomas Eakins Rediscovered*, pp. 451–52.

29. Berkowitz, *Adorn the Halls,* p. 188; "Thomas Eakins, Dean of Artists; Masterpiece 'The Clinic of Dr. Samuel D. Gross Hangs in Jefferson Hospital," *Philadelphia Inquirer*, July 2, 1916, p. 3.

30. See Appendix. On the turning tide of Eakins's reputation in the twentieth century, see Marc Simpson, "The 1900s," and Carol Troyen, "Eakins in the Twentieth Century," both in Sewell et al., *Thomas Eakins*, pp. 317–28 and 367–76, respectively.

Mark S. Tucker

The Changing Painting:
The Gross Clinic in the Nineteenth, Twentieth, and Twenty-First Centuries

AT THE MOMENT OF ITS COMPLETION, a painting typically represents the fullest embodiment and expression of the artist's will and, as such, is the most authentic bearer of the visual sensations and multiple dimensions of meaning then available to viewers. Being a material object, however, at that same moment it starts on a path of inevitable changes with time. Any alteration in a painting's visual aspect also diminishes in some degree its representation of the ideas that drove its creation, characterized it as a product of specific artistic concerns, and connected it to its original audience. All of our efforts to comprehend a work of art, care for it, and present it as a reliable reflection of the artist's vision therefore depend upon gaining the clearest possible understanding of changes it has undergone.

After the Philadelphia Museum of Art and the Pennsylvania Academy of the Fine Arts acquired Thomas Eakins's *Gross Clinic* in 2007, as its new institutional stewards we began a program of technical and historical study that would inform our decisions about the best possible care and most sympathetic display of the painting going forward. Our assessment of the painting's condition started with several fundamental questions: What can we determine about its original appearance? In what ways and how much has it changed, and what were the causes?

Whether changes to a painting are great or small, or happen quickly or slowly, depends on many factors, including the stability of the materials used and the artist's knowledge and skill in combining them. Circumstances of the physical environment such as light, temperature, humidity, and pollution also play a role, as do damages from pests, accidents, neglect, or vandalism. Some of the changes we observed in *The Gross Clinic* are of a kind not uncommon for a painting of its age, especially one that has had an intensely public existence. Having been moved numerous times to and from exhibitions and among various display locations at Jefferson Medical College (one being the landing of a high-traffic stairway where it hung for almost

forty years), it had sustained numerous small losses of chips and flakes of paint, though these damages affected only a small portion of the paint surface. The truly significant changes in *The Gross Clinic*, however, were not due to faults in the artist's technique, the aging of its materials, how it was moved, or where it was displayed. Instead, they resulted from early twentieth-century efforts to preserve and clean the painting—actions taken with good intentions but without the caution, ethical grounding, and standards of proof that would later become the necessary foundations of professional conservation practice. It has long been known that the interventions of early restorers had changed the painting; our study of dozens of Eakins canvases has shown that the kinds of alterations *The Gross Clinic* underwent are typical of a pattern encountered throughout the artist's work. As we will see, the causes of these changes and of their prevalence in Eakins's oeuvre lie in the artist's specific way of visualizing and painting his subjects.

Tone and Technique

When I began working with the large Eakins collection at the Philadelphia Museum of Art in the early 1980s, I quickly became aware that many of his paintings had been overcleaned by restorers who, by choice or accident, had removed some original paint. As a result, these pictures presented a confusing appearance and complex restoration issues. I learned from records going back decades and in discussions with colleagues that difficulties of this kind affected much of Eakins's work. While the problems were widespread and seemed mostly to have originated many decades earlier, the reasons for them were not well understood, and their impact on our comprehension of Eakins's artistic influences and aims had never been studied. The opportunity to look more deeply into questions raised by the condition of the artist's paintings arose with preparations for the 2001–2 retrospective exhibition *Thomas Eakins: American Realist*, which began in Philadelphia and traveled to the Musée d'Orsay in Paris and the Metropolitan Museum of Art in New York. In the exhibition catalogue, I and former Assistant Con-

servator Nica Gutman presented the findings of technical and historical research into Eakins's formal concerns and technique, an examination of the causes behind a pattern of damaging early twentieth-century cleanings of his paintings, and ways the resulting changes have interfered with viewers' perceptions of Eakins's artistic inclinations, ideas, and abilities.[1] At the heart of the investigation was Eakins's engagement with pictorial color, tone, and refinement of effect—all of which were subject to misunderstanding and disruption in early cleanings of many of his paintings, including *The Gross Clinic*. The study set technical observations from comparative examinations of more than 150 Eakins paintings against painting theory and technique as taught in art academies of his time, period art criticism and scientific thought about perception, and the artist's own writings on color and tone. The key realization that emerged was that Eakins held the command of color and, especially, tone to be a central challenge of painting met by the artists he admired most, and a standard by which his own success as a painter would most certainly be measured.

Eakins's writings show that he, like many other academically trained artists of his day, was centrally concerned—at times preoccupied—with controlling "tones" (or "values," as they are sometimes called), the relative levels of lights and darks in paintings, considered as distinct from "color." He understood this control to be the very foundation of convincing depictions of real objects occupying real spaces, and of overall artistic effect. His primary concern for mastery of this basic element of pictorial representation was also consistent with the expectations of the art critics and connoisseurs whose opinions could mean an artist's success or failure.

The single-minded seriousness of Eakins's engagement with the challenge of tonal control is evident in the so-called Spanish notebook, which he kept in 1869–70, toward the end of his student years in Europe, and in the first years after his return to Philadelphia.[2] A fascinating document of his state of mind at the threshold of his career, its earnest "notes-to-self" stream of observations and analysis of the relative merits of paintings and ways of working vividly reveal the urgency of his practical

quest to unlock secrets of the craft of painting. The notebook is also instructive for what it leaves unsaid: any explicit consideration of the actual subject content of paintings or for the role of inspiration in creating them. His overriding concerns, page after page, are with color, tone, and paint handling. In seeking the keys to technical competence, Eakins notes how various masters overcame (or, in some cases, failed to overcome) the difficulties of handling and representation to meet the demands of their art. In his analysis of Old Master and contemporary paintings alike, he identified sequential process—in a word, *layering*—as a requirement for success. No satisfactory end could be achieved without command of the proper means, which were, to Eakins, stepwise progress through a rational process of organization, study, lay-in, and refinement.[3] Finding *au premier coup* painting intrinsically inferior ("The Van Dycks in Madrid are superb in their draftsmanship, but are very weak in appearance next to the Riberas and Velasquezes because they were probably painted au premier coup") and attributing much of the success of the pictures that most impressed him to layering ("the manner of Bonnat and Fortuny, [where] my own instincts lie"), he reveals a disdain for prematurely binding choices forced by working toward immediate finished effects of tone and color.[4] Incrementally achieved effects—with decisions deferred each to its perfect moment in relation to what has gone before and what is to come—are the end and essence of this view of art-making.

The control of tones continued to be a point of frustration, and occasional crisis, throughout his early career. Evidence of Eakins's determination to master tones can be seen in his paintings of the early 1870s, where changes of color layer to layer often suggest a searching for control over the interactions and balances of tone and color. He expressed this frustration in a remarkable letter he drafted to his Parisian master Jean-Léon Gérôme in 1874, just months before he began work on *The Gross Clinic*, in which he offers an exasperated point-by-point analysis—four years and dozens of paintings after his return to Philadelphia—of basic difficulties of color and tone (and devilishly inconstant lighting) still causing his work to fall short of his own expectations.[5] The letter concludes with a plea for knowledge about surprisingly basic but still-elusive key principles: "What is the practice of the best painters? Is there a conventional solution?"

In April 1875 Eakins wrote to his friend Earl Shinn, ostensibly in reference to *The Gross Clinic*, "What elates me more is that I have just got a new picture blocked in & it is very far better than anything I have ever done." Notably, with respect to our interest in the role of his final adjustments to color and tone, he added: "As I spoil things less & less in finishing I have the greatest hopes of this one."[6] Here, at the very first stage of creating a painting meant to hold its own against the greatest works of the Old Masters and his contemporaries, Eakins refers to his difficulty (diminishing, to his relief) in finishing pictures well. His greatest hopes for this painting are pinned to avoiding missteps in the latter stages of execution, that is, in his final layers of glaze and touches of paint. Eakins assigns to those final additions and adjustments the make-or-break function of representing his sensitivity to visual phenomena, his most discriminating judgments, and his ability to strike a perfect balance between conceptual and compositional strength and refinement of handling and effect, between the power of the objectively analyzed subject and the affective impressions and associations the finished effect calls forth in the viewer—that is, pictorial mood. These finishing layers represent no less than the artist's ultimate judgments on the desired look of the work of art; they are the imprimatur, the sealing touch of a pictorial ideal.

Eakins's analysis of tonal balance and color and search for techniques to meet their considerable challenges led him to the layered method of painting he would utilize throughout his career. In practice, this meant that rather than just mixing the final color that would appear in the painting, he rapidly and decisively laid in a strong, solid, underpainting and then, in successive sessions, superimposed modifying layers of color, some opaque, some translucent. The final color of a given area could be quite different from the color applied initially (figs. 8.1, 8.2). In general, bright color and emphatic contrasts of light and dark were set in the early stages of painting, and subsequent layers would be used to adjust and refine—usually by lowering—

Figs. 8.1, 8.2. Lower paint layers very different from the surface color in details from two early Eakins paintings: (8.1) the initial bright blue-green painting of the water visible in gaps in the upper paint layer around the reflection of the oar in *The Champion Single Sculls (Max Schmitt in a Single Scull)*, 1871 (The Metropolitan Museum of Art, New York; purchase, The Alfred N. Punnett Endowment Fund and George D. Pratt Gift, 1934 [34.92]); and (8.2) the bright orange lay-in exposed by early overcleaning of the dark brown piece of furniture in *Kathrin*, 1872 (Yale University Art Gallery, New Haven, bequest of Stephen Carlton Clark, BA 1903)

tonal contrasts, color intensity, and "key" (overall brightness or darkness). This process, which the artist declared was "the only in my opinion that can give delicacy and strength at the same time," secured both boldness and a complementary subtlety.[7]

In the closing decades of the nineteenth century, as academic painting lost its hold on many thoughtful and progressive critics and collectors of contemporary art, its critical standards also lost currency, among them an at-times breathless esteem for low tone and even intentional obscurity as admirable pictorial qualities and signifiers of cosmopolitan taste and sophistication.[8] By the time of Eakins's death in 1916, these tastes had,

for most, long since slipped from favor and understanding. In a world of changed and changing aesthetics, the low key and subtly modulated tones of Eakins's pictures were not necessarily recognized or valued as conscious, painstakingly crafted reflections of the most refined sensibilities of that earlier moment. More importantly, his technique for achieving those effects—by layering darker tones over lighter and brighter foundation colors—would have dire consequences for the preservation of his paintings.

In the decades following Eakins's death, many of his paintings were sent to restorers who apparently had little grasp of his aesthetics and technique and felt that

the pictures would be improved if they looked brighter and higher in contrast. The consequences of misguided treatments to lighten paintings or parts of them were well known to Susan Macdowell Eakins (fig. 8.3), the artist's widow, who for the more than two decades that she survived her husband strove to protect his paintings from unsympathetic restorations and, in particular, cleanings that removed layers of original paint, disrupting the painstakingly calibrated final balance of tones that she knew to be an essential and masterful accomplishment of her husband's art.[9]

Such disruption of the tonal subtlety and balance that Eakins had carefully pursued throughout his career begins to show in cleanings done as early as 1917, the year after his death (fig. 8.4). Damage to some passages indicates that strong cleaning agents and aggressive techniques were used to override Eakins's efforts to construct his paintings so that his toning layers would withstand a properly careful cleaning. Restorers were willing to proceed so aggressively either because Eakins's final paint layers were not recognized as such—perhaps mistaken for grimy picture varnish—or because his care with pictorial tone and the aesthetic outlook it served were not properly appreciated, as they now are, as vital parts of his conception of consummate painting. Among the many casualties of this trend was *The Gross Clinic*, which in the late 1910s or early 1920s, despite Susan Eakins's efforts to prevent paintings from being thus damaged, was sent without her knowledge to a restorer who overcleaned the painting, exposing lighter and more colorful foundation layers that Eakins never meant to be seen in the finished picture.

The Visual Record of Changes

What can or should be done to preserve and clarify the original visual character of a work of art depends directly on the quantity and quality of information supporting restoration decisions. The more we know about the nature and extent of alterations to a painting and their detriment to its original visual, intellectual, and affective essence, the more we can do to address damages in specific ways that allow that essence, not the cumulative disruptions of damage, to dominate.

Fig. 8.3. Susan Macdowell Eakins (1851–1938), *Self-Portrait*, c. 1925. Oil on canvas, mounted to panel; 30 × 25 inches (76.2 × 63.5 cm). Pennsylvania Academy of the Fine Arts, Philadelphia. Charles Bregler's Thomas Eakins Collection, purchased with the partial support of the Pew Memorial Trust and the Henry C. Gibson Fund, 1985.68.39.1

The most direct way we can track changes in the appearance of *The Gross Clinic* is through reproductions and photographs made at various points in its history. We have an unusually informative record, due in part to the early and continuing recognition of the painting's importance.

The earliest image we have of *The Gross Clinic* is an astonishing one, made by Eakins himself as soon as the painting was finished—indeed, before all the paint would have been dry: a large, detailed replica to be used by a European publisher of art reproductions, Adolphe Braun and Company of Alsace (then part of Germany), in producing monochrome collotype reproductions (fig. 8.5).

Fig. 8.4. *The Pair-Oared Shell*, 1872 (Philadelphia Museum of Art), photographed in 1917 for the *Loan Exhibition of the Works of Thomas Eakins*, The Metropolitan Museum of Art, New York, November 5–December 3, 1917. Courtesy The Metropolitan Museum of Art. The light patches throughout the water's reflection of the distant trees and river bank at left are losses to Eakins's dark surface paint and glaze caused by a mistaken effort to lighten the tone of the painting.

OPPOSITE: Fig. 8.5. *Gross Clinic*, 1875–76. India ink and watercolor on cardboard, 23¾ × 19¼ inches (60.3 × 48.9 cm). The Metropolitan Museum of Art, New York. Rogers Fund, 1923 (23.94)

The process required an accurate image of the painting, but Eakins knew that photographs of the time could not record colors' correct relative levels of light and dark. He therefore went to the considerable trouble of making this replica in India ink and watercolor to record precisely how various hues should be represented in black and white, that is, how the lights and darks should relate to one another for a faithful monochrome reproduction of the painting. The pains he took to produce a drawing to send to Braun, rather than settling for a photograph (even a retouched one), indicate that his handling of value relationships in the painting was key to the achievement he wished to have represented in the collotype. He said his drawing "was made with the intention of coming out right in the photograph," by which he meant either in an intermediate negative or in the collotype plate itself.[10] No doubt aware that a collotype reproduction (see fig. 6.1) could not be made as deep or varied in tone as an oil painting, for clarity in the print medium Eakins made the drawing lighter overall, nonetheless taking care to confirm his view of the

painting's *relative* tones of dark and light. This information in the artist's own hand would prove invaluable during the restoration of *The Gross Clinic* in 2010.

After the 1875–76 drawing and the resulting 1876 collotype, the next known record of the painting's appearance is a photograph made on October 4, 1917 (fig. 8.6), a little over a year after Eakins's death, on the occasion of the *Loan Exhibition of the Works of Thomas Eakins* at the Metropolitan Museum of Art in New York.[11] Although the painting had already been worked on by at least one restorer (T. H. Stevenson, between October 1914 and September 1915), the figures, setting, and, most significantly, tonal relationships still look much as Eakins recorded them in his India ink and watercolor replica of forty-two years earlier.[12]

At some point in the eight years following the 1917 exhibition, the painting was worked on again—exactly when or by whom we do not know—as evidenced by the next image in the historical sequence. Discovered in the Thomas Jefferson University Archives during the course of our research in the summer of 2009, this

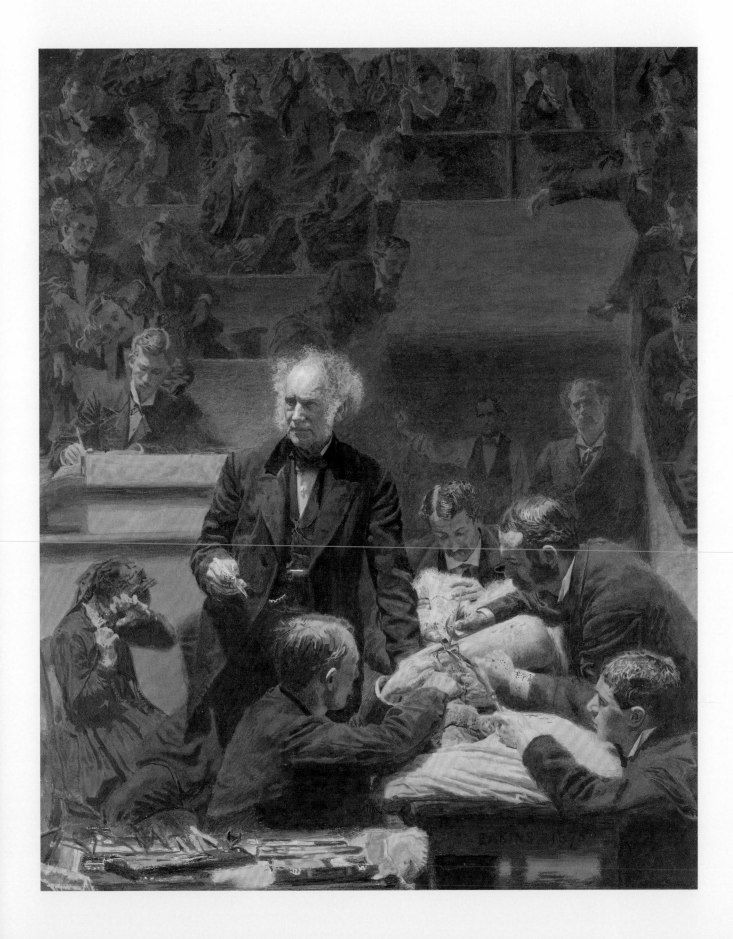

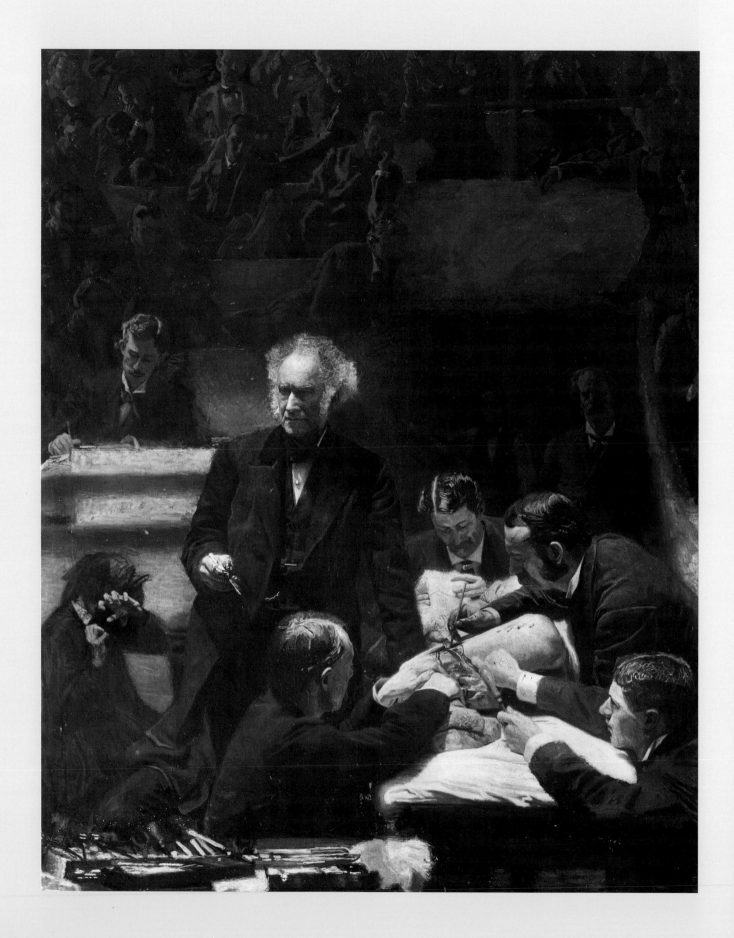

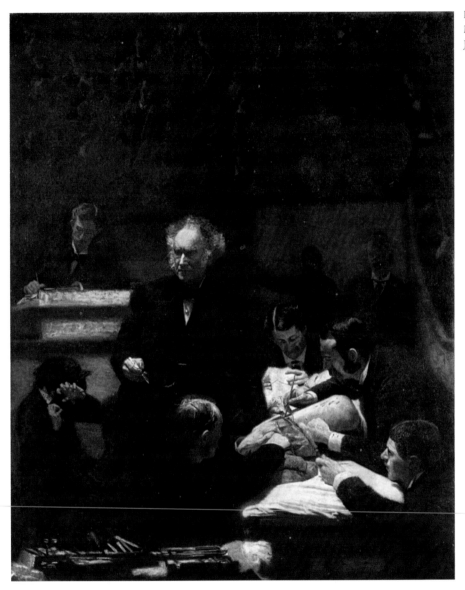

Fig. 8.7. *The Gross Clinic* as reproduced in the Jefferson Medical College 1925 yearbook. Courtesy Thomas Jefferson University Archives, Philadelphia

third of the known early images of the painting (fig. 8.7) records *the* critical juncture in its technical history—the moment separating the appearance of *The Gross Clinic* as Eakins had known it from the one by which it would be known from the 1920s on. This reproduction, the first in color, was made by Jefferson Medical College for the frontispiece in the school's 1925

OPPOSITE: Fig. 8.6. *The Gross Clinic*, photographed October 4, 1917, for the *Loan Exhibition of the Works of Thomas Eakins*, The Metropolitan Museum of Art, New York, November 5–December 3, 1917. Courtesy The Metropolitan Museum of Art, New York

yearbook and to be sold separately as a print. It was a significant time for Jefferson Medical College, which had celebrated its centennial the previous year. The college's desire at that proud moment in its history to have its greatest art treasure looking as fresh and vibrant as possible for display and for the color reproduction is likely what placed *The Gross Clinic* in the hands of a restorer around this time.

A comparison of the 1917 Metropolitan Museum of Art photograph and the 1925 Jefferson Medical College color reproduction reveals major changes in the relative tones of the painting. Just to the right of Dr. Gross and above the surgical group, the large area representing the

passageway into the operating theater has changed from dark to light. The two figures standing in the passageway (at left, clinic orderly Hughey O'Donnell; at right, Dr. Gross's son, Samuel W.) were originally lighter than the background; as of 1925, however, they appeared darker. Furthermore, this area, a sizeable portion of painting, imparts a strong reddish tone to the center of the composition. Susan Eakins strongly objected to its effect when she was shown the reproduction, apparently unaware that the image depicted changes that had been made to the painting itself some years earlier. In her 1929 letter of protest to Dean Ross V. Patterson of Jefferson Medical College, she wrote:

> The photograph [color reproduction] presents an operation being done by Dr. Gross under a fancy red light which fills the Clinic Room. The oil painting presents an operation being done by Dr. Gross in daylight. I have been in the Clinic Room as it was in Dr. Gross's time, also am quite certain at this present time, when artificial lights are the fashion, fancy lights would not be permitted on the serious performances of a Clinic.[13]

The influence of a strong red element on the composition clearly struck her as new and inappropriate. This formerly dark, recessive, and muted secondary passage of the painting now projected a strong false note of ominous, infernal color that competed with the foreground forms and Eakins's carefully placed touches of stronger color, notably the blood from the surgery. Its lightened, reddish tone upset the original organization of values, diffused the focus of the composition, and negated the recession of pictorial space within the passageway. As noted previously, this distracting change was caused by a restorer's misunderstanding encountered all too commonly among Eakins's paintings. Eakins had underpainted the passageway in the red-orange color, adding the dark surface tone and figures at a later point. Attempting to achieve any possible brightening of the painting, the restorer had discovered the color underneath this dark passage and, preferring it to Eakins's deep tone, uncovered this underlying base, fundamentally altering the overall appearance of the painting.

Mid-Century Treatments of the Painting

The next recorded treatment of *The Gross Clinic*, in 1940, was the work of Hannah Mee Horner, a restorer very active in the Philadelphia area.[14] It has recently been discovered that the plans for the 1940 treatment came to the attention of Eakins's disciple and champion Charles Bregler. Susan Eakins felt that Bregler understood the intended qualities of her husband's works, and with her approval he had undertaken treatments himself to preserve a number of them. After her death in 1938, Bregler carried forward Susan Eakins's oft-voiced concern for the fate of pictures placed in the hands of restorers lacking sufficient knowledge, skill, or respect for the artist's own aesthetic preferences. Alarmed upon learning of Jefferson Medical College's plans to engage a restorer in 1940 he attempted to intervene, but despite his direct connection to the Eakinses and appeals to others to contact the college in protest, he was unsuccessful in swaying those in charge of the painting, which was given over to Horner.[15] She removed a reinforcing canvas lining Stevenson had applied in 1915 and glued the painting to a plywood backing, an unusual treatment that she performed on many paintings in the 1930s and 1940s, assuming that plywood offered superior support. However, at eight by six-and-a-half feet, *The Gross Clinic* was too large to be backed with a single sheet of plywood, so Horner made the backing from two pieces, nailed side-by-side to a wooden framework. The seam between the pieces ran across the middle of the painting at the level of Dr. Gross's shoulders. The records at Jefferson indicate that she also cleaned and restored the painting. Our own experience through the years with a number of Horner's treatments has been that her cleanings were often aggressive; her retouching was broad, extending onto and hiding original paint surface; and her varnishes were applied extremely thickly. A 1950 examination by restorer David Rosen mentions that *The Gross Clinic* was considerably overpainted.[16] No record photographs for Horner's work on the painting are known, but regardless of whether she caused further damage through cleaning, she most certainly set the stage for eventual structural problems with her ill-advised mounting of the painting on the pieced plywood support.

Many of the difficulties created by the cleanings, restorations, and structural work of the first half of the twentieth century were confronted in major conservation treatments undertaken in 1960 and 1961. The crucial difference in these treatments was that the painting at last had the benefit of a knowledgeable conservator, Theodor Siegl of the Philadelphia Museum of Art (fig. 8.8), who had not only professional training, recognized credentials, and a specific interest in the artist, but most importantly a thoroughgoing commitment to high professional standards of examination, documentation, and ethical practice. His clearly expressed aim for the treatment was saving *The Gross Clinic* from structural deterioration while strictly avoiding any further harm to the canvas or paint.[17]

In the spring of 1960, Siegl cleaned and restored the painting for Jefferson Medical College. He worked in strict accordance with the absolute standard of responsible cleaning: that the removal of nonoriginal materials—such as restorers' varnishes and retouching—can proceed only if it can be accomplished without the slightest harm to the original paint. The 1960 cleaning required the removal of coats of varnish applied by Horner in 1940, which had since become yellowed, dark, and hazy. Siegl used combinations of solvents that allowed the removal of surface grime and the varnish, a small area at a time, without disturbing the original paint. He also painstakingly removed the accumulation of several earlier restorers' filling putty and retouching that covered old punctures and tears. Much of this retouching, some of it very tough and resistant, was disturbingly apparent due to poor color matching and extended well beyond the damaged areas, hiding Eakins's paint. The removal of nonoriginal materials from the surface clarified what was truly Eakins's own paint, but it also confirmed that earlier restorers who lacked the knowledge and skill necessary to clean the painting safely had in places worn away upper layers of the artist's paint. After cleaning and varnishing, Siegl retouched the damaged areas (an approach often called "inpainting" because the conservator's paint is applied only within the boundaries of loss), making no attempt at any substantial reconstruction of previously overcleaned areas. His report tells us he "merely toned down" a few damaged

Fig. 8.8. Philadelphia Museum of Art Conservator Theodor Siegl working on *The Gross Clinic*, 1961. Conservation Department, Philadelphia Museum of Art

areas he judged to be especially conspicuous, for example, the clothing and face of Gross's son and "the faces of students near the upper right and upper left corners." Finally, the painting was varnished with a coating formulated "to give a maximum brilliance of color without too much gloss," in the hope of reducing a persistent problem of glare off the surface.[18]

The following spring Siegl was asked to examine the painting to determine whether it was structurally sound enough to withstand travel proposed for a 1961 Thomas Eakins retrospective that would go from Washington, DC, to Chicago and finally back to Philadelphia. The organizers considered *The Gross Clinic* essential to the exhibition, but Siegl discovered that Horner's pieced plywood backing was creating serious problems, making the painting too fragile to travel. The flexing and warping plywood was causing a crease across the middle of the painting, threatening to split the canvas. In addition, the heads of many of the nails driven through the face of the plywood pieces to join them to the wood framework

Fig. 8.9. The artist Louis B. Sloan assisting with the removal of glue from the back of the painting's canvas, 1961. Conservation Department, Philadelphia Museum of Art

on the support's back had begun to work forward, pushing against the back of the fragile canvas, threatening to puncture it, and causing rows of unsightly bumps on the surface and some small losses of paint. The need for immediate action to prevent more damage was clear. Siegl submitted his findings, along with a treatment proposal, to Jefferson Medical College, which approved the project immediately. Attentive to the professional standards of the conservation field, Siegl carefully documented in writing and photographs all work carried out and the condition of the painting before, during, and after the treatment.

Over the summer of 1961 Siegl and his team were able to remove the plywood from the back of the canvas without causing any further paint loss. They secured the painting face-down on a large table constructed for the purpose, with the paint surface protected by layers of tissue and fine cotton cloth temporarily adhered to it. With this preparation the backing could be shaved away safely in stages, the first plies by controlled use of an electric planer, and the rest with scalpels and other hand tools. Finally, Horner's thick layer of glue was removed from the canvas itself (fig. 8.9). The painting could then be lined in a conventional manner, by attaching a strong new piece of linen

to the back of the original canvas. The tissue and cloth facings that had protected the face of the painting through these processes were removed and the painting was mounted on a new stretcher (an expandable wood framework for supporting painting canvases), completing the structural-preservation phase of the treatment.

The removal of residues of the facing tissue and lining adhesive from the painting's surface had disturbed Siegl's varnish and inpainting of the previous year, so he removed them. As he had before, he then applied a coat of varnish to saturate the painting's colors so they could be matched properly for inpainting areas of loss, as well as to isolate the 1961 conservation team's new retouching from Eakins's own paint, so the restoration materials would remain physically separate and easily distinguishable as such. Those materials were chosen to allow their safe removal if it should ever become necessary. This kind of foresight, a foundation of responsible conservation practice, acknowledges the possibilities that the inpainting could eventually shift in color and become conspicuous, that the varnish could discolor or present concerns about its easy removability, or that the objectives or extent of restoration might require reconsideration. These last two factors would emerge as motivations for our treatment of *The Gross Clinic* forty-nine years later, and the public for whom the painting is held in trust would be the beneficiaries of Siegl's professional approach (fig. 8.10).

The 2010 Treatment of *The Gross Clinic*

Following the acquisition of *The Gross Clinic* by the Philadelphia Museum of Art and the Pennsylvania Academy of the Fine Arts in 2007, a campaign of combined conservation and curatorial research began that would deepen our understanding of how the painting looked in its first few decades. We studied how Eakins's choices of materials and the systematic painting process to which he was committed were so effectively joined to his powerful subject to produce an unforgettably arresting result. Our investigations also brought to light and gave sharp definition to a history of problems of preservation and appearance, as well as compelling current reasons to consider conservation treatment. Discussions

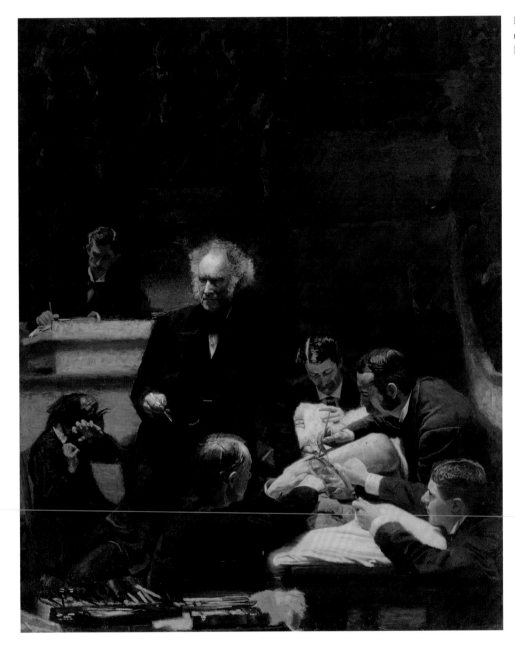

Fig. 8.10. *The Gross Clinic* in 2008 showing the painting as restored in 1961. Conservation Department, Philadelphia Museum of Art

of our findings and of the challenges and benefits of conservation treatment extended over many months, leading eventually to the decision to undertake cleaning and a new restoration in 2010. It had been nearly half a century since Siegl, under markedly different circumstances, had treated the painting, and we would be working with the advantage of the intervening decades' advances in our understanding of Eakins's technique and

aesthetics. Further, new priorities for and approaches to restoration had emerged, and their application by Philadelphia Museum of Art conservators to treatments of a number of damaged Eakins paintings between 1999 and 2001 had demonstrated a tremendous potential for making Eakins's personal aesthetic concerns more manifest. The treatment of *The Gross Clinic* was also viewed as especially timely because it would be informed

by the exceptional art historical expertise on hand, especially that of curator Kathleen A. Foster.

My own routine examinations of the painting in recent decades had confirmed that its structure had been well stabilized by the 1961 lining; loose paint had been securely reattached and the new linen canvas adhered to the back of the original canvas to reinforce it remained strong. Some things, however, had changed since the previous conservation treatment, presenting both need and opportunity.

One concern that had emerged was the stability of the picture varnish applied in 1961. That varnish, poly(n-butyl methacrylate), is a synthetic resin that was favored by many conservators in the mid-twentieth century for its durability and the initial belief that it was less prone to yellowing with age than traditional natural-resin picture varnishes such as mastic or dammar. Experience and scientific analysis, however, eventually showed it to be susceptible not only to significant discoloration as it aged, but also to a marked loss of solubility, so that with the passage of time its removal requires increasingly strong cleaning agents.[19] Small cleaning tests were made in representative areas of *The Gross Clinic*, and we were relieved to find that after nearly five decades, the varnish could still be taken off safely with solvents that would not cause harm to Eakins's own paint. We knew, however, that such ready solubility would not last, and that the removal of the varnish and its replacement with one of better long-term stability could not be delayed indefinitely.

The appearance of the 1961 varnish had also long been a serious impediment to appreciation of the painting. In the interest of protecting *The Gross Clinic*—displayed as it was between 1929 and 1968 at the top of the entry stairs of Jefferson Medical College's College Building, a busy public space right off the street—the 1961 varnish had been applied in several very thick coats, obscuring the lively variations in the surface textures of Eakins's paint.[20] The stairway location was also directly opposite a large doorway window, creating severe glare off the surface of the painting. To reduce this problem, the 1961 varnish had been applied to have a matte sheen, not the gloss of the natural resin (probably mastic) on which Eakins would

have depended to saturate the painting's dark colors and bring out their full depth.[21] The matte surface gave the painting a hazy, washed-out appearance, particularly obscuring the variety of closely related tones and colors in the darks.[22] Adding to the synthetic varnish's dulling effect on colors both light and dark was the strong yellow discoloration it had developed and a grayish film of fine airborne grime that had become embedded in its surface over the years.

The need to remove the varnish before it became more solvent-resistant was a pressing preservation issue, and the painting's appearance stood to benefit immensely by the revealing of its paint texture and the depth and variety of its colors. What made the prospect of cleaning even more compelling was that extensive testing had shown that the process would be straightforward. Siegl had endeavored to remove all earlier restorers' retouching in his 1961 cleaning. The only nonoriginal materials present on the painting, then, were the 1961 varnish and retouching, the latter physically isolated from the paint surface by Siegl's preliminary varnish coat. Our cleaning would require no more than the removal of that varnish and retouching, both very plainly distinguishable from the original paint in appearance and solubility. In so doing, the painting's actual state—that is, what remains of Eakins's original surface and the extent of previous paint loss—would be revealed. Much could be learned from the painting at this moment, but a new challenge opened from it. The restoration to follow (meaning the retouching, or inpainting, of damages to reintegrate the image and recover original visual qualities) would be a lengthy and demanding process, but one of exciting potential. Months of examination and study gave us reason to believe that far more could be done to bring the strengths of the intact sections to the fore, allowing Eakins's artistic concerns and achievement to show more clearly than at any time since the damaging cleaning that occurred sometime around 1925.

In late 2009, staff from the Philadelphia Museum of Art and the Pennsylvania Academy of the Fine Arts reviewed the pretreatment documentation of *The Gross Clinic* and held final discussions, weighing the reasons

for and advantages of undertaking a conservation treatment. A proposal was agreed upon for removal of the 1961 varnish and retouching and a new restoration that incorporated as fully as possible the evidence of what the painting had looked like originally.

Ethical ground rules both guide and constrain the restoration of paintings. Retouching may not cover even the least amount of intact original paint surface— it must be applied precisely and specifically within the boundaries of damage to original paint. In retouching damage, the conservator must respect the original visual character of the work, so far as it is known, so that the appearance of the restored painting is as consistent as possible with all evidence of its original state. The materials applied in a restoration must remain readily detectable by common examination methods, be clearly distinguishable from the materials of the painting itself, and remain removable without any harm to the original paint. The reason for this last requirement—easy reversibility—is the understanding that the materials applied in a restoration, however stable, will eventually change and need to be removed. But it is equally an acknowledgment that restorations reflect the state of knowledge and, inevitably, the intellectual concerns and aesthetic preferences of the historical moment in which they are carried out. If the materials we use in a restoration remain easy to detect and remove, future treatment options can be implemented without risk of harm to the original.

With the 1961 restoration materials removed, we would be looking at the very same surface and damage confronted by the conservation team of forty-nine years earlier, and in restoring the painting we would adhere to the same principles. Yet our approach and expectations for the outcome in 2010 were quite different, for two principal reasons. First, we had far more information about the painting, how it looked originally, and how, why, and when it had changed. The years since 1961 had seen tremendous advances in studies of the history, aesthetics, and techniques of nineteenth-century art, and the understanding of Eakins's work benefited from the groundswell of insights and information. What we have learned, especially in the past two decades, about Eakins's aesthetic convictions

and technique has also shed light on specific ways the changed condition of his paintings undermines the visual qualities and effect he sought. In addition, we would have the advantage of the extraordinary visual and written documentation we had compiled of the predamage appearance of *The Gross Clinic*. In particular, a major new influence on the priorities and goals of our restoration would be the recently raised awareness of the tremendous importance to Eakins and his artistic and critical peers of correctly observed and skillfully represented pictorial tones. We had come to understand that this component of the formal and affective language of Eakins's paintings was not only important, but also visually fragile; once a picture's tonal balance became disrupted, a defining component of the artist's sensibility was immediately and sometimes drastically diminished, if not rendered incomprehensible for the viewer.

The second distinction between the restoration approaches of 1961 and 2010 would be due to a shift in attitudes toward the limits and potential of retouching to compensate for paint lost through excessive cleaning or other types of damage. At the Twentieth International Congress of the History of Art, in New York in September 1961, the very moment of Theodor Siegl's restoration of *The Gross Clinic*, a distinguished gathering of art historians and conservators took up issues presented by damaged paintings, providing a fascinating snapshot of the options and attitudes of the time.[23] They roundly acknowledged that restoration has a subjective component and is an act of critical interpretation that requires limits to protect the integrity of the original. With that in mind, a clear majority of the discussants argued that only "a minimum" of retouching should be done to damaged areas.[24] This vague indication of an acceptable degree of retouching was put forth in the general agreement that paintings vary so widely in aesthetics, technique, and forms of damage that no single approach could be advocated above all others. Then, as now, "a minimum" can mean something different in each case and to each person. The term only takes on practical meaning when it is tied to specific goals: not just "a minimum," but "a minimum to accomplish thus-and-such." To the art historians and conservators gathered in

1961—indeed, to those of us working today—the goal of restoration is the characterization, preservation, and recovery of a picture's "unity," another broad, subjective, and necessarily flexible term. For the purpose of prioritizing what to address in a complicated restoration, however, pictorial unity—considered as a specific original interrelationship between total visual effect and its formal constituents such as composition and the mode by which forms, space, and light are represented in academic painting—can provide a useful basis for analysis and discussion. The firmer our knowledge of this interrelationship, the closer we can get to reinstating its character in a restoration. It was in large part the expansion of our understanding of *The Gross Clinic*'s original unity—particularly its dependence upon Eakins's carefully considered tonal relationships and key—that would account for the difference in goals and outcome of the 1961 and 2010 restorations.

A factor further distinguishing our restoration from those preceding it was a changed concept of the potential of restoration. Siegl's restoration of *The Gross Clinic* was fairly typical for those of professionally aware American conservators of the era in its effort to conform to the variously interpreted standard of "a minimum." He had just removed the earlier restorations and well knew the severity of damage from old cleanings. His treatment report notes that foreground darks had been abraded and that "on several of the observers' faces in the background delicate paint glazes had been previously removed." In describing his team's retouching, however, he says that "no attempt was made to reconstruct faithfully the original appearance of the picture" and that the retouching was "merely intended to disguise the shock of disturbing blemishes."[25] This restraint partly reflects an admission of the limits of what was known at the time about Eakins's technique and intended effects, but it is primarily a disinclination to do any more than hide the most conspicuous damage. This reluctance was very much part of a continuing backlash within the conservation profession against the excesses of earlier generations of artisan restorers who would falsify works by repainting them freely and creatively. As understandable as this reaction might be, the minimal disguising of only selected damages has a downside: it

can produce an unnecessarily incomplete or even misleading impression of the artist's aims and ability. The only types of paint damage addressed by the 1961 retouching were the most conspicuous abrasion and discrete losses of flakes of paint, with some selective broader retouching of a few obviously disfigured areas of old cleaning wear. Concealing only the smaller paint losses and disguising the severity of damage to selected areas without carefully and more consistently reconstructing what was missing gave an impression of superficial wholeness, though important qualities of the artistic statement actually remained badly interrupted and weakened. In other words, the painting was made to look plausibly complete without looking authentically so, suspended between its damaged appearance and its original appearance by a restoration that, in its conscientious, well-intended restraint, could do little to clarify either.[26] Consequently, during the nearly fifty years that the 1961 restoration was in place most viewers tended to accept what was actually a very altered painting as a fair representation of Eakins's skill and aesthetic judgment; few, if any, had remarked upon deficiencies in the painting's appearance, though all the evidence shows it to have been very far removed from what Eakins had worked so purposefully to achieve.

By contrast, the emphasis of the 2010 restoration would not be on what retouching could minimally and selectively *disguise*, but on what it could *clarify* about vital artistic concerns eclipsed by damage. We were convinced that with a more thoroughgoing restoration based on meticulous reference to all evidence of original appearance—and above all, that provided by the 1875 and 1917 images—the painting could give viewers a far more direct and reliable experience of the artistic imagination, judgment, and period and personal aesthetics it had so clearly proclaimed in its earliest years.

THE CLEANING

As the removal of the 1961 varnish began, the benefits were immediate and dramatic. The contrast between cleaned and yet-to-be-cleaned portions revealed the striking degree to which the varnish had been scattering light right at its surface, forming a hazy visual

barrier and flattening pictorial space. The cleaned areas showed a variety and depth of tone in the painting's vast dark passages that returned definition between one form and the next. The painting's lighter tones, no longer masked by a grime-laden and yellowed film, emerged from beneath the varnish with their own striking vibrancy. Over a period of several weeks, the cleaning revealed well-preserved passages as well as those marred by past cleaning abrasions and missing flakes of paint. As the work progressed, a clearer sense of the challenges and potential of the forthcoming restoration emerged.

One discovery of special importance, made while cleaning the varnish from the area of the passageway into the operating theater, was several surviving patches of the dark glaze Eakins had applied to his orange underpainting to produce the overall final tone of the entire passageway background. These patches had not been recognized in 1961 for what they were—all that remained of the original surface of this broad area. Consequently, they had been retouched to match the lighter orange underpaint exposed by the problematic pre-1925 cleaning. These remnants were the much-hoped-for concrete evidence of what broader tone and color were missing, a clear indication of what would need to be matched to restore the more recessive dark tone seen in the earliest images of the painting.

Once all of the 1961 varnish and retouching was cleared from the surface, we could finally assess the actual state of *The Gross Clinic* directly, with Eakins's own paint and all the alterations and incidental damages incurred over the previous 134 years fully revealed (fig. 8.11). At that moment, the visual gap separating the painting's present appearance from the way it looked originally was widest; however, the precise extent of Eakins's own remaining paint was also most fully apparent. The painting was photographed in this state to document in detail its completely unrestored condition. Staff from the Philadelphia Museum of Art and the Pennsylvania Academy of the Fine Arts met at this stage to discuss the course of the restoration ahead and the best approach, area by area, for mitigating the effects of the early twentieth-century cleaning damage and bringing the surviving essence of Eakins's work forward.

THE RESTORATION

Before the restoration could begin the painting was given a thin coat of varnish, the purposes of which were twofold: first, to eliminate variations in surface gloss, saturating the colors evenly so all would have their full depth and richness; and second, to isolate the original surface physically from the retouching that would follow so that in future examinations or cleanings there would be absolutely no doubt where the restoration retouching ended and the original paint surface began. The varnish used is a synthetic resin, MS2A, developed specifically for paintings conservation and in use in museums since the early 1960s.[27] It saturates colors and has a pleasing surface gloss very much like traditional natural resins, but is far less prone to discoloration and loss of ready solubility.

With the saturating/isolating varnish in place, the retouching could begin. The paints we used for this restoration are made of lightfast pigments ground in a colorless synthetic resin.[28] Restoration paints are intentionally formulated with a binding medium different from that of the original paint of the work of art so that they can be detected by standard examination methods and will stay easily removable decades into the future, as the need or desire arises; nevertheless, they can be handled to match the depth and translucency of oils, allowing the accurate color matches that are crucial in retouching damages to a painting as deep toned as *The Gross Clinic*.

From the very start of our investigation of changes that had taken place in the painting we had been closely studying and analyzing the 1875 and 1917 images, knowing that they would be the key to any restoration; without them the appearance of damaged areas would have remained thoroughly conjectural and no attempt at reconstruction would have been justifiable. The two images contained different but complementary information. Eakins's 1875–76 drawing confirmed the reliability of the tones as recorded in the 1917 photograph and gave an especially clear depiction of some details, but for the process of restoring the painting the photograph was the most directly relevant and useful image. The photograph's quality is high: the 8-by-10-inch negative is well exposed and has a long tonal range, rendering excellent detail throughout the painting's lights and darks. To be

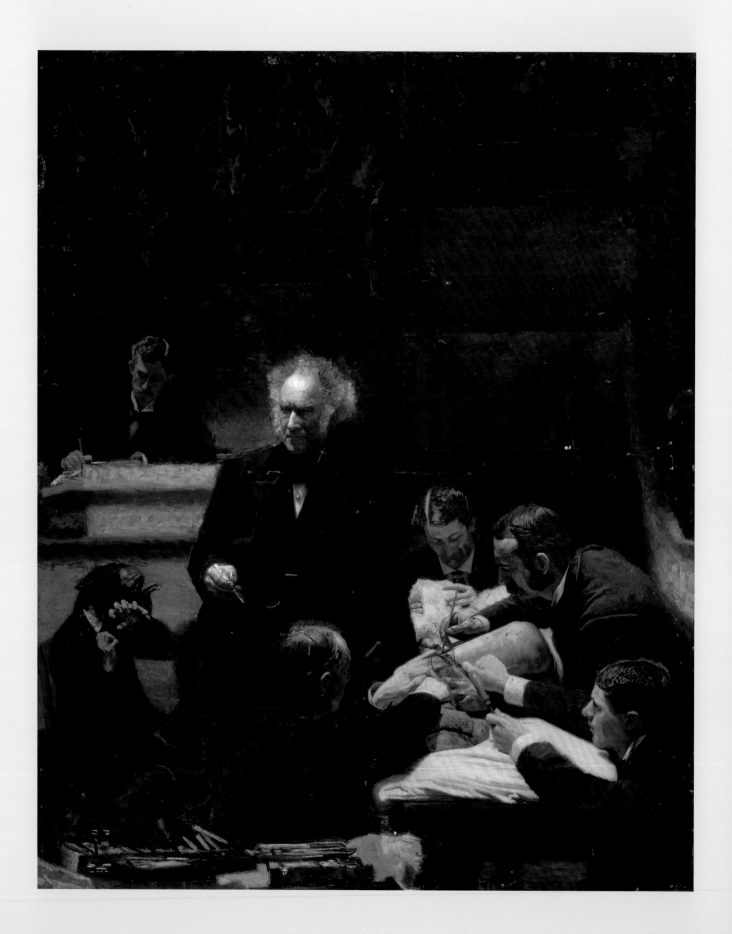

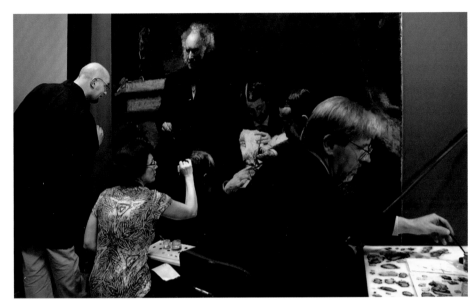

Fig. 8.12. Philadelphia Museum of Art conservators retouching *The Gross Clinic* in 2010. Left to right: Andrew W. Mellon Fellow Allen Kosanovich, Conservator of Paintings Terry Lignelli, and The Aronson Senior Conservator of Paintings Mark S. Tucker

Fig. 8.13. Precise inpainting of points of white priming exposed by cleaning abrasion in the coat of anesthetist Dr. Hearn

sure, the usual caveats had to be applied to the interpretation of an archival photograph of this period: the tonal rendering of colors, while superior to photographs of Eakins's time, still had to be correlated with a close reading of colors on the painting. This determined whether the photograph had recorded any given color as relatively lighter or darker than it appears to the eye when *The Gross Clinic* is viewed under the diffuse daylight that Eakins anticipated would be its optimal lighting condition. Throughout the months we devoted to the restoration, we referred constantly to both early images of the painting, enlarging them and using imaging software to extract as much information as we could.

I was joined in the restoration by two other conservators, Allen Kosanovich and Terry Lignelli (fig. 8.12). We began by meticulously retouching those places where paint had flaked away from the canvas or had been abraded from the surface by early cleanings. This point-by-point retouching eliminated the chaotic cumulative distractions of damages throughout the

painting, bringing definition back to forms and reviving the illusion of pictorial space (fig. 8.13). Although the restoration of large areas of contiguous damage often produces the most immediately striking change, the cumulative benefit of the painstaking inpainting of thousands of tiny losses and points of abrasion can have a tremendous positive effect (figs. 8.14a, b). Each instance of damage, however large or small, that could be reintegrated with Eakins's surrounding intact paint constituted a necessary step toward a restored pictorial unity (figs. 8.15a–c). One of the most gratifying aspects of restoration, in fact, is the way judicious elimination of a confusing overlay of irrelevant, distracting damage revives not just the coherence of forms

OPPOSITE: Fig. 8.11. *The Gross Clinic* in 2010 with the varnish and retouching of 1961 removed. Conservation Department, Philadelphia Museum of Art

Figs. 8.14a, b. Detail of Dr. Briggs (a) with 1961 retouching removed and (b) after the 2010 restoration, showing the original solidity of forms that is recovered with the retouching of hundreds of individual points of light-colored ground exposed by early overcleaning

and spatial ordering, but a clearer sense of the artist's touch, of the speed and pressure of the brush, of intense, focused control or expansive spontaneity in handling (figs. 8.16a–c). In addition to the damage to forms, which ranged from minor abrasions of thinly painted areas to nearly complete loss of parts of some background figures, very much at issue was broader cleaning damage that had upset the original studied, skillful disposition of color and, especially, tonal ordering throughout the composition, a significant part of Eakins's conception of fully realized representation and expression.

Figs. 8.15a–c. (a) Detail from the 1917 photograph of the area of an upturned hat on a background bench. (b) Abrasion of the paint had made the form of the hat nearly unrecognizable, as seen with the 1961 restoration removed. (c) With the hat's form and the surrounding dark background restored in 2010 with close reference to the 1917 photograph, the background once again appears to rest well behind Dr. Gross.

The 1961 restoration had not covered any preserved original paint surface, nor would the one of 2010; however, we did reintegrate damaged areas as accurately and completely as the visual evidence would allow, including many places that had been left unrestored or only reluctantly and sketchily retouched in 1961. The most consequential of these areas were the exposed red-orange underpainting of the tunnel opening into the operating theater and the figures within and adjacent to the tunnel. Inpainting of these badly abraded figures and other abraded forms throughout the painting brought their appearance back into better agreement with Eakins's drawing, modeling, and handling as it had survived in better-preserved passages and could be seen in the primary visual documents of the painting's early state, Eakins's 1875–76 wash drawing and the 1917 Metropolitan Museum of Art photograph (figs. 8.17a–d).

Aware as we were of the critical importance that mastery of color values held for Eakins, a priority of the restoration from the earliest discussions forward had been the recovery of a more representative sense of overall tonal unity. Key to this effort was the restoration of the large area of dark glaze wrongly removed from the passageway into the operating theater in the cleaning of the painting sometime between 1917 and 1925. The restoration of this area was based on our study of the surface color and pigments found in surviving fragments of Eakins's dark final toning layer and of the passageway's undamaged appearance in the 1917 photograph. A glaze of retouching paint (again, easily removable should a different approach to the restoration ever be desired) precisely matched to the remnants of original dark glaze was prepared and applied to the areas of exposed underpainting to reinstate the effect of the missing original dark surface layer. The restoration glaze is transparent, just like Eakins's, allowing the reddish-orange underpainting and variations within it to glow subtly through, producing once again the recessive deep brown of the passageway. Eakins's layering technique had been critical to achieving the richness and exact depth of tone needed for the convincing illusion of the dark figures' presence in this dimly lit space. With this area

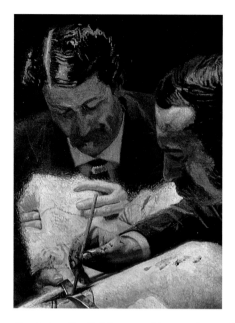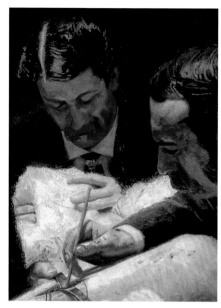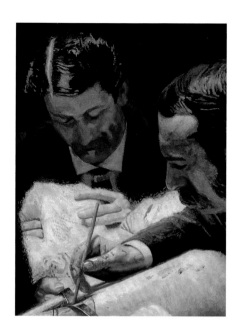

Figs. 8.16a–c. Detail of the center of the surgical group (a) from the 1917 photograph; (b) with the 1961 restoration removed, showing the extent of earlier damage; and (c) after the 2010 restoration of areas of missing paint. The distinction between the textures of the gauze that Dr. Hearn holds over the patient's head and the sheet pulled over his shoulder was lost through cleaning abrasion of defining strokes of darker paint. The remaining fragments of the affected brushstrokes were put back in context by reconstruction of the missing parts in close reference to the 1917 photograph, and the two fabric textures are again differentiated. This detail also shows the clarity of forms and spatial relationships between them restored through precise inpainting of paint losses in the tie and lapel of Dr. Hearn and in and around the hands of the doctors.

returned to a close semblance of its original darkness, it became possible—for the first time since the damage it sustained in the 1920s—to appreciate the crucial tonal relationship of the passageway to the entire painting.

The retouching of abrasions to the paint of the two figures in the passageway is an example of how the richness of a picture's details can be recovered by exacting restoration. In their broken-up state these figures were indistinct, shadowy shapes. With the careful retouching of the many small paint losses that interrupted the men's features, their personalities reemerged. In the greatest possible contrast to the emotions of the terrified woman on the other side of the painting, these men lean casually against the walls of the passageway, at ease with the work of the clinic

that is so familiar to them. On the left, clinic orderly Hughey O'Donnell once again looks out at us, the only figure in the painting whose eyes meet ours (figs. 8.18a–d). To his right is Dr. Gross's son, who was revealed by the restoration to be looking over at his father (figs. 8.19a–c). Another figure that connects by his gaze with Dr. Gross is that of Eakins himself, who, with his face carefully restored to its predamage expression, is once again the serious and eager observer, brow knit with concentration as he looks up from his pencil and paper (figs. 8.20a, b).

After hundreds of hours of retouching, the restoration was complete and the painting was given a light final varnish to even out any slight inconsistencies in the gloss of retouched areas. Because of the superior

Figs. 8.17a–d. Detail of severely damaged figures at the upper right of the painting as they appeared (a) in the 1917 photograph; (b) as the area was restored in 1961; (c) with the 1961 restoration removed, revealing the extent of earlier damage to the paint; and (d) after the 2010 restoration, which utilized information from the predamage image to achieve as complete and accurate a reconstruction as possible

a

b

c

d

a

b

c

d

Figs. 8.18a–d. Detail of clinic orderly Hughey O'Donnell
(a) from the 1917 photograph; (b) with the 1961 restoration
removed, revealing the extent of earlier damage to the paint;
(c) as restored in 1961; and (d) after the 2010 restoration of
areas of missing paint. Eakins had painted O'Donnell and
Dr. Gross's son, to his right, on top of the red-orange
underpainting of the passageway, exposed where the early
cleaning that removed the dark glaze also broke through parts
of these figures. The line of paint losses below the arm was
caused by shifting of the seam in the plywood to which the
painting was attached in 1940.

optical qualities and handling properties of the varnish
used in 2010, the amount needed to achieve an even
gloss and bring out the full richness of Eakins's colors
was a fraction of that used in 1961, so that the textures
of his work with brush and palette knife remain
apparent (see frontispiece).

RESULTS OF THE 2010 TREATMENT

The look of a painting—the impression it makes on the
viewer and its capacity to communicate ideas—
becomes, with the passage of time, some combination
of everything the artist put into it and everything
beyond the artist's control that diminishes it subse-
quently. An Eakins painting is far more than just his
choice of subject and arrangement of its elements, or of

a

b

c

Figs. 8.19a–c. Detail of the head of Dr. Gross's son (a) from the 1917 photograph; (b) with the 1961 retouching removed; and (c) after restoration in 2010

that subject's credible representation in a style that recalls in a general way academic and Old Master paintings. It is also a specific overall look, making a set of distinct impressions on the viewer. A significant measure of the individuality of an Eakins painting—of what made it an Eakins to his contemporaries—was the way he used upper paint layers to bring a picture to its expressive zenith. Given the abundant evidence that tonal unity achieved through layering was of central concern to the artist, when the nature and extent of its disruption can be sufficiently demonstrated—as it could in *The Gross Clinic*—we view restoration of the broken layers to be as important a goal as restoration of individual forms, which had been the nearly exclusive concern of all previous restorations.

The effects of time and chance upon works of art press upon each generation the responsibility for making conscientious and farsighted decisions about their care, interpretation, and presentation. The preservation of all that is original to a work of art, and its passing to succeeding generations in as intact and unchanging a state as possible, is now widely observed as an elemental obligation of cultural stewardship (though, as we have seen with *The Gross Clinic* and many other paintings, it was often not considered as rigorously before professional standards for conservation were formalized and refined over the course of the

Figs. 8.20a, b. Detail of Eakins's self-portrait at the far right of the picture (a) with the retouching of 1961 removed; and (b) after restoration in 2010

twentieth century). In contrast to the nearly universal acceptance of the obligation to preserve cultural property, there is no such clear or absolute consensus about how, within the bounds of what is ethically permissible, a damaged work of art should be restored. Restoration—in the restricted sense of retouching or other limited compensations to mitigate the influence of alterations that occurred beyond, and in apparent conflict with, the maker's will and judgment—always requires negotiating dilemmas. Divergent points of view may arise, for example, from a work of art's dual identity as an aesthetic and historical entity: retouching of damages to regain a better grasp of original appearance necessarily obscures evidence of an object's passage through time, while accepting the interference of accidents of deterioration and alteration by choosing to leave damages unrestored requires that each viewer puzzle over and try to look past condition for a sense of original effect. As a comparison of the results of the 1961 and 2010 restorations demonstrates, there is no single, correct way to address past damage to a work of art; changes in scholarship and the particular sensitivities, abilities, and interpretive priorities of the individuals involved in a restoration all have an effect on the outcome.

From the very first discussion of the needs and potential of *The Gross Clinic*, it has been our wish to be as forthcoming and clear as possible in sharing the issues presented by the painting's condition and our responses to them—that is, the aims and extent of our work. We have welcomed the opportunity to acknowledge the parts of our work that are necessarily interpretive, and to explain the reasoning behind our judgments. Knowing that such judgments are never absolute nor to be imposed on the original materials of the painting in any irrevocable way, we view and present our decisions regarding the degree and kind of compensation of damages as provisional. When the day does come that our restoration is no longer considered serviceable, it can be reversed. It is nonetheless our objective that those decisions, the product of our best efforts on the painting's behalf in 2010, will be seen for the longest possible time as usefully and faithfully serving Eakins's legacy.

The desire to be in closer touch with the initial appearance of a great work of art and all it had to offer visually at the height of its pristine power can be strong. It was especially so for *The Gross Clinic*, as our study of the artist and his time raised a powerful and poignant awareness of an entire facet of artistic concern

and achievement that had been dismantled and thrown into visual disarray by the painting's regrettable early cleanings. Even with intensive technical examination and the extraordinary historic documentation we have, we cannot know everything that has changed or been lost in a complex painting like *The Gross Clinic*. What we could say at the completion of the 2010 restoration was that the painting represented Eakins's vision and talents far better than it had at any time since being drastically altered eighty-five or more years ago. If the effects of damages can never wholly be undone, we did as much as the evidence supported to render them recessive enough that viewers can best appreciate the well-preserved passages and the long-absent logic and overall visual character of Eakins's tonal scheme. It was our intent that each form, tone, and brushstroke painstakingly restored in 2010 would contribute to a more valid and vivid awareness of Thomas Eakins's will, abilities, personality, and imagination as he strove to represent them in his greatest painting.

1. Mark Tucker and Nica Gutman, "The Pursuit of 'True Tones,'" in Darrel Sewell et al., *Thomas Eakins*, exh. cat. (Philadelphia: Philadelphia Museum of Art, 2001), pp. 353–65.

2. The Spanish notebook is now in Charles Bregler's Thomas Eakins Collection, Pennsylvania Academy of the Fine Arts (hereinafter cited as Bregler Collection, PAFA).

3. In the Spanish notebook, Eakins demonstrates the depth of his early investment in the tonal aims of traditional painting—particularly as they were represented in academic and critical discourse of the last half of the nineteenth century—and the importance of layered painting to their attainment. His critique of Eugène Delacroix's sense of color, which "pushed him involuntarily to seek the tones throughout his painting at the same time," makes clear Eakins's conviction that no matter what vision and talents an artist possessed, lack of attention to a process of stepwise refinement assured failure. He concludes with the declaration that "it was the shadows and purely mechanical difficulties that always defeated [Delacroix] and defeated him perfectly." Translation from Tucker and Gutman, "The Pursuit of 'True Tones,'" pp. 356–57.

4. Both quotes are from the Spanish notebook, Bregler Collection, PAFA.

5. Eakins, draft of a letter to Jean-Léon Gérôme, 1874, Charles Bregler Collection, PAFA.

6. Eakins to Earl Shinn, April 13, 1875, Cadbury Collection, Friends Historical Library, Swarthmore College, Swarthmore, Pennsylvania (see the Appendix for the full text of the letter). Many scholars have concurred that this letter refers to *The Gross Clinic*; the first to make this connection may have been Gordon Hendricks, *The Life and Work of Thomas Eakins* (New York: Grossman, 1974), p. 87.

7. Spanish notebook, Bregler Collection, PAFA (author's translation).

8. See Tucker and Gutman, "The Pursuit of 'True Tones,'" p. 425n16, for citations to period critics who embraced low-key and restrained-palette pictures.

9. Numerous expressions of worry and admonition about treatments of her husband's paintings can be found throughout Susan Eakins's correspondence. With regard to a restoration then being done on *The Gross Clinic*, the California painter George Barker, in a letter of April 22, 1940, to Charles Bregler, quotes from a Susan Eakins letter in his possession, in which she stated that "so many so called 'expert restorers' wipe out modelling in the effort to clean and make a picture shine, while they have not the faintest appreciation of the character of the work." Lloyd and Edith Havens Goodrich, Record of Works by Thomas Eakins, Philadelphia Museum of Art (hereinafter cited as Goodrich Archive, PMA).

10. Kathleen A. Foster, *Thomas Eakins Rediscovered: Charles Bregler's Thomas Eakins Collection at the Pennsylvania Academy of the Fine Arts* (Philadelphia: Pennsylvania Academy of the Fine Arts; New Haven, CT: Yale University Press, 1997), pp. 109, 256n16.

11. The exhibition ran from November 5 to December 3, 1917. The date of the photograph was provided by the Metropolitan Museum of Art Image Library, personal communication with the author, September 2009.

12. Because the lightweight linen canvas on which *The Gross Clinic* was painted had become brittle and weak as it aged, Stevenson had "lined" the painting in 1915, reinforcing the original canvas by attaching a new piece of linen to its back, a traditional way of supporting a fragile canvas painting. The November 1915 issue of *The Jeffersonian* reported that Stevenson had treated numerous paintings in Jefferson's collection that summer, among them "the masterpiece of the collection . . . 'The Clinic of Dr. Samuel D. Gross' . . . which hangs on the wall of the West Lecture Room." The January 1916 issue noted that all the pictures given to Stevenson "were cleaned and completely renovated, and the large painting of 'Clinic of Dr. Samuel D. Gross' relined." This was probably the first lining and not a "relining"; the terms are often confused. For information concerning this treatment, as well as other items from the Thomas Jefferson University Archives, I am grateful to archivist F. Michael Angelo.

13. Susan Macdowell Eakins to Fiske Kimball, November 13, 1929, Philadelphia Museum of Art Archives, Fiske Kimball correspondence.

14. The minutes of the Jefferson Medical College Board of Trustees for November 13, 1939, state that Dean Henry K. Mohler "was informed by Mr. Marceau's secretary at the Philadelphia Art Museum, that Mrs. Hannah Mee Hornor [*sic*], 24 Kent Road, Upper Darby, Pennsylvania, restores oil paintings." The board asked the Dean to invite Horner to inspect the College's portraits. She did so and presented a quote of $1,495 for restoring fifty-two portraits. The board discussed the matter on December 11, 1939, and "it was unanimously agreed to request Miss Horner to proceed at an early date with the restoration of 'The Gross Clinic' by Eakins, the work to be done in the College." As of January 8, 1940, it was noted that "Miss Horner expects to begin work on [*The Gross Clinic*] in the near future." On May 13, 1940, the minutes recorded that "the Dean reported the completion of the rebacking and restoring of 'The Gross Clinic' by Eakins, by Miss Hannah Mee Horner and presented a bill in the amount agreed upon for this work. This bill was approved for payment." Thomas Jefferson University Archives.

15. In his April 22, 1940, letter from California, George Barker writes to Charles Bregler that though he shares deep concern over the proper care of *The Gross Clinic* (and had written to Jefferson Medical College a year or more earlier urging them to consult Bregler on anything to be done to an Eakins painting), he did not think that he could be of much help at such a distance. He goes on to say, "It would be nothing short of sacrelege [*sic*] to let any one less than Charles Bregler or J. Laurie Wallace [another of Eakins's students] restore that painting. Mrs. Eakins would have fought the act with her last breath." In an October 13, 1940, letter of commiseration to Bregler, Eakins enthusiast and collector Seymour Adelman sharply criticizes the college's disregard for Bregler's

knowledge of Eakins's work and his attempts to advise and offer his services for the by-then-completed 1940 restoration. Adelman angrily observes, "And as for that precious Dr. Mohler [Dean of Jefferson Medical College], he doesn't realize that it was *far more dangerous* to put the *Gross Clinic* in the hands of an incompetent restorer than to lend it." Goodrich Archive, PMA.

16. In a letter of September 20, 1950, to Admiral J. L. Kauffman, president of Jefferson Medical College (Thomas Jefferson University Archives), Rosen mentions that the painting had previously been mounted on board and considerably overpainted. He advised against removing the repaints, but proposed laying down loose paint, removing the more disturbing repaints, and varnishing. It is not known whether any of this was done. (Rosen also served as a "technical advisor" and consulting restorer to the Philadelphia Museum of Art from the 1930s to the 1950s.)

17. See Theodor Siegl, "The Conservation of the 'Gross Clinic,'" *Philadelphia Museum of Art Bulletin*, vol. 57, no. 272 (Winter 1962), pp. 39–62.

18. According to Siegl's report of August 5, 1960, the varnish was five parts poly(cyclohexanone) resin AW2 (BASF) and one part poly(n-butyl methacrylate) resin Lucite 44 (DuPont). Conservation Department, Philadelphia Museum of Art.

19. Suzanne Quillen Lomax and Sarah L. Fisher, "An Investigation of the Removability of Naturally Aged Synthetic Picture Varnishes," *Journal of the American Institute for Conservation*, vol. 29, no. 2 (Fall 1990), pp. 181–91. For more on the decrease in solubility of poly(n-butyl methacrylate), see Shayne Rivers and Nick Umney, *Conservation of Furniture* (Oxford: Butterworth-Heinemann, 2003), pp. 339–40.

20. The installation in the College Building would have occurred on or after its opening in October 1929. See Julie S. Berkowitz, *Adorn the Halls: History of the Art Collection at Thomas Jefferson University* (Philadelphia: Thomas Jefferson University, 1999), pp. 192–93.

21. Susan Macdowell Eakins is cited as specifying that rectified turpentine be the only solvent used—sparingly—for removing dull or discolored picture varnish from the surface of Eakins's paintings, and that mastic in rectified

turpentine was the picture varnish to be reapplied after cleaning, almost certainly reflecting her husband's own practices. Her instructions for cleaning and revarnishing are recorded in a letter, dated November 30, 1935, from Elizabeth La Rue Burton (an artist whose family lived next door to the Eakinses), found on the inside of the backing of Eakins's 1906 portrait of her in the Minneapolis Institute of Arts; a copy of the letter is in the Eakins Research Collection, Philadelphia Museum of Art.

22. In 1968 the painting was moved to the new Jefferson Alumni Hall, where surface glare remained a problem until its 1982 installation in the dedicated Eakins Gallery, which had lighting that could be better controlled. See Berkowitz, *Adorn the Halls*, p. 193.

23. Philip Hendy, "Taste and Science in the Presentation of Damaged Pictures," in *Studies in Western Art: Acts of the 20th International Congress of the History of Art*, vol. 4, *Problems of the 19th and 20th Centuries*, ed. Millard Meiss et al. (Princeton, NJ: Princeton University Press, 1963).

24. Ibid. The opinions expressed and arguments made reflect a sophisticated range of theoretical issues and operational preferences, many remaining as valid now as they were then.

25. Theodor Siegl, "Report on Conservation of *The Gross Clinic* by Thomas Eakins, June to October 1961," Conservation Department Records, Philadelphia Museum of Art.

26. Reservations about even the superficial disguising of damage were raised at the Twentieth International Congress of the History Art in 1961. In his paper objecting categorically to retouching of any kind, Richard Offner cites the potential for falsification raised by the simplistic will in restorations to satisfy what he called "a universal greed for completeness." Offner, "Restoration and Conservation," in *Studies in Western Art: Acts of the 20th International Congress of the History of Art*, vol. 4, p. 156.

27. MS2A is a chemically reduced cyclic ketone resin manufactured by Linden Chemicals, headquartered in Algarve, Portugal.

28. We used R. Gamblin Conservation Colors (Portland, Oregon), comprising pigments ground in Laropal A81 urea-aldehyde resin (BASF).

Kathleen A. Foster and Mark S. Tucker

Conclusion: "Then and Now"

THE RECENT WHIRLWIND OF ACTIVITY surrounding Thomas Eakins's *Gross Clinic*, which began with the announcement of its pending sale in 2006 and culminated in the exhibition of the restored painting at the Philadelphia Museum of Art in 2010–11, offered us an opportunity to see this great work of art anew and from many perspectives: as a window into the history of science; as a piece of rhetoric addressed to the United States Centennial celebration; as a monumental artistic undertaking by an ambitious young painter; as a physical object altered over time; and as an image with a complex history of reception and interpretation. All of these stories are layered into this painting like glazes, beneath which glimmers the elusive identity of the painter; it has been thrilling to peer deeply into the surface of *The Gross Clinic* to explore these meanings.

As borne out in the layout of the exhibition, our exploration was divided into arenas of "Then and Now," inspired by the title of Samuel D. Gross's famous lecture to his entering students.[1] The visitor was first introduced to the context of the Centennial, then encountered *The Gross Clinic* displayed in a grand "salon" with *The Agnew Clinic* and *Professor Benjamin Howard Rand* (fig. 9.1)[2] before being presented, in a second gallery, with the research and findings of the conservation campaign and, finally, a documentary film produced for the occasion that showed the less-public face of the work done by the curators and conservators.[3] Having absorbed the history of the painting and its making, the story of the changes it has undergone over time, and its recent restoration, visitors circled back to see *The Gross Clinic* anew through the prism of the knowledge they had acquired. So, too, our study spiraled from "then" to "now" and back again, as evidence from the present examination led us to reassess the testimony of past spectators, and their observations in turn drove new questions.

Not all of these questions can be answered, of course, but some of the layers of meaning are closer to the surface than others. The most accessible story concerns the subject itself—Dr. Gross and his clinic at Jefferson Medical College. It is not hard to

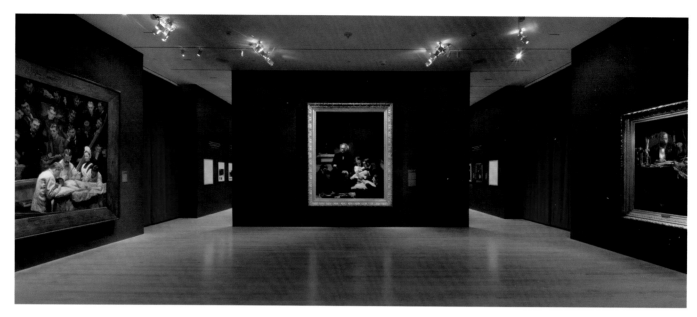

Fig. 9.1. Left to right: *The Agnew Clinic* (see fig. 7.1), *The Gross Clinic* (see frontispiece), and *Professor Benjamin Howard Rand* (see fig. 6.2) in the "salon" gallery of the exhibition *An Eakins Masterpiece Restored: Seeing "The Gross Clinic" Anew,* Philadelphia Museum of Art, 2010. Beyond this was a gallery that explored Eakins's painting technique, documented disruptions to his original tonal balances caused by early cleanings, and presented recent restorations undertaken to restore those balances. The final room was a theater for a documentary film that celebrated the 2007 acquisition of *The Gross Clinic*, expanded upon the visual content of the exhibition galleries, and showed visitors how the recent research and 2010 conservation treatment unfolded.

recover the important place that Gross, the "Emperor of American surgery,"[4] held in his profession in 1875. Nested in that subject are other stories—of the research in anatomy and innovation in surgery in Gross's lifetime; of the arrival of new knowledge about anesthesia, disease, bacteria, and antiseptic procedures; of the bolstering of the status of surgeons; and of the development of medical education in the United States. However unusual the subject may have seemed to his contemporaries in the art world, Eakins evidently saw Gross and his clinic as a Philadelphia story and a shining illustration of American progress, appropriate to the Centennial of the nation's birth. The artist left no written record of why he chose his subject. Perhaps it was because he knew Gross and

respected him. Perhaps he saw the surgeon as a self-made modern hero who represented the innovative thinking, discipline, and leadership that would propel teams of American scientists in the next century to new triumphs. Perhaps he hoped the project would open up new patronage. Perhaps he thought the subject would shock people and win him fame. All of these could be true; *The Gross Clinic* is a complex artifact, made over many months, distilling many of the artist's thoughts, emotions, and ambitions.

If we now understand Gross and the Centennial Exhibition in Philadelphia as the first layer of meaning for *The Gross Clinic,* it is interesting that Eakins's contemporaries, who had quite a lot to say about the picture (see the Appendix), wrote little about the

surgeon's distinguished reputation or the painting's glorification of modern American medical science and education as an expression of the Centennial message of progress. The reactions of those who saw *The Gross Clinic* in its original context remind us that we discern these grand themes from a distance impossible to achieve in 1876, when the response was more immediate and much about the painting's subject was either too alien or too obvious to be articulated.

What the first viewers did notice was the surgery—and the blood. Reading the period commentary and sorting our latter-day interpretations from the concerns of the original spectators, it becomes clear that the earliest audience for the painting was more various, subtle, and complicated in its response than has been acknowledged, but it was unanimously shocked by the depiction of surgery. Notwithstanding a small but distinguished group of precedents in pictures of anatomy lessons with gray cadavers, from Rembrandt van Rijn and Michiel van Mierevelt to Auguste Feyen-Perrin, surgery on a live patient was something very new and uncomfortable to contemplate in a painting. As the critic William C. Brownell noted in *Scribner's* in 1880, the painter "increased rather than diminished the intensity which it is evident he sought after, by taking for a theme a familiar and somewhat vulgar tragedy of every-day occurrence in American hospitals, instead of an historic incident of Rome or Egypt."[5] The combination of nudity, blood, and the possibility of death, enhanced by the remarkable professional detachment of the doctors as they confront these circumstances, created an astonishingly, almost intolerably modern scene, which Clarence Cook described in the *New York Tribune* as "one of the most powerful, horrible and yet fascinating pictures that has been painted anywhere in this century—a match, or more than a match, for David's 'Death of Marat,' or for Géricault's 'Wreck of the Medusa.'"[6]

In seeking comparable examples, Cook significantly put his finger on the contemporary setting: the murder of Marat and the shipwreck of the Medusa were recent headline stories for the respective artists, Jacques-Louis David (1784–1825) and Théodore Géricault (1791–1824). Susan Eakins, indignant about the jury's rejection of *The Agnew Clinic* for the Pennsylvania Academy of the Fine

Arts' 1891 exhibition because it "was not cheerful for ladies to look at," pointed to the plethora of violent, bloody paintings elsewhere in the Academy's galleries, but her examples were historical or mythological subjects, distant in time and space, while Eakins's work was modern.[7] The only other well-known surgical painting of this era, an 1887 canvas by Henri Gervex (1852–1929) titled *Before the Operation* (fig. 9.2), notably staged the figures in a sunny ward, prior to the procedure, and showed no bloody incision.[8] With Eakins's painting, contemporary viewers felt like they were "compelled" to look at something frightening and private that they shouldn't be seeing—but, as Cook protested, "Not to look at it is impossible."[9]

Even if we knew nothing about Eakins's personality and life experience, his choice of subject tells us much about him. First, it indicates his profound respect for the medical world and long association with Jefferson Medical College; clearly, Eakins aimed to compliment Gross and his community, just as he later even more obviously intended to please Agnew's students and associates at the University of Pennsylvania. Notably, the strongest objections to *The Gross Clinic* were heard when the painting was shown in art exhibitions; repeatedly, viewers commented that both of the artist's clinic paintings were appropriate in a medical school, but not in an art gallery visited by a general audience. Eakins's identification with the medical community would have been strengthened by his own decade of experience studying anatomy and dissection and depicting nude models, all of which desensitized him to the response of a nonprofessional audience to the naked human body.[10] Lloyd Goodrich noted that Eakins demonstrated "an obliviousness to popular reaction that was both naive and admirable,"[11] and indeed, beyond his acquisition of a dispassionate medical gaze, there seems to have been something obtuse and idealistic in his approach.

However, the inclusion of the recoiling "mother" betrays Eakins's awareness of the horror in this scene for the uninitiated, making it likely that he was also being deliberately modern, edgy, and aggressive. Such tendencies emerge throughout his career; many of his subjects seemed odd and unpicturesque to the critics,

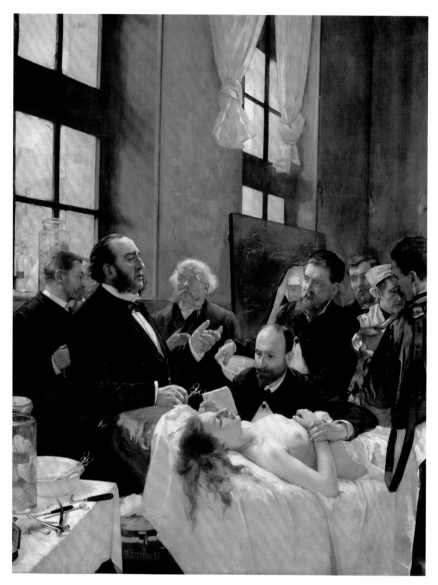

Fig. 9.2. Henri Gervex (French, 1852–1929), *Before the Operation (Dr. Jules Émile Péan Teaching His New Technique of Artery-Clamping at the Saint-Louis Hospital)*, 1887. Oil on canvas, 7 feet 11¼ inches × 6 feet 2 inches (242 × 188 cm). Musée d'Orsay, Paris. Courtesy Réunion des Musées Nationaux / Art Resource, New York

and, as Darrel Sewell remarked, his nudes consistently have the "ability to startle the viewer."[12] Scholars such as Michael Fried have suggested that there may be deeply buried personal narratives within such choices, driving the unresolved visual tension in Eakins's work.[13] At the very least, the scandals and contentiousness of his career suggest a troubled life. Taking a step back, however, we should remember that Eakins also had many heroes in Europe, from the Spanish Old Masters to French moderns such as David and Géricault, who challenged their audiences with similar subjects, and drew similar criticisms. His master, Jean-Léon Gérôme (1824–1904), was noted for sangfroid in treating

horrible subjects, such as *The Door of the Mosque El Assaneyn, with the Head of the Beys Massacred by Salek Kachef* of 1866 (Orientalist Museum, Qatar), which depicts Egyptian guards nonchalantly smoking alongside a pile of severed heads.[14] The naturalism that Eakins worshiped in Diego Velásquez (1599–1660) and Jusepe de Ribera (1591–1652) was also forcefully present in the younger painters he admired, such as Léon Bonnat (1833–1922), whose gruesome martyr subjects were the talk of the Paris Salon in the 1860s, when Eakins attended Bonnat's atelier. Bonnat's naturalistic *Christ* (Musée du Petit Palais, Paris), rumored to have been painted from a cadaver with chilling objectivity,

appeared at the Salon in 1874, inspiring revulsion and admiration in ways that echo the responses to *The Gross Clinic*. Eakins evidently took note: he would paint his own realist *Crucifixion* in 1880 (Philadelphia Museum of Art), seeking the appearance and affect of a frail human figure in natural light.[15] Evidently, he was not the only American to return from France with this taste: in 1882, a critic commented, "It is safe to say that nothing so fatal to artistic progress has ever been observed as the nightmare of ghastliness and brutality that seems to have settled on most of the pupils of Gérôme and Bonnat."[16]

Eakins also surely noticed Henri Regnault (1843–1871), another rising star in Paris in the 1860s, already anointed as an heir to Géricault and, like Bonnat, deeply smitten by Spanish naturalism. Just a year older than Eakins, the precocious Regnault won a Prix de Rome in 1866, the year Eakins arrived in Paris. He used his fellowship to travel in Spain in 1868–69, a few months before Eakins made the same trip. Moving on to Morocco, Regnault sent his sensational, insouciant *Salomé* (Metropolitan Museum of Art, New York) from Tangiers to the Salon of 1870, where Eakins studied it at length, making notes in his pocket journal.[17] The following year, Regnault was killed in action in the siege of Paris; his death at age twenty-seven rocked the art community, inspiring many subsequent paintings and an elaborate memorial in the court of the École des Beaux-Arts. Surely Eakins knew about Regnault's final work, *Execution without Trial under the Moor Kings of Grenada* of 1870 (fig. 9.3), which was purchased by the state and exhibited to much acclaim and controversy at a retrospective in Paris and at international exhibitions in London in 1871 and Vienna in 1873.[18]

Regnault's dramatic painting clearly speaks Eakins's language, though *Execution without Trial*, like *Salomé*, is more dazzlingly colorful and exotically distanced in space and time than *The Gross Clinic*. If, however, we substitute the romance of modern science for the fantasy of Orientalist cruelty, commonalities emerge. A master of perspective, Regnault places the horizon low, to set the severed head of the victim at the eye level of the viewer and make the executioner loom above us menacingly. His manipulation of the viewpoint also

Fig. 9.3. Henri Regnault (French, 1843–1871), *Execution without Trial under the Moor Kings of Grenada*, 1870. Oil on canvas, 10 feet × 4 feet 9½ inches (305 × 146 cm). Musée d'Orsay, Paris. Courtesy Réunion des Musées Nationaux / Art Resource, New York

thrusts the body of the dead man at the viewer, confusingly twisted and drastically foreshortened, a visual puzzle at once horribly enticing and repellent. Almost emotionless, the executioner coolly cleans his blade with his splendid robe and turns away, demonstrating a businesslike attitude that repeatedly thrilled contemporary critics.

Execution without Trial, like *The Gross Clinic*, features blood, knives, prostrate bodies, and a towering authority figure, and Regnault's painting attracted both praise and censure that are echoed in the critical response to Eakins's canvas and Bonnat's *Christ*. Although people were said to become faint at the sight of the blood dripping down the stairs in *Execution without Trial*, the effect was nonetheless praised in 1877 by the American critic S. G. W. Benjamin as "one of the finest bits of color in modern art." Even so, Benjamin thought that it was "a mistake to treat such a subject in this large style and realistic way, or, in fact, to choose it at all." Disregarding the laws of good taste and social ethics, the painting exerted "demoralizing influences" akin to the experience of watching such a scene in real life. "There seems to be an impropriety in admitting such a work to a public national gallery," asserted Benjamin, though he conceded that it could be exhibited more privately, "purely as a work of art, to those who would study it only from such a point of view."[19] When discussing *The Gross Clinic* a few years later, Benjamin likewise questioned the "propriety" of introducing such brutal subjects and invoked Regnault's work; like an execution, surgery was something that the public just should not see. This sentiment was shared by other critics of *The Gross Clinic,* who felt that more private or professional venues would be acceptable. As Benjamin's linkage between Eakins and Regnault and the parallel responses to unexpectedly bloody subjects on both sides of the Atlantic indicate, Eakins was driving into territory worked by some of the artists he most admired, hoping to create a painting that stood alongside the work of his heroes in the Prado and to win attention in the manner of his most popular and controversial contemporaries in Paris. We are reminded of Eakins's ambition, his eye on the Salon, and the lessons in large-scale, high-drama painting he

had learned in France and Spain. Reinterpreting these traditions with his own secular, naturalistic, democratic credo, he aimed to make Old Master paintings for modern America, and sensational contemporary art.[20]

Without the ingratiating color and Oriental exoticism of Regnault's work, the éclat of *The Gross Clinic* depended entirely on the astonishing realism of its subject. How Eakins accomplished this illusion has been the second topic of this study. Contemporary viewers had little sense of how the artist built his image, and he never described his method, so this layer of meaning was revealed exclusively by examination and analysis, which yielded many insights into his habits and aesthetic values. Modernist scholars often focus on process out of a general fascination with creativity or a desire to understand and amplify, by visual and technical analysis, the living presence of the object, celebrated almost without context. But the study of process also gives us access to the mind of the artist and to the larger culture in which he or she worked, which may be increasingly foreign as techniques and ways of seeing are lost or forgotten. As the overcleaning of *The Gross Clinic* (and many other paintings by Eakins) demonstrates, his taste and technique were misunderstood within a decade of his death.

Our first lesson in Eakins's process came from the evidence of changes he made in the painting. After more than a century of celebrity, *The Gross Clinic*, with its seeming naturalness and immediacy, has taken on an air of inevitability: it looks so real, so familiar, that surely this scene of surgery happened just as the artist depicted it. The discovery of alterations in the X-radiograph (see fig. 5.7) overturns that resolution, restoring a sense of the painter's initial excitement, experimental problem-solving, and artistic agency. His choices show that the painting could have been otherwise, and that he worked with care and good judgment to make it better. The X-radiograph also reminds us that Eakins, who was young and had never painted anything this large and complicated, was the creator of the space he depicts, not the passive realist recording "American life" as he found it, as many of his admirers have insisted. This understanding makes it unnecessary to find corroborating photographs of the interior of the surgical amphitheater at Jefferson, just as it undermines the need to identify

every Eakins background as a "real" space: all are invented, convincing, and willfully manipulated pictorial worlds. Changes in the position of the clerk in *The Gross Clinic* (see fig. 5.12) and in the foreground wall in both clinic paintings demonstrate clearly that Eakins was willing to revise his own spatial layout to improve his composition; perspective, his special realm of expertise, was a tool, not a master. By taking us back to the urgency of the painting's earliest stages and through Eakins's judicious refinements, the X-radiograph alone justifies an entirely new appreciation for his capacity and determination to paint a masterpiece.

Eakins's success in creating a convincing sense of space in *The Gross Clinic* rested upon the most rational and least visible of his strategies, linear perspective. The artist's scheme remains elusive, partly because the preparatory drawings he must surely have made did not survive, but also because of his artful campaign to remove clues from the image that would reveal his viewing position, which was actually far more distant (for purposes of constructing the space) than the immediacy his final effect suggests. His plan and elevation of the scene, blocked out before he began the painting, would have expressed a carefully worked-out solution to his problem: arranging his figures so that most of the doctors could be recognized, yet giving a clear view of the surgery and eminence to Dr. Gross. One doctor's face was concealed and the patient's identity obscured by the artist's final choice of vantage; perhaps, given all the factors he was negotiating, Eakins felt that the confusing end-view of the patient was the most informative overall, and so the best of many solutions. Certainly the doctors were his priority, and the objectification of the patient could have been out of respect for the boy's privacy, hoping to make the figure less personal, and so less charged. But for some viewers this suppression and obfuscation drew more attention to the patient. Even Eakins's friend William J. Clark, Jr., otherwise so full of praise, objected "on technical grounds" to "the management of the figure of the patient. The idea of the artist has obviously been to obtrude this figure as little as possible, and in carrying out this idea he has foreshortened it to such an extent, and has so covered it up with the arms and hands of the

assisting surgeons, that it is extremely difficult to make it out. It is a mistake to introduce a puzzle in a picture, and this figure is, at first glance, a decided puzzle."[21]

This puzzling figure in *The Gross Clinic* brings to mind Regnault's equally perplexing foreshortened corpse in *Execution without Trial*, suggesting that Eakins may have been deliberately provocative in his choice to put the incision right under our noses. *The Agnew Clinic* (see fig. 7.1), which—as in so many other ways—reworks the factors in this equation to the most different solution possible, shows the patient coherently, turned sideways, with the site of operation hidden. Was Eakins just seeking maximum novelty in *The Agnew Clinic*, or did he regret his earlier "decided puzzle"? And what about the hysterical "mother," who forcefully introduces the personal life of the patient—and also demonstrates that Eakins was fully aware of the reaction a layperson might have to this scene? No one occupies this territory—emotionally or compositionally—in *The Agnew Clinic*. Examination of the painting and analysis of the inherent perspective scheme confirm the awkwardness of her late arrival into the composition, exposing Eakins's tendency to work in a fragmented way, leaving the margins of his pictures to the end of the process. Again, we are reminded of Eakins's agency, the difficulty of his pictorial problem, and the deliberateness of his choices.

In addition to his careful manipulation of linear perspective, another source of power in *The Gross Clinic* is the modeling of the figures and the creation of an atmospheric space, bringing the scaffold of the perspective system into astonishing relief. Eakins began constructing this effect at the bedrock of the painting, with broad areas blocked in with moderately dark or intensely colored base tones. Close examination reveals the surprisingly idiosyncratic technique that followed: heavily impasted underpainting in the figures, and surprisingly strong colors in the background, all modified and to varying degrees obscured by successive layers of paint and glazes. This technique, Eakins asserted, was the only one that could give "la delicatesse et la force en même temps" (delicacy and strength at the same time),[22] serving a grand conceptual balance by which refined tonal gradations and relationships accomplished in

upper layers complement a powerful, broad structure set down at the start. Working backward from the finished effects he saw in Old Master paintings and attempting to re-create their luminous chiaroscuro, Eakins invented a personal method that had a physical and philosophical logic. Built up, literally, on a solid base constructed from broad strokes of the palette knife, many of his forms were modeled in paint with a sculptor's sensibility, reminding us of Eakins's fondness for modeling figures in clay and his insistence that his painting students do the same, to get a sense of form turning in space. The bright layers of underpaint likewise show a literalness grasped at the outset: the "real" local color of an object in sunlight was set down on the canvas and then gradually dimmed by glazes embodying intervening space or shadow.[23]

Both of these unconventional techniques demonstrate how Eakins, one of the most highly trained "academics" of his generation, was in fact something of an outsider, effectively self-taught, struggling in isolation in his studio, as a critic noted in 1881, "like an inventor working [out] curious & interesting problems for himself."[24] His method was, in a larger sense, a model of an academic system—with phases of drawing, perspective planning, oil sketching, and layout of the final canvas—but it was skewed to emphasize his special passions, such as anatomical study and perspective, and suppress practices he found difficult or wasteful, such as pencil sketching. The complicated method that unfolded in the making of *The Gross Clinic* illustrates his conviction, recorded in his pocket journal in 1870, that he worked best when problems were divided into compartmentalized tasks and conquered step by step.[25] Both composite and incremental, his method aimed at a realism that—unlike Impressionism or naturalism—was indirect, selective, and ponderously artificial in its execution. Apart from his subject, his painting meant to demonstrate, as his friend Clark wrote, "the command of all the resources of a thoroughly trained artist, and the absolute knowledge of principles which lie at the base of all correct and profitable artistic practice."[26] Arming himself with many strategies to insure the accuracy of his effect, including photographs and perspective layouts, and building his surface tones with a thousand overlaid

refinements and adjustments, Eakins controlled the world of his picture and modeled the role of modern painter.

The cumulative impact of these final touches brought his composition into unity and coherence, creating the compelling effect of space in *The Gross Clinic*. In doing this, Eakins drew on his mastery of light—what he called nature's "big tool"—to build a sense of bodies, textiles, and intervening air, as well as the emotional aura of mystery, terror, inspiration, and discipline that lies at the core of the painting's impact. In alliance with his calculated, rational perspective planning, Eakins's more intuitive, visual construction of form in space created *The Gross Clinic*'s compelling illusion, an effect that contemporary critics frequently described as its "force."[27] Although the painting has sometimes been described as photographic, William C. Brownell declared in 1880 that "a photograph would have fallen far short of the intensity of reproduction which the picture possessed."[28] Indeed, far from being uniformly detailed like a photograph, the surface of the painting is varied and visually dramatic, with broken, dotted contours and abrupt shifts in texture and focus in the manner of Rembrandt or Regnault. The stomach-turning, slippery blood delicately depicted on Gross's hand appears against a broadly troweled background mere inches away. Such contrasts, along with the blurring of the immediate foreground and the dimming of the background, serve to direct attention to the principal figures, enhancing the sense of high relief around Gross while maintaining the atmospheric unity of the entire group. Earl Shinn, Eakins's studio mate in Paris, complimented him as another painter would by remarking that the figures were "well subdued"; nonprofessionals like Brownell simply described the effect as "intense realism."[29] That effect, especially when seen from the proper viewing distance, created an illusion so natural that it disarmed all sense of the artist's extravagantly artificial process.

In drawing attention to the proper subordination of secondary figures, Shinn was responding particularly to the management of light and dark values—what Eakins called "true tones."[30] *The Gross Clinic* teaches us the importance of this delicate balance to Eakins's

effect, which resulted from thousands of fine choices the artist made across the surface of the painting, subduing certain areas, drawing other points forward, creating a sense of truthfulness and unity. Notwithstanding the growing taste for bright color in the 1870s, many painters and critics of the time believed that the mastery of chiaroscuro was the pinnacle of the painter's art, the first proof of deep and sensitive insights about the nature of the visible. In 1889 the sophisticated American critic Mariana Griswold Van Rensselaer asserted no less than that "the profound and accurate study of values—the knowledge how to keep tone perfect and yet keep color complete and true—is the greatest technical achievement of modern times."[31] If the language of tone had a common "grammar," it also allowed individual "syntax." Perfect tone could be accomplished by many paths, and personal choices in rendering and composing values provided a means for individual expression. As the artist and author of art manuals Karl Robert wrote in 1884, "It is in fact the correct observation of values [of light and dark] that constitutes the true skill of the artist, and, given that each person sees the visual world differently, it is on this that personality and originality are based."[32]

Eakins expressed his "personality and originality" in this aesthetic of tones by pushing to an extreme of darkness. His personal taste for low tones was, as Clark noted, especially hard to appreciate in an unevenly lit nineteenth-century gallery.[33] Some viewers didn't like the "tendency to blackness in the flesh-shades," while critic Susan N. Carter lamented, "It is a cause for regret that this able artist does not adopt a less smoky scheme of colors."[34] Van Rensselaer, the connoisseur of perfect tone, found "discordances in the scale of color" of *The Gross Clinic*, "which was too sombre to be so intensely vivified by the blood stains."[35] Such comments reveal the artist's fundamental organizing structure based on strong lights emerging from deep shadow, "vivified" by startling notes of red. Detailed examination of the painting in 2009 revealed that much of this effect had been lost due to earlier cleanings, and that *The Gross Clinic* was in many places lighter than it had been in 1875. Unlike many conservation campaigns, which seek to recover color and light in a painting by removing

grime and varnish, the 2010 restoration of *The Gross Clinic* returned passages mistakenly lightened by overcleaning to the closest possible semblance of their original darkness by inpainting areas of final glazes lost to abrasion. The responses of nineteenth-century critics (both positive and negative) helped consolidate our understanding of the painting's impact when it was new, confirm the evidence of its alteration, and guide our efforts to restore the tonality that Eakins sought.

A final remedy to the long-standing disunity of the painting concerned how it was lit in the gallery, a factor absolutely critical to nineteenth-century eyes sensitive to the benefits and perils of various colors and intensities of light. Eakins understood that light could wreak havoc on color and tone, and he puzzled over ways to anticipate the exhibition environment of his paintings.[36] *The Gross Clinic*, with its large passages of darks requiring a gloss varnish to define their tones, is by any standard a difficult picture to light. The solution, if one is set on full and simultaneous disclosure of the entire surface, is to light it very strongly, which was done throughout much of the twentieth century using intense and excessively warm-toned incandescent light of a kind that Eakins never imagined while making his finest judgments of color and tone under diffuse daylight.[37] Twentieth-century viewers' experience of the painting was sadly the poorer for a general loss of awareness of the ways Eakins's work acknowledged and played to a centuries-old taste for the deft use of intentional obscurity, for artful suggestion rather than literal exposition, for the slow unfolding of a picture as eyes rationalize and the imagination completes its internal world. We have found time after time that Eakins paintings, as low in key as they often are, activate in remarkable ways when lit with a modest level of properly color-balanced light resembling subdued daylight. As paradoxical as it may seem, the gripping effect of the painting's overall mood, illusionistic clarity, and power, remarked upon by so many visitors to the 2010–11 exhibition, was the result not just of the restoration, but of lighting this predominately dark picture at a lower level than in any gallery in which it had been displayed in the previous forty years or more. The carefully selected and installed

daylight-balanced lights produced a softer, cooler illumination, so that color values of the painting united much more as they had in Eakins's studio.[38]

In attempting to recover the visual experience of the past, our encounter with *The Gross Clinic* brought us full circle, returning us to the circumstances of the painting's creation and the earliest responses it provoked in order to inform our present-day examination and restoration. In the latter, we have aimed to restore the balance, focus, and effect the painting had when new, as indicated by the combined evidence of its original appearance and our study of Eakins's method. As part of this campaign, we have also hoped to elucidate for present-day viewers the visual language of tonal thinking so important and familiar to nineteenth-century academic artists and their audience, and point out how such thinking manifested itself in Eakins's work and the responses of his critics. Carter, writing the kind of mixed review that *The Gross Clinic* received on more than one occasion, commented in the *Art Journal* in 1879:

> There is a great deal of good composition in the massing of lights and shadows in this picture which cannot fail to commend itself; but the least critical person must have found the colour of the background black and disagreeable; and to sensitive and instinctively artistic natures such a treatment as this one, of such a subject, must be felt as a degradation of Art.[39]

Carter's comments demonstrate how audiences of Eakins's time appraised the way both the subject and its presentation—the look of the painting—confronted and engaged the viewer. Her invocation of critical standards about tone and color confirm what Eakins and all academic painters well knew and took into consideration at every stage of painting: that handling of pictorial tone was a key yardstick for pictorial achievement. Carter also assumes the sensitivity of even "the least critical person" to this dimension of pictorial language. Those possessing more cultivated critical faculties, of course, could effortlessly connect a matter of an artist's formal proclivities to an overarching moral judgment. For "sensitive and instinctively artistic

natures," it is not only the subject of the picture that is deemed a "degradation of Art," but particularly "such a treatment as this one"—the means of its representation. The importance, and impressiveness, of this melding of subject and effect seems to be part of the enduring power of *The Gross Clinic*. More than a century later, Randy Kennedy of the *New York Times* responded to this quality of the viewing experience, describing the restored painting in July of 2010 as "glowering once again with all the menace and murk its creator intended,"[40] noting once more how its particular emotional effect is bound inextricably to tone and key.

Herbert Spencer, the most popular philosopher in the English-speaking world in Eakins's lifetime and a writer the artist cited in letters to his father from Paris, argued that communication between object and viewer requires energy on both sides.[41] The artist (or the object) must skillfully present a message; the conscientious viewer must be educated and prepared to engage in the work required to read the object well. The richer the object and the more prepared and dedicated the observer, the more profound the exchange. Over time, such communication can erode if the object is damaged or altered, or if the audience loses knowledge or interest. Put in the terms of this project, Eakins's message and accomplishment cannot be sufficiently understood unless the painting itself expresses his intended effect in greater measure, and until the spectator has been taught to perceive and appreciate all the meanings he vested in such a complex object. Linking past to present, this book hopes to restore, in Spencerian fashion, the knowledgeable viewer, so that spectators today can see and understand Eakins's intentions and the nuances of his effect. This is a nineteenth-century position, now largely supplanted by postmodern theory, which welcomes the subjective experience of each new viewer as a valid response to any work of art. Indeed, great works of art are often those that remain stimulating to new audiences, sometimes for reasons far from the original intentions of the artist. Postmodernists would also assert that the past is largely unknowable and that "history" is a subjective construction, continually rebuilt to suit the agendas of each new moment. Recognizing these

conditions, the traditional art-historical mission of the curator and the conservator nonetheless endures in the museum context, hoping to preserve, albeit incompletely, the experience of the past, and to carry forward what understanding is possible of the original context of the work of art and the inspiration, constraints, and skills of its maker. With this knowledge, and with the painting now brought closer to its original appearance than it has been in almost a century, we have the thrill of seeing *The Gross Clinic* anew.

1. Samuel D. Gross, *Then and Now: A Discourse Introductory to the Forty-third Course of Lectures in the Jefferson Medical College of Philadelphia* (Philadelphia: Collins, 1867). See also Julie S. Berkowitz, *Adorn the Halls: History of the Art Collection at Thomas Jefferson University* (Philadelphia: Thomas Jefferson University, 1999), pp. 142–43.

2. Our effort to create a nineteenth-century context for the paintings was aided by the fact that all three retain their original frames, each evocative of its specific historical moment.

3. The twenty-four-minute documentary, *An Eakins Masterpiece Restored: Seeing "The Gross Clinic" Anew*, was produced by Suzanne P. Penn, Conservation Department, and the Audio-Visual Department, Philadelphia Museum of Art, 2010, with a generous grant from the Richard C. von Hess Foundation. Available on DVD, it recounts the 2006 campaign to keep the painting in Philadelphia, research into Eakins's technique and the changes his paintings have undergone, and the aims and process of the 2010 restoration.

4. Berkowitz, *Adorn the Halls*, p. 141.

5. William C. Brownell, "The Younger Painters of America," *Scribner's Monthly*, vol. 20, no. 1 (May 1880), p. 12 (see Appendix).

6. [Clarence Cook], "The Society of American Artists: Second Annual Exhibition—Varnishing Day," *New York Tribune*, March 8, 1879, p. 5 (see Appendix). See Ellwood C. Parry III, "*The Gross Clinic* as Anatomy Lesson and Memorial Portrait," *Art Quarterly*, vol. 32, no. 4 (1969), pp. 376–80, discussing Rembrandt's *Anatomy Lesson of Dr. Tulp* of 1632 (Mauritshuis Museum, The Hague) and Feyen-Perrin's *Anatomy Lesson of Dr. Velpeau* of 1864 (Musée de l'Assistance Publique-Hôpitaux de Paris), a work that was exhibited without controversy at the Centennial art exhibition. Elizabeth Johns enlarges on such precedents in *Thomas Eakins: The Heroism of Modern Life* (Princeton, NJ: Princeton University Press, 1983), pp. 70–75. John Maas adds the precedent of Mierevelt's *Anatomy Lesson of Dr. Willem van der Meer* of 1617 (Stedelijk Museum Het Prinsenhof, Delft) in "Surgery and Sex" (typescript, 1983), pp. 7–9, 15; Lloyd and Edith Havens Goodrich, Record of Works by Thomas Eakins, Philadelphia Museum of Art. Michael Fried, *Realism, Writing, Disfiguration: On Thomas Eakins and Stephen Crane* (Chicago: University of Chicago Press, 1987), pp. 8–10, was dubious about the relevance of these precedents, reminding us of the danger of normalizing with such contextualization a painting that was strikingly original and aggressive. Even fifty-five years later, the Motion Picture Production Code (the so-called Hays Code), adopted in 1930 to identify and limit morally objectionable content in films, included "Surgical operations" under Section XII, "Repellent Subjects" to be avoided in motion pictures produced as popular entertainment.

7. Susan Eakins cited William-Adolphe Bouguereau's *Orestes Pursued by the Furies* of 1862 (now in the Chrysler Collection, Norfolk, Virginia), given to the Academy by Mrs. Sarah Harrison in 1878 and in the 1890s installed over the main stairway, including its "most prominent figure a nearly nude woman with a dagger stuck in her heart with the blood gushing out," as well as Benjamin West's "*Death on a Pale Horse* and other horrors"; "Notes on Thomas Eakins," Charles Bregler's Thomas Eakins Collection, Pennsylvania Academy of the Fine Arts, microfiche series II 4/A/4–5 (hereinafter cited as Bregler Collection, PAFA). Contemporary battle paintings, such as P. F. Rothermel's huge Civil War panorama *Battle of Gettysburg* of 1871 (State Museum of Pennsylvania, Harrisburg), featured at the Centennial, seem to have been exempted from this rule, perhaps because they were framed by historical and patriotic rationales.

8. Maas, "Surgery and Sex," pp. 10–12, notes the similarities between *The Agnew Clinic* and Gervex's composition and claims that several reproductions of *Before the Operation* would have been available to Eakins; he describes Dr. Péan's expertise in breast surgery, as well as his famous calm demeanor, and notes that French observers praised Gervex's painting as a "timely and gripping" depiction of modern progress. Contemporary French critics also noted the eroticized treatment of the subject, and credited Gervex with inspiring a "flood" of similar hospital pictures in France in the following decades.

9. [Cook], "Society of American Artists," p. 5. Sarah Burns, *Painting the Dark Side: Art and the Gothic Imagination in Nineteenth-Century America* (Berkeley: University of California Press, 2004), pp. 188–205, argues that the public was sensitized to the violence in this surgical subject because of contemporary scandals concerning use of corpses stolen from cemeteries for anatomical dissection in medical schools, as well as outrage over vivisectionist research.

10. Amy Werbel, *Thomas Eakins: Art, Medicine, and Sexuality in Nineteenth-Century Philadelphia* (New Haven, CT: Yale University Press, 2007), pp. 35, 49–52, commented on this "medical vision," noting that the clinic paintings were for "initiates."

11. Lloyd Goodrich, *Thomas Eakins*, 2 vols. (Cambridge, MA: Harvard University Press for the National Gallery of Art, 1982), vol. 1, p. 126.

12. Darrel Sewell, "Thomas Eakins and American Art," in Sewell et al., *Thomas Eakins*, exh. cat. (Philadelphia: Philadelphia Museum of Art, 2001), p. xvi.

13. See Fried, *Realism, Writing, Disfiguration*, pp. 1–90.

14. After appearing at the Salon, this painting was purchased in 1866 by A. T. Stewart, an American collector in Paris, but not before it was reproduced by Goupil and Company. See Gerald Ackerman, *The Life and Work of Jean-Léon Gérôme, with a Catalogue Raisonné* (New York: Sotheby's, 1985), no. 161, p. 218. In this period, Gérôme also painted several contemporary and historical murder subjects, including *The Duel after the Masked Ball* of 1857 (Musée Condé, Chantilly, France), *The Death of Caesar* of 1867 (Walters Art Museum, Baltimore), and *The Death of Marshal Ney* of 1868 (Graves Art Gallery, Sheffield, England), all known to Eakins from reproductions or exhibition at the Exposition Universelle of 1867.

15. Bonnat's *Christ*, also known as *Christ on the Cross*, was the sensation of the Salon of 1874, a moment when Eakins was attentive to art news from Paris because his own paintings were on view there. The criticism of this painting in the French press echoes in an uncanny fashion the response of American critics to *The Gross Clinic*; see Kathleen A. Foster, *Thomas Eakins Rediscovered: Charles Bregler's Thomas Eakins Collection at the Pennsylvania Academy of the Fine Arts* (Philadelphia: Pennsylvania Academy of the Fine Arts; New Haven, CT: Yale University Press, 1997), pp. 44–45, 241n35. On Eakins and Bonnat, see Elizabeth Milroy, "'Consummatum Est . . .': A Reassessment of Thomas Eakins's *Crucifixion*," *Art Bulletin*, vol. 71, no. 2 (June 1989), pp. 269–84. On Bonnat's painting and the tradition of such violent subjects in French art from David and Géricault to the end of the nineteenth century, see Jean Clair et al., *Crime et Châtiment*, exh. cat. (Paris: Musée d'Orsay, 2010), p. 175.

16. "The Fine Arts," *Philadelphia Press*, January 20, 1882, p. 2.

17. Earl Shinn, who was in Paris with Eakins, described Regnault as a "sort of later Velasquez"; *The Nation*, vol. 19, no. 494 (December 17, 1874), p. 405. On Eakins and Regnault, see Foster, *Thomas Eakins Rediscovered*, pp. 47, 251n52. Goodrich, *Thomas Eakins*, vol. 1, p. 63, excerpts Eakins's original French text from the Spanish notebook (now in the Bregler Collection, PAFA), with translations. Another translation appears in William Innes Homer, ed., *The Paris Letters of Thomas Eakins* (Princeton, NJ: Princeton University Press, 2009), p. 305. Charles Blanc, *Les Artistes de mon Temps* (Paris: Librarie de Firmin-Didot, 1876), p. 357, described "une sorte de poésie sauvage de l'extreme réalité des choses" (a kind of savage poetry of the extreme reality of things) in *Execution without Trial* and commented on the unfortunate modern taste for "bizarrerie" indulged by Regnault's followers. For additional period bibliography on Regnault and his *Salomé*, see Charles Sterling and Margaretta M. Salinger, *French Paintings: A Catalogue of the Collection of the Metropolitan Museum of Art*, vol. 2, *XIX Century* (New York: Metropolitan Museum of Art, 1966), pp. 200–204.

18. The French title is *Execution sans jugement sous les rois maures de Grenade*, sometimes translated as *Summary Execution under the Moorish Kings of Grenada*. Alice Meynell, "Henri Regnault, *Magazine of Art*, vol. 4 (1881), p. 73, noted that "the picture has been made familiar to the public of every city in Europe by means of the engravings." On the emotional outpouring after his death and the cult of Regnault, see Marc Gottlieb, "Legends of the Painter Hero: Remembering Henri Regnault," in *Nationalism and French Visual Culture, 1870–1914*, ed. June Hargrove and Neil McWilliam, Studies in the History of Art 68 (Washington, DC: National Gallery of Art, 2005), pp. 101–27.

19. S. G. W. Benjamin, *Contemporary Art in Europe* (New York: Harper and Brothers, 1877), p. 102. Burns, *Painting the Dark Side*, pp. 205–6, also noted the connection made between *The Gross Clinic* and Regnault's *Execution* by Susan N. Carter in *The Art Journal* in 1879 (see Appendix), as well as American distaste for the "perverted sensualism" of contemporary French art.

20. Although he was inspired by the realism of Bonnat and Regnault, Eakins rarely ventured biblical or exotic subjects, with the exceptions of his *Crucifixion* of 1880 (Philadelphia Museum of Art) and his American analogs to Gérôme's picturesque genre figures, discovered in cowboys, fishermen, and athletes. He was also disdainful of "coal-scuttle" naturalists, who painted low subjects with extreme fidelity to appearances. Setting his own naturalist mission on a different tack, he adopted a composite realism that embraced pictorial manipulation and artifice; see Thomas Eakins to Benjamin Eakins, March 6, 1868, in Homer, *The Paris Letters of Thomas Eakins*, 2009, pp. 197–99.

21. William J. Clark, Jr., "The Fine Arts: Eakins' Portrait of Dr. Gross, *Philadelphia Evening Telegraph*, April 28, 1876, p. 4. Another writer, evidently paraphrasing Clark, noted: "The one serious fault in the picture is the manner in which the body of the patient is treated. It is so much foreshortened and so covered by the arms of the clinical assistants that it is a perfect puzzle. The artist's intention evidently was to render this portion of the painting as free from the disagreeable as possible. He has succeeded so well as to bring upon himself rather severe criticism. Indeed, it is difficult to discover whether the incised limb of the patient be the leg or an attenuated thigh. It more nearly resembles the latter." W. H. Workman, "Letter from Philadelphia," *Boston Medical and Surgical Journal*, vol. 95, no. 5 (1876), p. 153. A correspondent for a medical journal was confused enough to describe the surgery as an amputation; see Richard J. Dunglison, "Correspondence: Medical Centennial Affairs," *Medical Record*, vol. 11 (1876), p. 389. See the Appendix for excerpts of all three reviews.

22. Eakins, Spanish notebook (Bregler Collection, PAFA); quoted in Goodrich, *Thomas Eakins*, vol. 1, p. 61. The balancing of delicacy and strength was a pictorial ideal that Eakins apparently passed along to Susan Macdowell

Eakins; she would invoke the paired terms in a March 27, 1934, letter to Charles H. Sawyer, director of the Addison Gallery of American Art, pointing out that an unsatisfactory photograph of *Elizabeth at the Piano* (1875) failed to capture "the delicacy and strength of the original" (Addison Gallery of American Art, Phillips Academy, Andover, Massachusetts). For further discussion of the importance of tonal values for many artists and critics in this period and the implications for Eakins's own aesthetics and technique, see Mark Tucker and Nica Gutman, "The Pursuit of 'True Tones,'" in Sewell et al., *Thomas Eakins*, pp. 353–65.

23. An example of this practice can be seen in Eakins's *Between Rounds* of 1898–99 (Philadelphia Museum of Art), where he painted the distant banner at the left a bright red and yellow—perhaps its actual color—which were subsequently layered with a blackish glaze to create a sense of the smoky atmosphere of the boxing arena. The overcleaning of this distant zone of the painting, resulting in a visual disruption similar to the lightening of the doorway in *The Gross Clinic*, was mitigated through restoration of the lost parts of the glaze in 2001; see Tucker and Gutman, "The Pursuit of 'True Tones,'" pp. 354–56. The bright color in the rowing sketch beneath his compositional study for *The Gross Clinic* (see fig. 5.6) suggests the work of Auguste Renoir and Claude Monet at this date, illustrating Eakins's account of how he "made a little boat out of a cigar box, and rag figures with red and white shirts, and blue ribbons around their heads, and put them out in the sunlight on the roof and painted them, and tried to get the true tones." See Goodrich, *Thomas Eakins*, vol. 1, p. 108.

24. Mariana Griswold Van Rensselaer to S. R. Koehler, June 12, 1881, S. R. Koehler Papers, Archives of American Art, Smithsonian Institution, Washington, DC; cited in Sewell, "Thomas Eakins and American Art," p. xi. Van Rensselaer visited Eakins in his studio in 1881 and came away with the impression of him as a "decidedly . . . *lower* middle class" man, "a clever but most eccentric mechanic"; cited in ibid.

25. "All the progress that I have made until today," Eakins wrote in 1870, "has been the result of discoveries that have allowed me to divide my powers and means of working. Always divide to begin as strongly as possible." Spanish notebook, Bregler Collection, PAFA; quoted in Foster, *Thomas Eakins Rediscovered*, p. 50.

26. Clark, "Eakins' Portrait of Dr. Gross," p. 4.

27. Thomas Eakins to Benjamin Eakins, March 6, 1868, in Homer, *The Paris Letters of Thomas Eakins*, pp. 197–99. For comments on the forcefulness and power of the painting, see the 1879 reviews from the New York *Herald*, *Daily Graphic*, *Times*, and *Tribune* and the *American Architect and Building News*, as well as Charles H. Caffin's 1904 comments in *The Critic*, all reprinted in the Appendix.

28. William C. Brownell, "The Younger Painters of America," *Scribner's Monthly*, vol. 20, no. 1 (May 1880), p. 4 (see Appendix).

29. [Earl Shinn], "Fine Arts: Exhibition by the Society of American Artists," *The Nation*, vol. 28, no. 716 (1879), p. 207 (see Appendix).

30. Goodrich, *Thomas Eakins*, vol. 1, p. 108.

31. Mariana Griswold Von Rensselaer, *Six Portraits: Della Robbia, Correggio, Blake, Corot, George Fuller and Winslow Homer* (Boston: Houghton Mifflin, 1889), p. 185.

32. Karl Robert, *Traité pratique de peinture à l'huile (Paysage)*, 4th ed. (Paris: Georges Meusnier, 1884), pp. 99–100; cited in Albert Boime, *The Academy and French Painting in the Nineteenth Century* (London: Phaidon, 1971), p. 153.

33. William J. Clark, Jr., "The Centennial: The Art Department: American Section," *Philadelphia Evening Telegraph*, June 16, 1876, p. 2 (see Appendix).

34. [Shinn], "Fine Arts," p. 207; [Susan N. Carter], "The Academy Exhibition," *Art Journal*, n.s., vol. 5 (May 1879), p. 158 (see Appendix). Marc Simpson, "The 1870s," in Sewell et al., *Thomas Eakins*, p. 32, notes similar

comments about the "blackish fog" in *Elizabeth at the Piano* (Addison Gallery of American Art), also shown at the Centennial, in which "blackness descended like a blight." Simpson (p. 34) also cites similar comments made in this period about *The Chess Players*, described as "voluntarily" or "mistakenly" painted in a low tone, which if "well flooded with light" compared favorably to the best modern French painting.

35. M[ariana] G[riswold] Van Rensselaer, "The Spring Exhibitions in New York: The National Academy of Design, the Society of American Artists, etc.," *American Architect and Building News*, vol. 5, no. 176 (1879), p. 149 (see Appendix).

36. Eakins was obsessed by the impact of different lighting on his pictures. "A picture suitable for any sort of light can be utterly spoiled by too strong a light," he commented in the Spanish notebook (Bregler Collection, PAFA) translation from Homer, *The Paris Letters of Thomas Eakins,* p. 306. On his struggles with the impact of changing light, see his draft of a letter to Gérôme, in Foster, *Thomas Eakins Rediscovered,* pp. 135–36.

37. It is said that the Eakins house did not have electric light, even at the time of the artist's death in 1916. Margaret McHenry, *Thomas Eakins, Who Painted* (privately printed, 1946), p. 60.

38. The masterful lighting of the exhibition was accomplished by Philadelphia Museum of Art Lighting Designer Andrew Slavinskas.

39. S[usan] N. Carter, "Exhibition of the Society of American Artists," *Art Journal* (New York), n.s., vol. 5 (May 1879), p. 156 (see Appendix).

40. Randy Kennedy, "Shedding Darkness on an Eakins Painting," *New York Times,* July 10, 2010, p. C1.

41. "I think Herbert Spencer will set them right on painting," wrote Eakins to his father in 1868, referencing an undescribed argument between Benjamin Eakins and his friends about the nature of the artist's creativity. This often-cited letter, in which Eakins frames his aesthetics in metaphors of boating in the marshes, includes his own comment on the combination of memories, knowledge, and imagination embedded in any work of art and the difficulty of sorting out the sources later: "At the very first combination no man & less of all himself could ever disentangle the feelings that animated him just then & refer each one to its right place." Thomas Eakins to Benjamin Eakins, March 6, 1868, in Homer, *The Paris Letters of Thomas Eakins,* pp. 197–99. On the influence of Spencer on Eakins, see Elizabeth Milroy, "Thomas Eakins's Artistic Training, 1860–1870" (Ph.D. diss., University of Pennsylvania, 1986), pp. 225ff. Spencer's discussion of the interpretation of art appears in "What Knowledge Is of Most Worth," in *Essays on Education and Kindred Subjects* (1861; reprint, London: J. M. Dent and Sons, 1911), pp. 30–37.

Appendix
Commentary on *The Gross Clinic*, 1875–1917

**Thomas Eakins to Earl Shinn, April 13, 1875. Cadbury
Collection, Friends Historical Library, Swarthmore College,
Swarthmore, Pennsylvania**

At last. The photographer has printed me some. I send you one
tomorrow. If you want the other say so and I will send it on. They
are both a little better than the ones you saw. My pictures were
delayed more than two weeks longer than they should have been.
My letters to Gerome & Billy announcing having sent the pictures
arrived but the box didn't come. As the time grew near for the last
day of admittance to the saloon [*sic*], the anxiety increased.
Gerome himself feezed and sent to all the depots & express
companies to see where it was detained. Gerome told Billy I was
one of his most talented pupils and that he was most particularly
anxious about me. At the last moment the box not arriving,
Gerome ordered the old ones at Goupil's to be sent. Next day Billy
went up to Gérômes Sunday. The box had just arrived, and
Gerome was opening it. There were two decorated artists there
friends of Gerome that Billy did not know. Gerome pitched into
the water of the big one said it was painted like the wall, also he
feared (just fear) that the rail shooting sky was painted with the
palette knife. The composition of this one they all found too
regular. They all said the figures of all were splendid. The drifting
race seemed to be liked by all very much. The nigger they had
nothing against. Gérôme said he would put in the saloon the rail
shooters & the drifting race as the jury had not yet passed on them
and he thought he could easily change them in explaining why.
Next time Billy went to Gerome he said he had changed his mind
that he would leave the old ones in the saloon. They were not so
good but the figures were larger, and Goupil wanted the four new
ones for London. This London exhibition he seems to conceive of
more importance & Billy thinks too that there is more chance

there for such pictures. Gérôme said he was going to write me
soon all he thought about my work. Billy himself has not yet
written fully. It was only the little note sent me before a mail left.

Billy & Gerome are very truthful so I am very elated for I see by
their reception that my little works have produced a good impres-
sion. But what elates me more is that I have just got a new picture
blocked in & it is very far better than anything I have ever done.

As I spoil things less & less in finishing I have the greatest
hopes of this one.

My life school boys seem to be getting on very well considering
the little time they have. Some are very earnest.

But some continue to make the very worst drawing that ever
was seen.

Thomas Eakins

I wouldn't send you such a damned egotist letter but I feel
good, and I know you will be pleased at my progress.

**"Centennial Exhibition: Views of a New York Artist; The Art
Department," *Philadelphia Evening Bulletin*, September 10,
1875, p. 1**

There is another—Thomas Aiken [*sic*]—who is called by his
admirers here the best draughtsman of the figure-painters of the
United States. He was a favorite pupil of Gerome, who still takes a
keen interest in his success. He is a very modest man, but is now
acting as instructor of the life class of the Philadelphia Sketch Club.

**William J. Clark, Jr., "The Fine Arts: The Penn Club Reception,"
Philadelphia Daily Evening Telegraph, March 8, 1876, p. 4**

The most striking works were the two contributed by Mr. Thomas
Eakins, a young artist who is rapidly coming into notice as the
possessor of unusual gifts. One of these was a photograph from his
large portrait of Dr. Samuel D. Gross—representing that eminent

surgeon holding a clinic. The original of this picture has never been out of the artist's studio, but reports of it have gone abroad and much curiosity has been excited with regard to it. It is a work of great learning and great dramatic power, and the exhibition of the photograph last night will certainly increase the general desire to have the picture itself placed on exhibition at an early day.

William J. Clark, Jr., "The Fine Arts: Eakins' Portrait of Dr. Gross," *Philadelphia Daily Evening Telegraph*, **April 28, 1876, p. 4**
There is now on exhibition at Haseltine's galleries, No. 1125 Chestnut street, Mr. Thomas Eakins' portrait of Dr. Samuel D. Gross, in which that eminent surgeon and teacher is represented as attending a clinic at the Jefferson Medical College. This picture until within a few days past has only been visible in the studio of the artist, but the reports of those who have seen it with regard to its many very striking qualities have stimulated the curiosity not only of art lovers but of people who do not under ordinary circumstances take much interest in art matters. Mr. Eakins has been living and working in Philadelphia for the last four or five years—ever since his return from Europe, after completing his artistic education—but he has exhibited very seldom, and such of his works as have been placed on view here have not been of a character to attract general attention, although their great technical merits have received ample acknowledgment from competent judges. The fact is, Mr. Eakin's [sic] has been in the habit of sending his best things to Paris, where they have found a ready sale, and where his delineations of American sporting scenes especially have been greatly admired. The public of Philadelphia now have, for the first time, an opportunity to form something like an accurate judgment with regard to the qualities of an artist who in many important particulars is very far in advance of any of his American rivals. We know of no artist in this country who can at all compare with Mr. Eakins as a draughtsman, or who has the same thorough mastery of certain essential artistic principles. There are men who have a knack of choosing more popular and more pleasing subjects, who have a finer feeling for the quality that can best be described by the word picturesqueness, and who are more agreeable if not more correct in color. For these reasons it is not difficult to understand that the pictures of men who cannot pretend to rival Mr. Eakins as masters of technique should find more favor with the general American public than his have been able to do. With regard to Mr. Eakins' color, however, there is this to be said—and it is a point that must be considered by those who may be disposed to regard his color as odd, not because it does not represent nature, but because it does not look like what they have been accustomed to in other pictures—his aim in color, as in drawing, is to represent, as near as is possible with the pigments at command, the absolute facts

of nature, and a misrepresentation of facts for the purpose of pleasing the eyes of those who do not know what nature looks like is something that his method does not contemplate. The genuineness of Mr. Eakins' method is abundantly exemplified in the picture under consideration, and on a sufficiently large scale for a just opinion with regard to it to be formed.

The picture represents Dr. Gross standing in the centre of the amphitheatre at the College engaged in delivering a lecture on the subject of an operation which he has just performed. The patient is stretched upon a bed to the right, and is surrounded by the members of the clinical staff. To the left is a most expressive figure of a female relative of the patient, whose attitude of horror is in strong contrast to the deliberation of the surgeons, and to the eager intentness of the rows of students in the seats above the principal actors. Behind Dr. Gross the clerk of the clinic is seen making his notes, and in the doorway stands the janitor and Dr. Samuel Gross. The principal figures are illuminated by a skylight immediately above their heads, which brings out the group in strong relief, while the students on the seats above and the persons in the background are in shadow. The picture being intended for a portrait of Dr. Gross, and not primarily as a representation of a clinic, the artist has taken a point of view sufficiently near to throw out of focus the accessories, and to necessitate the concentration of all his force on the most prominent figure. Dr. Gross is delineated as standing erect, one hand resting upon the bed, while with the other, which holds the instrument with which he has been operating, and which is stained with blood, he is making a slight gesture, as if to illustrate the words he is uttering. To say that this figure is a most admirable portrait of the distinguished surgeon would do it scant justice; we know of nothing in the line of portraiture that has ever been attempted in this city, or indeed in this country, that in any way approaches it. The members of the clinical staff who are grouped around the patient, the students and other lookers-on, are all portraits, and very strking [sic] ones, although from the peculiar treatment adopted they do not command the eye of the spectator as does that of the chief personage. The work, however, is something more than a collection of fine portraits: it is intensely dramatic, and is such a vivid representation of such a scene as must frequently be witnessed in the amphitheatre of a medical school, as to be fairly open to the objection of being decidedly unpleasant to those who are not accustomed to such things. The only objection to the picture that can well be made on technical grounds is in the management of the figure of the patient. The idea of the artist has obviously been to obtrude this figure as little as possible, and in carrying out this idea he has foreshortened it to such an extent, and has so covered it up with the arms and hands of the assisting surgeons, that it is extremely difficult to make it out. It is a mistake

to introduce a puzzle in a picture, and this figure is, at first glance, a decided puzzle.

Leaving out of consideration the subject, which will make this fine performance anything but pleasing to many people, the command of all the resources of a thoroughly trained artist, and the absolute knowledge of principles which lie at the base of all correct and profitable artistic practice, demand for it the cordial admiration of all lovers of art, and of all who desire to see the standard of American art raised far above its present level of respectable mediocrity. This portrait of Dr. Gross is a great work—we know of nothing greater that has ever been executed in America.

"Some Recent Art," clipping from an unidentified newspaper, c. April 1876, in Charles Bregler's Thomas Eakins Collection, Pennsylvania Academy of the Fine Arts

It seems scarcely creditable to the management of the Academy of Fine Arts that while half of its new galleries are filled with rubbish, we must go to a private gallery to see so notable a work as Mr. Thomas Eakins' picture of Dr. Gross at his clinic, which is on exhibition at Haseltine's. It is an unpleasant picture, it is true, but the Academy's own collection is full of horrors, and this at least is decent, while the Academy has this year hung one large canvas so disgustingly indecent that no other reputable institution in the world would have given it wall space. Subject aside, Mr. Eakins' picture is certainly one that would attract attention in any exhibition. It represents Dr. Gross at a surgical clinic at Jefferson College. He stands beside the operating table, where the patient, of whom little can be seen, is lying, surrounded by a group of surgeons. The professor holds in his right hand the scalpel with which he has made an incision, and while his assistant is securing the severed vessels, he turns to address the class. At the opposite side, and behind him, sits a woman, presumably a relative of the patient, with the clerk of the clinic, and in the background rise the benches on which the students are seated. Behind the table is seen the entrance to the amphitheatre, with two men standing in careless attitudes. The principal figures are of life-size, that of Dr. Gross being shown at three-quarters length. In describing such a picture our first question is, What is it intended to represent? We have been told, apparently on the artist's authority, that it is intended for a portrait of Dr. Gross, and not primarily as a representation of a clinic. If so the intention is badly carried out. Dr. Gross is, indeed, the central figure of the picture, but he is not the one absorbing object of interest. The other surgeon, who is intently at work, divides attention with him, and draws the eye to the patient, or to the operation he is undergoing. It is evident that some great thing is being done, and the introduction of the female

figure, writhing like one of Le Brun's Passions, concentrates our thought upon the patient and his suffering, while to give this thought further intensity the one positive piece of color in the whole picture, if we except the wound, is the blood upon the surgeon's fingers. The picture is thus the picture of an operation, not a portrait of the surgeon operating. And what is the operation? Is it one especially characteristic of Dr. Gross? one that made him famous, or that marked an epoch in surgery? Is it an operation so important in its character or so critical in its nature that it should be commemorated on a ten-foot canvas? As far as we can make out it is none of these things. Just what it is is not very clear; it might be an operation for necrosis of the femur, or the litigation of an artery, or any one of many operations familiar to medical students. But whatever it is, it is not a subject to be thus vividly presented upon canvas. It is rather a subject to be engraved for a text-book on surgery. This appears to us the fundamental fault of Mr. Eakins' picture, and its technical strength only makes its wrong conception more obtrusive.

It is drawn with very great skill. Especially admirable is the figure of Dr. Gross, who stands with the easy dignity of a man entirely the master of himself and his surroundings, feeling the dignity of his work, but in no way oppressed by it, and keeping himself quite *en rapport* with his class and with the spectator. If we could cut this figure out of the canvas and wipe the blood from the hand, what an admirable portrait it would be! There is equal skill in the drawing of the other figures, except for a bewildering complication of legs and arms that exacts too much study of the spectator; and though we feel that the perspective is too violent, that the figures diminish too rapidly, that is a technical point on which the artist ought to know more than we, and on which so careful a draughtsman as Mr. Eakins must have used his knowledge, so we yield, with a protest. The picture is painted in the modern French manner, with great mountains of paint, not dashed on with a trowel, but laboriously and conscientiously piled up with the brush. Color there is none. We think we have never seen a more entirely achromatic picture, and we should have liked it better had there been no pretense of color at all. Remembering Rembrandt's painting of the dissecting lesson, one cannot help thinking what a different thing Rembrandt would have made of this group, so well composed here, with the full light falling from above upon the surgeon and upon the operating table, and how he would have filled it all with his wonderful luminous shadows. These shadows are utter darkness, as black and cold as lampblack can make them. Even the white hair, that is the great surgeon's crown of glory, is black, blue black, upon a head as hard and cold as the head of a bronze statue, but without its warm reflections. Everything is as cold as though the sun had withdrawn his light, except for a suggestion of sunshine somewhere out through

the door in the passage beyond. There is no other warmth in the whole picture. We do not dwell upon these points ungraciously; there have been few pictures painted here lately that we should take the trouble to criticize thus, and in spite of his unfortunate subject, and of what appear to us faults in execution, Mr. Eakins has produced a work that is most creditable to himself and to the city. He has not been afraid to treat his subject in a realistic manner, boldly and vigorously, and the great strength of drawing and handling that he has shown in this picture, as admirable as it is rare, mark him as an artist from whom we can expect very much.

[William J. Clark, Jr.?], "The Fine Arts: The Exhibition of the Academy of the Fine Arts," *Philadelphia Daily Evening Telegraph*, April 29, 1876, p. 5

The most noteworthy picture after Mr. [H. Humphrey] Moore's [*Almeh*] although it is as diminutive as his is imposing in size, is Mr. Eakins' water-colors [*sic*], entitled the *Zither Player*, No. 335 [see fig. 10.1]. This is in many respects the best performance of a thoroughly accomplished artist who has, during the four or five years that have elapsed since he first exhibited in Philadelphia at one of the Union League art receptions, been steadily growing in the regards of those who know what fine artistic workmanship really is. It has a freedom of handling and a color quality that his previous productions have to some extent lacked. As a piece of drawing it is thoroughly fine, and the "movement" of the principal figure—a man in his shirt sleeves playing upon a zither—is expressed with a refinement of skill that no other American artist we know of can begin to equal. This little masterpiece is better worth the consideration of visitors who desire to know what good work really is than whole galleries full of such canvases as those which compose the bulk of the exhibition. This and a photograph from his large picture of *Dr. S. D. Gross Attending a Clinic*, are the only contributions of Mr. Eakins to the exhibition. It is much to be regretted that he has sent nothing that would attract on account of its size, as such masterly work as his deserved more consideration than it has yet received from the general public.

"Our Great Show," *Philadelphia Evening Bulletin*, May 17, 1876, p. 2

Even more disappointing to Americans is the very mixed character of the works exhibited in the section of the United States, and while this disappointment is in a measure tempered by the reflection that things might have been worse, the consolation so derived is cold and barren. The two large American pictures best entitled to admission to the Exhibition—Thomas Eakins's portrait of Dr. Gross and H. H. Moore's "Almeh, a Dream of the Alham-

Fig. 10.1. *The Zither Player*, 1876. Watercolor on cream wove paper, 11¾ × 9¹⁵⁄₁₆ inches (29.8 × 25.2 cm). The Art Institute of Chicago. Olivia Shaler Swan Memorial Collection, 1939

bra"—were rejected by the committee for reasons which had nothing to do with the artistic merit of the works themselves. . . .

Of course, there are very many pictures by American artists altogether creditable to the nation. . . . Eakins has three works, a strongly painted portrait of a lady; a clever little bit of *genre*, "The Chess Players," and his portrait of Dr. Rand, a portrait which is made a picture by the many accessories introduced and which is one of the best contributions to the section.

"The Exhibition. Medical Department U.S.A.," *Philadelphia Evening Bulletin*, May 30, 1876, p. 8

In connection with the Government display, that of the medical department is one of the most elaborate of that given at any previous exposition, and one which no visitor to the grounds should fail to see. Many people who see it from the outside, and

see the words "Medical Department, U.S.A.," imagine that it is not open to the public, but when we say that it is not only open, but that within its walls are to be seen the most complete system of the medical department of the army, the visitor will hail with pleasure the announcement, and consider their visit incomplete till an inspection is made. The exhibit of the medical department is in charge of Dr. J. J. Woodward, with Dr. H. C. Yarrow as assistant, in charge of the hospital department, and represents in as comprehensive a manner as possible the character of the work of the medical staff, in peace and war. The building is situated northwest of and adjoining the Government Building, and consists of a neat, plain building, two stories high, and surrounded by walks and flower beds. It represents the entire workings and appliances of a 24-bed hospital.

On the first floor two rooms are devoted to the kitchen and dining room, furnished with all the accessories for the proper use of the same. Outside are hospital tents, ambulances and a medical cart used by the army while in action. A room on the first floor with 12 beds is also shown. In this room may be also seen a large oil painting of Prof. Gross performing a surgical operation, a splendid work of art in itself, while hanging on the walls are micrographs of various medical and scientific subjects, with transparent specimens of the same kind in the windows. Adjoining this room is the dispensary, containing samples of hospital stores, chemicals, etc., which are forwarded to all post hospitals. The appliances here are all of the most complete character. Across the hallway from the latter is a room devoted to the display of surgical instruments, medical books, periodicals, etc. One of the cases contains surgical instruments used in the revolutionary war, side by side with those in use in the war of 1812. The old, rusty, cumbrous articles look like antiquated meat axes, and are in strong contrast with the highly-polished instruments adjoining. The latter are ranged in neat cases, and will give a good idea of the advance made in surgical science during the first century of our existence.

Letter to the editor, *Medical and Surgical Reporter*, June 3, 1876, p. 458

At the end of the room opposite the door is a large oil painting, representing a clinic by Professor Gross. Unfortunately, it is so hung that the figures are obscure, and I found much difficulty in recognizing the familiar faces which surround the operator.

Richard J. Dunglison, "Correspondence: Medical Centennial Affairs," *Medical Record*, vol. 11 (June 10, 1876), p. 389

There is on exhibition on the first floor a large portrait of Prof. Gross in the act of performing an amputation in the presence of his class, painted by Mr. Thos. Eakins, of this city. The picture has much merit, and the likeness is excellent; but the coloring is not pleasant, and the subject is so repulsive, the Professor's unnecessarily bloody hand being the conspicuous feature of the scene, that we are not surprised that, for this latter cause alone, it was refused a place in the Art Gallery by the Committee of Selection, to find a more appropriate niche in the Army Hospital.

James D. McCabe, *The Illustrated History of the Centennial Exhibition* (Philadelphia: National Publishing Co., 1876), p. 585

The *Medical Section* of the army makes no exhibit in the Government Building, but confines its display to the Post Hospital, which stands in the government grounds to the north of the principal building. The hospital is a plain but neat frame structure, two stories in height, with a wide piazza running all around it. It is designed to show a complete post-hospital of twenty-four beds of full size. The principal room on the lower floor shows the arrangement of the beds, and the conveniences provided in the army hospitals for attending to the wants of the sick and wounded. The treatment of wounds and other hurts is illustrated by papier-maché figures placed in the beds in the positions necessary to the proper treatment of such injuries. Upon the walls of the room and the halls adjoining it are hung photographs of difficult and successful amputations.

In this room is Mr. Thomas Eakins' fine picture of Dr. Gross delivering a clinical lecture to a class of students. It is one of the most powerful and life-like pictures to be seen in the Exhibition, and should have a place in the Art Gallery, where it would be but for an incomprehensible decision of the Selecting Committee.

In the adjoining rooms are models of the barrack "General Hospitals" used during the civil war; models of hospital steamers, such as were used during that struggle on the tidewater rivers of the East and on the Western rivers; and models of hospital railroad trains. Here also is a case of medical and surgical curiosities from the Army Medical Museum at Washington. A third room is fitted up as a dispensary, and contains samples of medical supplies. Opposite this is the office, with a collection of surgical instruments, medical works, and the blanks and record books used in the hospital service. A fifth room is fitted up as a dining-room, and contains a display of table-ware and mess furniture. Opening into this room is a kitchen with a full equipment of cooking utensils and other articles needed in this department.

William J. Clark, Jr., "The Centennial: The Art Department: American Section," *Philadelphia Daily Evening Telegraph*, June 16, 1876, p. 2

In commenting upon Mr. Thomas Eakins' portrait of Dr. Gross when it was on exhibition at Haseltine's galleries previous to the opening of the Centennial Exhibition, we said that nothing finer had been done in this city. There is nothing so fine in the American section of the Art Department of the Exhibition, and it is a great pity that the squeamishness of the Selecting Committee compelled the artist to find a place for it in the United States Hospital building. It is rumored that the blood on Dr. Gross' fingers made some of the members of the committee sick, but judging from the quality of the works exhibited by them we fear that it was not the blood alone that made them sick. Artists have before now been known to sicken at the sight of pictures by younger men which they in their souls were compelled to acknowledge were beyond their emulation. The figure of Dr. Gross in this picture is the representation of a man and not of a shadow, and the contrast between it and even so excellent a work as Elliott's portrait of General Bouck is so marked that the most uncultivated eye ought to be able to perceive wherein consists the merits of the one and the deficiencies of the other. Mr. Eakins has two other portraits, which are hung with the other American pictures. One of them represents a young lady in profile playing on the piano [see fig. 10.2], and the other is a portrait of Dr. Rand [see fig. 6.3], who is shown seated behind his library table—upon which are scattered a number of articles, such as a microscope, books, papers, etc.—with one hand petting a Maltese cat, and with a finger of the other following the lines on a page in the book before him. The composition in this last-named picture is rather too elaborate for a portrait, and the eye is confused by the multitude of objects that are introduced. The picture is carefully and consistently worked out, however, and although it lacks the simplicity that is desirable in a portrait, it is an admirable example of genuinely artistic workmanship. The lady playing at the piano is very simple in composition. The action is rendered with the utmost refinement, and there is superb painting on it. Unfortunately, both of these pictures are in too low a key for their best qualities to be easily discerned in the badly-lighted galleries in which they are hung. It can be seen at a glance, however, that the artist has attempted something more than the mere making of a recognizable likeness, and has aimed to make his portraits pictures in every sense of the word.

Fig. 10.2. *Elizabeth at the Piano*, 1875. Oil on canvas, 6 feet × 4 feet (183.2 × 122.4 cm). Addison Gallery of American Art, Phillips Academy, Andover, Massachusetts. Gift of an anonymous donor, 1928.20

"The Centennial Exhibition: The Fine Arts: United States Section—Paintings in Oil," *Philadelphia Evening Bulletin*, July 10, 1876, p. 2

Classed as a portrait is a large canvas (No. 135 a), by Thomas Eakins, a lady seated at a piano forte. In this work the drawing is vigorous and true, and there is infinite richness of color, but the face—as in the portrait of Dr. Rand—is so deeply sunk in shadow as to require a painful effort to distinguish it. In a picture dealing with matter of fancy such an arrangement would, under many

circumstances, tend to greatly heighten the desired effect; but in a portrait, a picture professing to deal with exact fact, such an arrangement is not to be tolerated; it is an obvious violation of the fundamental principles of this branch of art. Considered simply as a picture, there is nothing better in the room than this painting by Mr. Eakins; but considered as a portrait it is very far from deserving such emphatic praise.

W. H. Workman, "Letter from Philadelphia," *Boston Medical and Surgical Journal*, **vol. 95, no. 5 (1876), pp. 152–53**
Perhaps the most striking and attractive object in the structure is the large oil painting by Eakens [*sic*], which hangs in the model ward. This painting is a portrait of Prof. S. D. Gross, and represents him, surrounded by the members of his clinical staff, in the performance of an operation in the college clinic. He has made an incision into the leg of the patient, who lies stretched upon a bed at the professor's left hand. Dr. Gross has paused in his operation in order to explain the disease, or its remedy, to the students who are dimly seen in the background. The painting being intended as a portrait of Dr. Gross, and not primarily as the representation of a clinic, the artist has thrown the accessories out of focus and concentrated his force upon the most prominent figure. Professor Gross stands erect, one hand resting upon the bed; with the other, which holds a scalpel, both knife and fingers stained with blood, he is making a slight gesture, as if to enforce the words he is uttering. The portrait is of life-size and a most admirable likeness of the strong face and tall figure of the surgeon. One can hardly conceive of a more perfect resemblance. At the right of the professor is a most expressive figure of a female, whose clenched hands and general attitude of horror are in strong contrast to the concentrated attention of the students in the seats above the operator. The clinical assistants are grouped around the patient, one mopping out the wound; others separate the lips of the cut; another administers chloroform (Gross never uses any other anæsthetic); the clinical clerk is writing at his desk; in a doorway in the background stand Dr. S. W. Gross and a janitor. These are all faithful portraits. About slipping to the floor from the operating table is a gouge-chisel, which suggests that the operation is for necrosis. Cases of instruments and other surgical necessities are ranged upon a side-table, and all the well-known detail of such scenes are represented. The principal figures are illuminated by a sky-light directly over their heads. Thus the central group is brought out in strong relief, the students being in shadow. The one serious fault in the picture is the manner in which the body of the patient is treated. It is so much foreshortened and so covered by the arms of the clinical assistants that it is a perfect puzzle. The

artist's intention evidently was to render this portion of the painting as free from the disagreeable as possible. He has succeeded so well as to bring upon himself rather severe criticism. Indeed, it is difficult to discover whether the incised limb of the patient be the leg or an attenuated thigh. It more nearly resembles the latter. As a whole, however, the picture is a great work, and wins much admiration. It was originally offered to the art committee, but the details of the picture proved so shocking that two or three members of the committee actually became faint, and it was deemed wise to reject it; so that although there are in memorial hall pictures which are far more gory, this fine work of art at last found its way to the government hospital building. Let me advise those of your readers who visit the Exhibition not to miss a view of it.

The Society of American Artists Exhibition, Kurtz Gallery, New York, March 1879

"Fine Arts: Second Exhibition of the Society of American Artists," *New York Herald*, **March 8, 1879, p. 6**
Thomas Eakins' immense canvas, with life size figures, "The Clinic," hangs on the east half of the north wall. It is decidedly unpleasant and sickeningly real in all its gory details, though a startlingly lifelike and strong work.

"Fine Arts: The Society of American Artists," *New York Daily Graphic*, **March 8, 1879, p. 58 (includes a reproduction of the painting)**
"The Clinic," by Thomas Eakins, is a large and important canvas which commands attention both from its subject and treatment. It is a work which will attract as much comment as any picture in the collection. The painting represents a surgical operation in the amphitheatre of a medical college. Grouped around the central figure—which is a striking portrait of Dr. Gross, the well-known surgeon of Philadelphia—are the students who assist in the operation. The patient lies upon the table, nearly covered from sight, the face being hidden under a cloth saturated with ether, held by one of the attendants. The light is arranged to throw out the central group in bold relief. The entire picture is a serious, thoughtful work, and we can readily understand what a fascination a subject like this must have for an artist who is himself a profound student of anatomy. There is thought and feeling of a high order in this painting, and in this respect it is in marked contrast with many of the works that surround it.

"The American Artists: Varnishing Day of the Second Exhibition: The Venuses of Eaton and La Farge—Surgery by Eakins—Landscapes of Homer Martin," *New York Times*, March 8, 1879, p. 5

A picture whose size might have given it preference over either of these two [an unnamed work by Julian Alden Weir and Wyatt Eaton's *Venus*] is a portrait of a surgeon at a class lecture, surrounded by his students, and engaged in an operation on a man's thigh. It is by Eakins, of Philadelphia, an artist whose strength lies in anatomy, and whose life was begun in a surgeon's office. He was asked to paint a great surgeon of Philadelphia, and decided—it is many years ago—to introduce him at a critical moment in an operation. He has terribly overshot the mark, for, although his method of painting is not disgusting in colors, as that of some foreign artists is, but rather wooden and academic, yet the story told is in itself so dreadful that the public may be well excused if it turn away in horror. The ugly, naked unreal thigh, the pincers and lancets, the spurting blood, and the blood on the hands of the Professor and his assistant are bad enough, but Mr. Eakins has introduced, quite unnecessarily, an additional element of horror in the shape of a woman, apparently the mother of the patient, who covers her face and by the motion of her hands expresses a scream of horror. Above and in the background, are the students in their seats in the surgical amphitheatre. The composition is rather confused. This violent and bloody scene shows that at the time it was painted, if not now, the artist had no conception of where to stop in art, of how to hint a horrible thing if it must be said, of what the limits are between the beauty of the nude and the indecency of the naked. Power it has, but very little art.

[Clarence Cook], "The Society of American Artists: Second Annual Exhibition—Varnishing-Day," *New York Tribune*, March 8, 1879, p. 5

Larger and more important still is Mr. Eakin's [*sic*] "The Anatomist," one of the most powerful, horrible and yet fascinating pictures that has been painted anywhere in this century—a match, or more than a match, for David's "Death of Marat," or for Géricault's "Wreck of the Medusa." But the more one praises it, the more one must condemn its admission to a gallery where men and women of weak nerves must be compelled to look at it. For not to look at it is impossible.

"The Studio: The Society of American Artists," *Art Interchange*, vol. 2, no. 6 (March 19, 1879), p. 42

The attention of the visitor to the gallery is attracted at once by a large canvas entitled "Professor Gross," by Thomas Eakins. It is the property of the Jefferson Medical College of Philadelphia; and although vigorously treated, it ought never to have left the dissecting room. The subject is a surgical operation, the principles of which Professor Gross is quietly explaining to a group of students. The scene is revolting in the last degree, with the repulsiveness of its almost Hogarthian detail.

[Earl Shinn], "Fine Arts: Exhibition by the Society of American Artists," *The Nation*, vol. 28, no. 716 (March 20, 1879), p. 207

If one painter may hope to get inspiration out of a courtly Mirandola-like adolescence, another may hope to derive something solid from a youth passed among the exact sciences. Professor Eakins, so far as he is an artist, proceeds from the exact photographic realism of Gérôme, modified by the robust realism of Bonnat, who paints his figures so solid that you seem to see all around them. He, too, plays with languages. He has opinions on the various readings of Dante, and makes pastime of mathematics. When he wishes to draw the ripple of a river for a boating subject, he protracts a set of waves on a paper in theoretical perspective, and lays out on each facet the shape of the reflected object which it would properly send off to the eye. Disguising the formality of this process by a sufficient quantity of variations, he paints from his diagram, secure that nobody will ever deny that his river is flat. His classes are coached through the difficulties of anatomy by an accumulation of illustrations not probably approached in any school in Europe. While a prosector lifts up a given muscle in the dead body upon the dissecting-table, a nude model is made to exhibit the same muscle in prominence by its being shocked from an electric battery. A third exhibition of the muscle is made on one of Auzoux's detachable manikins; a fourth upon Houdon's anatomical figure; a fifth upon the most suitable among the antique statues, of which he has painted some of the slenderer ones—like the Fighting Gladiator and Jason—into a map-work of red muscles and white tendons. Not much confusion can henceforth exist about that detail in the mind of the pupil thus made to see its ideal shape in the antique, its vital energy in the life model, and its reality in the dissection. With all this patience in laying up facts, it is to be seen whether the artist has the artistic faculty to apply them. He sends to the exhibition a kind of challenge to Rembrandt, a modern "Anatomy Lesson." The subject, however, is evidently living, from the chloroformed towel which conceals the head, and from the anguish of the old mother

who covers her eyes in a corner; otherwise, it is simply a contemporary Dr. Tulp, explaining the secrets discovered by his scalpel to an audience of respectful pupils. The picture, ordered for Jefferson Medical College by a body of its alumni, and representing Dr. Gross in the familiar working attitude in which he had earned the reverence of his class, is no more amenable to questions of mere taste than Rembrandt's is. Rembrandt's has been removed from considerations of conventionality by the remoteness of its period and the interest of its art, and this may be held to be so removed by the remoteness of its destination in a college and the technical partiality of its future spectators. There can be no great harm in letting it be seen for a space, in an exhibition especially technical, as it passes on its way to the collegiate museum it is destined to remain in. The picture's scale is that of life, and at least twenty figures are included, the subordinate ones well subdued, though all connected with the central action by the most vivid expression of interest. The effect of the aged and quiet professor, in a sharp perpendicular light, as he demonstrates very calmly with a gesture of his reddened fingers, is intensely dramatic. Equally so is that of the horror-stricken mother, in decent and seedy dress of ceremony, overcome by a sudden horror which scatters ceremony to the winds. These two figures, telling by their contrast of professional habitude and unaccustomed terror, are relieved with great constructive skill from the accessory groups, massed together by ingenious combinations or devices of shadow. Few professors have got themselves painted in so interesting a presentment for posterity. A tendency to blackness in the flesh-shades is the principal artistic infelicity in this curious and learned work.

[Clarence Cook], "The Society of American Artists: Second Annual Exhibition," *New York Tribune*, March 22, 1879, p. 5

The more we study Mr. Thomas Eakins's "Professor Gross," No. 7, the more our wonder grows that it was ever painted, in the first place, and that it was ever exhibited, in the second. As for the power with which it is painted, the intensity of its expression, and the skill of the drawing, we suppose no one will deny that these qualities exist. With these technical excellencies go as striking technical faults. There is no composition properly so called; there is of course no color, for Mr. Eakins has always shown himself incapable of that, and the aerial perspective is wholly mistaken. The scene is in the lecture-room of a medical college. The Professor, announced as a portrait, and said to be an excellent one, has paused in an operation, apparently one of great difficulty, and is making a remark to his class. The patient lies extended upon the table, but all that we are allowed to see of the body is a long and shapeless lump of flesh which we conclude to be a thigh because,

after eliminating from the problem all the known members, there seems nothing but a thigh to which this thing can be supposed to bear any likeness. We make out that one of the Professor's assistants is holding a cloth saturated with chloroform over the patient's face, meanwhile two students hold open with flesh-hooks a longitudinal cut in the supposed thigh; another assistant pokes in the cut with some instrument or other, and the Professor himself, holding up a bloody lancet in bloody fingers, gives the finishing touch to the sickening scene. A mile or so away, at a high-raised desk, another impassive assistant records with a swift pen the Professor's remarks, and at about the same distance an aged woman, the wife or mother of the patient, holds up her arms and bends down her head in a feeble effort to shut out the horror of the scene. She is out of all proportion small compared with the other figures, and her size is only to be accounted for on the impossible theory that she is at a great distance from the dissecting table. This is the subject of a picture of heroic size that has occupied the time of an artist it has often been our pleasure warmly to praise, and that a society of young artists thinks it proper to hang in a room where ladies, young and old, young girls and boys and little children, are expected to be visitors. It is a picture that even strong men find it difficult to look at long, if they can look at it at all; and as for people with nerves and stomachs, the scene is so real that they might as well go to a dissecting-room and have done with it.

It is impossible to conceive, for ourselves, we mean, what good can be accomplished for art or for anything else by painting or exhibiting such a picture as this. It was intended, we believe, for a medical college; but, surely, the amorphous member we have spoken of would create such doubts in the minds of neophytes, and such sarcasm in the minds of experts, as to make it a very troublesome wall ornament. As a scientific exposition, it is on this, as well as on other grounds, of no great value. The Professor's attitude and action are apparently very unusual, and give an uncomfortable look of "posing" to the principal figure, which of course could never have been intended by the artist. Then, again, is it usual for the relatives of a patient who is undergoing a serious operation to be admitted to the room? And, whether it be or be not, is it not unnecessary to introduce a melodramatic element—wholly hostile to the right purpose of art—into the scene, to show us this old woman writhing her body and twisting her hands as the Professor details the doings of the scalpel in the house of life of some one dear to her! Here we have a horrible story—horrible to the layman, at least—told in all its details for the mere sake of telling it and telling it to those who have no need of hearing it. No purpose is gained by this morbid exhibition, no lesson taught—the painter shows his skill and the spectator's gorge rises at it—

that is all. It will be seen that we admit the artist's skill, and that skill would be more telling if he had known to confine himself to the main group. The recording scribe in the distance is well painted; no matter how slight the thing Mr. Eakins's people are doing, they always are doing it as effectually as if their painted bodies were real ones. And the old woman is well painted too; but neither the recording scribe nor the old woman has any right at all to be in the picture. They are only here for the sake of effect.

M[ariana] G[riswold] Van Rensselaer, "The Spring Exhibitions in New York: The National Academy of Design, the Society of American Artists, etc.," *American Architect and Building News*, vol. 5, no. 176 (May 10, 1879), p. 149
Further, there were deserving of notice a small and not very remarkable interior by Mr. James Whistler, and a large canvas by Mr. Eakins representing a surgical demonstration by professor Gross. This was realistic art, of a surety. It was in general very well done and in parts powerfully. The figure of the professor was admirable. But there were faults in the perspective of the subordinate figures and discordances in the scale of color, which was too sombre to be so intensely vivified by the blood stains.

S[usan] N. Carter, "Exhibition of the Society of American Artists," *Art Journal* (New York), n.s., vol. 5 (May 1879), p. 156
The largest and most important picture on this side of the room was a portrait of Professor Gross (No. 7), surrounded by half a dozen medical students in a dissecting-room, by Eakins. Many of our readers will recall to mind Reynaud's [*sic*] painting of a decapitation in the gallery of the Luxemburg [see fig. 9.3], and will remember the fiendish expression of the murdered man as he gazes up with a look still full of life into the face of his murderer. Pools of blood cover the floor, and their truth to nature renders this one of the most disgusting of modern works of Art. The picture of the dissecting-room by Eakins has many of the same revolting features, and the surgery and the red dabblings were not offset, in the judgment of most visitors to the exhibition, by the great skill shown in the beautiful modelling of the hands, or even by the animated and eager interest depicted on the countenances of the young men who surround the professor. There is a great deal of good composition in the massing of lights and shadows in this picture which cannot fail to commend itself; but the least critical person must have found the colour of the background black and disagreeable; and to sensitive and instinctively artistic natures such a treatment as this one, of such a subject, must be felt as a degradation of Art. In Rembrandt's famous picture, in Holland,

of the doctors over a dead body, the reality of the corpse is so subordinated as to have scarcely more life than a statue, while nothing of the internal structure of the body brings its conditions vividly to the mind of the spectator; but this painting is considered to trench on the limits of the æsthetic, though it is ennobled by fine colour and by an admirable group of portraits.

[Susan N. Carter], "The [National] Academy Exhibition," *Art Journal* (New York), n.s., vol. 5 (May 1879), p. 158
Near to [William Morris Hunt's portrait of Bishop Williams] is a very vigorous full-length likeness of Dr. Brinton by Eakins. The pose is natural and effective, and it is in every respect a more favourable example of the artist's abilities than his much-talked-of composition representing a dissecting-room. It is a cause for regret that this able artist does not adopt a less smoky scheme of colours.

"The Two New York Exhibitions," *Atlantic Monthly*, vol. 43, no. 260 (June 1879), p. 782
Eakins, who has shown heretofore a considerable talent for making a naturally attractive subject disagreeable, —like his woodeny Philadelphia belle of last year, supposed to be standing as a model for the sculptor William Rush, —has in a ghastly scene in a dissecting-room a subject to his mind. It is a swarm of surgeons and assistants performing an amputation in a lecture-room, the surrounding air of which is faintly full of student heads, like attendant spirits. It is powerful work, and there is a fine seriousness in the principal figure, lifting a silvered, intellectual head momentarily from the grim labor. For its purpose and from its point of view, it is doubtless right, but for any less special destination the realistic dwelling on the raw, quivering limb, the gory hands that hold the scalpels, the blood spurted in jets over the white wristbands, would be horrid and inexcusable. The subject is but too impressive in itself, with these details withdrawn as much as possible from notice.

[S. G. W. Benjamin], "Art: The Exhibition of the Society of American Artists," *Library Table*, vol. 4, no. 65 (March 29, 1879), p. 56
Mr. Eakins [*sic*] ambitious painting called "The Professor," is in parts so good that one regrets that the work as a whole fails to please or satisfy. Admirable draughtsman as this painter is, one is surprised that in the arrangement of the figures the perspective should have been so ineffective that the mother is altogether too small for the rest of the group, and the figure of the patient so

indistinct that it is difficult to tell exactly the part of the body upon which the surgeon is performing the operation. The monochromatic tone of the composition is perhaps, intentional, in order to concentrate the effect on the bloody thigh and the crimson finger of the operating professor. But the effect now is to centre the attention at once and so entirely on that reeking hand as to convey the impression that such concentration was the sole purpose of the painting. In similar paintings by Ribeira [sic], Regnault, and other artists of the horrible, as vivid a result is obtained without sacrificing the light and color in the other parts of the picture, and the effect while no less intense, is therefore less staring and loud. As to the propriety of introducing into our art a class of subjects hitherto confined to a few of the more brutal artists and races of the old world, the question may well be left to the decision of the public. If they demand such pictures, they will be painted, but if the innate delicacy of our people continues to assert itself there is no fear that it can be injured by an occasional display of the horrible in art, or that our painters will create many such works. It is stated that this composition is intended for a hospital. One would supposed that in such a place more cheerful pictures would be preferable.

S. G. W. Benjamin, *Art in America: A Critical and Historical Sketch* (New York: Harper and Bros., 1880), p. 208–10 (includes a reproduction of a detail of the painting on p. 204)

One of Mr. Eakins's most ambitious paintings represents a surgical operation before a class in anatomy. It is characterized by so many excellent artistic qualities, that one regrets that the work as a whole fails to satisfy. Admirable draughtsman as this painter is, one is surprised that in the arrangement of the figures the perspective should have been so ineffective that the mother is altogether too small for the rest of the group, and the figure of the patient so indistinct that it is difficult to tell exactly the part of the body upon which the surgeon is performing the operation. The monochromatic tone of the composition is, perhaps, intentional, in order to concentrate the effect on the bloody thigh and the crimson finger of the operating professor. But as it is, the attention is at once and so entirely directed on that reeking hand as to convey the impression that such concentration was the sole purpose of the painting. In similar paintings by Ribeira, Regnault, and other artists of the horrible, as vivid a result is obtained without sacrificing the light and color in the other parts of the picture; and the effect, while no less intense, is, therefore, less staring and loud. As to the propriety of introducing into our art a class of subjects hitherto confined to a few of the more brutal artists and races of the Old World, the question may well be left to the decision of the public. In color Mr. Eakins effects a low tone that is sometimes almost monochromatic, but has very few equals in the country in drawing of the figure. Some of his portraits are strongly characteristic, and give remarkable promise.

Pennsylvania Academy of the Fine Arts, Annual Exhibition, April 1879

Thomas Eakins to the Board of Directors, Pennsylvania Academy of the Fine Arts, April 24, 1879. Pennsylvania Academy of the Fine Arts Archives, Philadelphia

Gentlemen

Your Board wishing to make this spring an unusually large and attractive exhibition, obtained from the Society of American Artists the loan of their this year's exhibit.

The agreement was that their exhibit should not be mixed with the other pictures, but should be kept entire and catalogued together as the Collection of the Society of American Artists.

Some very few of the pictures by members of the Society having been already disposed of at the time of the agreement, these members promised to replace these few pictures withdrawn and beyond their control, by others equally important so that nothing might be lost in the character or fulness of their exhibit.

An interval existing between the closing of the exhibition of the Society in the Kurtz Gallery in New York and the opening of the Pennsylvania Academy exhibition the pictures were in the meanwhile redistributed to the artists and then recollected by agents of the Academy at the Academy's expense.

In the redistribution my picture of Prof. Gross, a conspicuous and important part of the Society's exhibition was returned to Philadelphia and I then told Mr. Corliss [secretary of the Academy] that it was at Haseltine's where he could send for it at any time.

I frequently asked about the arrival of the other New York pictures and on the arrival of the first of them I again reminded Mr. Corliss of my picture.

He said nothing to me of his sly intention of sending for all the other pictures and neglecting mine and it was not until after the arrival of all the rest and on my again asking after mine that he informed me that he did not intend to send for mine without special orders from the committee on hanging.

I am sure that he falsely accused me to the Committee of some neglect and misinformed them of the circumstances which he well knew for it was he who had finished all the business details of the arrangement with the Society having been sent by you to New York for the purpose.

The committee acting on misinformation refused my picture.

They reconsidered and decided to accept it if I assumed the trouble and expense of bringing my own picture which I did.

I herewith enclose the receipted bill for that expense and ask your Board to refund me the amount.

I ask in justice to myself and the Academy and in honest fulfilment of the compact between the Academy and the Society of American Artists that my picture be hung in the room with the other New York pictures and nowhere else and I suggest that the conduct of Mr. Corliss be investigated.

I accuse him of acting the miserable and tricky partisan and not the honest servant of the Academy whose interest I have much at heart.

<div style="text-align: right">

Yours respectfully,
Thomas Eakins
Philada. April 24, 1879

</div>

Transcription by Lloyd Goodrich of a draft of a letter from Thomas Eakins to George S. Pepper, c. May 1879. Lloyd and Edith Havens Goodrich, Record of Works by Thomas Eakins, Philadelphia Museum of Art

My dear Mr. Pepper,

My Gross picture & Mr. Thos. Moran's Florida picture having both of them an unfortunate notoriety I ~~must call~~ feel I must call your attention as Chairman of the Committee on ~~Hanging~~ Exhibition to ~~of~~ the bad feeling ~~likely~~ certain to be engendered by the present disposition of them & protest against it.

The Directors asked for the Exhibition of ~~the American~~ Society.

Mr. Moran's picture of Florida was rejected ~~by the S~~ justly or unjustly by the Society whose exhibition you asked for. It now occupies the most prominent place in all the Academy among their work.. to ~~att all~~ who know the facts It seems a direct insult to the most influential Society that ~~the~~ trouble

Enclosed please find a newspaper slip of n . . .

Even at this late ~~date~~ day, I strongly advise you to consider the propriety of instructing Mr. Corliss to ~~write~~ forget the list of pictures of the Exhibit ~~find out exactly what~~ the Society of American Artists to write to the officers ~~m.~~ It will not do to assume it is their fault that no list has come. Since the ~~Academy~~ pictures were collected in New York at the Academy's expense it is not unlikely that the Academy's agents have been at fault & not the Society or that the list may have been lost in the mail. ~~or destroyed~~

Anyhow, I feel that the Academy will be greatly blamed for what will seem to the Society a direct insult ~~to them & the only excuse that can be made will be~~

The two pictures which have ~~certainly~~ acquired the most unhappy notoriety in the Society are Mr. Moran's and mine. ~~asked~~

~~for~~ Mine accepted by them is removed from their collection & Mr. Moran's rejected by them has been given the place of honor in their collection here. ~~Mr. Corliss, every one knows it~~ It was the Academy directors who asked the Society for the loan of their pictures & the answer was yes if their pictures would be kept together & marked as the exhibit of their Society.

Our committee must not judge the merits of their pictures ~~I call you~~ I regret exceedingly ~~that I have been suspected by anyone of wanting to quarrel. I never like such notoriety. It hurts & yet it is hard to convince you~~ the difficulty of convincing some of the gentlemen of the exhibition committee that I ~~have no no cause of quarrel with them & that I am not seeking~~ hate such ~~notoriety in as comes from quarreling. From not seeking a~~ have no cause for quarrel ~~but trying~~ with them ~~but or a notoriety~~ for my picture. ~~nor am I seeking the not. for myself notoriety of advertising~~

~~Enclosed~~ Please ~~read~~ find ~~criticisms in the Boston paper which I which I would like returned to me slip given me out of at some time return to me~~ which please return me. the enclosed slip from a Boston paper. . .

<div style="text-align: right">

Thom

</div>

"The Artistic World: Academy of Fine Arts—Annual Exhibition of Pictures," *Philadelphia North American,* **April 29, 1879, p. 1**
In the same corridor is a large and pretentious production by Mr. Thomas Eakins—a "Portrait of Professor Gross." It is well but blackly painted, and is no doubt a good portrait, but as the learned professor and his assistants are represented as engaged in the thick of a serious surgical operation—the crimson evidences of which are more than obtrusively presented—it may be seriously doubted whether the walls of Jefferson College have not been denuded without any sufficiently good reason. There is an especially objectionable finger and thumb, which will go far to cause the corner in which this grisly picture is hung to be severely let alone during the duration of the exhibition.

"The Academy Exhibition," *Art Interchange,* **vol. 2, no. 10 (May 1879), p. 79**
The subject of most interest during the past fortnight has been the annual exhibition of the Academy of the Fine Arts which in addition to the pictures by Philadelphia artists has received a valuable supplement in those sent by the Society of American Artists. These have been on exhibition at the Kurtz gallery, New York and have been fully noticed already in *The Art Interchange.* Curiously some difficulty again arose with reference to Mr.

Moran's and Mr. Eakin's [*sic*] pictures. The first was hung for some time, the latter rejected as part of the Society of American Artists exhibit. The misunderstanding, for such it appears to have been, was attributable to a very simple cause. No official list was received by the Academy from the Society of the pictures to be hung, and the only guide that the committee had was an indefinite shipping list which led naturally to the errors of which there has been much complaint.

H. M. J., "Pennsylvania Academy of the Fine Arts: Fiftieth Annual Exhibition," *Newark (NJ) Daily Advertiser*, May 20, 1879, p. 1

Mr. Thomas Eakins, a favorite artist here, has chosen to perpetuate all the horrors of the dissecting room in a large and finely executed picture. After this had been twice rejected here [in Philadelphia] on account of its disagreeable subject, it was sent to the [Society of] American artists [in New York] and accepted. Of course it came back with its new friends to its own country. But no stamp of approval gained abroad, has won honor for the people here. As a token of parental displeasure it was separated from its fellows and hung outside their door.

"Culture and Progress: The Art Season of 1878–9," *Scribner's Monthly*, vol. 18, no. 2 (June 1879), pp. 311

A picture by Mr. Thomas Eakins exhibited a celebrated Philadelphia surgeon lecturing to a class of medical students over the exposed thigh of a patient. It was noticeable that the horribleness taught nothing, reached no aim; and that especially disgusting, and by no means likely to the facts, was the presence of the mother of the sufferer, wringing her hands and apparently screaming with horror. It is painted in a dry but highly technical manner, which, in one sense, may be said to have agreed with the subject.

The Gross Clinic, The Agnew Clinic, and the Chicago World's Fair, 1880–1901

"Society of American Artists: Opening of the Third Annual Exhibition This Afternoon," *New York Evening Post*, March 15, 1880, sec. 4, p. 7

Mr. Eakins of Philadelphia who last year sent a surgical professor[,] a dead body, and arterial blood, comes forward with an immense size picture of a fashionable lady in an [*sic*] blackish fog playing upon a piano or an organ.

William C. Brownell, "The Younger Painters of America," *Scribner's Monthly*, vol. 20, no. 1 (May 1880), pp. 4, 12–13

Mr. Eakins is another instance of a painter who knows how to paint. Whatever objection a sensitive fastidiousness may find to the subject of his picture, exhibited here a year ago, entitled "An Operation in Practical Surgery," none could be made to the skill with which the scene was rendered. It was a canvas ten feet high, and being an upright and the focus being in the middle distance, it presented many difficulties of a practical nature to the painter; the figures in the foreground were a little more, and those in the background a little less, than life size, but so ably was the whole depicted that probably the reason why nine out of ten of those who were startled or shocked by it were thus affected, was its intense realism: the sense of actuality about it was more than impressive, it was oppressive. It was impossible to doubt that such an operation had in every one of its details taken place, that the faces were portraits, and that a photograph would have fallen far short of the intensity of reproduction which the picture possessed. What accuracy of drawing, what careful training in perspective and what skill in composition this implies, are obvious. Of his two pictures in last year's Academy Exhibition the same may be said. . . .

Mr. Eakins's power almost makes up for the lack of poetry. His "Surgical Operation" before-mentioned as a masterpiece of realism in point of technique, is equally a masterpiece of dramatic realism, in point of art. The painter increased rather than diminished the intensity which it is evident he sought after, by taking for a theme a familiar and somewhat vulgar tragedy of every-day occurrence in American hospitals, instead of an historic incident of Rome or Egypt. The play of emotions which is going on is strong and vivid. The chloroformed patient is surrounded by surgeons and students whose interest is strictly scientific, his mother who is in an agony of fear and grief, and the operator who holds a life in his hand and is yet lecturing as quietly as if the patient were a blackboard. Very little in American painting has been done to surpass the power of this drama. But if the essence of fine-art be poetic, an operation in practical surgery can hardly be said to be related to fine-art at all. Many persons thought this canvas, we remember, both horrible and disgusting; the truth is that it was simply unpoetic. The tragedy was as vivid as that of a battle-field, but it was, after all, a tragedy from which every element of ideality had been eliminated. The same thing is true, with obvious differences of degree, of most of Mr. Eakins's work. He is distinctly not enamored of beauty, unless it be considered, as very likely he would contend, that whatever is is beautiful.

Susan N. Carter, "The New York Spring Exhibitions. II. The Society of American Artists," *Art Journal* (New York), n.s., vol. 6 (May 1880), p. 155

Mr. Eakins, of Philadelphia, has adopted a somewhat similar mode of treatment in "The Portrait at the Piano," where a dark room, with a dark piano, and a dark woman's form are touched here and there by a tint of light on a cheek, on the side of a hand, upon a flower, and the hair on the edge of the woman's head. The dark tones are often rich in this picture, but it seems rather painted as an *effect* than to be a thoughtfully wrought-out picture, which its large size would warrant the spectator to expect; and for close study it is less good than the artist's scene in a dissecting-room of last season.

"Art in Philadelphia: The Exhibition at the Academy of Fine Arts—Pictures from American Artists—Some Notable Works—The Permanent Collections—The Philadelphia Artists," *Boston Daily Evening Transcript*, October 30, 1880, p. 6

Mr. F. F. de Crano's "Juliet" is excellent in its strong coloring, and Mr. Thomas Eakins, whose realistic treatment of a rather startling scene in a clinic affrighted some of the visitors to the exhibition of the Society of American Artists a year ago, has chosen as a harmless subject, Mr. Fairman Rogers's coach and four. This he calls "In the Park," and has made it remarkable for its admirable drawing, as well as attractive in other respects.

"Notes and Queries," *The Continent* (Philadelphia), vol. 3, no. 22 (May 17, 1883), p. 702

WHAT surgical operation is supposed to be in process of performance in the engraving of Eakin's [sic] portrait of Dr. Gross, published in THE CONTINENT of January 17?

SEVERAL READERS.

In order to be perfectly sure of our ground a note of inquiry was addressed to Dr. Gross, and called forth the following reply:

DEAR SIR: The operation referred to in your letter of yesterday was performed for the removal of a diseased thigh bone, seldom a bloody procedure, although so represented by the artist in my picture.

Very respectfully, S. D. GROSS.

Charles de Kay, "Movements in American Painting: The Clarke Collection in New York," *Magazine of Art*, vol. 10 (1887), pp. 38–39

Mr. Thomas B. Clarke received the impulse to collect pictures, oddly enough, from a landscapist of genius who has never worked satisfactorily in *genre,* the elder George Inness. Landscapes therefore help to enliven the halls and drawing-rooms of the dark New York house, land in the city being so costly that only the very rich can show their pictures to the best advantage. But *genre* pictures predominate in a way that shows how early in his collecting years Mr. Clarke began to encourage the department of American art which seemed to him to stand most in need of assistance. . . .

Not so many years ago a young merchant who should be so reckless as to buy American pictures unless avowedly a millionaire, would run the risk of financial taboo, owing to the suspicion his proceedings might arouse in this mercantile *camorra.* But if anything is sure, this is—that better things may be expected of a given art if ten men of moderate fortune encourage it than if one man of colossal fortune deigns to assume the part of patron. As a matter of fact the Vanderbilts, Morgans, and other great buyers of paintings in New York have neglected the talent at their doors, and turned the heads of foreign painters whose success was already as great as they could bear.

Only four painters can be spoken of here, and of the four two have studied in Europe; two are homebred. Thomas L. Eakins is a Philadelphian who returned to his native place after a very thorough training at the École des Beaux-Arts and in the studios of the painters Bonnat and Gérôme, together with a certain amount of work with the sculptor Dumont. He has done much teaching in Philadelphia, where, until lately, he was instructor in the life-school of the Pennsylvania Academy of the Fine Arts. In 1878 he taught in the School of Practical Anatomy, and is now at the head of a schism from the Academy schools. Eakins made his mark at the Centennial Exhibition with "Chess-players," a broadly and severely painted interior, very dark, very realistic, very sober. He has painted many portraits, including those of Professor Rand and Dr. Brinton, the distinguished writer on American Indians; of Professor Gross, also, attending a surgical clinic at Jefferson College, less pleasing than the "Chess-players," but rudely powerful; and an historical painting of William Rush, the first Pennsylvanian who did anything in sculpture, carving in wood his ideal figure representing the River Schuylkill. Eakins has iron-bound limits in execution, but very remarkable originality. He has boldly seized on subjects never attempted before by artists of his training and parts, such as a water-colour of the national pastime called "Baseball" [see fig. 10.3], an oil-painting of an expert sculler seated in his outrigger, a sportsman "Whistling for Plover" [see fig. 10.4], and a view of the

Fig. 10.3. *Baseball Players Practicing*, 1875. Watercolor over charcoal on paper, 10¾ × 13 inches (27.3 × 33 cm). Museum of Art, Rhode Island School of Design, Providence. Jesse Metcalf Fund and Walter H. Kimball Fund. This watercolor and *Whistling for Plover* (fig. 10.4) appeared in the Centennial Exhibition.

Fig. 10.4. *Whistling for Plover*, 1874. Transparent watercolor and small touches of opaque watercolor over graphite on cream wove paper; 11⁵⁄₁₆ × 16¹¹⁄₁₆ inches (28.7 × 42.4 cm). Brooklyn Museum, New York. Museum Collection Fund, 25.656

Fig. 10.5. *Professionals at Rehearsal*, 1883. Oil on canvas, 16 × 12 inches (40.6 × 30.5 cm). Philadelphia Museum of Art. The John D. McIlhenny Collection, 1943-40-39

Delaware river covered with such uncouth sailing craft as factory operatives can obtain when they wish to take a sail. The picture here produced [*Professionals at Rehearsal*; see fig. 10.5] is not his best, but it is far from his worst; perhaps "Chess-players" and one other, "Listening to Music," surpass it. The people's note is struck again. Here is the stage robbed of all glamour, the actor and musician in shirt-sleeves, ding and devil-may-care, who tinkle on the zither in preparation for the evening's work. It is peculiarly characteristic for just that reason, since Mr. Eakins is always inclined to put things as badly as possible, as if he had a perfect hatred of neat and showy outsides.

J. Howe Adams, M.D., "Correspondence: Philadelphia Letter," *Southern Practitioner*, **vol. 11, no. 10 (October 1889), pp. 423–24**
Mr. Thomas Eakins, the artist, who has made a specialty of medical and surgical subjects in his profession, was engaged in the spring by the students of the University of Pennsylvania to paint for them a portrait of Prof. Agnew, which they intended to present to the University. Mr. Eakins' painting of Prof. Samuel D. Gross attracted a great deal of attention and remark at the Centennial Exposition, and he determined to paint Dr. Agnew in a similar style. The painting which is now complete, will be exhibited first by Mr. Eakins in a number of cities during the winter, and then be placed in either the new library building or the old Wistar and Horner Museum.

It represents Dr. Agnew in a clinic; he has just finished the operation, and has stepped back against the railing of the amphitheatre and is explaining the details of the operation to the students, who are ranged around on the benches. His assistants are dressing the case, which was one of cancer of the breast, and a few visitors are looking on. The size of the picture is tremendous, the figures being three-fourths natural size, and the likeness of the venerable professor, his assistants, and the students are most admirable. To represent the students sitting in a semi-circular form, and looking at the same point, is one of the most difficult things to do in painting, and in this arrangement the great genius and versatility of the artist are shown, for every student is in a typical position, some taking notes, some watching the dressing, and others looking at the lecturer.

"Pennsylvania Art Exhibit to Be Sent to the Columbian Exposition," *Philadelphia Public Ledger*, **January 16, 1893, p. 6**
Thomas Eakins, however, is represented by ten pictures, of which the most ambitious is his well-known "Crucifixion." But the advisability of including his portraits of Dr. Agnew and Dr. Gross, which are merely excuses for depicting the horrors of the dissecting table, will be severely questioned. While the portraits and the technique of a difficult composition are really excellent, the surroundings and accessories are scarcely in good taste for a public exhibition. "The Sculptor," by the same artist, is of interest as being an exceedingly good likeness of Mr. Donovan at work. Mr. Eakins is also seen to advantage in a romantic painting, which has never previously been exhibited, of two cowboys at home, one of whom is lustily carolling a song to the accompaniment of a guitar.

Martin Church, "The Fine Arts: The Philadelphia Exhibit of Works for the World's Fair," *Boston Daily Evening Transcript*, January 17, 1893, sec. 6, p. 4

The large paintings of an operation in the amphitheatre of a hospital and a dissection by Thomas Eakins, are seen in this exhibition. It is said that these pictures were refused by committees at Philadelphia, also the Christ on the Cross at the side of the larger picture. But judging from their now being on the line, there has come from the good men of Philadelphia a change of heart.

They are strong, well-drawn works of art. The subject is not pleasing and one may doubt if this sort of art ever lifts the mind of men, but as pure technique they are good examples of a wonderful power of managing color and position.

Montague Marks, "My Note Book," *Art Amateur* (New York), vol. 29, no. 2 (July 1893), p. 30

The hospital class of picture to which Mr. [Frederic] Harrison refers [in "The Decadence of Art" in *The Forum*], it so happens is not found in the French section of paintings at The World's Fair; but it is aggressively conspicuous in two large paintings hung in the gallery of the American section. As they are directly in the line of vision, it is impossible to escape from Mr. Eakins's ghastly symphonies in gore and bitumen. Delicate or sensitive women or children suddenly confronted by the portrayal of these clinical horrors might receive a shock from which they would never recover. To have hung the pictures at all was questionable judgment. To have hung them where they are is most reprehensible.

E. J. M., "Art at the World's Fair," *Chicago Daily Tribune*, September 17, 1893, p. 35

To find the celebrated American picture which is often compared with [Adalbert Franz] Seligman's [*Prof. Billroth's Clinic at the General Hospital, Vienna*] one must go up-stairs to United States Gallery No. 113. There will be found Thomas Eakins' "Portrait of Dr. Hayes Agnew," (No. 385, United States), prints of which are so common throughout the country. The original is lent to the Exposition by the University of Pennsylvania. Mr. Eakins is represented at the Art Palace by half a dozen works which testify to his skill and versatility. He has been an instructor for many years at the Philadelphia [*sic*] Academy of Fine Arts, having conducted for a long time a class in anatomical drawing. He is famous chiefly for the present "Portrait of Dr. Agnew," as it is properly called, for it is greater as a portrait of the physician named than it is as a general composition. The moment chosen is after the surgeon has performed an operation. Dressed in white

from head to foot, with the instrument he has used still in his hand, with the right hand still dripping with gore (a sad mistake this!), he stands in the foreground a graphic figure, dominating everything about him—the master surgeon. It is a powerfully realistic portrait; but there is too much bespattering of gore, and the right hand, however realistic it may be, is unpardonable; it is revolting to a layman in its unnecessary grossness. On account of its profusion of gore this picture will offend every non-professional spectator, except, perhaps, some little savage like Budge or Toddy in "Helen's Babies," one of whom—one forgets which—never tired of the story of David and Goliath, because he was entranced with the giant's head, which was "all bluggy!" Of the details of this composition one alone was much admired—that of the young, prim, calm-eyed nurse, who stands beside the operating physician. Many would say that a tender expression should be put in that countenance so strangely in contrast with those about it; but one does not think so.

In the same gallery with the Dr. Agnew portrait is one of Dr. Goss [*sic*] of Jefferson Medical College of Philadelphia (No. 389 United States). This also is painted by Mr. Eakins, but it was executed as long ago as 1875. After gazing at it a few moments one is convinced that certain improvements have been introduced into the practice both of surgery and painting during the intervening years. In the Dr. Goss picture both the operator and his associates wear the common civilian dress; and it is distressing to think into what far different kinds of rooms these professional gentlemen will carry their broadcloth habiliments. In conceiving this work the artist evidently entertained the notion that what the public would be interested in would be the subject rather than the operators. Following this fallacious theory the Mr. Eakins of 1875 has displayed the unfortunate limb into which Dr. Gross is industriously delving with much of the same gusto that a butcher would feel in putting a prime roast of beef in a conspicuous position. "But something too much of this," as Hamlet once had occasion to remark. One cannot take leave of the Dr. Gross clinic without remarking that one of the spectators in the frame, whose feelings have been greatly wrought upon, is practicing some rôle of the Mr. Hyde order.

Sadakichi Hartmann, *A History of American Art*. (Boston: L. C. Page, 1901), vol. 1, pp. 200–207 (includes a reproduction of the painting on p. 202)

[Winslow Homer's] brother artist, Thomas Eakins, of Philadelphia, is quite a different character. Nearly every one who looks at his "Operation," the portrait of Doctor Gross, a Philadelphia medical celebrity, lecturing to a class of students in a college amphitheatre,

exclaims, "How brutal!" And yet it has only the brutality the subject demands. Our American art is so effeminate at present that it would do no harm to have it inoculated with just some of that brutality. Among our mentally barren, from photograph working, and yet so blasé, sweet-caramel artists, it is as refreshing as a whiff of the sea, to meet with such a rugged, powerful personality. Eakins, like Whitman, sees beauty in everything. He does not always succeed in expressing it, but all his pictures impress one by their dignity and unbridled masculine power. How crude his art is at times we see in the startling effect of blood on the surgeon's right hand, in the portrait of Dr. W. D. Marks.

As a manipulator of the brush, however, he ranks with the best; he does not stipple, cross-hatch, or glaze, but slaps his colours on the canvas with a sure hand, and realises solidity and depth. His work may here and there be too severe to be called beautiful, but it is manly throughout—it has muscles—and is nearer to great art than almost anything we can see in America.

His "Christ on the Cross," a lean, lone figure set against a glaring sky, —austere, uncouth, and diabolically realistic as it is, —is a masterpiece of artistic anatomy, in the knowledge of which nobody approaches him in this country.

Thomas Eakins's art and personality remind one of the dissecting room (where he has spent so many hours of his life), of the pallor of corpses, the gleam of knives spotted with red, the calm, cool, deadly atmosphere of these modern anatomy lessons with the light concentrated upon the dissecting table, while the rest of the room is drowned in dismal shadows. And yet, with all his sturdy, robust appearance, he is as naïve and awkward as a big child that has grown up too fast, and his eyes have the far-away look of the dreamer. Indeed a quaint, powerful personality!

Late Reviews and Commentary, 1904–17

Charles H. Caffin, "Some American Portrait Painters," *The Critic*, vol. 44, no. 1 (January 1904), p. 34

Other men of [Frederick P. Vinton's] standing in years are Thomas Eakins, Benjamin C. Porter, Frank Duveneck, and Wyatt Eaton. Eakins's masterpiece is the "Surgical Clinic of Professor Gross," which belongs to the Jefferson College collection in Philadelphia. The fine head of the Doctor occupies almost the centre of the picture, as calmly and lucidly he explains to the tiers of students, assembled in the amphitheatre, the progress of the operation which is being conducted on the table beside him. Contrasted with his impassive intelligence is the concentrated eagerness of the surgeon as he plies his scalpel, of the students who are holding back the flesh from the wound, and of him who is administering

the anæsthetic. The light is centred on the table, gleaming upon white cloths, the white limb, the instruments, the livid wound, and spots of blood. With a passivity as complete as the professor's, and an observation as minutely searching as the surgeon's, Eakins has grasped the scene, recording it with a direct force and yet with a breadth of realization, that includes in a scheme of chiaroscuro its artistic suggestion. There is no other painter in this country, few elsewhere, who could have treated the same subject at once so realistically and so pictorially.

J. W. Buel, ed., *Louisiana and the Fair: An Exposition of the World, Its People and Their Achievements* (St. Louis: World's Progress, 1905), p. 2465

Thomas Eakins, of Philadelphia, had two large canvases which attracted great attention: The Clinic of Prof. Gross, lent by Jefferson Medical College, Philadelphia, and the Clinic of Prof. Agnew, lent by the University of Pennsylvania. The subjects scarcely appeal to the popular taste, and are not in themselves artistic, but were adapted to the places where they were hung, which cannot be truthfully said of all pictures. So great a master as Rembrandt chose a subject equally dismal, in his "Lesson in Anatomy," to be seen at the Hague. These two pictures illustrate the difference between the asceptic [*sic*] surgery of to-day and surgery as practiced twenty odd years ago. A portrait of Physicist, Prof. Rowland, of Johns Hopkins University, is called by Coffin "a marvelously faithful human document."

Charles H. Hughes, M.D., "The Louisiana Purchase Exposition, the Neurasthenic and the Brain-Tired," *Canadian Journal of Medicine and Surgery*, vol. 17, no. 1 (January 1905), pp. 31–33

But the neurasthenic will go to the World's Fair, as well as the strongly nerve-centred, and we should guide him on his way, if we can, against unrecuperable exhaustion, as we shall have him to treat, if he escapes our friend, the man of the black pall and plume, at the conclusion of his Exposition experience. . . .

The clinic picture, with portrait, of the late Professor Gross, of the Jefferson Medical College, on exhibition in the art section, a picture of blood with the horror-stricken mother, in a side light in an attitude of despairing shock and grief, is not a good picture calculated to help toward recovering the sanguiphobic neurasthenic. Cutting down upon a necrosed bone or on an artery for ligation is never a cheerful picture to any onlooker, and not especially so to the most hopeful patient, unless he takes an anesthetic pleasantly and passes soon into dreamy forgetfulness, much less to morbidly unstable nerves, as in neurasthenia.

The painting is one of Thomas Eakins' best, among many good productions there on exhibition. The eminent surgeon's expression, intent upon his task, like a veteran warrior commander amid the carnage of battle, indifferent to all else, though lives about him are shattered and hearts bleeding, is true psychologically to nature. The picture, however, does not meet the requirements of either modern psychiatry or surgery, for the operators all have on their ordinary clothes, the principles of Lister are not in evidence in the proceeding, and to-day the poor, despairing mother would not be permitted in the operating room.

The complementary picture of D. Hayes Agnew, in the amphitheatre by the same artist, in the same hall, represents an operation under more advanced aseptic precautions. The picture must have been painted towards the close of the session, with a senior class for an audience, for many of them showed tired faces, and some are asleep, and some appear to be developing that pathological neurasthenia, which is too often the sequence of the modern medical colleges' exacting and exhausting curriculum, especially where the students are so imprudent as to indulge in engrossing side pleasures in late night hours, in addition to the exacting study college duty demands.

The pictures of Gross and Agnew, coupled with the biography of their regular, steady, driving, striving, systematic lives, are a defiance of that premature neurasthenia, such as befalls the less systematic and prudent worker in the fields of medical endeavor. They worked much, but they rested betimes and were not worn out by those vices and indulgences which exhaust so many. . . .

To the man of ceaseless demands, the man of affairs, the weary and heavily laden professional, business or domestic burden bearer in this strenuous age, diversion is recuperation, and recreation is rest and may be made to conduce to recuperation, even at a great Universal Exposition like the World's Fair at St. Louis is. But to conduce to this end, its attractions should be taken slowly and in moderation, with the length of weeks and months expended upon them and not by a few days of brain-racking sightseeing. Not by trying to encompass its wondrous exhibits or comprehend its numberless world studies in limited days or even weeks, can he or she of meagre nerve power reserve, do it without self-harm, but by doing the observation of its cosmic wonders with leisure and discrimination, diverting and resting the mind, and adequately feeding and sleeping the body between visits to its thousands of entertaining and instructive and mind-diverting attractions, and by blending its tranquilizing, soothing and refreshing adjunctive influences with its wondrous sights.

Charles H. Caffin, "The Story of American Painting: French Influence," *American Illustrated Magazine*, vol. 61, no. 5 (March 1906), pp. 592–93 (includes a reproduction of the painting on p. 591)

As Rembrandt in his "Lesson in Anatomy," portrayed the celebrated surgeon, Dr. Tulp, so Eakins has commemorated the personality of Professor Gross, in this picture representing a "Surgical Clinic." It involves an effectively artistic composition as well of lines and masses as of light and shade, and fine characterization in the individual figures, but the inherent power of the picture is the product of the artist's own point of view. He has approached the incident in precisely the same kind of condition of mind as the surgeons engaged in the operation. The patient, for the time being at any rate, is but a "subject," toward which their attitude of mind is absolutely impersonal, but on which they concentrate all their knowledge and skill, so that their own personality declares itself masterfully in a complete control of the situation.

Charles Frankenberger, "The Collection of Portraits Belonging to the College," *The Jeffersonian*, vol. 17, no. 132 (November 1915), pp. 1–2

The masterpiece of the collection is the "Clinic of Doctor Samuel D. Gross," painted by Thomas Eakins in 1875, which hangs on the wall of the West Lecture Room.

Mr. Eakins was a student in Jefferson, taking a special course in anatomy in connection with his art work, and it was while in attendance at the College that he saw Doctor Gross in action and placed upon canvas his impressions of what he saw.

In the painting Professor Gross is seen standing in the center, scalpel in hand, talking to the class as was his custom during an operation. The patient is a man from whose thigh is being removed a piece of dead bone. Seated directly in front of Doctor Gross is Doctor Charles S. Briggs, while seated in the first row of seats to the right of Professor Gross is the Clinic Clerk, Doctor Franklin West. Doctor W. Joseph Hearn, now Emeritus Professor of Clinical Surgery, is seated at the end of the operating table nearest the entrance to the amphitheatre, administering chloroform, the anesthetic employed by Doctor Gross. Doctor James M. Barton is seen on the opposite side of the operating table, directly across from Professor Gross, probing in the incision made, while Doctor Daniel Apple [*sic*], seated on Doctor Barton's left, is holding a tenaculum. Doctor Samuel W. Gross, the son of Professor Gross, who succeeded his father in the Chair of Surgery, is seen leaning against the side of the entrance way into the room. The individual, just faintly distinguishable in shirt sleeves, to the rear of Doctor S. W. Gross, is "Hughey," the janitor, who was well known to every Jefferson

student of those times. In the extreme left-hand corner can be seen the mother of the patient, under severe nervous stress, in the attitude of shielding her eyes from the horror of what is happening to her son. What a contrast this scene is,—with those operating and assisting in their ordinary street clothes,—to our present-day surgical clinics, with their complete antiseptic methods!

The painting shows wonderful skill by the marvelous way in which every detail in each figure has been brought out, and the excellent coloring.

It was exhibited at the Centennial Exhibition in Philadelphia in 1876. Although it was refused a place in the Public Art Gallery, because of being such a bloody subject, it, however, was placed with the Government collection. It has been exhibited at the expositions in Chicago, Buffalo, and St. Louis, where in 1904 it was awarded the Gold Medal. It is considered by art critics to be Mr. Eakins' masterpiece.

"Thomas Eakins to Be Honored by Exhibition," *New York Times Magazine*, August 26, 1917, p. 12

Perhaps it was because of [Eakins's] pleasure in work that he liked painting people at their own tasks. He could get in that way the essentials of character coming to the surface at moments of stress and concentration. His most striking work in this kind is the "Clinic of Professor Gross," now in the Jefferson Medical College, where students will look at it understandingly. It has been called a modern variant of Rembrandt's famous "Lesson in Anatomy" and is, of course, similar in subject. Apart from technical and artistic differences, it is interesting to note the difference in mental attitude. In Rembrandt's picture Dr. Tulp is lecturing placidly to a group of men who listen attentively, but only in the case of three with anything approaching concentration. The atmosphere of the picture is serene and leisurely, and there is a certain regularity of disposition in the heads of the surgeons that suggests planned portraiture. In the "Clinic of Professor Gross" the realism is more acute. Each attitude and gesture speaks of a state of mind. The men at work are thinking only of the surgical significance of their subject. Those in the background are taking notes or craning their heads to see the operation. The light and shadow are considered in a Rembrandtesque spirit; but nothing makes so deep an impression on the mind of the observer as the way in which the character of each person is drawn out and emphasized. No one in the picture ever could be taken for any one else, however slight the glimpse given of his physiognomy. Only in the head of the professor is there the merest hint of formal portraiture, of a pose prolonged and an expression fixed ever so little beyond the limit of spontaneity. A study of this head was in the little group of paintings by Eakins shown this year in

the annual exhibition of the Pennsylvania Academy and commanded attention by the alert vitality of the features under their crackled patina, a fragment more vivid than the elaborated portraits.

J. McClure Hamilton, "Thomas Eakins, Two Appreciations," *Bulletin of the Metropolitan Museum of Art*, vol. 12, no. 11 (November 1917), p. 220

In the two large and imposing works, The Gross Clinic and The Agnew Clinic, Eakins reveals himself as the great master, standing with Manet at his best and, in many respects, reminding us of those wonderful portrait groups in the Museum of Haarlem by Frans Hals. Eakins has immortalized the Guild of Surgeons of Philadelphia just as Hals has made famous the guilds of Holland but, unlike the Dutch painter, Eakins had no brilliant color to deal with—no frills and laces, no slashed doublets and lawn sleeves, no emblazoned banners but only the dull drab and gray clothes of the surgeons and students of the Quaker City. The glitter of steel instruments and a touch of blood give the only color notes to these two pictures, pictures that speak loudly of the virility of the painter and of the complete seriousness of a mind bent upon solving every problem of grouping, form, chiaroscuro, perspective, and realistic effect.

There may be a conflict of opinion respecting the comparative merits of the two portrait groups—the exponents of "light" favoring The Agnew Clinic—but no one can deny that in The Gross Clinic there has been nothing omitted that the artist deemed necessary to make his conception of that class-room and its distinguished head, a real and living record of a useful and necessary, if painful, scene.

When speaking upon the art of Japan, a Japanese once said quaintly, "Were we artistic, we did not know it." It can be said sadly of Thomas Eakins, that he did not know, what his countrymen soon shall know, that he has painted the two really great portrait masterpieces of America in the nineteenth century.

Henry McBride, "News and Comment in the World of Art," *New York Sun*, November 4, 1917, p. 12 (includes a reproduction of the painting)

The strength of the late Thomas Eakins as a painter, it is safe to promise, will come as a revelation to most of the students and connoisseurs who will visit the memorial exhibition of his work that will open to-morrow to invited guests and on Tuesday to the general public in the Metropolitan Museum of Art.

The name of Eakins is unfamiliar to the present art public, is practically unknown to our great collectors and is strangely absent

from the lists of so-called honors meted out by artist juries at the time of public exhibitions. Nevertheless, Eakins is one of the three or four greatest artists this country has produced, and his masterpiece, the portrait of Dr. Gross, is not only one of the greatest pictures to have been produced in America but one of the greatest pictures of modern times anywhere.

Under the circumstances it can be seen that the Metropolitan Museum has undertaken an enterprise of importance—nothing more nor less than the crowning with honors of one of our most neglected geniuses. It will place the fame of Thomas Eakins. It will make more history, although it will not be more important, than the memorial exhibition to Albert P. Ryder, which is to take place later in the season at the museum, for in a way Ryder has long since found his audience and his place. Consequently in the most emphatic manner possible the public is urged to begin at once the study of the Eakins pictures and to study them long.

I say "study them long," for it is possible that the timid portion of the population unless held sternly in check will imitate the silliness of the timid people of years ago, who were stampeded from the "Portrait of Dr. Gross" by the cry, "It is brutal."

The picture is brutal, if you will, but it is brutal as nature sometimes is and science always is.

It is a stupendous painting nevertheless. It is great from every point of view, impeccably composed, wonderfully drawn, vividly real and so intensely charged with Eakins's sense of the majesty of modern science as personified by Dr. Gross that the elevation of the artist's spirit is communicated to the beholder, and the ghastly blood stains—for Dr. Gross is shown in the clinic, pausing in the midst of an operation—are forgotten. It is not the blood that makes the painting great, any more than it is the blood that makes "Macbeth" great. However, the public will probably wish to dilate upon this blood, and it is welcome to the theme, providing it does not allow itself to be hoodwinked into vulgarizing the painting. I once knew a dear old lady who assured me that "Macbeth" was a poor play, basing her contention upon the undoubtedly correct plea that *Lady Macbeth* was "horrid." . . .

The "Portrait of Dr. Gross," as I have said, was found brutal by the artists of the day at the time that it was painted. The same objection was held for the "Portrait of Dr. Agnew." It was rejected by the jury of that year at the Philadelphia Academy. . . .

I am aware that hitherto the "Dr. Agnew" in a private way has been called number one, but now that the paintings hang in the same gallery the extraordinary power of the "Dr. Gross" will probably pass unquestioned.

The "Dr. Agnew" is full of impassioned painting that is characteristic of all of our artist's work, and the attitudes of the personages are as unconscious and the realism of the operation

that is proceeding before us is as terrifying as that in the first named work, but the grouping is not so happily arranged and the picture does not rise to an overpowering climax in the central figure as in "Dr. Gross." Besides, the students on the arena benches in the background are confusedly placed and distracting.

In the "Dr. Gross," on the contrary, every actor in the drama is first rate in his part, and every detail of the picture has the highest distinction as painting.

There is a danger at this time with the question of surgery again so prominent in the public consciousness because of the war that there will be a difficulty in gaining public attention for the study of the style in these two important pictures, so absorbed and perhaps so shocked will the layman be by the spectacle.

Henry McBride, "News and Comment in the World of Art," *New York Sun*, November 11, 1917, p. 12

In the series of Eakins's portraits the "Dr. Gross" and the "Dr. Agnew" take a preeminence that probably will pass undisputed.

Francis J. Ziegler, "Eakins Memorial Exhibition in New York," *Philadelphia Record*, November 11, 1917 (includes a reproduction of the painting)

At last, Thomas Eakins has attained fitting recognition as one of the greatest of American painters, the memorial exhibition of his works now on view at the Metropolitan Museum being the first adequate display of his pictures ever presented to the public.

It is one of the ironies of fate that the homage now paid could not have come during his lifetime. A chosen few knew him as a prince of painters and many keen-sighted critics were able to sense the greatness of his art, but the austerity of his work and his own almost morbid dislike of publicity never permitted a general appreciation of his genius.

Such masterpieces as his two wonderful pictures of clinics, the monumental portraits of Dr. Gross and Dr. Agnew, the first owned by the Jefferson Medical Hospital of Philadelphia, the second by the University Hospital, of the same city, were known to artists and to some of the medical profession, but their subject matter, with its realism of execution, caused the ordinary person not in sympathy with the ideals of realistic painting, to look at them askance as unpleasant things which ought not to be depicted.

It is a matter of artistic history that when the Gross portrait, now described by a leading critic as the greatest picture ever painted in America, was offered as a contribution to the art section of the Centennial Exhibition it was rejected by the jury. In this instance the doctors showed themselves better judges than the

painters; for, discarded by the artists, it was hung in the Army and Navy Building with the hospital exhibit, a thing of power which forced its impress on the memory of the visitor.

"The Gross Clinic" was painted in 1875 and was shown at the expositions at Chicago, Buffalo and St. Louis, securing more distinguished consideration at these cities than it did in the artist's home town and being awarded a gold medal in 1904.

A Matter of Contrast

When Eakins painted the Gross Clinic surgeons were wont to operate in their street attire, the central figure and the assistant physicians in this composition all being clad in the ordinary professional garb of that period. This circumstance imparts a general sombreness to the canvas, which the artist used to great advantage in accentuating the face of Dr. Gross, but which led some critics of those days to say that Eakins knew how to draw, but was not a colorist.

Eakins was not a man who paid much attention to criticism, either lay or professional, but this charge must have rankled a little because he remembered it when it came to the painting of the Agnew Clinic years afterward. Surgical practice, by changing the garb of the operating room from black to white, played into his hands, but he started the work with the avowed intention of showing the world that he knew how to handle color, sketched the composition in a much higher key than his earlier canvas, and achieved another masterpiece along different lines.

A little bit of intimate history regarding the geniuses [*sic*] of this picture—"The Agnew Clinic"—may not be amiss in this place.

The graduating class of the University of Pennsylvania—the exact date slips the memory, but was something like 1890—was anxious to present their school with a portrait of Dr. Agnew and raised a sum for that purpose, which they expected would be sufficient to pay for an ordinary-size portrait head. Eakins accepted this as the amount of his commission and produced the large canvas in question, in which there are at least 30 portraits,

the various members of the class and the artist himself being recognizable with ease in the composition.

When the artist's study of Dr. Agnew's figure for this work was sold in Philadelphia a year or so ago, it brought many times the amount of money paid for the finished work.

"Thomas Eakins: Another Neglected Master of American Art," *Current Opinion*, vol. 63, no. 6 (December 1917), p. 412 (includes a reproduction of the painting on p. 411)

The bent of Eakins's mind was strongly scientific. Science and scientists held great sway over him all his life. His study of anatomy led him to the clinics of great surgeons. His two great pictures of Dr. Gross and Dr. Agnew were the outcome of this interest. He admired skill in all fields, in science, sports, and recreations, as many of his canvases attest.

William Sartain, "Thomas Eakins," *Art World*, vol. 3, no. 4 (January 1918), pp. 291–93 (includes a reproduction of the painting on p. 292)

On his more particularly specializing as portraiture, his most important subject was the "Dr. Gross' Clinic," a most notable work, which, however, the Pennsylvania Academy of Fine Arts would not hang. About this time the Society of American Artists was formed in New York. La Farge, who had been badly treated in the Academy exhibitions, Samuel Colman, George Inness and other National Academicians were among the founders. To its first exhibition Eakins sent his "Dr. Gross' Clinic" and it produced a profound impression. This exhibition was such a decided success that the Pennsylvania Academy asked that it be sent to them to form a section of their spring exhibition—and thus—somewhat against their wishes—was Eakins' masterpiece seen in his native city. Exhibited lately in the Metropolitan Museum of Art in a collection of his paintings, this work has been again seen and its place accorded a high rank in the art of our country.

Bibliography

For sources on the history of medicine as reflected in Thomas Eakins's clinic paintings, see also the notes to Mark S. Schreiner's essay in this volume. For period commentary on The Gross Clinic, *see the Appendix.*

Ackerman, Gerald M. "Thomas Eakins and His Parisian Masters Gérôme and Bonnat." *Gazette des Beaux-Arts*, 6th per., vol. 73 (April 1969), pp. 235–56.

Adams, Henry. *Eakins Revealed: The Secret Life of an American Artist.* Oxford: Oxford University Press, 2005.

———. "Thomas Eakins: The Troubled Life of an Artist Who Became an Outcast." *Smithsonian*, vol. 22 (November 1991), pp. 52–67.

Adams, J. Howe. *History of the Life of D. Hayes Agnew.* Philadelphia: F. A. Davis, 1892.

Adelman, Seymour. "Thomas Eakins: Mount Vernon Street Memories." In *The Moving Pageant: A Selection of Essays.* Lititz, PA: Sutter House, 1977.

Agnew, D. Hayes. *The Principles and Practice of Surgery.* 3 vols. Philadelphia: J. B. Lippincott, 1883.

Aponte, Gonzalo E. "Thomas Eakins." *Jefferson Medical College Alumni Bulletin*, vol. 12 (December 1961), pp. 2–5.

———. "Thomas Eakins (1844–1916), Painter, Sculptor, Teacher." *Transactions and Studies of the College of Physicians of Philadelphia*, vol. 32 (April 1965), pp. 160–63.

Athens, Elizabeth. "Knowledge and Authority in Thomas Eakins' *The Agnew Clinic.*" *Burlington Magazine*, vol. 148 (July 2006), pp. 482–85.

Barker, Clyde F. "Thomas Eakins and His Medical Clinics." *Proceedings of the American Philosophical Society*, vol. 153 (March 2009), pp. 1–47.

Berger, Martin A. *Man Made: Thomas Eakins and the Construction of Gilded Age Manhood.* Berkeley: University of California Press, 2000.

———. "Modernity and Gender in Thomas Eakins's 'Swimming.'" *American Art*, vol. 11 (Autumn 1997), pp. 32–47.

———. "Thomas Eakins and the Anatomy of Manhood." In *Thomas Eakins: Painting and Masculinity / Peinture et masculinité*, edited by Stéphane Guégan and Veerle Thielemans, pp. 55–73. Giverny, France: Terra Foundation for American Art, 2003.

Berkowitz, Julie S. *Adorn the Halls: History of the Art Collection at Thomas Jefferson University.* Philadelphia: Thomas Jefferson University, 1999.

———. *The Eakins Gallery.* Philadelphia: Thomas Jefferson University, 1997.

Berman, Avis. "A Meditation on Belonging." *ARTnews*, vol. 83 (November 1984), pp. 35–36.

———. "Thomas Eakins: Master of Realist Art." *Saturday Review* (June 1982), pp. 24–28.

Birk, Eileen P. "Eakins Portraits at the Philadelphia Museum of Art." *Antiques*, vol. 96 (August 1969), pp. 184, 188.

Bolger, Doreen, and Sarah Cash, eds. *Thomas Eakins and the Swimming Picture.* Exhibition catalogue. Fort Worth, TX: Amon Carter Museum, 1996.

Borowitz, Helen Osterman. "The Scalpel and the Brush: Anatomy and Art from Leonardo da Vinci to Thomas Eakins." *Cleveland Clinic Quarterly*, vol. 53 (Spring 1986), pp. 61–73.

Braddock, Alan C. "'Jeff College Boys': Thomas Eakins, Dr. Forbes, and Anatomical Fraternity in Postbellum Philadelphia." *American Quarterly*, vol. 57 (June 2005), pp. 355–83.

Bregler, Charles. "Thomas Eakins as a Teacher." *The Arts*, vol. 17 (March 1931), pp. 379–86.

Brieger, Gert H. "A Portrait of Surgery: Surgery in America, 1875–1889." *Surgical Clinics of North America*, vol. 67 (December 1987), pp. 1181–1216.

Brodsky, Michael Ian. "Portrait of an American Surgeon: Thomas Eakins's *The Gross Clinic.*" *The Pharos*, vol. 60 (Summer 1997), pp. 4–8.

Burns, Sarah. "Ordering the Artist's Body: Thomas Eakins's Acts of Self-Portrayal." *American Art*, vol. 19 (Spring 2005), pp. 82–107.

———. *Painting the Dark Side: Art and Gothic Imagination in Nineteenth-Century America*. Berkeley: University of California Press, 2004.

Burroughs, Alan. "Thomas Eakins." *The Arts*, vol. 3 (March 1923), pp. 185–89.

Byrne, Janet S. "Prints of Medical Interest." *Metropolitan Museum of Art Bulletin*, vol. 5 (April 1947), pp. 210–14.

Cameron, Andrew MacGregor. "Developments in American Surgery from 1875 to 1889 as Portrayed in the Surgical Portraits of Thomas Eakins." A.B. thesis, Harvard University, 1991.

Canaday, John. "Thomas Eakins." *Horizon*, vol. 6 (Autumn 1964), pp. 88–105.

Carney, Ray. "When Mind Is a Verb: Thomas Eakins and the Work of Doing." In *The Revival of Pragmatism*, edited by Morris Dickstein, pp. 377–403. Durham, NC: Duke University Press, 1998.

Carr, Carolyn Kinder. *Revisiting the White City: American Art at the 1893 World's Fair*. Washington, DC: National Museum of American Art and National Portrait Gallery, 1993.

Cash, Stephanie. "Eakins Painting to Stay in Philly." *Art in America*, vol. 95 (February 2007), pp. 29, 31.

Cercone, Diana. "Art/Architecture: A Four-Sided Celebration of Eakins." *New York Times*, September 30, 2001.

Clark, William J. "The Iconography of Gender in Thomas Eakins Portraiture." *American Studies*, vol. 32 (Fall 1991), pp. 5–28.

Conn, Steven. *Do Museums Still Need Objects?* Philadelphia: University of Pennsylvania Press, 2010.

Cortissoz, Royal. *American Artists*. New York: Charles Scribner's Sons, 1923.

Dacey, Philip. "Thomas Eakins' *The Gross Clinic* (1876)." *Academic Medicine*, vol. 78 (January 2003), pp. 108–9.

Danly, Susan, and Cheryl Leibold. *Thomas Eakins and the Photograph: Work by Thomas Eakins and His Circle in the Pennsylvania Academy of the Fine Arts*. Washington, DC: Smithsonian Institution Press for the Pennsylvania Academy of the Fine Arts, 1994.

D'Arcy, David. "Philadelphia Museum of Art: 'Sharp Cold Cutting True Sea Brine.'" *Art Newspaper*, vol. 12 (October 2001), p. 30.

Doyle, Jennifer. "Sex, Scandal, and Thomas Eakins's *The Gross Clinic*." *Representations*, no. 68 (Autumn 1999), pp. 1–33.

Eakins, Thomas. *A Writing Manual by Thomas Eakins*. Edited by Kathleen A. Foster. Philadelphia: Philadelphia Museum of Art, 2005.

"The Eakins Centennial Exhibition." *Antiques*, vol. 45 (June 1944), pp. 315–16.

"Eakins' Pictures at Brummer's." *Art News*, vol. 21 (March 24, 1923), p. 2.

Eckenhoff, James E. "The Anesthetics in Thomas Eakins' 'Clinics.'" *Anesthesiology*, vol. 26 (September/October 1965), pp. 663–66.

"Editorial: A Question of Roots." *Apollo*, vol. 121 (May 1985), pp. 290–93.

Eggers, George William. "Thomas Eakins." *News Bulletin and Calendar*, vol. 20 (January 1930), pp. 86–94.

Fairbrother, Trevor. "Thomas Eakins." Review of *Thomas Eakins* by Lloyd Goodrich. *Burlington Magazine*, vol. 126 (June 1984), pp. 366–67.

Falk, Peter Hastings, ed. *The Annual Exhibition Record of the Pennsylvania Academy of the Fine Arts: 1876–1913*. Madison, CT: Sound View Press, 1989.

Flam, Jack. "Eakins in Light and Shadow." *American Heritage*, vol. 42 (September 1991), pp. 57–71.

Folds, Thomas M. "The Great American Artists Series." Review of *Thomas Eakins* by Fairfield Porter. *Art Journal*, vol. 20 (Fall 1960), pp. 52, 54, 56.

Fosburgh, James W. "Music and Meanings: Eakins' Progress." *Art News*, vol. 56 (February 1958), pp. 24–27.

Foster, Kathleen A. "American Drawings, Watercolors, and Prints." *Metropolitan Museum of Art Bulletin*, vol. 37 (Spring 1980), pp. 2–52.

———. *Thomas Eakins Rediscovered: Charles Bregler's Thomas Eakins Collection at the Pennsylvania Academy of the Fine Arts*. Philadelphia: Pennsylvania Academy of the Fine Arts; New Haven, CT: Yale University Press, 1997.

Foster, Kathleen A., and Cheryl Leibold. *Writing about Eakins: The Manuscripts in Charles Bregler's Thomas Eakins Collection*. Philadelphia: University of Pennsylvania Press, 1989.

Frankenberger, Charles. "The Collection of Portraits Belonging to the College." *The Jeffersonian*, vol. 17 (November 1915), p. 2.

Fried, Michael. "Realism, Writing, and Disfiguration in Thomas Eakins's *Gross Clinic*, with a Postscript on Stephen Crane's 'Upturned Faces.'" *Representations*, vol. 9 (Winter 1985), pp. 33–104.

———. *Realism, Writing, Disfiguration: On Thomas Eakins and Stephen Crane*. Chicago: University of Chicago Press, 1987.

Frumovitz, Michael M. "Thomas Eakins' *Agnew Clinic*: A Study of Medicine through Art." *Obstetrics and Gynecology*, vol. 100 (December 2002), pp. 1296–1300.

Fryer, Judith. "'The Body in Pain' in Thomas Eakins' *Agnew Clinic*." *Michigan Quarterly Review*, vol. 30 (Winter 1991), pp. 191–209.

Gerdts, William H. *The Art of Healing: Medicine and Science in American Art*. Exhibition catalogue. Birmingham, AL: Birmingham Museum of Art, 1981.

Giberti, Bruno. *Designing the Centennial: A History of the 1876 International Exhibition in Philadelphia*. Lexington: University Press of Kentucky, 2002.

Gilman, Roger. "American Tastes in Painting." *Parnassus*, vol. 11 (November 1939), pp. 4–7.

Goodbody, Bridget L. "'The Present Opprobrium of Surgery': *The Agnew Clinic* and Nineteenth-Century Representations of Cancerous Female Breasts." *American Art*, vol. 8 (Winter 1994), pp. 32–51.

Goodrich, Lloyd. "The Art of Thomas Eakins." *Portfolio*, vol. 4 (September/October 1982), pp. 60–75.

———. "An Eakins Exhibition." *Magazine of Art*, vol. 32 (November 1939), pp. 612–21.

———. "The Painting of American History, 1775 to 1900." *Corcoran Gallery of Art Bulletin*, vol. 5 (February 1952), n.p.

———. *Thomas Eakins*. 2 vols. Cambridge, MA: Harvard University Press for the National Gallery of Art, 1982.

———. *Thomas Eakins: His Life and Work*. New York: Whitney Museum of American Art, 1933.

———. "Thomas Eakins, Realist." *The Arts*, vol. 26 (October 1929), pp. 72–83.

———. "Thomas Eakins Today." *Magazine of Art*, vol. 37 (May 1944), pp. 162–66.

Goodrich, Lloyd, and Henri Marceau. "Thomas Eakins Centennial Exhibition." *Philadelphia Museum Bulletin*, vol. 39 (May 1944), pp. 119–35.

Goodyear, A. Conger. "All Good Americans." *Parnassus*, vol. 10 (April 1938), pp. 15–19.

Gould, George M., ed. *The Jefferson Medical College of Philadelphia: A History*. 2 vols. New York: Lewis, 1904.

Grafly, Dorothy. "Loan Exhibition of Eakins Work at Philadelphia Museum of Art." *Art News*, vol. 28 (April 5, 1930), pp. 19–20.

Greiffenstein, Patrick, and James Patrick O'Leary. "Eakins' Clinics: Snapshots of Surgery on the Threshold of Modernity." *Archives of Surgery*, vol. 143 (November 2008), pp. 1121–25.

Gross, Samuel D. *Autobiography of Samuel D. Gross, M.D.* 2 vols. Philadelphia: George Barrie, 1887.

———. *A Manual of Military Surgery; or, Hints on the Emergencies of Field, Camp and Hospital Practice*. Philadelphia: J. B. Lippincott, 1861.

———. *A System of Surgery: Pathological, Diagnostic, Therapeutic, and Operative*. 2 vols. Philadelphia: Blanchard and Lea, 1859.

———. *Then and Now: A Discourse Introductory to the Forty-Third Course of Lectures in the Jefferson Medical College of Philadelphia*. Philadelphia: Collins, 1867.

"The Gross Clinic by Thomas Eakins." *British Medical Journal*, vol. 301 (October 3, 1990), p. 707.

Harris, James C. "The Agnew Clinic." *Archives of General Psychiatry*, vol. 64 (March 2007), pp. 270–71.

Hemingway, Andrew. "Critical Realism in the History of American Art." In *Visions of America since 1492*, edited by Deborah L. Madsen, pp. 111–44. New York: St. Martin's, 1994.

Hendricks, Gordon. "Eakins' William Rush Carving the Allegorical Statue of the Schuylkill." *Art Quarterly*, vol. 31 (Winter 1968), pp. 383–404.

———. "Gross Dereliction" (letter to the editor). *Art in America*, vol. 64 (May/June 1976), p. 5.

———. *The Life and Works of Thomas Eakins*. New York: Grossman, 1974.

———. *The Photographs of Thomas Eakins*. New York: Grossman, 1972.

———. "Thomas Eakins's *Gross Clinic*." *Art Bulletin*, vol. 51 (March 1969), pp. 57–64.

Hendy, Philip. "Taste and Science in the Presentation of Damaged Pictures." In *Studies in Western Art: Acts of the 20th International Congress of the History of Art*, vol. 4, *Problems of the 19th and 20th Centuries*, edited by Millard Meiss et al. Princeton, NJ: Princeton University Press, 1963.

Hills, Patricia. "Thomas Eakins's *Agnew Clinic* and John S. Sargent's *Four Doctors*: Sublimity, Decorum, and Professionalism." *Prospects*, vol. 11 (1986), pp. 217–30.

Hogarth, Burne. "Outline of American Painting: Painters of Realism and Romanticism in the Industrial Era (1870–1900)." *American Artist*, vol. 26 (March 1962), pp. 57–68.

Homer, William Innes. *Thomas Eakins: His Life and Art*. New York: Abbeville, 1992.

———, ed. *Eakins at Avondale and Thomas Eakins: A Personal Collection*. Chadds Ford, PA: Brandywine River Museum, 1980.

———, ed. *The Paris Letters of Thomas Eakins*. Princeton, NJ: Princeton University Press, 2009.

Hyman, Neil. "Eakins' *Gross Clinic* Again." *Art Quarterly*, vol. 35 (Summer 1972), pp. 158–64.

Ikard, Robert W. "Dr. Gross's Assistants in *The Gross Clinic*." *Journal of the American College of Surgeons*, vol. 211 (September 2010), pp. 424–30.

Johns, Elizabeth. *Thomas Eakins: The Heroism of Modern Life*. Princeton, NJ: Princeton University Press, 1983.

Johns, Elizabeth, Jerome J. Bylebyl, and Gert H. Brieger, MD. *Thomas Eakins: Image of the Surgeon*. Exhibition catalogue.

Baltimore: Walters Art Gallery and Johns Hopkins Medical Institutions, 1989.

Jordanova, Ludmilla. "Probing Thomas Eakins." Review of *Realism, Writing, Disfiguration: On Thomas Eakins and Stephen Crane* by Michael Fried. *Art History*, vol. 11 (March 1988), pp. 115–18.

Juler, Caroline. "Thomas Eakins and the American Tradition." Review of *Thomas Eakins* by Lloyd Goodrich. *Studio International*, vol. 196 (August 1983), pp. 48–49.

Katz, Leslie. "Thomas Eakins Now." *Arts Magazine*, vol. 30 (September 1956), pp. 18–23.

Katz, Marisa Mazria. "Philadelphia's Eakins Restored to Health." *Art Newspaper*, vol. 19 (June 2010), p. 26.

Kaufman, Jason Edward. "Philadelphia Raises $68M to Beat Wal-Mart to the 'Clinic.'" *Art Newspaper*, vol. 16 (February 2007), p. 15.

Kennedy, Randy. "Shedding Darkness on an Eakins Painting." *New York Times*, July 10, 2010.

Kessler, Charles S. "The Realism of Thomas Eakins." *Arts Magazine*, vol. 36 (January 1962), pp. 16–22.

Kimmelman, Michael. "A Fire Stoking Realism." *New York Times*, June 21, 2002.

Kirk, Margaret. "If This Painting Is So Great. . . ." *Today: The Inquirer Magazine*, May 30, 1982, pp. 8–11, 21.

Kirkpatrick, Sidney D. *The Revenge of Thomas Eakins*. New Haven, CT: Yale University Press, 2006.

Korman, Amy Donohue. "The Art of the Deal." *Philadelphia Magazine* (May 2007), pp. 140–55.

Kramer, Hilton. "Realist Thomas Eakins—He's Back, Still Beloved." *New York Observer*, October 15, 2001.

Lambert, James H. *The Story of Pennsylvania at the World's Fair, St. Louis, 1904*. Philadelphia: Pennsylvania Commission, 1905.

Legrand, François. "Les enjeux anatomiques de Thomas Eakins." *Beaux Arts Magazine*, no. 213 (February 2002), pp. 70–75.

Leja, Michael. "Eakins and Icons." *Art Bulletin*, vol. 83 (September 2001), pp. 479–97.

Levi, Jan Heller. "Fried's Scalpel." Review of *Realism, Writing, and Disfiguration: On Thomas Eakins and Stephen Crane* by Michael Fried. *ARTnews*, vol. 87 (February 1988), p. 51.

Lister, Joseph. *Introductory Lecture Delivered in the University of Edinburgh, November 8, 1869*. Edinburgh: Edmonston and Douglas, 1869.

Long, Diana E. "Eakins's Agnew Clinic: The Medical World in Transition." *Transactions and Studies of the College of Physicians of Philadelphia*, ser. 5, vol. 7, no. 1 (1985), pp. 26–32.

———. "The Medical World of *The Agnew Clinic*: A World We Have Lost." *Prospects*, vol. 11 (1986), pp. 185–98.

Lubin, David M. *Act of Portrayal: Eakins, Sargent, James*. New Haven, CT: Yale University Press, 1985.

———. "Projected Images (*Thomas Eakins: American Realist*)" (exhibition review). *Artforum International*, vol. 40 (September 2001), pp. 69–70.

———. "Projecting an Image: The Contested Cultural Identity of Thomas Eakins." *Art Bulletin*, vol. 84 (September 2002), pp. 510–22.

Marceau, Henri Gabriel. "American Painting in the Braun Collection." *Bulletin of the Pennsylvania Museum*, vol. 25 (May 1930), pp. 18–23.

———. "An Exhibition of Thomas Eakins' Work." *Bulletin of the Pennsylvania Museum*, vol. 25 (March 1930), pp. 2–5.

Mathiasen, Helle. "The Heroic Physician and *The Gross Clinic*." *American Journal of Medicine*, vol. 120 (2007), pp. 916–17.

May, Stephen. "The Art of Thomas Eakins." *American Arts Quarterly*, vol. 8 (Fall 1991), pp. 8–14.

———. "Thomas Eakins: Historic Realist." *American Artist*, vol. 65 (November 2001), pp. 44–51, 72.

McCabe, James D. *The Illustrated History of the Centennial Exhibition, Held in Commemoration of the One Hundredth Anniversary of American Independence*. Philadelphia: National Publishing, c. 1876.

McCarthy, Cathleen. "Thomas Eakins' Philadelphia." *Art & Antiques*, vol. 30 (September 2007), pp. 101–3.

McCaughey, Patrick. "Thomas Eakins and the Power of Seeing." *Artforum*, vol. 9 (December 1970), pp. 56–61.

McFeely, William S. *Portrait: A Life of Thomas Eakins*. New York: W. W. Norton, 2007.

McHenry, Margaret. *Thomas Eakins Who Painted*. Privately printed, 1946.

"Medical Class of 1889: Commissioning of Thomas Eakins to Paint *The Agnew Clinic*." University of Pennsylvania Archives, www.archives.upenn.edu/histy/features/1800s/1889med/ agnewclinic.html.

"Merely Custodians." *Art Digest*, vol. 15 (November 1940), p. 23.

Milroy, Elizabeth, with Douglass Paschall. *Guide to the Thomas Eakins Research Collection, with a Lifetime Exhibition Record and Bibliography*. Philadelphia: Philadelphia Museum of Art, 1996.

Montgomery, Thaddeus L. "The Gross Clinic: It's [*sic*] Future at Jefferson." *Jefferson Medical College Alumni Bulletin*, vol. 30 (Spring 1981), pp. 11–16.

Moynihan, Rodrigo. "The Odd American." *Art News*, vol. 69 (January 1971), pp. 50–53.

Mulford, Wendy. "In Differences Lies Diversity." *Modern Painters*, vol. 6 (Summer 1993), pp. 62–63.

"New Accessions at the Metropolitan." *Art News*, vol. 22 (December 15, 1923), pp. 1–12.

Nochlin, Linda. "Issues of Gender in Cassatt and Eakins." In *Nineteenth-Century Art: A Critical History*, edited by Stephen F. Eisenman, pp. 255–73. London: Thames and Hudson, 1994.

"Note on Thomas Eakins." *Artwork*, vol. 6, no. 23 (1930), pp. 196–99.

Novak, Barbara. *American Painting of the Nineteenth Century: Realism, Idealism, and the American Experience*. New York: Praeger, 1969.

Nuland, Sherwin B. "The Artist and the Doctor." *American Scholar*, vol. 72 (Winter 2003), pp. 121–25.

———. *Medicine: The Art of Healing*. New York: H. L. Levin, 1992.

O'Connor, John, Jr. "Thomas Eakins, Consistent Realist." *Carnegie Magazine*, vol. 19 (May 1945), pp. 35–39.

Orcutt, Kimberly. "H. H. Moore's *Almeh* and the Politics of the Centennial Exhibition." *American Art*, vol. 21 (Spring 2007), pp. 50–73.

Ormsbee, Thomas Hamilton. "Thomas Eakins, American Realist Painter." *American Collector*, vol. 13 (July 1944), pp. 6–7, 13, 17.

Pacchioli, David. "'And Who Is Eakins?'" *Pennsylvania Heritage* (Fall 1989), pp. 19–25.

Parker, Gilbert Sunderland. "Thomas Eakins: An Appreciation." *Bulletin of the Pennsylvania Museum*, vol. 25 (March 1930), pp. 5–7.

Parry, Ellwood C., III. "*The Gross Clinic* as Anatomy Lesson and Memorial Portrait." *Art Quarterly*, vol. 32 (Winter 1969), pp. 373–91.

———. "Thomas Eakins and the Everpresence of Photography." *Arts Magazine*, vol. 51 (June 1977), pp. 111–15.

———. "Thomas Eakins and *The Gross Clinic*." *Jefferson Medical College Alumni Bulletin*, vol. 16 (Summer 1967), pp. 3–12.

Parry, Ellwood C., III, and Maria Chamberlin-Hellman. "Thomas Eakins as Illustrator, 1878–1881." *American Art Journal*, vol. 5 (May 1973), pp. 20–45.

Patterson, Ross V. "The Gross Clinic." *Jefferson College of Medicine Alumni Bulletin*, vol. 1 (April 1925), pp. 7–8.

"Phila. Art Sequestered." *Art News*, vol. 17 (March 15, 1919), pp. 1–10.

"Philadelphia Sees 60 Pictures by Eakins." *Art Digest*, vol. 4 (mid-March 1930), p. 8.

Pointon, Marcia. *Naked Authority: The Body in Western Painting*. Cambridge: Cambridge University Press, 1990.

Porter, Fairfield. *Thomas Eakins*. New York: George Braziller, 1959.

Prown, Jules David. "Thomas Eakins' *Baby at Play*." *Studies in the History of Art*, vol. 18 (1985), pp. 121–27.

Reason, Akela. *Thomas Eakins and the Uses of History*. Philadelphia: University of Pennsylvania Press, 2010.

Riley, Maude. "Philadelphia Honors Thomas Eakins with Centennial Exhibition." *Art Digest*, vol. 18 (April 15, 1944), pp. 5, 20.

Riley, Robin, and Elizabeth Manias. "Rethinking Theatre in Modern Operating Rooms." *Nursing Inquiry*, vol. 12 (2005), pp. 2–9.

Roberts, Jennifer. "Gross Clinic: A New Book Dishes the Dirt on Thomas Eakins." Review of *A Drawing Manual* by Thomas Eakins and *Eakins Revealed* by Henry Adams. *Bookforum* (October/November 2005), pp. 27–29.

Robertson, Bruce. "Thomas Eakins's 'Wrestlers' and the Practice of Art." *American Art*, vol. 23 (Fall 2009), pp. 82–90.

Rose, Joel. "Operation to Save 'The Gross Clinic' a Success." *ARTnews*, vol. 106 (February 2007), p. 56.

Rosenberg, Eric M. "'. . . One of the Most Powerful, Horrible, and Yet Fascinating Pictures . . .': Thomas Eakins's *The Gross Clinic* as History Painting." In *Redefining American History Painting*, edited by Patricia M. Burnham and Lucretia Hoover Giese, pp. 174–92. Cambridge: Cambridge University Press, 1995.

———. Review of *Realism, Writing, Disfiguration: On Thomas Eakins and Stephen Crane* by Michael Fried. *Burlington Magazine*, vol. 129 (December 1987), p. 813.

Rosenzweig, Phyllis D. *The Thomas Eakins Collection of the Hirshhorn Museum and Sculpture Garden*. Washington, DC: Smithsonian Institution Press, 1977.

Russell, John. "Is Eakins Our Greatest Painter?" *New York Times*, June 6, 1982.

Rutkow, Ira M. *American Surgery: An Illustrated History*. Philadelphia: J. B. Lippincott, 1998.

Sartain, John. "Report of the Chief of the Bureau of Art." In United States Centennial Commission, *Report of the Director-General, Including the Reports of the Bureaus of Administration*, vol. 1, pp. 148–49. Philadelphia: J. B. Lippincott, 1879.

Scanlon, Lawrence E. "Eakins as Functionalist." *College Art Journal*, vol. 19 (Summer 1960), pp. 322–29.

Schendler, Sylvan. *Eakins*. Boston: Little, Brown, 1967.

Sellin, David. *The First Pose, 1876: Turning Point in American Art; Howard Roberts, Thomas Eakins, and a Century of Philadelphia Nudes*. New York: W. W. Norton, 1976.

———. *Thomas Eakins and His Fellow Artists at the Philadelphia Sketch Club*. Philadelphia: Philadelphia Sketch Club, 2001.

Seltzer, Ruth. "Doctors by the Dozens Inspect 'Art of Medicine.'" *Philadelphia Evening Bulletin*, November 24, 1965.

Sewell, Darrel. *Thomas Eakins: Artist of Philadelphia*. Exhibition catalogue. Philadelphia: Philadelphia Museum of Art, 1982.

Sewell, Darrel, ed. *Thomas Eakins*. Exhibition catalogue. Philadel-phia: Philadelphia Museum of Art, 2001.

Shi, David E. "Realism on Canvas." In *Facing Facts: Realism in American Thought and Culture, 1850–1920*, pp. 126–53. New York: Oxford University Press, 1995.

Siegl, Theodor. "The Conservation of the 'Gross Clinic.'" *Philadelphia Museum of Art Bulletin*, vol. 57 (Winter 1962), pp. 39–62.

———. *The Thomas Eakins Collection*. Philadelphia: Philadelphia Museum of Art, 1978.

Silver, Larry. "A New World—Masterpieces of American Painting, 1760–1910" (exhibition review). *Pantheon*, vol. 42 (April/June 1984), pp. 198–200.

Smith, Margaret Supplee. "*The Agnew Clinic*: 'Not Cheerful for Ladies to Look At.'" *Prospects*, vol. 11 (1986), pp. 161–83.

Southgate, M. Therese. "The Cover." *Journal of the American Medical Association*, vol. 250 (July 15, 1983), p. 352.

Stretch, Bonnie Barrett. "'Thomas Eakins: American Realist': Philadelphia Museum of Art" (exhibition review). *ARTnews*, vol. 100 (December 2001), pp. 144.

Sweeney, James Johnson. "The Bottles Were O'Donovan's." *Partisan Review*, vol. 11 (Summer 1944), pp. 335–41.

Taylor, Francis Henry. "Thomas Eakins—Positivist." *Parnassus*, vol. 2 (March 1930), pp. 20–21, 43.

Teachout, Terry. "Anatomy of a Classic Painting." *Wall Street Journal*, June 20, 2002.

Terry, James S. "Artistic Anatomy and Taboo: The Case of Thomas Anshutz." *Art Journal*, vol. 44 (Summer 1984), pp. 149–52.

Wagner, Frederick B. "Revisit of Samuel D. Gross, MD." *Surgery, Gynecology & Obstetrics*, vol. 152 (May 1981), pp. 663–74.

Walker, John. "Eakins in Washington." *Art in America*, vol. 49 (1961), pp. 57–58.

Wallach, Alan. Review of *Realism, Writing, Disfiguration: On Thomas Eakins and Stephen Crane* by Michael Fried. *Art Journal*, vol. 48 (Spring 1989), pp. 956, 997.

Wasserman, Burton. "Thomas Eakins: Artist in Search of Truth." *Art Matters* (November 2001), pp. 16–17.

Watkins, Franklin. "Philadelphia's Centenary of Its Leading XIX Century Artist." *Art News*, vol. 43 (April 15–20, 1944), pp. s11–13.

Weinberg, H. Barbara. "Thomas Eakins and the Metropolitan Museum of Art." *Metropolitan Museum of Art Bulletin*, vol. 52 (Winter 1994/95), pp. 5–42.

Werbel, Amy Beth. "Art and Science in the Work of Thomas Eakins: The Case of *Spinning and Knitting*." *American Art*, vol. 12 (Fall 1998), pp. 30–45.

———. *Thomas Eakins: Art, Medicine, and Sexuality in Nineteenth-Century Philadelphia*. New Haven, CT: Yale University Press, 2007.

White, J. William. *Memoir of D. Hayes Agnew*. Philadelphia: College of Physicians, 1893.

Willard, De Forest. *D. Hayes Agnew, M.D., LL.D.: Biographical Sketch*. Philadelphia: Philadelphia County Medical Society, 1892.

Williams, Tom C. "Thomas Eakins: Artist and Teacher for All Seasons." *American Artist*, vol. 39 (March 1975), pp. 56–61.

Wilmerding, John. *American Art*. The Pelican History of Art. New York: Penguin, 1976.

———. "Philadelphia: Thomas Eakins." *Burlington Magazine*, vol. 124 (September 1982), pp. 583–85.

Wilmerding, John, et al. *Thomas Eakins and the Heart of American Life*. Exhibition catalogue. London: National Portrait Gallery, 1993.

Zigrosser, Carl. *Medicine and the Artist*. New York: Dover, 1970.

Index

Photography Credits